Drawing France

Joel E. Vessels

Drawing France

French Comics and the Republic

University Press of Mississippi / Jackson

www.upress.state.ms.us

The University Press of Mississippi is a member of the
Association of American University Presses.

First printing 2010
∞
Library of Congress Cataloging-in-Publication Data

Vessels, Joel E.
 Drawing France : French comics and the republic /
Joel E. Vessels.
 p. cm.
 Includes bibliographical references and index.
 ISBN 978-1-60473-444-7 (cloth : alk. paper) 1. Comic
books, strips, etc.—France—History and criticism.
2. Comic books, strips, etc.—Belgium—History and
criticism. I. Title.
 PN6710.V47 2010
 741.5'6944—dc22 2009041253

British Library Cataloging-in-Publication Data available

Contents

Illustrations

Acknowledgments

It's said that success has many fathers and failure but one. I'll willingly accept the role of parent for the present work (and hope for something at least in the middle of the two possibilities above) and just as happily admit that there are many who deserve my gratitude for their role in helping me shepherd this project from inchoate idea to finished manuscript. I am sure that there are many that I will forget here, but I can assure you that even if a name that should not be is omitted, when it comes to this thing here there are no small roles only . . . well, there are no small roles.

I once again thank Herman Lebovics; though his later role in the process was more inspirational than anything else, his work on museums and national identity remains my clearest model as a historian and scholar. Getting to this point has been a long trek, and I have benefited from the kind words and sharp ideas of many. If Lebovics is something of a model, Richard Kuisel was an early guide, and I will remember his admonition that the evidence must always speak for itself. I have been lucky these past few years to have had the support of my colleagues in the Department of History, Political Science and Geography at Nassau Community College (NCC). I hope the entire department understands that I could easily thank them all, but I will make specific mention of Spencer Segalla, whom I have known since our days together at Stony Brook University and with whom I have exchanged ideas on French identity, student behavior, and assessment, all while we furtively asked each other about the progress of our respective first books. Department chair Phil Nicholson has always been unflagging in his support, and I have long appreciated and admired the catholic breadth of his knowledge and depth of his understanding. Finally, I thank our secretaries, Ms. Sugar and Mrs. Geri—where would I be at NCC without the both of them?

Outside the familiar confines of my home institution(s) I have many to thank, first among them John Lent, who has taken an interest in my work

from the start. There have been many others along the way but rather than try and remember a list of them let me mention here Laurence Grove. He has provided insightful comments on my work as it appeared in the pages of the *International Journal of Comic Art*, and our electronic correspondence over the past few years has been invaluable in terms of filling in gaps in my knowledge of BD scholarship specifically. I must also thank him and his colleague from the International Bande Dessinée Society Wendy Michallat for their gracious help (at a late hour) with the 1930s images of *Le Journal de Mickey* and *La Semaine de Suzette* that are so important to chapter 2 of this work. It is with their permission that I use these images from their personal collection and the archives of the IBDS. Their work on the history and significance of the medium is among the best examples of BD scholarship available, and I have frequently benefited from conversation, correspondence, or simply reading their work. In presenting my work in myriad forms at various conferences my ideas have always benefited from their public airing, and I should make mention of the encouragement and thoughtful critical analysis I have received in these forums from Charles Hatfield, Nicole Freim, and Joelle Neulander. I am very grateful for Seetha Srinivasan, without whom the University Press of Mississippi likely would not have the formidable comics scholarship publishing section that it does—and in my case, it was she who first thought that my work "would make an interesting contribution" is how I believe she put it. And now that she has moved on to a much-deserved retirement I should thank her able stand-in, Walter Biggins, who has borne my delays with much understanding and (even better) good humor. I'll presume that it was a combination of their good judgment that sent out the manuscript in its earlier stages to the anonymous reader who very thoughtfully commented on the work in its entirety. The whole of it was made much stronger by the reader's insightful critiques and suggestions. Lastly, the careful handling of Anne Stascavage and Shane Gong and the deft touch of copyeditor Debbie Self made the whole of the editorial process virtually painless while Randall Scott provided an index and much more. A first-time author could not have asked for anything more.

My research has been helped along at various points by a number of people. I should mention Brian McKenzie, who helped me navigate the shoals and eddies of the bureaucracy of both the Archives Nationales and the Bibliothèque Nationale de France and (cycling enthusiast that he is) made sure that I witnessed Lance Armstrong's fourth consecutive victory in the Tour de France in the summer of 2002. Of all the staff help at the various archives I visited that summer, I have to mention those at the relatively small Centre des

Archives contemporaines in Fountainbleu as those who likely made my second research trip worth the price of admission. In this I thank head archivist Didier Leclercq—who was surprised then that an American was in France to study the politics of BD—and his chief assistants Arlette Lagrange and Christine Petillat, who made sure that I always made the center-provided mini-bus back to the train station at the end of the day and allowed me free rein to copy whatever I wanted on my own and pay what seemed to me, after some days of frustration, only a nominal fee at the end of my time there. Back in New York, I did a fair amount of work in the Print Collection, Miriam and Ira D. Wallach Division of Arts, Prints, and Photographs, New York Public Library, Astor, Lenox, and Tilden Foundations. Here again I should mention the help I received from Ann Aspinwall, Nicole Simpson, and Margaret Glover, all of whom not only tracked down the illustrations and journals I asked for but pointed out other resources of which I was entirely unaware. It is courtesy of this archive that I include the important caricatures of Philipon and the Dreyfus-era journal *Psst . . . !*, particularly figures 1.1 "Les Poires"; 1.2 "The Replasterer"; 1.3 "A quatorze millions! . . . "; 1.4 "Ch'accuse . . . !"; 1.6 "Coucou, le voilà"; and 1.8 "At the Races."

Sections and pieces of this work have appeared previously in various places. Discussion of the Muhammad cartoon affair and Vichy-era politicization and censoring of BD journals that make up parts of the epilogue and chapter 4 appeared in "Today's Right to 'laugh at anything' was once Vichy's Comic Concerns: The politicization of Bande Dessinée under Pétain," *Contemporary French Civilization* (Winter–Spring 2009). The research and ideas that make up chapters 1 and 2 appeared as "What Your Children are Reading!" in the *International Journal of Comic Art* (Fall 2004), and the historical analysis of the 16 July 1949 Law showed as "Vive la France, Now Who Are We?" in the same journal (Fall 2009). It is with the permission of the journal publishers and their editors, Larry Schehr and John Lent, respectively, that the work appears here now.

Finally, friends and family have long made this journey a bit less arduous and certainly less lonely. As always the Vessels clan serves as an example by dint of simply being who they are, and as I have said before, the support of my parents, who have often asked what I studied but never why, has been among the most important moorings in my life. The folks from the Samizdat reading group have kept me sharp and interested in more than just what is between these covers. Christin Cleaton, Mark Coleman, Ari Grossman, the already mentioned Brian McKenzie, Sahak Saraydarian, and many others all

played important roles in helping me fashion this project in its early stages. My closest friend, Jon Faith, still reminds me that intellectuals don't live in the ivory tower alone, while Robert Saunders continues to force me to think about big ideas in detail and detailed ones in broad form. My greatest debt and deepest thanks, however, go to Lena Jakobsson. Throughout, she has borne my frequent moodiness, my common petulance, and my constant obstinacy with a grace and good humor that I can only presume comes from more care, kindness, and love than I deserve. My writing is sharper because of her eye, my life richer because of her heart. This work is only possible because of her support and is for her.

Drawing France

Introduction

A Force to Beckon With

Better to write of laughter than of tears,
For laughter is the essence of mankind.
—Françoise Rabelais

Deep down, my only international rival is Tintin.
—Charles de Gaulle

In the middle pages of its 2008 year-end issue, the British *Economist* magazine offered a detailed discussion, an explanation really, of the popularity of the Franco-Belgian comic strip—or bande dessinée (BD)—*Tintin*. If the magazine's readers, particularly those across the Atlantic, truly wanted to understand the long-standing appeal of the eponymous boy reporter they "should look at him through the prism of post-war Europe."[1] An easily discerned *old* European sentiment—the gentlemanly hero almost cavalierly capable in nearly all things—commonly runs through the stories; Tintin, for instance, carries no gun himself but is a crack shot when necessary and skilled enough in the art of self-defense that he is capable of dispatching foes double his size with little trouble. He eschews money, even turning down sizable rewards, and is certainly no radical, politically or otherwise, defending monarchies against revolutionaries and, in early stories, was quite comfortable with extremely paternalistic colonial attitudes. Hergé's BDs often appeared to offer up a certain "disdain for transatlantic capitalism." "Villains are frequently showy arrivistes," the *Economist* article suggested. "Old money is good. A gift (as opposed to gainful employment) allows his best friend, Captain Haddock, to buy back his family's ancestral mansion."[2]

3

For all of the apparent Old World surety and ability of the young title character and his expansive cast of friends and companions (save for the bumbling police detectives Thomson and Thompson) the postwar concerns of a shaken Franco-Belgian world ultimately unsure of its geopolitical place are evident from the start. Citing Hergé Studios in-house historian, Charles Dierick, the *Economist* insisted that the "key to Tintin is that he has the mindset of 'someone born in a small country.'" Using cleverness and quick-thinking rather than naked strength or brute force, Tintin is the "little guy who outsmarts big bullies." But, his adventures, as valiant as they might be, operate in a sharply delimited context; one that recognized the borders of action afforded even crafty citizens of Europe's self-consciously second tier of first-rank nations. "He rescues friends, and foils plots . . ." noted the journal, "[b]ut when he finds himself in Japanese-controlled Shanghai . . . he can do nothing to end the broader problem of foreign occupation." That sort of aid and assistance is simply beyond the young reporter, and he—and his creator—well knew it.[3]

Recognition of (resignation to?) global political realities was not the only reason for Tintin's restraint, however. His creation might not have been an enthusiastic capitalist, but Georges Remi—the man behind the pen name of Hergé—certainly was, and as such he frequently demonstrated a keen willingness to adapt his BD for different audiences in order to make it more immediately familiar. Hence, for the Anglo-American market, not only do certain character names get changed (most famously perhaps Tintin's anthropomorphized dog and constant companion becomes "Snowy" rather than the slightly more challenging and personal "Milou") but their "history" is altered as well. Fellow adventurer and the closest thing to a father figure in Tintin's BD world, Captain Haddock, for instance, becomes the descendent of a hero of the British Royal Navy rather than the fleet of Louis XIV and his ancestral mansion "changed from the Chateau de Moulinsart into Marlinspike Hall."[4] This adaptability was pressed even further in the case of the boy reporter himself by making him something of an *everyman* character. While important, though ultimately complementary, characters like Haddock had their stories fitted to specific places, postwar Hergé traditionally (and purposefully) obfuscated Tintin's own background, leaving it at little beyond his being an adolescent of a (pan-) European history. This part of the larger iconic nature of the character, akin even to the slightly blank and open style of the depiction of Tintin himself against a highly detailed and realistic background, "allows readers to mask themselves in a character and safely enter a sensually stimulating world."[5] In the tremulous years of the cold war, when technology made

it possible to travel the world at speeds that only a short time before were the thing of fiction and threatened its destruction at an even faster pace for what sometimes seemed unseen reasons, the ultimately nonthreatening pluck of the young adventurer resonated with and found fans around the globe—particularly among those who felt that they had been rendered powerless in a strikingly bipolar, two superpower-driven world; something that Hergé was aware of and careful about keeping a hold over.

For all of this, there still has never been any real mistaking Tintin's cultural sense of place even if a specific geographic location was made purposely slippery. In commenting on the politics of postwar children's comic strips the media scholar Lynn Spigel once referenced a 1969 *New York Times* article that looked to the chosen mascots of the American space agency, NASA, as evidence of the "very different spirit in which Moscow and Washington approach the cosmos. The Kremlin," the *New York Times* piece continued, "used its Venus rockets to further the cult of Lenin. . . . Apollo 10's astronauts chose to call their two rockets 'Charlie Brown' and 'Snoopy,' after two comic strip characters who represent no ideology . . . but do exemplify the human condition in a frustrating world." Here Spigel pointed out the bald irony of the *New York Times* article by noting that "obviously, the fact that the *New York Times* saw it appropriate to compare Snoopy to a Russian leader underscores the very thing that the author so completely denies. Comic strip characters do suggest ideologies and political choices; they do represent nations."[6] For myriad reasons, this was certainly true (if somehow slightly askew) of Charles Schulz's frequently ennui-riddled Charlie Brown and his kinetic and hyperimaginative beagle Snoopy and the United States. When it came to Tintin, it was always impossible to miss at least his cultural provenance—and in postwar Belgium and France, that was the important thing.

Charles de Gaulle, leader of Free France, head of the Provisional Government in the immediate postwar months, and founder of the Fifth Republic a decade later, was said by André Malraux—himself notable as aesthete, novelist, Resistance fighter, and the first minister of culture—to have compared himself to the BD character "because both were famous for standing up to bullies."[7] No doubt, in the decade-plus that de Gaulle directly governed the country, confronting the shoals of decolonization and the eddies of a two superpower-driven world, that image of unpressed dignity and moral authority is precisely what the general-turned-president would wish to cultivate, though his preferred description of the nation if not himself was more the "Madonna in the frescoes."[8] Though it likely only burnished his reputation among the French,

Tintin was never in need of the general's shrugging endorsement. They long ago overlooked the fact of his creator being Belgian and have simply adopted him as their own, generally pointing to the influence of the French artists Benjamin Rabier and Alain Saint-Ogan on the young Hergé as reason enough to do so should there even be need.[9] To mark Tintin's seventy-fifth "birthday," January 10, 2004, was declared an official day of appreciation with special expositions in honor of Remi unveiled in Paris and the day's programming on the state radio given over to commentary on the importance of the character himself. Meanwhile, the right-of-center *Le Figaro* published a special 114–page edition of the newspaper with 250 illustrations. This was not, however, the first time that the French state paid official attention to the intrepid boy-reporter. In 1999, lawmakers argued the ideological leanings of Tintin in a public debate simply entitled: "Tintin, is he left or right?"; a jovial discussion that was nonetheless occasioned by the seriousness of Assemblée nationale members who also held membership in the official "Club de Tintin."[10]

Yet, for anyone even passingly familiar with the French, if the love of Tintin remains something of a minor mystery—made hazy by the choppy contours of similar cultures fired in separate forges and hammered by different blacksmiths—the consumption of BDs themselves certainly is not. Indeed, though not often commented on with any serious reflection (at least outside of France), there are few cultural artifacts that are now so casually and recognizably French as the beautifully bound, and dutifully collected, BD album while *les journaux illustrés* and (now) even American-style comic books command a broad audience from across the political spectrum, often with seemingly little regard for the age or gender of the reader. In 1986, sixteen thousand French teenagers were asked to list their top choice of reading material as part of a larger poll on general literacy; BDs topped the list with 53 percent of the respondents ranking them as their favorite literary source.[11] Nor are they the typical fare of only the young, uneducated, or, even more pointedly, the intellectually simple. An earlier survey that appeared in *Le Monde* on November 12, 1982, revealed that BDs accounted for some 7 percent of all reading material for the French. Moreover, it seemed to also indicate that the reading of BDs was a largely white-collar and urban phenomenon with many, at least occasional, readers likely to enjoy a rather high socioeconomic and educational status.[12]

As perhaps evidenced by Assembly members being unabashed fans of Tintin, not only does private and individual consumption of BDs *not* bear any real cultural stigma in France, but appreciation of the medium is a widely

recognized and distinctly communal activity. In the last two decades, French BD enthusiasts, or *bédéphiles*, with growing support from the state, have jockeyed their way to a position of being perhaps the greatest critics and appreciators of BDs in the world with an unquenchable hunger for almost all things graphic no matter their origin. Since the early 1970s there has been an increasingly formalized BD "salon" held in Angoulême where the likeminded have gathered to discuss and debate the merits and finer points of the medium and to bestow upon the comic and BD artists who create it any number of prizes and accolades, chief among them the now-coveted *Grand Prix de la ville d'Angloulême*. In 1982, Jack Lang, minister of culture under then-president François Mitterand, began funding BD publishers and artists; and in the grandest demonstration of state support, the *Centre National de la Bande Dessinée et de l'Image* (CNBDI) was opened in 1991 during the now annual festival. Not unlike the famed film festival at Cannes, the annual gathering of BD authors, publishers, and enthusiasts from around the globe in the provincial city has provided a location for *bédéphiles* to come together in ecstatic celebration of the medium. It also lent an air of cultural and aesthetic legitimacy to the form when seen against the backdrop of what is likely Europe's if not the world's greatest repository and research archive of BDs and graphic material.

To paraphrase Spigel, it is not only *specific* cartoon and comic characters that can suggest ideologies or represent nations, but in the case of France at least, the medium itself can be said to do so. In spite of what might seem to be an obvious point—if also seemingly overblown (to some at least)—there have been, and still are, many who would argue its validity. In the last ten years or so, refutations concerning the place that BDs hold in the nation's cultural pantheon have come, interestingly enough, from within the amorphous community of BD artists, publishers, bédéphiles, and (increasingly) archivists, academics, and scholars who insist that much of the state support amounts to little more than tokenism and that maintaining the CNBDI in the medieval city of Angoulême, well outside the capital, is but an attempt to assuage the most ardent fans of a culture-industry that had grown too large to be ignored.[13] More consistently, and for much longer, however, complaints about the casual acceptance of BDs as a healthy part of the country's cultural landscape have come from critics of the medium who have insisted that it was (and is) at best an ugly distraction and at worst a bitter poison for the nation's youth and citizenry.

These critiques of BDs and the arguments about their place within France and the nation's recognized, *legitimate* culture are at the very heart of this

book—the historical grist for my analytical mill as it were. In their 1972 study of comics, Reinhold Reitberger and Wolfgang Fuchs wrote that while it "was the French who first opened the eyes of the Americans to the merits of their mass medium as regards their form and content," they had also been "the biggest puritans in the field of comics."[14] Casting the French as both the world's greatest appreciators of the medium and those most conservative in their approach does not have to be seen as inherently contradictory. In fact, given the right context (or contexts), both positions are perfectly understandable and defensible, and it is these political and cultural contexts with which this work is concerned. Nearly forty years ago the American historian Thomas Milton Kemnitz counseled that "Joke cartoons—and their modern offspring, the comic strip and comic book offer intriguing possibilities to historians beyond the evidence of social attitudes. . . . They will provide," Kemnitz was convinced, "a rich lode of evidence when historians approach humor as an important and revealing facet of society." At roughly the same time the discipline-bounding cultural anthropologist Clifford Geertz offered a similar thought, more succinctly put, when he insisted that to understand a joke is to understand a culture. I have taken both notions as guiding principles here, adding only that it is often just as necessary and equally revealing to understand why the audience laughs at a particular joke—or not.[15]

If BDs, and popular graphic art and literature broadly, are a well-accepted and even embraced cultural form and artifact in the France of today, it was not long ago that the general impression and political fortunes of the medium was markedly different. One has but to look back only as far as the first few years of the new millennium to find an example of both national prejudice and cultural chauvinism. The 2004 BD festival at Angoulême offered its first official celebration and recognition of *manga*, the favorite Japanese style of BD. In doing so, the festival roused a broad chorus of voices in opposition. Though manga is often both hyper-violent and sexual in its graphic content, neither of these concerns seemed to have been the real reason for the uproar. This is not to ignore or dismiss those who have raised issue on these or similar grounds. The prominent socialist politician and 2007 presidential candidate Ségolène Royal, as both a mother and a figure entrusted with some measure of care over the public good, has long declared an open issue with the BD "genre" and its frequently brutal portrayal of women and made her concern a popular part of her political persona.[16] However, when it came to manga, the issue was in many ways simpler than even objection to the common violent and sexual obscenity; the concern was more than anything else the seemingly sudden and

deep penetration of the Japanese-derived product into the cultural sphere.[17] In 2003, manga accounted for nearly a third of the 1,860 new BD comic books or albums produced that year, a figure that represented a three-fold growth in the BD market from only two years prior. The fear of many who voiced concerns was that France would soon become like Japan, where some 40 percent of all publications are manga related and far fewer people read what is most often simply called "serious literature."[18] On the other side of this debate were the suppositions by some that this latest craze in the BD industry might well be saving the French publishing industry.[19]

All of this was interesting and important for myriad reasons, not least of which because it nearly mirrored a debate from the 1930s in tone if not tenor. Then, it was the American-derived BD journals vanguarded by the *Journal de Mickey* and a clamoring that consumption of the relatively new medium amounted to a particularly insidious form of *Americanization* that would lead to illiteracy among the young, and worse yet, foster a disposition toward fascism. Plainly it is not just Tintin, but the cultural importance and political weight generally afforded BDs in France is sometimes difficult for American observers to quite understand. Yet, though now often forgotten, the United States had its own cultural wrestling match with cartoons and comic strips. It was a furor crystallized, if not begun, by the New York–based psychiatrist Fredric Wertham and his polemical *Seduction of the Innocent* and included congressional hearings in the mid-1950s. However, the adoption of a self-censoring "Comics Code" by the industry in the United States likely circumvented, if not ended, much of the public debate over the medium that was to continue in France.[20]

In France, the situation was different and—paraphrasing the influential French sociologist Pierre Bourdieu—when speaking of cultural products one should always realize that they talk also of politics; a notion made abundantly clear by the article from the *Economist* magazine, referenced at the start here, which opens with the lines: "It is one of Europe's most startling laws. In 1949 France banned children's books and comic strips from presenting cowardice in a 'favourable' light on pain of up to a year in prison for errant publishers." Commonly referred to as simply the "16 July 1949 Law" in recognition of its date of passage, the law, as the *Economist* article demonstrates, has most frequently been characterized as having its "main aim" be "to block comics from America."[21]

This interpretation comes from a distillation to its most essentialist components the argument of Pascal Ory (likely the best-known French historian of

BD) in his groundbreaking historical essay on BDs and Americanization and even French anti-Americanism. For him, the success of BDs and the entire graphic/illustrated medium marks a stark victory for the French over their principal rivals in matters cultural post–World War II—a site of *désaméricanisation* or de-Americanization.[22] Their very popularity signaled to Ory that the French are fully aware of the medium's worth and merit as an art form and their appreciation is an (unconscious perhaps) example of the special responsibility the French have as caretakers of the world's cultural heritage.[23] Yet, as intriguing as much of Ory's analysis is, it remains too caught in the present climate of overt appreciation of the medium that has prevailed in the country (among at least some) for the last thirty-plus years as well as the perceived threat to the national culture of France that America's stultifying mass culture posed post-WWI. Nonetheless, his work on the political history of BD and his analysis of its cultural import has generally been the most influential paradigm in studying the medium in France.

Even where the idea has been taken further and (as a matter of history) farther back, the focus has remained on demonstrating that the bulk of the clamor for censorship of the medium have most always been in response solely to an invasion *étrangère*, and one that was principally American in origin. Frequently, this is then dovetailed into a version of Ory's articulation of cultural victory by insisting that the relative *âge d'or* of French BD in the decade or so after WWII was the result of a shift in the taste of young French consumers who now hungered for realistic tales inspired by the French Resistance rather than the banal offering made by most American-derived or -inspired BDs. This argument is often partnered with a further insistence that the 16 July 1949 Law—and the Oversight and Control Commission established by the legislation—was not directed specifically at American BDs; strictly and legally true, but as a matter of consequence near to irrelevant given that American examples of the medium were often held to be, and used as, examples of all that was worst about BD. Moreover, many have simply held that the legislation ultimately had little practical effect on the *presse enfantine*. Its edicts, as Maurice Horn has suggested, more honored in the breach than not.[24] For those, including Ory, who argue a version of this, there is a certain sense in which their telling of the history of BD in France leaves the phenomenon of its popularity as one rooted entirely in a ground-level, *French* man on the street, organic approval of the illustrated journals. In this, and even with Ory's shriller, more militaristic sounding, pronouncements of "victory" muted there remains a certain Pells-ian sense in which the French, in a familiar process of

appropriation by expertise, have taken on an underrealized cultural artifact and made it their own.[25]

No doubt this telling of things fits well in the broader postwar narrative of the French nation and people as the world's cultural arbiter. It also reduces much of the history (until recently perhaps) of BD and the image in modern France to one that leaves it as something that happens/ed largely outside *l'Hexagone* and *to* the country—something it must react to in one way or another, for some (see above) a literal fending off of a foreign invasion. Time and time again, however, when considering the ambivalent relationship of the French state and people with BDs we are drawn back by domestic issues and into the nation's internal concerns by the currents of the metropole even as it was, itself, being constructed.

The cultural issues raised in passing the 16 July 1949 Law have often been dismissed as mere cover for economic protectionist policies or, as in the case of the *Economist* article, as high-minded rhetoric papering-over baser ideological politics.[26] In some measure both estimations are correct in their own fashion but allowing for that is not so much a concession to economic materialists or political essentialists as much as it is recognition of the place of culture at the heart of the French Republic. At various points in the nation's history the fragmenting pull of regionalism, clericalism (and its political mirror-image monarchism), and, particularly in the twentieth century, non-European immigrants have forced the "French state to concern itself deeply with the cultural life of its citizens in the areas of language and aesthetics." "Culturally," wrote Herman Lebovics, "national unity took the form of a population assimilated to a common civilization" while "French republicanism interpreted the logic of the nation-state as requiring that political boundaries approximate cultural ones, or more exactly, that to share in the life of the nation one had to be part of *the* national culture."[27] After WWII, with its legacies of the Third Republic's quick capitulation, the years of Occupation, and Marshal Pétain's collaborationist regime, there was arguably an even greater need to rebuild the nation's sense of self and the national space all citizens shared than the buildings that had been demolished or the rail lines that had been torn up.

National cultural spaces, like national identities, are constructed and evolving. Hewn out by principal institutions such as educational and political systems, print culture and other media, they are, to latch onto Benedict Anderson's persuasive idea, "imagined communities" that allow masses of people to huddle under the gathered tents of religious, ethnic, historical, linguistic, or simply cultural sameness.[28] For much of the last two centuries, the

French have tended to resist or deny, at least at the institutional level, straying from a national culture defined fundamentally by secular republicanism and appreciation of (high) art, limned by literacy and language fluency that served as the key to its navigation. But this vision of the national self, the body politic as vigorous and unified, requires frequent and direct massaging to be maintained, for it is an image of the state that demands active citizens who (seemingly) freely leave aside parochialism and privilege the national over the local. In France this has meant that the existence of "centralized, highly privileged institutions has long been characteristic of French cultural life."[29] They have been a political tradition in fact, dating back at least to the monarchy of Louis XIV, where they were necessary for his "transformation . . . from a weak monarch into the all-powerful *roi soleil*" that dominates the historical narrative of the *natural-ness* (to borrow from Roland Barthes) of the potent centralized state in France.[30] Something that was made all the more necessary, as an increasingly broad audience recently learned (or was reminded), by the fact that it was not much more than a hundred-plus years ago that as a country, France (and the French) was still more a "vast encyclopedia of micro-civilizations" than it was a unitary national whole.[31]

As a consequence, the basis of the imagined community of the French nation-state, its "fictive ethnicity," is fixed from the center by way of an adherence to a "linguistic community" that binds its communicants to what can be "a terribly constraining ethnic memory, but . . . nonetheless possesses a strange plasticity: it immediately naturalizes new acquisitions." The act of speaking the language, and the whole of discursive action, then creates a web that is both forever present and self-renewing and that connects all parties within the community by an "uninterrupted chain of intermediate discourses" no matter the physical distance or disparity of power between them.[32] In France, language competence and, even more, literacy allow access to the national cultural space and are also the tools by which the particularities of various cultural signifiers are managed so as to transform a potential "battleground of meaning" into "a shared point of departure." The result of this is the turning of mere cultural homogeneity into "hegemonization," a more thorough process, though often limited to the direct metropole with its effects loosening in "the social margins."[33] As a result, the state has long been invested in protecting the *French* language and guarding against its corruption as it also serves the function of a powerful "symbolic 'border guard'" not only admitting citizens to the national cultural space but steadfastly refusing entrance to those without the

necessary linguistic tools and limiting the voice of those whose skills are less than perfect.[34]

There is little doubt that the state has long demonstrated a great deal of serious concern if not always effective control over the language in France, with the annual pronouncements of L'Académie française concerning corrupted language and banned words often providing spots of unintentional humor for many both inside the country and out. But language and language uniformity was also at the heart of the most revolutionary parts of the national project almost from its beginning, and when the parliament voted in 2008 to offer official constitutional recognition to the more than seventy regional languages that once flourished in the country L'Académie française issued a stern warning that to do so was "an attack on French national identity."[35] Whether these sorts of stuffy pronouncements appear out of place in today's increasingly digitized and globalized world they do serve to demonstrate the central place of importance that language holds in the construction and maintenance of a specifically French national identity and it is with this understanding that we must consider the complicated relationship between the French people, the French nation, and BD.

In many respects, bande dessinée has at least two strikes against it from the perspective of traditional national culture. It will likely always be a difficult cultural sell to convince most people that the medium is anything more than commercial art at best and certainly not high art as the category (slippery as it may well be) is typically understood. Second, because BD does not *fit* as art, it must instead be primarily a means of general communication and, as such, is deficient for its reliance on crude and exaggerated drawings of appeal largely to the lower instincts. As such, it was long seen as suspect and, given the popularity of illustrated prints and posters in the years after the Revolution, the image was believed to be "potentially more dangerous than the printed word."[36] These were the presumptions and prejudices that animated the charges of *lèse majesté* against caricaturists and publishers like Charles Philipon in the nineteenth century, that drove public debate over the dangers of the medium for children from both Catholics on the political right and Communists on the left (while both were publishing their own *journal illustré*) in the 1930s, and demanded the passage of the 16 July 1949 Law as the nation was rebuilding post-WWII.

While allowing for the shifts of different political personalities and the particularities of specific historical incidence, suspicion and derision then has

been the context for BD and images for much of the history of the French Republic. But the context today is much different; where before there was active prosecution now there are state-supported festivals, and where there had been a social presumption that BD journals were the simple fare of the delinquent there is now recognition that sophisticated professionals favor many journals. Still, this is not simply a triumphalist history of a maligned medium finally taking its place in the nation's pantheon of celebrated cultural forms as *Le Figaro* was to declare after the plans for the Centre National de la Bande Dessinée et de l'Image came to light during François Mitterand's presidency. As will be seen in the pages that follow, criticism of the unmediated image, in both the nineteenth century and the twentieth, tended to be most vehement in times of political crisis and evolution of the national experience and experiment. Conversely, its slow valorization as an art form began in the 1960s in the midst of the *trente glorieuses*, or thirty glorious years of economic development, and after the bloody worst of what ultimately was an ugly process of decolonization, and reached its apex (thus far) as a nodal point in Jack Lang's reconception of the nation's cultural policy during Mitterand's presidency. In short, there is a striking and discernible trend wherein either the criticism or valorization of BD and sundry images has been most vehement at nearly the precise historical moments when concern for the stability of the French state and the definition of what it meant to be *truly French* was most pointed.

This book then is not so much a history of BD or the unmediated political image in the Republican era, and it is certainly not a meditation of the evolution of the modern BD in France (some of the better examples of both are listed in the bibliography). Rather, it explores the shifting political and cultural place of the image and BD through a rough combination of social discourse, governmental policy, and popular culture. The subject of the work is not simply the place of BD in French society but the eternal construction of *Frenchness* itself—a moment and method of investigating the nation as it transitioned from civil monarchy to civic republic and finally to a multiethnic, multicultural and multitongued nation; from choppily literate, to a Republic of Letters, and now a vivid multi-imaged state.

One quick, if important, note: with its renovation and expansion, the CNBDI also underwent a name change to the Cité International de la bande dessinée et de l'image (CIBDI) in 2009. As most people are still most familiar with the institution by its original name—and are likely to remain so for the

immediate future at least—I have kept to the CNBDI throughout the present work. That does raise one additional issue concerning the terminology used here. In general, deference is given to the French names of various cultural products and I have tried to avoid the easy Americanism of "comic book" because, unless the topic is the specifically American-style thirty-paged single-story small magazine, there is nothing specifically analogous in the French illustrated press. In addition, for those who are specialists of the medium or simply sticklers for precision in description, this work might well prove irritating. I have both interpreted and used the terms bande dessinée, journal illustré, and so forth quite liberally throughout and with little real or overt distinction made between the single-paneled cartoon, caricature (political or otherwise), the multipaneled BD, or the journals in which any of them appeared. This is not to say that I treat each of these as essentially analogous, and in many instances throughout the book, the distinction is likely clear enough for those for whom such makes a difference, and an occasionally pointed reference is made to one characteristic or another that indicates that a journal or BD should be seen in one tradition or another. However, there is just as often little explicit discussion of medium form or the name given to it. In part, this has been done with purpose. The state did little to distinguish either its reprobation or more recently the championing of either BDs or the political cartoons of Muhammad in 2007. Instead, most all instances of the illustrated press in France were approached from a similar place of presumption; *Le Journal de Mickey* in the 1930s, for instance, was treated with much the same concern and described with much the same language as that used to condemn Philipon's *Les Poires* in the 1830s. In fact, it too often seems that the distinctions and categorizations made by specialists between one type of illustration and illustré or another in the nation's graphic tradition have made the parceling of its history not only possible but also seemingly appropriate. As a result seldom has an overarching history that directly ties the development of the medium to the development of the nation itself been managed; this work seeks to redress that oversight.

Chapter One

Stirring up Passions

Politics, Bande Dessinée, and Images in the
Nineteenth Century and the Late Third Republic

The picture-story . . . has great influence at all times, perhaps even more
than written literature.
—Rodolphe Töpffer

Caricature is not only a grotesque picture. We use it in turn to make a mirror
for the ridiculous, a whistle for the stupid, a whip for the wicked.
—Charles Philipon

I am one of those who believe that caricature is a weapon of the disarmed.
Laughter makes a hole in the wood of idols.
—Jules Valles

Our system of culture is founded on printing.
—Georges Duhamel

Drawing from Europe's palette but pushed by profit, the developmental history of the comic strip/bande dessinée in the United States is fairly straightforward despite its variegated forms today. In the urban and largely immigrant settings of Hearst's and Pulitzer's publishing enterprises, the daily comic strip was a colorful and eye-catching balance to the staid rows of type—especially for those who might not have the firmest grasp of the English language. By

the early 1930s, the pollster George Gallup had issued a report that "the only parts of a metropolitan newspaper consistently 'read' by over forty percent of both men and women were pictures and comics." Product advertisements were placed in BD supplements and themselves made use of the aesthetic conventions of the medium, further blurring the line between entertainment and calls to consumption, while Hearst sold advertisers on the opportunity to share space on the page with his most popular *stars*.[1] In short, the American BD, since its inception, has been both a product and reflection of the visual-, or image-, dependent consumer culture that has been developing in the United States, and the West generally, since the late nineteenth century.

The history of the medium in France begins earlier and is more sinuous and directly political than that in the States.[2] This is the case for a number of reasons, not the least of which being simply that raising originary questions for BDs in France opens debate as to definition of the medium, as well as its antecedents and authors. But even more, while the comic strip of the United States might well be considered the medium's modern form, it is also associated with the weekly and daily newspaper as a constituent part of a larger whole. The result of technological advances in the printing process (the colorization of print, for instance) and turn-of-the-century newspaper wars, the comic strip had behind it an economic and commercial concern.[3] The BD in France, however, emerged as a separate entity and (often political) publication, or *journal*, all its own, *le journal illustré*.

It would be both easy and, by some definitions of the medium, correct to simply begin with the Swiss schoolmaster and draftsman Rodolphe Töpffer and his "histoires en estampes" (picture stories), as any number of scholars have done, when considering the insular history of the medium in France—particularly given the broad francophone, cosmopolitan, and synthetic nature of French literature generally and BDs specifically.[4] Indeed, his little books attacking "human frailties or ridicul[ing] some current absurdity" were immensely popular in both Switzerland and France, and his influence across Europe in the nineteenth century is hard to deny.[5] Goethe once commented of him that, "if for the future, he would choose a less frivolous subject and restrict himself a little, he would produce things beyond all conception."[6] However, beginning with Töpffer ignores that France had a tradition of pictorial storytelling that predated the appearance of the Swiss man's work.

A style of didactic religious pictograph storytelling emerged in France dating from the fifteenth century, intended for a largely illiterate public. Perfecting it in 1796, Jean-Charles Pellerin created what is now known as the "Images

d'Epinal," named for the town in France that quickly became the center of production for these picture stories. These often highly detailed and colored pictographs and broadsheets were painstakingly produced by first engraving the desired image on a wooden plank and printing each sheet individually with a black-and-white reproduction which was typically then colored with stencil key sets by an illustrator. Prior to the Napoleonic age, they were used by both anticlerical revolutionaries and antirevolutionary Catholics to spread their respective messages. With the inauguration of Napoleon as emperor, these pictorial storyboards were marshaled by the government to spread the "Legend Napoléonienne." In other words, the production of prints and pictographs and their use as a potent form of political culture developed right alongside the French Republic. In fact, so popular were many of these prints among the masses in the years after the Revolution, posters and illustrations were often "considered potentially more dangerous than the printed word."[7]

With the Bourbon Restoration and the Constitution of 1815, a cautious freedom of the press was reestablished. However, in debates over the proliferation of "Images d'Epinal," circulating as posters and broadsheets in the commercialized spaces of Paris and other cities, conservative legislators nonetheless expressed concern about the potential for the development of a new crop of revolutionary sansculottes. In 1822 Claude-Joseph Jacquinot-Pampélune addressed his fellow deputies in the Chamber: "Caricatures and drawings, offer a means of scandal that is very easy to abuse and against which repressive (post-publication) measures can be only of very little help . . . as soon as they are exhibited in public, they are instantly viewed by thousands of spectators, and the scandal has taken place before the magistrate has had time to repress it." His fellow deputy, Louis-Ferdinand Bonnet, agreed and pushed for a broader censorship of published illustrations because "there is nothing in the world more dangerous and whose danger is propagated more quickly than the sale and exhibition of drawings that offend mores or laws, or that manifest factious intentions."[8] Nearly a decade of governmental press "watching" followed, though, as might be expected from the above, caricature and political images generally bore the fullest brunt of repressive legislation.

The legislative start of the July Monarchy of Louis-Philippe in 1830, however, brought a liberalization of legal strictures against caricature, and there was a concurrent explosion of the form that quickly settled into a quasi-monopoly of the market by one man—the graphic artist and entrepreneur Charles Philipon. Little is really known of the man who dominated illustrated publishing in France prior to his emergence in the first years of the July Monarchy save

for what he revealed himself in an 1854 letter written to his friend, the caricaturist-turned-photographer Félix Tournachon, who used the professional pseudonym of Nadar. Written in response to a request from Nadar for information to be included on an entry about the successful publisher in a popular biographical journal, Le Musée français, it was wrapped in a romantic gauze of jovial self-criticism that detailed his early years as being ones of political idealism and professional struggle in the student quarters of Paris's Left Bank. The son of a Lyon wallpaper manufacturer he studied art in Paris and likely was more known, in those days, for his wit at the dinner table than for any work he actually produced. Some vague involvement in a republican political rally after he had begrudgingly returned to Lyon to work for his father designing new prints and patterns precipitated his happy return to Paris in 1824.[9]

Though even some contemporaries seemed to believe that his devotion to Republican politics came second to an inherent sense for commercial opportunity, Philipon boasted before the Cour d'Assises, when charged with slandering Louis-Philippe in a caricature in 1831, of fighting in the streets during the July Days insurrection that preceded the citizen-king's assumption of the throne.[10] No matter the reasons, not long after establishing his own print and publishing house in 1830, La Maison Aubert, Philipon directed the largest and most cohesive caricature journals in all of France. And, with the flagship title, La Caricature, carried on a relentless attack on the citizen-king's government for almost the entirety of its "life" from November 1830 to August 1835.

Such a withering and consistent critique of the Orléanist monarchy did Philipon appear to direct from the pages of his journal that even foreign commentators passed judgment on the import and impact of his publications. In his 1834 work on French politics and society, the English baron Henry Lytton Bulwer asserted "no thorn goes deeper into the side of the King of the French than Mr. Philippon [sic]" and guessed that his work was more important and influential in French politics than the combined houses of the legislature.[11] It also landed him before the court on several occasions, costing him months of freedom, as he was sentenced to more than thirteen months in prison and thousands of francs in fines. Between late 1831 and mid-1833, he was convicted before a jury at least three times and he wrote himself that he "could no longer count the seizures, the arrest warrants, the trials, the struggles, the wounds, the attacks and harassment of all types, anymore than could a carriage-rider count the jolts on his trip."[12]

The first two months of La Caricature's printing was a succinct period of maturation for the journal with little cohesion between articles and

lithographs, with Philipon instead allowing his stable of artists to sketch their fancy of the moment; but, on December 23, 1830, the definitive format and direction of the journal was set.[13] Sold exclusively through subscriptions with lithographs of collectible quality, Philipon courted the idea that subscribers to *La Caricature* were part of a discriminating community. However, whether it was due to commercial opportunism or heartfelt political belief, he also forged a strict alliance of the journal with the republican ideals of liberty and equality. "All truth is good to speak," was to be his motto and he promised "war with [government] abuses!" "When they try to crumple me," he swore to shout and though the government would try and "hang my voice," at least "I will have shouted. . . . For the man who thinks, dumb suffering is a crime, or at least cowardice." At the first of his numerous trials, Philipon criticized the government "for being frightened of a drawing" and coming to "fight body to body with a caricature." What a powerful "adversary," he continued, it had chosen "in its noble fights." Insisting that Louis-Philippe and his regime had belittled themselves by prosecuting his insignificant drawing, he argued that they had also made clear the direction and task of caricature generally and his journal specifically: "Such is the mission of Caricature, to excavate the ridiculous and to make justice of it."[14]

Philipon did advertise *La Caricature* as one of the cheapest means available for servicing a lithographic collection of exclusive prints. However, the personal reporting on nearly every seizure of an issue by the authorities (usually accompanied by a rebuttal or rebuke) as well as his court appearances meant that the community of subscribers, fully aware of the sort of publication they were supporting, were also engaging in a willful political act. Because of the inexact manner in which the information was gathered by the regime, circulation figures for the journal are hard to pin down. However, though a bit suspect (as we could expect Philipon to inflate the number of subscribers in an attempt to concomitantly inflate the newspaper's importance and influence) it is possible to get a sense of the growing popularity of the journal by charting his own published apologies for a lack of promised colored prints and delays in production.

Starting as early as the beginning of February 1831, he was forced to admit that the unexpected success of the journal in its first few months had limited the number of colored lithographs (which still had to be done largely by hand) to far fewer than he had promised his subscribers. The task of hand inking prints had simply proven to be too much for his small staff. Over the next year, there were at least four more apologies and calls for patience as promised

prints and issues would be released as soon as they were available. Each time, the problematic number grew, from some eight hundred in February 1831 to two thousand by March 1832.[15] While his practice was to keep a reserve stock of back issues for new subscribers, issue number 84, June 7, 1832, carried a warning that the entire store had sold out but a second printing was on its way.

Given that a newspaper subscription was still a relative luxury for most during the July Monarchy, a subscription rate of between one thousand and two thousand for *La Caricature* would place it among the ranks of the more popular journals of the day. Moreover, several hundred of those subscriptions were held by cafés, *cabinets de lecture*, and other clubs, all of which served to widen readership even further; those who might not be able, or care, to maintain a full subscription could peruse what they wished over a glass of wine or even, for a meager fee, take issues home for the evening. The role of these establishments in formation of social and political relations among the French populace is almost impossible to overstate. Since the days of the Revolution and the first Napoleon, restaurants had operated as quasi-public/semi-private spaces; providing "polite male society with" a "necessary safety valve" while everything about them, from the "voluminous wine lists . . . to the smells emanating from [the] kitchen's street-level grates" bespoke the "progress of modern urban life."[16] Cafés, on the other hand, referenced (and lauded) not private accomplishment but public community and sociability and fostered the creation of "micro-societies," which contemporaries called "café friendships." Men of differing social and economic stations milled about together, engaged in discussion and serving as (sometimes unsuspecting) pedagogues for one another in interactions that were "an ever shifting and intricate mosaic . . . of social relations . . . that was simultaneously intimate and anonymous."[17] These physical settings, both semiprivate and communal, coupled with ready availability to the days' popular journals, served to create, in the loosest sense perhaps, an interpretive community that gleaned direction from both within and without. And, in a social and political landscape where the parameters of dress, habit, and behavior for a society based on achieved, rather than assigned, station were still being defined, caricatures—particularly when "read" in sites of such easy comparison and juxtaposition—often served to visually define markers of distinction of various social types, providing a means of concatenation with or against them.[18]

The frequency of café and restaurant references, both print and image, in Philipon's sister publication to *La Caricature*, *Le Charivari*, might actually evince that the editor-artist-publisher was well aware of the impact and

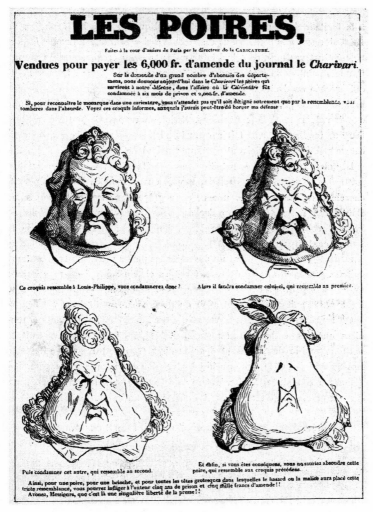

FIGURE 1.1 "Les Poires" as it appeared in Philipon's other journal, *Le Charivari*, January 17, 1832. Courtesy of the Print Collection, Miriam and Ira D. Wallach Division of Art, Prints and Photographs, The New York Public Library, Astor, Lenox and Tilden Foundations.

importance of these establishments.[19] Still, in the case of *La Caricature*, however, there is no need to rely solely on circulation numbers, whether held by individuals or institutions, however precise or open to question they may be, to gauge his success or the journal's influence. Rather, the adoption of a common piece of fruit—*la poire*—as a symbol first for Louis-Philippe and then

the entire regime by those in opposition to the government might serve as a far better indicator. There have been few political caricatures, in France or elsewhere, as ballyhooed as Philipon's *Les Poires* (fig. 1.1).[20] His four-step progression from a likeness of the king's face and head to a near overripe pear was so popular and so widespread in its adoption as a symbol of opposition to the July Monarchy that its stature in the history of BD, as well as the political history of the period, continues to grow. Consequently, the body of literature on it has itself become so immense that at least one commentator has insisted that it has become impossible to think of Louis-Philippe's reign without now, at least cursorily, thinking also of that plump fruit.[21]

Interestingly, the caricature itself has become so (in)famous that its origin—its *raison d'être*—has often been simplified, obscured, or simply lost. What has not been overlooked are its roots somewhere in the midst of the legal battles that Philipon often found himself embroiled in the first five years of the 1830s. Still, *les poires* has generally overshadowed the offending image that forced Philipon's appearance before the *Cour d'Assises* and become the presumptive offense in many of the concerned narratives. For instance, E. H. Gombrich insisted in his interesting discussion of caricature that "when Philipon's satirical papers continuously pilloried the King as a poire, the editor was finally summoned and a heavy fine was imposed." "The famous sequence," Gombrich continued, "a kind of slow-motion analysis of the process of caricaturing, was published in his paper as his defense. It rests on the plea of equivalence. For which step, it asks, am I to be punished?" In fact, some version of Philipon defending himself by asking if it was his fault that the king's head looked like a pear has become the reflexive refrain and beginning point in nearly all analysis of the event or the caricature's significance. Given that a "poire" was also slang for a "fathead" or imbecile (as well as having a number of other, even less savory, meanings) Gombrich insisted that this was an example of the best attributes of caricature. "For this is the secret of good caricature—it offers a visual interpretation of a physiognomy which we can never forget and which the victim will always seem to carry around with him like a man bewitched."[22]

While this analysis of the impact of Philipon's most famous caricature is likely aesthetically correct, it remains a case of, at best, the end justifying the means because it is incorrect both chronologically and by Philipon's own artistic intent. Most immediately, it was not the famous morphing cartoon that brought on the charge of *lèse-majesté* for the publisher of *La Caricature*. Rather, it was a far more modest lithograph, which

FIGURE 1.2 "The Replasterer," *La Caricature*, June 30, 1831. Courtesy of the Print Collection, Miriam and Ira D. Wallach Division of Art, Prints and Photographs, The New York Public Library, Astor, Lenox and Tilden Foundations.

appeared in his journal June 30, 1831, titled *The Replastering*, which had the king (or a figure which resembled him), dressed as a common mason, white-washing over the promises of 1830 plastered on the walls of Paris. A simple yet loaded image, it did far more than project the citizen-king as plebeian. It was a pointed reminder of the political fact that Louis-Philippe was to rule as a monarch *of*, not *for*, the people, while referencing Adolphe Thiers's public action of postering Paris during the heady July Days having been instrumental in birthing the *Orléanist* regime (fig. 1.2).

Charged with attacking the person of the king as well as his authority, Philipon was brought before the *Cour d'Assises*, on November 14, 1831. Addressing the judge and jurors of *Procès du No35, de La Caricature*, he noted that the government's case was based on nothing more than that the workman in the drawing bore a resemblance to the king. However, this could not be enough for a true court of law.

Though almost in passing, Philipon wondered aloud whether the "dignity of the monarch" was not offended more by the "publicity of these debates" surrounding a sketch some three months old than by any passing resemblance shared between a fictive mason and the crowned king. Still, he argued that the sensible jurors who sat in his judgment had before them a decision: were they going to rely on something as slippery as a resemblance, as if it "were the property of one man," to determine guilt? Because, he claimed, that could lead only, and at best, to a "system of accusation" not a tribunal based on fact. There had to be more than simple resemblance, for as Philipon insisted:

> That the person of the king can be reached [by image alone] is very doubtful. A resemblance, even if perfect, is never an attack, you should not recognize it as such, and you must keep from sanctioning it as such by a conviction. The injury [charge] is precise and is proven only by the name of the king, by his titles or his insignia joined with his image, in which case, resemblance or no, is guilty and deserving of punishment.[23]

Surely, if the inviolability of the monarch were impugned, the guilty was deserving of punishment. However, Philipon insisted that appearances, resemblances, were too passing and too common a balance on which to wager a man's liberty. Identity was a thing made (by individual or society it did not matter, so long as it was understood to be created) and notated, while appearance was physical and the court had to recognize the distinction to maintain its own legitimacy. Because of this, he continued in his defense by asking if "the king is designated in our drawing by his name, by his titles, or by his insignia? Not at all! Therefore you must believe me when I say to you: It is power that I represent by a sign, by a resemblance that can belong just as well to a mason as to a king; but this is not the king."[24]

With his lecture on legal semiotics in the courtroom, Philipon hastily proffered as explicative evidence the now famous caricature of Louis-Philippe morphing into a pear, drawn as he sat before the jurors. The four sketches related to one another by a near "insensible link" that tied them together as

a recognizable whole. However, while the "first resembles Louis-Philippe" and, by progressive link, the "last resembles the first" it still was not the king. Emphatically Philipon insisted, "It is a pear!"[25] If the court could not recognize that royal identity was secured more by the station than the man who sat on the throne it "would not be able to absolve this pear."[26]

A system of relying on resemblance to condemn graphic work would soon "fall into absurdity," Philipon warned, as "you would [then] have to condemn all caricatures in which one could find a narrow head at the top and a wide bottom." If this was to be the legal path taken, Philipon promised them more of a task than they might wish, as "mischievous artists" would enjoy demonstrating "these proportions in a crowd of things more than bizarre." He made a final, perhaps more practical, appeal, insisting that such actions would not be simple mischievousness on the part of a handful of designers but backlash from the thousands of artists and printers whose livelihoods such a decision would imperil; how would that raise royal dignity? Unfortunately, none of Philipon's ingenious defense arguments swayed the court. After thirty minutes of deliberation, the jury returned a guilty verdict and sentenced him to six months in jail and a 2000–franc fine.[27]

Nonetheless, the proof of Philipon's warning was borne out by the speed with which his association of the king with a pear was adopted in the popular political culture. Ten days after his trial, as he had promised to do in a footnote to the transcript of his defense which appeared in the previous issue, Philipon published a lithograph of his courtroom caricature in issue number fifty-six of La Caricature. While the authorities reacted predictably in confiscating every copy of the issue they could, the assimilation of Louis-Philippe with a pear was nearly instantaneous and its adoption by the monarchy's critics was equally rapid. From January to April 1832, there were no fewer than eight caricature lithographs that made direct use of a pear in reference to royal authority or action and at least three more which made pyriformic references—relying on images that were wide bottomed and tapered at the top, often with some manner of curlique standing in for the fruit's stem—in La Caricature alone. The caricatures were not simply broad jest made at the heavy-jowled citizen king's expense; in more than one instance a shined (and seemingly golden) pear was used to apparently indicate that the king had become an expensive and, ultimately, useless extravagance.[28] But it was not from Philipon's publishing house alone that the image made its way into the public sphere. In short order, pears made their way on to the walls and into the arcades of most every major city in France. The mayor of Auxerre, according to Philipon, was forced to alter

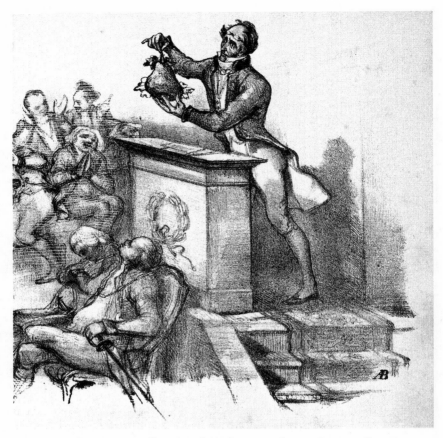

FIGURE 1.3 "A quatorze millions! . . . ," *La Caricature*, January 19, 1832. Courtesy of the Print Collection, Miriam and Ira D. Wallach Division of Art, Prints and Photographs, The New York Public Library, Astor, Lenox and Tilden Foundations.

his municipal signs, adding a prohibition against the "drawing of any form of pear" in addition to the more traditional "no dumping of any form of garbage."[29] Only four months after Philipon's pearification of the king, the German poet and satirist Heinrich Heine referred to the fruit as France's "standing national joke"[30] (fig. 1.3).

Philipon was clearly pleased with this turn of events writing that:

We admit that it is not without a legitimate sense of paternal vanity that we have been watching this grotesque figure invade the walls of the capital, and not only of the capital. . . . It is by the quantity of pears in such

and such a place that ministers now judge the extent of local hostility to the government. This circumstance has become one of the indispensable notations in every cabinet report on France's state of mind.[31]

This though, was to be Philipon's last original contribution to the history of the political image and development of the modern BD. By 1834, his politics had ossified and the various journals and prints he managed from his shop had long since quit shaping and reflecting public disillusionment and instead sported a fairly staid republican line. The end came for the pear as an "official" symbol of resistance to the July Monarchy with the last issue of *La Caricature*, dated August 27, 1835. While Philipon had not been ordered to quit publishing the journal, its place of prominence as an organ of opposition had made it too costly to continue. Philipon's editorial in the final issue bore only an explanation of why La Maison Aubert found it necessary to stop publishing the newspaper, the type cast to resemble a pear and carrying the headline "Other Fruits of the July Revolution."[32]

The political tide had been turning against caricature for sometime, and by August 1835, deputies in the Assembly were insisting that "caricature is a means to elude the law."[33] The difference in audience or reader reception between the printed word and images hinted at in the early 1820s was made explicit by legislators and government officials in 1835. The minister of justice now insisted that the demand to institute repression of printed images was permitted on grounds that protection from censorship granted by the Constitution of 1830 did not apply to "opinions converted into actions." Publishers and illustrators, he argued, would be free to publish their thoughts and concerns in written form. Words speak only to "the mind," but "when opinions are converted into acts" by publication of an illustration "one speaks to the eyes. That is more than the expression of an opinion, that is a deed, an action, a behavior, with which the Charter is not concerned."[34] The bill that passed through the government on September 9, 1835, effectively censured political caricature until the 1880s and ended Philipon's most overt public influence. It also branded caricature, or nearly any image unmediated by text, with an effective scarlet letter, marking the medium as one capable of much influence but often nefarious intent.

This perception of images persisted well into the century and the argument, opinion made into action by illustration, can be found in official government records into the Third Republic. In 1880 deputy François-Emile Villiers warned that a "drawing strikes the sight of passersby, addresses itself to

all ages and both sexes, startles not only the mind but the eyes. It is a means of speaking even to the illiterate, of stirring up passions, without reasoning, without discourse."[35] Nonetheless, in a decade that also brought free, compulsory, and secular education under Jules Ferry, the Act of 29 July 1881 established the basic parameters for a free and unconstrained press that remains the legal framework for all publishing in France.

A single graphic never again grabbed hold of the public political culture in France the way Philipon's pear had, but a host of virulent images shook the country during the Dreyfus affair at the turn of the century.[36] Right-wing and anti-Dreyfusard newspapers began running cartoons and illustrations that were specifically anti-Dreyfus and generally anti-Semitic almost from the outset of the affair, and it has been suggested that the illustrations were used to attract the semiliterate peasants of rural France to the conservative cause.[37] Whether the producers of these "Images d'Epinal" and other commodities were attempting to sell a particular idea is not clear; however, what did become apparent was that anti-Semitic images in myriad forms sold extremely well. In fact, anti-Semitism was used to sell nearly everything. Men played cards printed with caricatures of Dreyfus and leading Dreyfusards like the novelist Emile Zola and smoked cigarettes rolled with papers that carried reprints of the document, or *bordereau*, that had been used to implicate Dreyfus as a traitor while women cooled themselves with fans printed with even more virulently anti-Semitic cartoons. At their feet, children ate candies wrapped in prints of popular Catholic and anti-Semitic figures and played with toys that allowed them to hang Dreyfus by the neck or drop Zola's pants.[38]

With its beginnings in 1894, when an unsigned letter, apparently meant for the German military attaché in Paris, was discovered and suspicion quickly centered on a young, Jewish, artillery captain, Alfred Dreyfus, by 1898 the vast majority of France's (at least educated/literate) population had committed to either his innocence or guilt. The appearance of Zola's long article titled simply "*J'accuse*" in a leading liberal newspaper in January of the same year only served to galvanize the public further.[39] Less than a month later and in the midst of anti-Semitic riots that ripped through Paris, if not the whole of France, a new anti-Dreyfusard caricature journal, *Psst . . . !*, appeared with its front cover taken entirely by a single image of a stereotypical Jewish figure in a long overcoat dropping sheaves of paper through a slot into what appears to be a guard shack and a caption that read simply "Ch'accuse . . . !" (fig. 1.4).[40]

Of typical tabloid-newspaper size but made-up entirely of cartoons and caricature, the journal was the work of two caricaturists by the names of Jean-

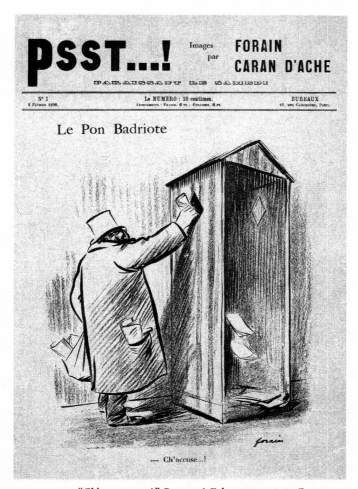

FIGURE 1.4 "Ch'accuse . . . !," *Psst . . . !*, February 5, 1898. Courtesy of the Print Collection, Miriam and Ira D. Wallach Division of Art, Prints and Photographs, The New York Public Library, Astor, Lenox and Tilden Foundations.

Louis Forain and Emmanuel Poiré who went by the pseudonym Caran d'Ache. The latter of whom had already made a name for himself as a caricaturist after the 1892 publication of his Carnet de Chèques, a series of cartoons printed on check-sized sheets and depicting, in a stop-motion, flip-the-page fashion, the bribing of government officials, satirizing the Panama Canal affair.[41] In 1895, he began publishing a weekly cartoon in *Le Figaro* where, in February 1898, his most famous cartoon appeared; ironically depicting a large family sitting at

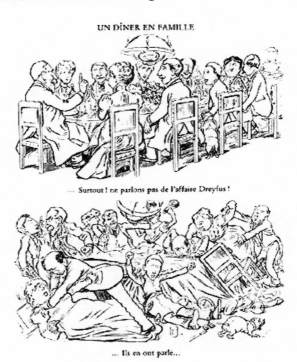

UN DÎNER EN FAMILLE

... Surtout ! ne parlons pas de l'affaire Dreyfus !

... Ils en ont parlé...

FIGURE 1.5 "A Family Dinner," *Le Figaro*, February 13, 1898. Courtesy of the Print Collection, Miriam and Ira D. Wallach Division of Art, Prints and Photographs, The New York Public Library, Astor, Lenox and Tilden Foundations.

dinner, in two panels it cautioned against discussing "l'affaire Dreyfus" offering that polite political disagreement would quickly devolve into brutal physical confrontation (fig. 1.5).

Considered by many BD scholars to have been an important artist in the development of the modern BD in France for his *Pages d'Histoire*, Caran d'Ache spent most of his time as an illustrator defending the honor of the army, extolling the virtues of tradition, and denigrating those who would attack either.[42] He was a gifted caricaturist, however, able to isolate trends and popular tropes and blend them in his work, sometimes achieving surprisingly nuanced cartoons mired in the worst images. All of this comes out in a deceptively simple cartoon that appeared in middle pages of the tenth issue of *Psst . . . !* in 1899 (fig. 1.6). Playing off the visual icon of Truth emerging from a well, a tropic mainstay in several of the political battles of the nineteenth

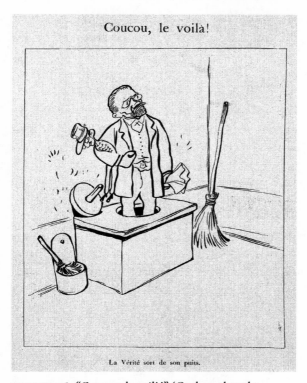

FIGURE 1.6 "Coucou, le voilà!" (Cuckoo, there he is!), *Psst . . . !*, 1899. Courtesy of the Print Collection, Miriam and Ira D. Wallach Division of Art, Prints and Photographs, The New York Public Library, Astor, Lenox and Tilden Foundations.

century but particularly (and on both sides of the divide) during the Dreyfus affair, he sought to denigrate Zola, and his supporters, by having him emerge from the still new invention, an indoor toilet; bringing with him not a spray of pure and edifying water but dank waste. That Dreyfus was reduced to a flaccid doll beneath the novelist's arm only served to indicate how unimportant he had become in what was increasingly cast as an epic struggle between the forces of liberal republicanism and modernism and conservative tradition.

Psst . . . ! ran for only eighty-five issues, closing before the end of the century. Afterward, both Caran d'Ache and his partner continued their careers as graphic artists. As part of the grand redecoration of the Hotel de Ville in the first decade of the twentieth century, Forain, who had been responsible primarily for the front covers of the journal and was likely the more gifted

"artist" of the two, was given the task of designing a mural for one of the reception halls by then-president Émile Loubet. In the years immediately before World War I, he gained acclaim for his gritty and realistic prints of the Parisian working class and poor as part of the "Society of Humorist Draftsmen."[43] After *Psst . . . !*, Caran d'Ache worked continually for *Le Figaro* and a number of other illustrated journals as well before his death in 1909. Still, if these two artists' reputations did not suffer for their unseemly cartoons during the divisive Dreyfus affair, the reputation of graphic images to forcefully carry most any message directly to the baser instincts of their readers was hardly salved, and the French were once again reminded of the politics of illustrations.

With the educational reforms early in the Third Republic, literacy rates across France increased rapidly and dramatically among the country's younger generations and with it came a concomitant growth in publications that catered to them; *les journaux des enfants*. However, the mandated literacy of the children of France was as much a political project as a social one. "Well taught children," one governmental official insisted, "will make wise citizens."[44] Literacy had long since become the key to inclusion in the social contract of the French republic; central not only to meaningful engagement in the political sphere but also the surest guard against irrational social movements headed by demagogues. In short, being literate was seen as a, if not the, central tool held by an individual to be counted as a citizen and truly French.

Still, despite the believed importance of literacy to the republican political project in France, attitudes toward and thinking on the matter were decidedly ambivalent among both the general public and those in the government. While the practice of reading developed into an activity engaged in by an increasingly wide swath of the French population (evinced in part by the increased number of reprint editions of popular authors in the 1870s and 1880s), libraries were often viewed as being "cemeteries" for "dull collections of old books."[45] Within the government and other institutions of social engineering, like the Church, "rampant" and unchecked literacy was something to be both guarded against and directed into the proper channels. The establishment of free and compulsory education during the first decades of the Third Republic, in some measure, actually served to strengthen this prevailing attitude. The idea of a collectively literate populace was attractive to advocates of republicanism as it fostered reasoned participation within the public sphere and hence was a collective good. However, the threat of individual literacy was something of which to be mindful. By the late nineteenth century, reading was often no longer a communal experience with one person reading aloud to others, but a

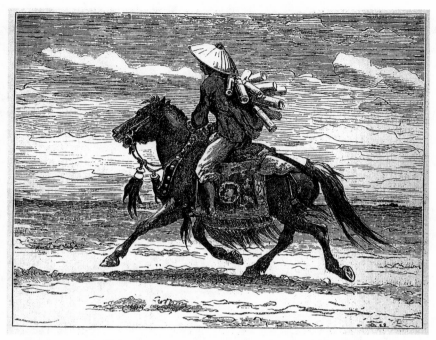

FIGURE 1.7 A typical example of an illustration from *Le Journal de la Jeunesse* from 1901. Author's personal collection.

private one that left the literate person isolated from others and hence not just demonstrating individual independence from the community but potentially also falling prey to untoward and socially unacceptable ideas. Consequently, "impressionable" readers, it was often argued, should be dependent on careful guidance through a well-defined canon of specific and vetted texts to protect both public order and morality.[46]

Because of this and the presumed politicized nature of illustrations, journals produced for the youth of France were generally illustrated journals driven largely by a textual narrative. First published in the early 1870s and lasting until the First World War, *Le Journal de la Jeunesse*, for example, was one of the premier examples of *les journaux des enfants* in the *belle époque* and the first decades of the twentieth century (fig. 1.7)

Serialized stories of adventure and intrigue set in exotic locales like Africa and the colonies of French Indo-China shared space with vague morality tales and stories of young women whose hearts were broken because they had loved unwisely; interspersed throughout the journal were jauntily written educational

FIGURE 1.8 "At the Races," *Le Musée ou Magasin Comique de Philipon,*
from the mid-1850s. Courtesy of the Print Collection, Miriam and Ira D.
Wallach Division of Art, Prints and Photographs, The New York Public
Library, Astor, Lenox and Tilden Foundations.

essays on art, travel, horticulture, and science.[47] Not suspecting the journal's
end would come in only a few years, the publisher, Hachette Bookshop, offered
a timely summary evaluation of its contents in 1912. *Le Journal de la Jeunesse*
filled eighty bound volumes when all its issues were collected, and it had intro-
duced legions of young readers over the years to one hundred and sixty novels,

thousands of stories and chronicles of all sorts of various lengths, and been illustrated with twenty thousand engravings.[48]

Still, in comparison to Philipon's last journal of any real significance, *Le Musée ou Magasin Comique de Philipon*, *Le Journal de la Jeunesse* was barely a *hebdomadaire illustré* at all. Appearing in cafes and on newsstands in the first decade of the reign of Napoleon III, the journal was described by its well-known publisher as a "Musée sans prétention" on the title page of the inaugural issue. More than that, however, the "currency" of the journal, "our banner" Philipon insisted, was to be "Peu de Texte et Beaucoup D'Images" (little text and many images).[49] La Maison Aubert largely kept to its pledge and the great bulk of the journal was indeed consumed by images, generally in a sequence, the following of which—with coinciding and meager but entertaining and cutting text—related some supposed bourgeois morality tale.[50] Risibly derisive of popular figures in the social (though cautious of the political) milieu and wealthy bourgeoisie who adopted the "refined" pastimes of the former aristocracy, *Le Musée* made a regular practice of skewering behavior that Philipon and his stable of artists found laughable (fig. 1.8).

Nonetheless, the intent always remained the same, the holding of a mirror to the ridiculous while providing an expressive outlet for "all those who, by taste, position, mistrust or unconcern, do not read or do not read any more." Indeed, Philipon intended "a historical, comic and even philosophical gallery" that would be as educative as it was amusing.[51] The example of *Psst . . . !*, and others of its ilk, notwithstanding, the form and content of *Le Journal de la Jeunesse* demonstrates that to the self-conscious Third Republic—born only a few years before the journal and described by its conservative president as the form of government which divided the French people the least—the task of educating the public, be it urban children or illiterate rural peasants, was too important for it to be left to unmediated graphic images.[52] And this theme would remain a frequently visited constant in both popular and official criticism of the visual medium throughout much of the next century.

What Your Children Are Reading

Bande Dessinée, Catholics, and Communists

Où sera votre Exposition? Dans les kiosques.
—**Jean-Louis Forain**

Vive l'Americain!
—**Jubilant crowd cheering Charles Lindbergh**

The milieu determines everything; it controls both farce and tragedy.
—**Claude Aveline**

On May 21, 1927, Charles Augustus Lindbergh's specially designed single-engine airplane, the Spirit of St. Louis, split the night's clouds and landed gently at le Bourget field outside of Paris under the wary gaze of a massive throng numbering over one hundred thousand people.[1] After two false reports and mistaken sightings had filtered through the crowd, shaking their sense of expectant jubilation and sowing it with pessimism, the lanky aviator with only five years of flight experience touched down at 10:24 P.M. Disheveled but smiling, Lindbergh closed the adventure begun across the ocean in Roosevelt, New York—then some 3,600 miles and nearly thirty-four hours in the past—with a simple, "Well, I made it." Before he could even jump from his cockpit, he was

lifted from the cabin and borne along the shoulders of spectators who could no longer stay removed from the landmark event. A contingent of soldiers armed with rifles and fixed bayonets attempted to hold back the now crushing and swarming mob but soon gave in to the excitement of the moment themselves and joined in the mad rush. It seemed that no one could resist becoming a part of the history they were witnessing.

When the young poet Filippo Marinetti stirred the political and aesthetic waters of France with the publication of the "Futurist Manifesto" on the front page of *Le Figaro* in 1909, he (and his few compatriots) clamored for fevered motion and praised the "roaring motor car which seems to run on machine-gun fire." The aggressive embrace of a dynamic technology and modern urban life struck a chord with many in the years just prior to 1914. However, in the decade after the "War to end all wars" it was difficult to maintain the same, nearly lascivious, appreciation for the Futurists' declaration that war was the world's only hygiene.[2] Despite the importance of trains, also championed by Marinetti, to the actual mobility of the French and the automobile in the imagination of many, both were now smeared, as they remained bound to the earth; the firmament that had been dug through and which had been the scene of so many deaths.[3] The airplane, on the other hand, transcended this linear plane and suggested "growth and hope."[4]

For the French particularly, the airplane had already long been an object of technical and popular fascination while the successes of the nation's early aerial pioneers were championed as evidence of the nation's vitality. In 1909, Louis Blériot had been the first to cross the English Channel in an airplane of his own design and construction, the Blériot XI. His achievement was immediately assumed as a point of victory for the nation as a whole and taken as demonstration of the country's strength; after all, "a nation that was capable of producing a Blériot was not a nation in decline, as so many pessimists were claiming."[5] Immediately after World War I—amid a contentious postwar political climate that saw France trying to demonstrate continued (if not renewed) strength and modern vitality as a people on one hand while trying to secure ironclad defense agreements with Britain and the United States on the other— it was the Frenchman-turned-New-York-City-hotelier Raymond Orteig who staked the $25,000 prize that Lindbergh was pursuing.[6] Though the French people hoped that the aerial feat would be accomplished by one of their own, upon landing, Lindbergh was treated as if he were a successful Icarus. Having reached for the sun and returned gently to the earth, he was mobbed by the

masses and fêted by the elites of French government and society and awarded by President Doumergue the cross of the Légion d'honneur, the first time an American received the honor.

The presentation of Lindbergh with the exclusive political award of France's high political society was only the most obvious attempt made by the French to if not adopt the American aviator, then to demonstrate that they understood the importance of his flight. Much as Louis Blériot's cross-channel accomplishment had been co-opted by the entire nation as a symbol of the country's vitality nearly twenty years prior, Lindbergh was immediately taken up as an extension of the modern technological development that had twined the two great Republics of the United States and France through the seminal innovations of the North Carolinian bicycle mechanics Orville and Wilbur Wright, and the long-distance flight successes of the Blériot XI. Indeed, as if to cement this connection, even before most of the celebrations of France's high society, political or otherwise, Lindbergh was treated to a semiprivate luncheon with France's aviation pioneer. More plebeian efforts also were common. In what has been called "an obvious attempt to Gallicize him and claim him as one of their own," Modris Eksteins recounted that "two Paris restaurants offered to feed him and a tailor proposed to dress him gratis for the rest of his life."[7]

It has long been a French tradition to lay claim to achievement through honorifics, and Lindbergh's experience is a perfect example of this nearly unique cultural behavior of the nation. Recountings of the mélange of gifts and honors that the American aviator was presented with from all quarters generally include those already referenced here, from the Légion d'honneur to a lifetime of steak frite. What has often been forgotten, however, was his gracious acceptance of an "Alfred" medallion, which he carried on the fuselage of his famous plane during his flight from Paris to Brussels a week after landing at le Bourget.

This was no mere piece of historical flotsam. Eksteins has argued in his history of the interwar period that the reason for the clamorous celebration of Lindbergh's achievement, from all quarters of society, was that it "seemed to satisfy two worlds, one in the throes of decline and the other in the process of emergence."[8] If the symbol of the old declining order is taken to be the Légion d'honneur, then that of the emerging one was what might be named the *Médaille de Alfred*; the emblazoned "Alfred" was none other than the sardonic penguin companion of the young quixotic travelers of Alain Saint-Ogan's now classic French bande dessinée *Zig et Puce*. One of the first examples of

independent merchandising of a BD character in France, Alfred's image was coined, stamped, stitched, and otherwise transferred onto products as disparate as radiator caps, bedsheets, and the aforementioned medallions. Indeed, in the two years between the first appearance of the BD, which is typically considered the first truly "modern" example of the medium in France, in the adult weekly *Dimanche Illustré* and Lindbergh's trans-Atlantic flight, Alfred was adopted as something of a modernist St. Christopher talisman for adventurers in nearly all fields of endeavor, kept by popular entertainers such as Jeanne Bourgeois, whose stage name was Mistinguett, Yvonne Printemps, and the American phenomenon Josephine Baker. Only weeks before Lindbergh's successful trip, Alfred medallions had been carried by two of France's most celebrated air aces from World War I, Captain Charles Nungesser and navigator/mechanic Coli on their own ill-fated flight.[9]

In the days following Lindbergh's triumphant landing it has been estimated that he was offered upwards of $650,000 in cash and various material awards, the great bulk of which he politely refused.[10] While he resisted the urge to personally enrich himself, he was well aware of the historic importance of his trek and, consequently, judicious in the choices he made and associations he kept that were now afforded him. Likely, the modest midwesterner was not conscious of making a particularly modernist statement by accepting an "Alfred" and adorning his famous airplane with it, but that is precisely what he managed. Lindbergh's carrying with him an image of the penguin Alfred was symbolic of the place the illustrated press had, in France particularly, at the heart of the cultural politics of the modernist era; a relationship laid bare by returning to the work of an artist already discussed and one of the illustrated journals he contributed to in the last years of his life.[11]

Before his death in 1909, Caran d'Ache contributed his name and work to at least one other controversial satirical illustrated weekly, *L'Assiette au Beurre*, which ran for 594 issues from March 1901 to October 1912. Composed almost entirely of drawings, caricatures, and cartoons—generally sixteen per issue— and the result of the efforts of more than a hundred artists and fifty writers, its pages interpreted the day's current events. Whether well known, like Caran d'Ache and his former partner Forain, who also drew for the journal, or less so (at least then), like the Dutch émigré artist Kees van Dongen, later a leading light in the Fauvist movement, most all of the contributors shared a general sense of political engagement, even if they would quibble over the details of practical implementation. Often characterized as leftist and anticlerical, the journal would better be described, politically, as vaguely anarchistic. Social

Le Snob connaisseur.
— *Faites-moi donc quelque chose dans les tons verts... Le sujet m'est égal... c'est pour aller dans un salon mauve...*

FIGURE 2.1 "Le Snob Connaisseur," *L'Assiette au Beurre*, 1901. Author's personal collection.

and political issues from across the political spectrum and of every hue were savagely lampooned in its pages.

Discernible themes ran throughout the hebdomaire, and common topics ranged from the venality of both priests and judges to the exploitation of the poor—directly by villainous employers and indirectly by a rapacious capitalist system—through to rueful send-ups of the banal affectations of bourgeois dandies (fig. 2.1). The artists and authors addressed many of the social ills of the modern age like poverty, juvenile delinquency, alcoholism, and various "social diseases"—with particular focus on the prevalence of absinthe use and syphilis among the avant-garde—as well as confronted a supposed vehicle of much of the populace's stupefaction: the rest of the popular press.[12] A strident

political tone was set early on in the journal's existence: in the May 16, 1901, issue the journal's pages declared that "social justice" was to be its primary goal. An early issue in September 1901, for instance, savaged England's actions in the Boer War, and particularly the existence of a "concentration camp" in Transvaal, while the "logic" of the death penalty in a lawful society was lambasted in 1907. Tying graphic images to broad political activism and awareness once again, the editors—in an echo of Töpffer's gleeful proclamation and the laments of several nineteenth-century Assembly members—asked: "How could one better do that than by the drawing, which engraves an idea with an energy that the effort of the most powerful writer can never achieve?"[13]

In the first years of the century, the English author and critic E. V. Lucas, a one-time editor for the satirical magazine *Punch*, offered his judgment of the popular press in France in his well-received *A Wanderer in Paris*. For him, the newspapers of England and France could not be more different, with those of the Isle being far more "diffuse" while French papers had the gift of "brevity" for their readers. The reason for this, he surmised, was that the French were more natural conversationalists, given to greater (and more meaningful) social interaction, and just as likely to take in the current events from the theater and illustrated press, examples of which "one sees everywhere." For the former assistant editor of one of the most daring journals in all of Europe, most examples of French "comic papers" deserved to languish on newsboys' racks as they nearly all turned too quickly on a single joke or tired witticism. "For a people with a world-wide reputation for wit," he bemusedly wrote, "this is very strange." *L'Assiette au Beurre*, however, was the exception:

> *Le Rire, Le Journal Amusant, La Vie Parisienne* and scores of cheaper imitations may depend for their living on the one joke; but *L'Assiette au Beurre* is more serious. *L'Assiette au Beurre* is first and foremost a satirist. It chastises continually, and its whip is often scorpions. Even its lighter numbers [issues], chiefly given to ridicule, contain streaks of savagery.[14]

Whatever the savage wit on display in the pages of the journal, its influence, or that of the artists and writers involved, would be hard to deny. Reaching even across the Atlantic, it served as a direct inspiration for the American socialist journal *The Masses*. In a personification of the political anarchism of the *illustré*, one of its principal editors, Henri Guilbeaux, was an early Communist and friend to Lenin while he was in hiding in Switzerland. He later abandoned the party in favor of Mussolini's brand of fascism in the 1920s. He

was also a caustic critic of both cubism and the art establishment in the years prior to World War I and introduced a generation of Europe's avant-garde to the American poet Walt Whitman.[15]

The work of already celebrated authors, like Anatole France, appeared in the journal's pages alongside the graphic images of relative unknown artists such as Benjamin Rabier. Though not much remembered today, Rabier's work in the 1890s and the first decades of the twentieth century left indelible marks on France's nascent modern popular/consumer culture. Originally a book-keeper, after meeting Caran d'Ache in the *belle époque* he began working as a graphic artist and caricaturist; his drawings appeared in *Le Gil Blas*, *Le Chat Noir*, and the children's journals *La Jeunesse Illustrée* and *Les Belles Images* as well as *L'Assiette au Beurre*. Crossing over to the burgeoning mass-market advertising field as an illustrator, his work continues to appear around the globe every day as the creator of the advertising character "La Vache qui Rit" (the Laughing Cow)—the "face" of the cheese of the same name—in 1921. Also considered a pioneer of French BDs, his illustrated text "Tintin Lunti," first published in 1897, was a direct influence on the cartoonist Hergé three decades later while his anthropomorphized animals in the BD *Gédéon*, begun in 1908, had a lasting impact on the "funny-animal" genre of the medium.[16]

The example of Rabier illustrates that the evolution of the modern BD in France was not only occuring alongside the relative explosion in the general popular and political press but also was an intimate part of it, sharing both artists and influences. Accordingly, given the grave concerns that had been expressed about the untoward influence of unmediated images, it was in this milieu that the "long time format of the European picture-story, the final experiment before the birth of the [modern] comic strip in the United States," was perfected by a young Sorbonne professor of natural science, Georges Colomb, who signed his work "Christophe."[17]

Seeking to supplement his modest professor's income, Christophe sold drawings he had done to entertain his son and quickly became a regular contributor to the popular late-nineteenth-century children's journal *Petit Français Illustré* after publishing first in *Le Journal de la Jeunesse*. Initially, his drawings were bereft of any accompanying text, but as his son learned to read he began including lines of descriptive narrative beneath the sequence of pictures. A gifted and nuanced artist/cartoonist who enjoyed the invention of new cartoons and characters, it was his most famous creation "La Famille Fenouillard," which debuted in 1889, that by its popularity set the standard for French BDs into the 1920s (fig. 2.2).[18]

Being in need of a change of clothes, Mr. and Mrs. Fenouillard return home. Mrs. Fenouillard would like to break out in bitter complaints, but since her mouth is full of cheese she simply maintains a dignified and solemn calm. The young ladies are wailing in touching harmony.

In the evening, now that she has finished swallowing her cheese, Mrs. Fenouillard is finally able to make a few noises. She tells her husband that from now on she won't listen to him when he tries to tear her away from her home on the pretext of a trip. Thus ends the first trip of this interesting

FIGURE 2.2 A typical example of the brow-beaten father and the quotidian adventures of Christophe's famous *La Famille Fenouillard*. Author's personal collection.

Following Christophe, the practice of using a lengthy narrative beneath the sequence of illustrations, instead of speech balloons within the frames, to carry along the action was one of the "hallmarks" of French BDs. What one historian of BDs has largely dismissed as little more than "literary shibboleths" caused publishers and educators to frown on the balloon as "nonliterate."[19] Nonetheless, throughout the years of World War I and the decade of the 1920s, American influence on the French *illustrés* became more and more apparent, either by artists overtly copying the style of American BDs or publishers of French journal supplements making increasing use of imported American material by way of the syndicates that had been established in the United States early in the century. French adoption of the technique that has often been characterized as essential to the modern BD, the thought or speech balloon, came in 1925 when Alain Saint-Ogan created *Zig et Puce*; the first French BD to make extensive use of the balloon to provide all "textual" information. The first episode of the BD, incidentally, was entitled *Zig et Puce Veulent Aller en Amérique*—Zig and Puce want to go to America (fig. 2.3).

Where the history of BD in France has been chronicled, there has often been an artificial cleft drawn (by silence if nothing else) between the political cartoons and caricatures of the nineteenth century and the developing medium of BD in France, as if it developed outside of the political and cultural milieu of the era or was an anomolous example of *sui generis* creation. As demonstrated above, the briefest examination of principal authors in the medium's early days

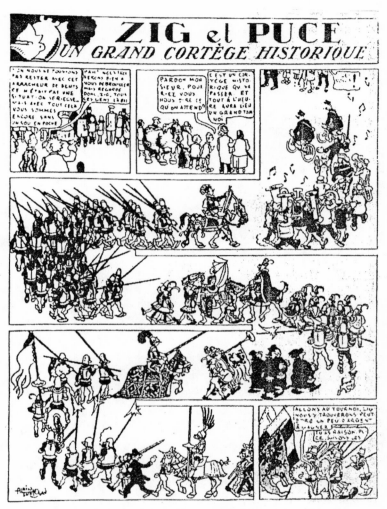

FIGURE 2.3 An early example of Saint-Ogan's famous *Zig et Puce* from
the 1920s. It is worth noticing how he is continuing to play with the idea
of narrative here by upending and reversing the direction of the parade.

reveals just how tightly bound the illustrated press in France was to the polit-
ico-cultural concerns of the day and how seamlessly it should be folded into,
and seen as part of, the ethos most often referred to as the Modernist move-
ment. Indeed, almost as if she had the narrative conventions of BD in mind,
the art historian Patricia Leighten has offered a definition of modernism in
the arts in pre-WWI France that privileges a crossing of mediums and "abrupt

transitions, antinarrative structure, surprising juxtapositions" which removes it from the purview of a "small handful of ivory-tower artists fixed in a (post–World War I) canon that valorizes a few isolated careers." Rather, with this definition and aesthetic starting point "one sees a broad field of artists making artistic choices in response to the hot realities of cultural and political life."[20] While her analytical gaze remains fixed largely on a widened canon of sorts, the insistence that political concerns directly impacted the art field in not just subject but technique and tools is well grounded. After all, this heady era birthed the age of mechanical reproduction as art, to nearly upend the title of Walter Benjamin's most famous essay. While the opposite of his supposition as to the plummeting worth, the value, of original—auratic—artworks from before the age has proven more the case than not the situating of art in the practice of politics has borne out.[21]

The chaotic migrations of thought and discourse characteristic of modernism were not limited to simply the arts, however. Particularly after WWI, developments in both transport and communications technology allowed for the movement, the migration from one field to another, of not just goods and ideas but of people, on an unprecedented scale.[22] No doubt, as the continental foe on the western front during the war, France had withstood the worst of the German offensive from the opening shots of the conflict. The country was forced to absorb the damage wrought by four years of total war aiming at woesome attrition. While much of its most verdant farmland was being cleaved by infantrymen's spades rather than farmers' plows, the nation's industrial sector, already less developed than either Britain's or Germany's, also suffered gravely, with production a year after the war in 1919 less than half what it had been in 1913. These material losses were not the worst of it, however; the massive mobilization that the French populace was forced to undergo put the country under enormous strain. Bringing nearly eight million men into the armed forces with more than a million of those killed, and another near three million otherwise debilitated, was a blow for a nation already struggling with demographic stagnation from which it was nearly impossible to recover. Indeed, the loss of men to war and the decline in births that resulted meant that between the 1911 census and that a decade later France suffered a net loss in population of 2.3 million; from 41.5 million to just over 39 million. The loss of roughly a quarter of the young adult male population, those aged eighteen to twenty-seven, robbed the country of "the demographic resiliency inherent in a young and fertile population" and left a hole in the society that impacted the country well into the 1930s.[23]

Nonetheless, while the war was fought (in the west) largely on French soil, it was won there as well. Indeed, costly as the victory was, it served to *re*-republicanize much of the populace, as the oft-criticized government of the Third Republic had proven capable and flexible enough to survive the onslaught of a rigid and authoritarian Germany. By almost any analysis of WWI, it was caused as much by brinkmanship, saber-rattling taken two steps too far, as any royal assassination. This, in turn, had been occasioned by anxiety of place, on all sides, on Prince Metternich's century-old scale of Great Powers and the balance thereof. Among the populations of the warring countries the conflict was cast in terms of an epic struggle between competing conceptions of culture: France and the liberal west's *Zivilisation* and German *Kultur*, as it was posed in the kaiser's lands.[24] Consequently, despite the calamitous damage the war wreaked upon the country, the Allied victory left France the military power on the continent while the apparent triumph of liberal *Civilisation* over authoritarian and aggressive *Kultur* reconfirmed France's position as the cultural heart of the West—at least the western side of the Rhine. Arguably, in terms of human cost and material loss, this was a Pyrrhic victory at best. Nonetheless, when considering the social impact of the war on the nation, rather than force a great rift with the past politically, economically, or socially as some have insisted, save for the massive public debt that the conflict saddled the country's citizenry with, it arguably did little more than hasten trends that had already begun.[25]

Winnowing out the effects of the war on industry, for instance, can sometimes be difficult; scores of opportunists became millionaires to be sure, but the war's impact on the industrial sector as a whole, beyond noting its deficiencies and sheer tonnage of production, is a suspect science. However, where the supposition of quickened social paces as a result of war is undoubtedly correct was in the acceleration of the politicization of culture and cultural products. The evolution of any number of cultural goods in France, even before the war, must be understood in political terms. The musicologist-*cum*-cultural-historian Jane Fulcher, for instance, has demonstrated that it is impossible to understand the compositional developments of such luminaries of French music as Claude Debussy and Erik Satie without reference to the reactionary and conservative discourse of the Action Française and the nationalist turn of the country with the January 1913 election of Raymond Poincaré to the presidency.[26] In the realm of the plastic arts, the work of some of those mentioned above, as well as those of the burgeoning Cubist movement, was often critiqued not simply in aesthetic terms but decidedly political ones.

Brought into debates about national character, they were labeled an "attack on the social fabric," while the likely response, and stated goals, of those involved with *L'Assiette au Beurre*, at least, has already been noted.[27] Still, it was never a simple matter of social clashes between political conservatives and a cultural avant-garde. With the start of World War I "self-control, self-abnegation, and self-denial of so many kinds became a national modus vivendi" in France that touched everyone and everything in the country.[28] Well into the 1920s, there remained a striking similarity between the discourse of France's avant-garde artists and the rhetoric of the political right wing with calls to "clarity" and "order" finding resonance among both groups and across the political spectrum.[29]

Whatever the internal cultural concerns of the country were, with the return of peace, France generally and Paris specifically once again took its place as the destination for travelers seeking enlightenment of one sort or another. Even if Paris was no longer the innovator of culture it had once been, it remained the place where cultural novelties and developments were brought for legitimation and validation. As Eksteins put it, the French considered the role of "cultural arbiter to the world . . . a permanent international bequest," and the rest of the liberal West seemed at the time either incapable or uninterested in disabusing them of this prejudice.[30]

The aforementioned ease of travel made journeying to France all the more accessible and people from around the globe, and particularly from European countries such as Italy and Poland, flooded the country. The need for labor, forced by the war losses, made the country all the more attractive to both extended-stay visitors and immigrants and made the nation effectively, if mutedly, socially multicultural well before the concept was birthed politically. By 1926, there were nearly two and a half million resident aliens and a quarter million naturalized citizens of France; immigration accounted for nearly three quarters of the more than 2.6 million person increase in the population between the census years of 1921 and 1931. However, even this high figure underestimated the "contribution of the immigrant to the population growth of France, since the higher fertility of . . . migrant women contributed to the maintenance of an excess of births over deaths in the total population of the country."[31]

In terms of sheer numbers, a disproportionately significant part of this veritable invasion *étrangère*, which the French begrudgingly admitted was necessary for the rebuilding of their economy, was a clamorous "American colony." A loose collection of businessmen and entrepreneurs, diplomats

and technicians, and (often black) servicemen who never left and artists and authors just arriving, numbered more than thirty thousand by the middle of the 1920s. All of these different peoples, from disparate countries, no matter what their reasons for traveling to France, brought with them something of their past, their previous cultural selves and situations. And all of this only served to add to the modernist stew that simmered on a burner of automobiles, airplanes, motion pictures, and an admixture of hope for the future and lament for what might be lost.[32] The American "colonials" in particular and perhaps because many had the financial wherewithal to do so, constructed their own "miniature America" within the Hexagon. By the end of the 1920s it had become possible to live from cradle to grave entirely as an *American* inside France, all while various publications, groups, and agencies linked Americans abroad to one another forming a discernible (if nomadic and amorphous) and specifically American community. Americans, in 1920s France, "were not only bringing goods and money to France but an entire way of life."[33] So apparent was their presence that had they chosen, neither Georges Duhamel nor Louis-Ferdinand Celine would have found it truly necessary, as novelists, to travel to the United States in search of information for their critiques of American—or the future—life and peoples. The situation being such that the research notes from a tour of American émigrés living in Paris, coupled with the literary inventiveness possessed of both men, would likely have provided more than enough fodder for the near harangues they ultimately wrote.[34]

Typically, the two decades of the interwar period have not been recognized by historians as years of deeply penetrating *Americanization*. No doubt, and particularly in terms of scale, the real impact of American economic, political, and cultural influence came after World War II and the massive aid and investment of the Marshall Plan. Still, if the United States, in the 1920s and 1930s, was not yet the overt economic and political force in French life that it was to become, many of its cultural products had become the harbingers of a janus-faced specter of opportunity and loss—or forced change—that the country could not avoid comparing itself to. Though most of the unease did not, as yet, crystallize into overt anti-Americanism, there was a broad sense that something distinctly and historically *French* was in peril and risked being lost.

What struck many French commentators about the American experience was how swift and providential the United States' climb from bloody step-child of Europe to potential world master seemed to be; not even the laws of history that had bound "old Europe" to its course seemed relevant. "For them," Régis Michaud wrote of the United States and Americans in 1929, "no

burdens of historical tradition, no domestic quarrels, no envious or covetous neighbors, no militarism, no anti-clericalism, no communism," nothing that might weigh down the American experiment seemed to stick to the psyche of the people the way such things did for the French.[35] The fear of the French was that the American style of life, with its hectic mechanized pace and standardized, assembly-line-created products, was not simply a challenge to their own order of things, but a way of life that was simply incompatible with their older European civilization.

This idea, the social and cultural variety of French life, became a rallying point, the foundation upon which to mount a defense of French customs and the manner in which they wished to live their lives. In 1927, the influential political scientist and columnist for *Le Figaro*, André Siegfried, published *America Comes of Age* where he commented on the positives of the American experience and the economic and military might the country could summon in times of need. However, this had come at great cost in terms of the possible variety of the life that might be lived, and hence its intrinsic quality. Or as Siegfried himself insisted:

> Organization of industry is one thing; standardization of the product is another. In older civilizations, where tastes vary according to local customs and refinements of culture, industry is obliged to furnish a great range of models and cannot specialize on a limited number of articles. On the other hand, the 100,000,000 individuals in the United States are astonishingly alike.[36]

So estranged had some commentators come to believe that they were from the American experience that Duhamel insisted in his own best-selling work, *America the Menace*, that "the adult inhabitant of Western Europe who is normal and educated, finds himself more at home among the troglodytes of Matmata than he does in certain streets in Chicago."[37]

This reference to far off and exotic lands in Duhamel's work might not have entirely been a literary device or happenstance occurrence. Rather, when facing the model of the future presented by the American example the French turned, at least in part, to their past and embraced the grandeur of the nation's colonial history and imperial might. The other side of the ease of movement and travel that the interwar period brought was a boom in mass tourism and leisure travel and not simply movement for the sake of relocation for economic reasons.[38] In the case of France, this took the course in the late 1920s

and into the 1930s of guidebooks and organized tours of what was proffered at the time as "colonial tourism," designed with the intent of providing a means for "typical" French citizens to come to "know" their empire.[39]

Even more, for some months in 1931, there was no need for "colonial tourists" to actually travel outside of the Hexagon. Citizens and foreign guests were provided the opportunity to range across the ruins of Indo-China and sample the exotic wares of Africa in a single afternoon at the International Colonial Exposition.[40] The timing of the Exposition was fortuitous though not entirely planned. A near comedy of scheduling concerns (if not errors), and bloody conflict of course, delayed the event from the planned opening of a colonial Exposition in the city of Marseille in 1916, for which President Poincaré had laid the first stone in 1914. The impact of WWI, a renewed recognition of the importance of colonial resources and troops to the welfare of the nation, squabbles between the local governments of Paris and Marseille, and a flurry of imperial ceremony by other powers on the continent all colluded in delaying the opening of the Exposition until May 6, 1931. Nonetheless, while the event had not originally been planned "to counteract the Great Depression of the 1930s," Governor General Marcel Olivier, the rapporteur-general assigned to the exhibition, suggested at the time that it might be considered a "lucky delay."[41]

Whether the Exposition's delay was lucky for economic reasons or not, the opening of the event in the first years of the Great Depression was of great propagandistic value, coming as it did as some were beginning to question the unbridled economic policies of the American model. The Exposition, however, offered a view of economic development that was more stable, autarkic, and variegated—and, perhaps, simply more French. It offered a view of the colonial empire, and by extension France itself, that was vibrant and nothing short of "radiant." "The beauty of the display," according to Herman Lebovics, was that it had the effect of transforming "aesthetic appreciation into political ontology: the show became a token of the worth of the colonial effort and of a new grander vision of what it was to be French." The juxtapositions of the solidly primitive and the gleamingly modern—a collapsing of image, site, and even memory—at the heart of this vision of *la plus grande France* were decidedly multivalenced and presented its viewers with a broad picture of what it meant to be French and how privileged they were to be citizens of such a brilliant, modern, *and* legacied nation. It was a picturesque theme of unity through diversity that did not ignore the particularities of the *petit pays*. Instead, it offered legitimacy by the "wrapping of cultures around a French

core" while partaking in "the universal identity of a French-defined and French-administered humanity."[42]

The timing of the Exposition and its emphasis on the rich variety of life and experience in *la plus grande France* might, at first blush, appear to cast it as an experiment directed precisely at offering a counter-discourse to the life-standardizing model presumed of the United States. However, while it was undoubtedly, at least in part, intended to do just that, it was also the result of concerns perhaps steeped by the American presence but decidedly internal to the politico-cultural milieu of the roiling nation. The 1920s, a decade characterized as a "time of even more than usual self-examination" for the French, gave way, in the following decade to a near full-blown war of cultural ideologies on the Left and Right as to what exactly constituted the "True France."[43]

This was a conflict that had been developing for decades however, predating even the changes occasioned by WWI. As the earlier reference to Fulcher's analysis of the music of early twentieth-century French composers makes clear, cultural friction in the country had been growing for decades. Since the Dreyfus affair, rightist groups like Charles Maurras's *Action Française* had been shifting "the field of contestations" to culture; insisting that it was the "peculiarity of the French" experience that was both the key to their identity and also under threat. "This idea of an exclusive identity of France," it has been argued, "was the chief strategy, the hegemonic project, of conservative cultural thought and practice." This notion—"that there can be only one way to participate in the culture"—became so prevalent that it was, in its own manner, also held by the Left.[44]

The conservative vision of True France was generally rural and traditional, buttressed and girded, at least in the Maurrasian view by Catholicism and monarchism. True France was, "according to these new ultrarightists . . . a nation made up of many regional cultures but only one national one; it was a nation in which everyone had two *patries*, each commanding a different kind of loyalty." This was a conception of France that looked to the peasant as the nation's foundation and, if it did not overlook the "urban" all together, it excluded the urban worker. That of the left was more Republican, urban, and inclusive of workers though generally just as essentialist. In fact, "the vision of France held by both Frances [the Left and Right] overlapped remarkably," as evinced by "the forces of the Popular Front [yielding] to the temptation to fight to *include* the urban working class in this conservatively theorized metaphysic of national identity."[45]

Hence, the terrain for the culture wars that gripped France in the decade preceding the Second World War were mapped by the forces of the right while those on the left willingly engaged them there. Why the French left, particularly the Communist Party (PCF), took an active part in this struggle—shoehorning the working class into a restrictive concept of *citoyen* and substituting their own heroes as the variables in a conservative equation of patrimony—has been approached in a variety of ways. Indeed, given that Lenin is reputed to have once told a French Catholic visitor that "Communism and Catholicism offered two diverse, complete and *inconfusible* conceptions of human life," the question is one decidedly worth some meditation.[46] Lebovics, after considering the rising fascist threat in Europe in the years before WWII and the need for cooperation among all the forces of the political center to the extreme left, argued that the real root of "explanation lies . . . in the historic role of the party as an important mediator of social promotion." The constituencies of the party were often those most in need of immersion in the "culture of France—the language, the arts, the things-that-go-without-saying" in order to "*be* fully French. More or less without interruption (except under Vichy) since the 1880s, that was the cultural version of the republican contract." Consequently, the party could serve them best by accepting traditional "bourgeois culture and its institutions as normative" and to that end "Socialist and Communist cultural criticism focused on increasing and democratizing access to it."[47]

Nonetheless, it would be a mistake to label this acceptance of a cultural paradigm constructed by the right as mere acquiescence or resignation to a situation beyond the left's control. Catholic neo-traditionalists like Maurras might well have been expressing a fervent nostalgia for invented traditions and an idealized past but, as has been argued elsewhere, simply deriding nostalgia "as reactionary is scarcely sufficient."[48] To do so is to ignore that the experiences of rapid change and social fragmentation just as often foster responses of trepidation as they do freedom and liberation. Consequently, there often develops a "counter-response which seeks to establish a sense of continuity and stability by invoking the metaphorical power of an imagined past." "The yearning for the past," so the argument goes, "may engender active attempts to construct an alternative future, so that nostalgia comes to serve a critical rather than a simply conservative purpose."[49]

This is not to deny, however, that "a conservative construction of a True France played a major deleterious role in French thought and cultural practice in much of the twentieth century."[50] Rather, it is only to note that, damaging or not, the search for, and hewing out of, a True France was part of an active

process of national definition by people across the political spectrum dur-
ing the "hollow years."[51] That this was the case is borne out in Lebovics's own
study of the era's interest in ethnography and the development of a cultural
anthropology, while both Fulcher and Kenneth Silver have demonstrated that
various segments of the "high arts"—music and art, respectively—were also
not immune to twisting by these concerns. That it also reached down into the
deepest pockets of popular culture, and perhaps is even best revealed there,
is made evident by examination of the battle between Catholics and Com-
munists over of *les journaux des enfants*. After all, it was the 1930s that wit-
nessed the emergence of politics as pageant wherein *culture* and quality of life
issues took center stage in the political programs of Léon Blum's fragile Popu-
lar Front coalition—or in the words of Julian Jackson, when the "problem of
leisure" emerged as a serious issue.[52]

A number of factors, not least the influence on the industry by pressures
coming from America, had pressed changes on the illustrated press indus-
try and in French BD by the mid-1920s and early 1930s. The most obvious of
these changes was the slow adoption of the speech or thought balloon. Just
as important, if not immediately apparent however, was a turn toward enter-
tainment rather than political commentary for the medium, and the growth
of a specific sector of the publishing industry, *les journaux des enfants*, while
specifically adult and political journals like *L'Assiette au Beurre* slowly fell out
of fashion. The resultant shift in audience did little to slow the growth of the
illustrated press in France, as several of the weekly journals aimed specifically
at the youth of France had circulations comparable to almost any of the "adult"
publications available.

By the early 1930s, there were some twenty-three different *journaux des
enfants* available for the reading pleasure of France's youth. Typically of a fairly
small size and largely black and white, color was used sparingly and the style of
the BDs was generally more dependent on the text driven tradition of Chris-
tophe than obviously influenced by contemporary American examples of the
medium. Among the more popular were *La Jeunesse Illustrée*, which began
publication in 1903 and often featured the work of Benjamin Rabier, whose
illustrations also appeared in the pages of *L'Assiette au Beurre*, and *Les Belles
Images*, published from 1904 to 1936 and most remembered as the first journal
to publish the American BD "Betty Boop," renamed "Betty Star" for French
audiences, before it folded. Both of these weeklies were produced by the sto-
ried Fayard publishing house and managed a respectable weekly circulation
of roughly forty thousand issues each.[53] However, the real force in the field of

l'allure d'un escargot¹ en lançant de joyeuses péta-
rades² et le bon docteur Clément s'écriait avec angoisse:
— Pas tant de bruit! Vous allez les réveiller.
Chose étrange, la voiture finit par s'arrêter tout à
5 fait dans la cour d'honneur du château de Vallangou-
jard.
M. Théotime Kapock, M. Séraphin Pipe et le nègre
Bamba attendaient sur le perron de cette demeure
illustre. On aurait pu lire une espèce d'émotion sur le
10 visage des deux messieurs nommés en premier. Quant
au visage de Bamba, il était si noir qu'on ne pouvait y
lire absolument rien.
— Eh bien? demandèrent d'une seule voix Messieurs
Kapock et Pipe.
15 — Eh bien, nous voici, répondirent d'une seule voix
les deux docteurs. Nous arrivons tous les quatre.
— Allons directement dans la nursery, dit M. Pipe,
qui prit la tête du cortège.
La nursery, que l'on venait de préparer dans une

¹ mail. ² explosions.

— Trop vite! Je fais du cinq¹ à l'heure. Parole
d'honneur! Qu'est-ce que vous avez, Clément?
— Rien. Je ne sais pas s'ils respirent, mais je
crois qu'ils font autre chose. Mon genou est un peu
mouillé. 5
— Vous devez vous tromper, mon cher; à cet âge-là
ce n'est jamais bien considérable.
— Oui. On dirait que ça remue.² Je vous en supplie,
allez moins vite.
— Je n'ai qu'une façon d'aller moins vite, c'est de 10
m'arrêter tout à fait.
La voiture s'arrêtait un peu, puis elle repartait à

¹ cinq (kilomètres), i.e., scarcely more than three miles. ² is stir-
ring.

FIGURE 2.4 An typical example of the illustrations by the painter and lithographer
Berthold Mahn in Duhamel's slim book *Les Jumeaux de Vallangoujard* which first
appeared in 1931. Author's personal collection.

children's journals in the first decades of the twentieth century was the Société
parisienne d'éditions (S.P.E.). Founded in 1899 by the six Offenstadt brothers,
the S.P.E. published six of the leading children's journals including *Le Petit
Illustré* (1906–1937) and *L'Epatant* (1908–1939), both of which showcased the
popular and ribald work of Louis Forton.[54]

So popular had the form become that even the curmudgeonly Georges
Duhamel tried his hand at publishing work in a similar vein. *Les Jumeaux de
Vallangoujard* was first published in 1931 and its simply written story revolved
around "Professor Pipe," who had invented a foolproof method for bringing
happiness to the world by removing individual personalities; the twins of the
title being his test cases. A quirky distillation of the most salient ideas from his
earlier *Scenes From the Life of the Future* and appearing a year before Aldous
Huxley's still famous *Brave New World*, it was widely popular and provided
Duhamel the opportunity to make literary hay once again from the standariz-
ing civilization of America and, by his own estimation, bogus scientists and
pedantry. Befitting his traditionalist sensibilities, *Les Jumeaux de Vallangou-
jard* was far more akin to the illustrated texts of the nineteenth century than
even the hebdomadaires mentioned above. Nonetheless, the influence of the
contemporary press is apparent in the sixty whimsical sketches of the painter

and lithographer Berthold Mahn that pepper the work in their simple design and the fact that they actually relate, and add, to the written text (fig. 2.4). Often, the designs that accompanied earlier illustrated texts related to the storyline only in so much as they might share a relation to the general subject.[55]

Overt politics in the *journaux des enfants* made their appearance with the Catholic Union des Oeuvres weekly *Coeurs Vaillants*. From the journal's first appearance, its underlining sentiment was made evident by the December 8, 1929, launch—in Catholic liturgy, the feastday of the Immaculate Conception. Originally unremarkable in material and design, within a year of its initial publication the journal had set itself apart by being one of the first to completely abandon the tradition of a directive text appearing beneath the illustrated panels, and embraced speech and thought balloons as the textual driver of their BDs. Issue number 38, appearing in August 1930, debuted the early science fiction BD "Fred, Bodédig et Bibédog" on its first page. Soon after, the work of the man most often credited as the father of the francophone BD, Hergé, and his most famous creation, the boy reporter Tintin, began appearing in issue number 47, October 26.[56] A combination of the adoption of the modern technique of the speech/thought balloon, the skill of contributors like Hergé, and a strict adherence to Catholic doctrine in its articles all came together to guarantee a stable public future for the journal as it also initially relied on distribution through a network of parishes and Catholic schools.[57] From the first issue in 1929, which numbered thirty thousand, it soon had a circulation of ninety thousand and, in the years immediately before WWII, eclipsed all but the most popular "secular" journals with a distribution of nearly two hundred thousand issues weekly.[58]

Groundbreaking examples of the modern BD were not the only designs imagined or intended by the publishers of the journal, however. Rather, they hoped to position the weekly squarely in the modern militant Catholic movement and, as a consequence, placed the hebdomadaire at the heart of the struggle over True France. By late 1933, young readers of the journal were encouraged to choose and earn badges and procure an official *Coeurs Vaillants* uniform, a beige short-sleeved shirt with an orange and green scarf. By early 1934, the journal was regularly publishing photos of young "valiant hearts" gathered around their parish or troop flag. Eschewing the political neutrality that was typical in many of the other journals, *Coeurs Vaillants* eagerly jumped into the politico-cultural concerns of the decade. This most often came through in blocky, pablumesque distillations of the current fray between the left and right in suggesting that rather than playing "cops and robbers" or

"cowboys and indians" subscribers of the journal play "good Catholic" versus atheist or, more pointedly, Communist. However, more than one article truculently warned against the "sirens of Moscow" and, in at least one issue, subscribers were offered a debate between between M. Ferdinand, representative of *Coeurs Vaillants*, and M. Jacquot, from the Communist hebdomadaire *Mon Camarade*. Not surprisingly, readers were always treated in these articles to demonstrations proving the "undeniable dialectical superiority" of the Catholic knights in maintaining social order.[59]

Though it was nearly four years later, the PCF began publishing its own hebdomadaire, *Mon Camarade*, in June 1933 under the direction and editorship of the surrealist-turned-Communist Georges Sadoul. Far better known as a film historian and critic, his work with the PCF's BD journal is seldom mentioned in any biographical sketch but after taking the position at the urging of his close friend Louis Aragon, it was Sadoul who set the tone and direction of the weekly as he became, over the course of the decade, the most vociferous voice of both chastisement and defense of the medium within the party.[60] Published by the PCF's Fédération des enfants ouvriers et paysans, a subset of the Association des Ecrivains Révolutionnaires (AER) founded the year before by Aragon, the journal itself was, when it first appeared, an austere example of the hebdomadaires that were available at the time. Unimpressive in size, and comprised of eight black-and-white pages, the title of the illustré was jarringly scrawled in italicized font and colored a deep red; orginally its only bit of color. The weekly had only one—highly didactic—BD "Les Aventures de Pipe et Pomme, enfants de prolétaires," and like *Coeurs Vaillants*, *Mon Camarade* was intended to develop the political conscience of its young readers though it lacked both the nuance and approachability of the Catholic example. The effect of this less-inviting format was apparent from the outset and after a year of publication circulation of the PCF's children's journal numbered only ten thousand.[61]

Despite the paltry circulation numbers of the journal in comparison to not just the rest of the field but particularly when considered beside the success of its Catholic ideological counterpart, it is likely the situation would have nonetheless gone along relatively unchanged had it not been for the appearance of the new *Journal de Mickey* (JdM) on June 1, 1934 (fig. 2.5). Roughly twice the size of most French *illustrés enfantine* and riotously colorful, its contents were almost entirely made up of BDs, most of which were American, with its "star" Mickey Mouse leading the way. An immediate success among youngsters, it soon boasted a then-startling circulation of nearly 400,000 issues a

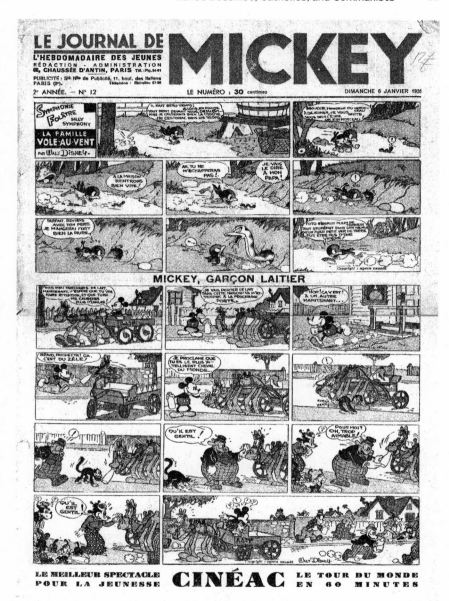

FIGURE 2.5 *Le Journal de Mickey*, January 6, 1935. Courtesy of the personal collection of Laurence Grove.

week and spawned some fifteen or so imitations in both France and Belgium in the following years. Many of the more traditional *illustrés*, which had not significantly altered their production techniques or updated their content for decades, were left to sit on the shelves, abandoned by their former readers, and forced to either change or be pushed out of publication all together.[62]

Some of the oldest, and previously most influential, examples of the genre fell as casualties of the influence of the *Journal de Mickey* on the field before the end of the decade. In fact, the Offenstadt family concern, the S.P.E., either folded or changed the name and format of almost their entire stable of children's journals in the three years between 1936 and 1939, including *L'Intrépide*, *Cri-Cri*, and the two Forton-dominated journals *Le Petit Illustré* and *L'Epatant*.[63] While *Coeurs Vaillants* never matched the *Journal de Mickey* in sheer terms of issues circulated each week, the combination of exciting, innovative BDs from the pen of artists like Hergé and a stable and committed base of support-ers among the parishes and parochial schools ensured that the hebdomad-aire would not founder as so many others did in these years. However, and likely much to his consternation, even Sadoul was forced to admit that *Mon Camarade* had to adapt or face disappearing all together. Ultimately, deciding that the weekly was too important as a political and educational alternative for the children of France to suffer such a fate, in 1936 the journal adopted a more lively and appealing appearance, relying more on BDs to carry its mes-sage than had previously been the case. Expanding from eight pages to twelve, each issue now contained four pages of colored BDs, two adventure stories, one romance, a science page, collectible stamps and sporting news, serialized foreign novellas, games, riddles, and all the appropriate "distractions for small girls and little boys."[64]

Undoubtedly, the effect of the *Journal de Mickey's* launch in the world of the *journal l'enfantine* was momentous enough that there is good reason for some to have suggested that the "cultural phenomenon of the modern francophone bande dessinée" actually begins with its debut.[65] If nothing else, the journal represented a new method of production in the field; one that was reliant not on indigenous "in-house" artistic talent but rather syndicated BDs that were the product of authors and designers far removed, and in the case of the *Journal de Mickey*, from the United States. The hebdomad-aire, and its new style of production, was the brainchild of Paul Winkler and his Opera Mundi syndicate, which advertised itself as a purveyor of all the "works of the world."

A native of Budapest, born in 1898 into a prominent banking family, as a young man Winkler traveled and lingered in Germany, England, and Holland before settling in Paris in 1922. There he founded a small journal for other Hungarian émigrés and wrote articles on the cultural and political life of Paris for American, English, and German newspapers. In 1928, after seeing the success and fortune made by the Hearst publishing empire in the United States with their own King Features Syndicate (KFS), he decided to attempt something similar and with "an office, a telephone, and an assistant," established the first real press syndicate in France. Opera Mundi became the exclusive French agent for such KFS titles as "Mandrake the Magician," "The Katzenjammer Kids" (in France known as "Pim Pam Poum"), "Flash Gordon" ("Guy l'Eclair"), "Prince Vaillant," "Jungle Jim," and of course "Mickey Mouse," all of which became the foundation for the two children's weeklies Winkler would publish in the 1930s.

While the importation of individual BDs for use in French publications was not unheard of, syndicates, and the manner in which they conducted business through the liscensing of work to other publications for a fee, were rare in France in the 1920s and 1930s. In many respects, at least in the eyes of Winkler's critics, this afforded him an immense advantage over more tradition-bound French publishers. Initially, he had in fact attempted a more specifically American model of business than producing his own illustrated journal, selling rights for the BDs in his press stable to the French daily newspapers rather than the illustrated press or the *journaux l'enfantine*. Only after being rebuffed by publishers who saw no place for BDs in their serious dailies did Winkler turn to the idea of producing his own illustré, with the quiet support of the Hatchette publishing house acting as a silent partner in the venture.[66]
Now, Winkler began producing the *Journal de Mickey* at a distinct economic advantage over his French counterparts. Free of the need to maintain a stable of artists and writers to create BDs himself, Opera Mundi's only immediate financial outlay was translation and the insertion of new text into the speech balloons of the BDs he was importing. So significant was this one advantage that by some contemporary estimates, even with all the other innovations of the journal the production cost of imported BDs versus those produced by French authors directly was seven to eight times less.[67] This huge disparity in the cost of producing the "heart" of the journals contributed to everything from the much larger size of Winkler's hebdomadaires to a more liberal use of expensive coloring in their printing as even the additional costs of these

production outlays were ameliorated by the initial savings afforded by Opera Mundi's exclusive arrangement with KFS.

As already noted the wild success of *Journal de Mickey* brought a variety of responses from across the French publishing industry. Most radically, between 1935 and 1936 French draftsmen directed the efforts of a commercial union, the Union of French Artists and Designers (UADF), toward defending their position within the industry and lobbying the government for protection against the supposed invasion *étrangère* of BDs from outside the Hexagon. Many in the general public shared the union's position. As Sadoul lamented at nearly the same time, foreign BDs were pouring into the country without any customs control or tariffs.[68] The UADF addressed these issues by pushing for a legislative project that would limit foreign material in French publications to no more than 25 percent of the entire work. While the proposed legislation enjoyed some quiet support in the parliament of the Third Republic's Popular Front, it was to fall to the wayside with the Republic's collapse in the first months of World War II.[69]

As the political machinations of French artists were being wrestled with outside the public's direct view, Winkler began publishing his second, wildly successful, weekly in April 1936. With *Robinson* nearly all of the popular "adventure" BDs that had not appeared in the *Journal de Mickey*, from "Mandrake the Magician" to "Guy l'Eclair" and the newer "Popeye," found a welcome home. Weekly circulation soon nearly equaled that of the earlier journal, giving Winkler's Opera Mundi by far the two most popular children's illustrés on the market. The publishers of France's other, more indigenous, *journaux l'enfantine* were faced with adopting their own survival tactics in an attempt not simply to save the jobs of individual artists, but keep the entire industry afloat amid what more and more of them were coming to describe as a tidal wave of change. This generally took three forms: no change at all and attempting to chart a course all their own; spot changes which sometimes led to the most disastrous of results; and wholesale change of direction and titles that occasionally brought a new vibrancy to the industry and foreshadowed the strength of the indigenous BD tradition that would bloom in the decades after the Second World War.

The publisher of *La Semaine de Suzette*, Gautier-Languereau, decided it best to hew closely to the formula and format that had directed the journal since it appeared in 1905 and is perhaps the best example of the first option taken by French publishers of *journaux l'enfantine*. A periodic change in the number of pages in each issue was the only significant alteration to the weekly

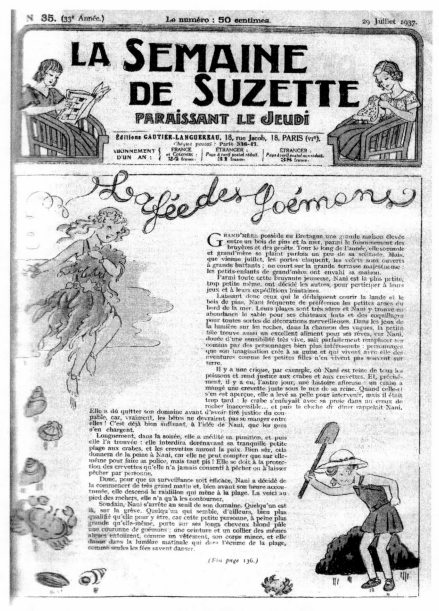

FIGURE 2.6 *La Semaine de Suzette,* "a proper journal for proper girls," July 29, 1937. Courtesy of Wendy Michallat and the archives of the International Bande Dessinée Society.

in the 1930s, and even that was the result of editorial and publishing decisions influenced more by the changing cost of paper and largely divorced from the impact of the *Journal de Mickey* and *Robinson*. The producers of the weekly meant specifically for young girls resisted even the modernizing trend of the transition to balloons in the body of their BDs, apparently believing that the more tradition-bound Images d'Epinal influenced *histoires* of the journal fit better with their self-charged task of educating young girls about becoming proper and productive women (fig. 2.6). A strong reputation as a fine periodical for young girls, its low price in comparison to some of the other weeklies, and a love—from parents and daughters alike—of the simple and good-natured adventures of the naïve Bécassine, title character of the journals most famous BD, all provided the grounds for the hebdomadaire to survive until the outbreak of WWII. Beyond then, however, not even the journal's simple, traditional, wisdom could save it from the pressures not of Mickey, but invading Germans.

The second option, that of including a new, typically foreign and often American, BD in an already established journal, and the consequences of doing such, was most clearly demonstrated by the example of the Fayard house weekly, *Les Belles Images*. As already noted, this journal is most remembered for having introduced French youth to the ribald adventures of the American BD character "Betty Boop." In an attempt to offer something of the new and kinetic work that seemed to mark Winkler's journals, the editors of *Les Belles Images* began printing the comparatively risqué adventures of the short-skirted ingénue in late 1935, but with few other changes to the journal. Perhaps because of the lack of a more complete reinvention, and the sense that an attempt was being made by its publishers to trade upon the history of the publication as "proper" for children while bowing to the pressures of changes in the industry, the parents of the journal's traditional readers decried the new BD as scandalous and the hebdomadaire soon lost thousands of subscribers. Not much more than a year after this publishing blunder the journal, one of the oldest of the modern *journaux l'enfantine*, was forced to fold for lack of a consistent audience. On December 3, 1936, the final issue of the weekly, number 1681, opened with a letter from the editors beneath the banner head, rather than the typical BD adventure, which read in part: "Dear readers, it is with deep regret that we announce to you that *Les Belles Images* will cease appearing. This number is the last of a journal which, during thirty-three years, distracted, diverted and even educated innumerable French young people who were our friends at the same time as our readers."[70]

Finally, the last response, that of reinvention and wholesale change in an attempt to meet the challenge of Winkler's journals on the very ground charted by them, was epitomized by that of the Maison Offenstadt (formally, S.P.E.). The leader in the field of *journaux l'enfantine* prior to the appearance of the *Journal de Mickey*, while their more traditional *hebdomadaire's* struggled just as those of their French competitors were, they also looked to proactively address the new situation by producing entirely new journals that were similar in look and appeal to those of Opera Mundi. However, far from becoming simply a clearing-house for foreign BDs, the S.P.E. instead invested in and fostered innovation in indigenous BDs. Their new journal *Junior* began appearing in kiosks in April 1936 and was one of the first weeklies from a traditional French publishing house to match Winkler's journals in size and colored, stylized appearance. Moreover, the blend of popular American BDs, like Harold Foster's "Tarzan," and new French examples, particularly the science-fiction BD "Futuropolis," in its pages proved not only financially successful, as circulation of the new journal quickly reached over 200,000 issues weekly, but has been pointed to as an early example of a vibrant "golden age" for French BDs that would flourish primarily post-WWII.[71]

While these commercial, generally pragmatic, and necessary issues were being pitched across by the various publishing concerns, the very idea of the modern BDs—their origins, content, ideologies, and general impact—became political fodder for those involved in the struggle over the "content" of a True France. Largely ignoring *Coeurs Vaillants* and other *French* examples of the new journals, most disturbing to many critics was the primacy that was now afforded the paneled image rather than developed text beneath the sequenced pictures. A near coalition of voices, led primarily by the nation's educators, decried this new model as "nonliterate" and feared that it would lead to the raising of a "nation of illiterates."[72] In 1938, while still editor of *Mon Camarade*, Sadoul published the highly polemical critique of the "Americanized" medium, *Ce que Lisent vos Enfants*. Nearly a decade before the famous proclamation by the German philosophers and social theorists Max Horkheimer and Theodor Adorno that Donald Duck takes his beating in the cartoons so the workers watching in the audience will not have to, Sadoul insisted that consumption of these BDs resulted in weak-mindedness and susceptibility to fascist propaganda.[73]

Like Duhamel's *America the Menace: Scenes from the Life of the Future* from earlier in the decade, Sadoul's lengthy tract found some purchase with adherents of every shade of political opinion and offered testimony to any who desired

it for whatever motive.[74] This popularity across the political board might itself indicate the amount of "conceptual" overlapping there was in the left and right visions of France. However, it should not eclipse the position that Sadoul held within the PCF, and as such, his role in the political and cultural struggles of the decade. The leftist and anti-fascist Popular Front government that took power in France in June 1936, two years after the violent right-wing demonstrations that threatened to bring down the republican government (often referred to as the Stavisky riots), signaled the formal emergence of mass politics in France, or politics as pageant as Julian Jackson has termed it.[75] Consequently, culture and quality-of-life issues for the plebeian classes also took center stage in the political programs of Léon Blum's fragile coalition of anti-fascists.

The PCF supported Blum's government and in fact had helped to ensure its election. However, party leaders had refused any cabinet positions in an attempt to both maintain their freedom of action and, likely, not alarm the more moderate members of the alliance. What this also meant was that the "PCF could influence events only by bargaining with its [Assembly member] votes and steering public opinion to pressure the government." Not in power, but standing beside a friendly government, the PCF actively engaged in, and nearly spearheaded for the movement, a "defense of culture against the Right . . . the culture of the Enlightenment and its heirs."[76] In this, they supported the formal, official, plans of the Popular Front, which had undertaken a sweeping program of social reform almost immediately after assuming power. Girding the program was the nationalization of the central bank and the armaments industry, but the government is most remembered for introducing the forty-hour week and paid holidays for the country's workers. Decidedly a victory for the working class, it also made the "problem of leisure" a central issue for the government; what were the masses to do with their free time and on holiday?[77]

No doubt, the holiday jaunts that many young French workers took in these first years helped to turn the abstract "hexagon" of the nation into a "moral unity." However, the often improvised and ad hoc nature of the trips brought many to wonder how the time might be better used. Much as there was a fair measure of overlap in the vision of France held by those on the left and right, there was also a sniggering belief held by many on both sides of the political divide that if left to themselves, the working (or simply lower) class would most likely only drink, or otherwise fritter, away their leisure time. The fact that a sporting and automotive magazine, L'Auto, ranked among the favorite reading materials of many younger workers, and cheap nightly openings of

the Louvre had to be canceled for want of interest only seemed to sharpen this concern for many within the Popular Front, as well as its sympathizers.[78]

There was, consequently, a subtle and reluctant conviction that intellectuals and the government both had to meet the working classes in the more popular milieu as well as guide them to proper cultural and leisure-time choices. If this proved unlikely, as evening hours for the Louvre had, then the Popular Front would simply have to produce its own "appropriate" cultural products for consumption. It is not without good reason that alongside the workweek and paid holidays, it is the government's embrace of and experiments with the cinema for which it is remembered.

The cinema in 1930s France was a dynamic art and industry. While it was true that the French had not been able to lay claim to being a world leader in the production of film since before WWI and were beginning to wrestle with the impact and influence of American films shown in their theaters, the work of such seminal cinematic masters as Jean Renoir has also led many to label the decade as a golden age for French film.[79] Renoir, son of the impressionist painter Auguste Renoir and unofficial film director of the Popular Front, famously insisted early in the government's life "we must give the cinema back to the people of France."[80] The removal of barriers between social classes, the "championing" of "the *political* virtue of *social solidarity* . . . were the deep values that informed Renoir's films in this period."[81] This theme, the unity of all Frenchmen, was at the heart of his most famous Popular Front film, the 1938 *La Marseillaise*, and it was widely acclaimed as a masterpiece example of the medium and a triumph of these ideals.

Sadoul, writing for the PCF's cinema journal *Regards*, insisted that "humanity, in every sense of the word, undoubtedly is the essential characteristic of *La Marseillaise*, this full, all encompassing *humanity* which marks all of Jean Renoir's work." Remarking on the theme of unity, Sadoul continued by noting that this "humanity extends not only to the people but also to the aristocrats and the king. Never has anyone given better parts to their enemies."[82] Nor did praise come only from the left. Though he was far more circumspect and wary than Sadoul, the critic for *Action française*, François Vinneuil, wrote that the film "is the work of an artist who shuns bric-a-brac and oratories . . . who seeks a beat of human truth—qualities that should distinguish the French cinema more often."[83]

While still a relatively young medium, the French had been leaders in film development since its earliest days and cinema had quickly become an accepted part of the larger society; or as Sadoul insisted to little protest, "an

FIGURE 2.7 Sadoul's example of the "crude" Italian BD journal *Hurrah!* as it appeared in his lengthy 1938 critique of the medium, *Ce que Lisent vos Enfants*.

important part of our culture" worthy of archiving and protection.[84] It is interesting to consider the general condemnation of BDs, the twentieth century's other popular culture visual form, as an enervating pastime at best given the prominence that film held in the cultural sphere of the Popular Front generally and Sadoul and the PCF specifically. Made even more so by the fact that while Sadoul made repeated reference to the invasion *étrangère*, or the large number of foreign BDs on the French market, his concern was not nakedly anti-American (though it was anti-fascist and generally anticapitalist). In fact, he wrote that the "technical virtuosity of *Mickey* is incontestable and . . . Walt Disney is certainly an artist of the first order," while also admitting that educators had fought against "certain French publications . . . because they were stupid and vulgar." Further, while discussing the "invasion," he goes so far as to make a distinction between the quality of American and Italian BDs which were, by his estimation, even more directly propagandistic and of a poorer, more crudely drawn, quality (fig. 2.7).[85] What Sadoul was doing in his critique was defending a position staked out in the political culture of France that predated even the Third Republic. As Duhamel had already pointedly argued, France was, after all, based on a print culture. The corrupting power of the image in the milieu of *journaux des enfants* had to be tempered with discourse inducing text; barring that, the message of this medium that "strikes the sight" and stirs up passions "without reasoning" had to be didactically marshaled.

A close reading of Sadoul's tract demonstrates that while he buffers his polemic with figures and statistics concerning foreign content and the like, his primary concern was with the educative value of the BDs, as well as their cultural and even moral content. When discussing the BD "Brick Bradford," described as an Italian version of "Guy l'Éclair" (Flash Gordon), which debuted in the illustré *Hurrah!* in 1937, he depicted the aesthetics of the strip as that of the music-hall: "Nude women and marches of plumed girls . . . kiss and embrace everywhere . . . and it is more or less a direct call to sex." This

FIGURE 2.8 Sadoul's choice of a panel from the *Flash Gordon* knock-off, *Brick Bradford*—a world peopled by generals and muscled athletes—as it appeared in his lengthy 1938 critique of the medium, *Ce que Lisent vos Enfants.* The BD was actually another KFS product.

in a journal meant for readers between the ages of eight and sixteen. It is the nature of such work, he wrote, to "compromise their formation and their sexual balance." For the ardent Communist, the morality of "Brick Bradford" was also suspect. By the nature of its heroes, it proposed that children admire only "a muscled athlete" and that the world was broken down into "princesses . . . princes . . . generals and soldiers" (fig. 2.8). A system of militaristic power was proffered as admirable while social classes, as they existed in the world, were ignored. As for the fantastic feats of BDs like "Mandrake the Magician," transforming ferocious tigers into harmless kittens and turning invisible, such "puerile adventures" affect students negatively by "turning the child away from reality and making him pursue impossible dreams."[86] When imposed, unchecked, on an impressionable child, such things make it

impossible for the child as student to distinguish between fact and fiction and imperils their potential for education.

Not surprisingly, Sadoul was not alone in raising these concerns. Those from the more conservative and Catholic political spectrum made similar, and occasionally more strident, complaints. At roughly the same time that Sadoul's polemic appeared, the Abbé Paul-Emile Grosse wrote a lengthy article for the Catholic education journal *La Patronage* that was strikingly similar in concern. Using language and descriptions of the *Journal de Mickey* that might have come from Sadoul himself, the priest asked: "What does this Journal offer the youth of France? In the first four pages of . . . images the scrapings of daily American life and women in short skirts or skimpy bathing suits. Elsewhere one discovers old clichés: bandits in cars or planes and trips to the moon. Murders and wars abound in these poor stories that never offer a breath of fresh air." With an even more conspiratorial eye, Grosse added that "occult corporations, use this means to soil the youth of France and make them stupid." Indeed, the very future of France was imperiled as "these adventures undermine authority and allow perverse ideas to infiltrate young minds. Not only does this all have the effect of harming children but by them the family and the society of tomorrow."[87] Tellingly, his condemnation of the new journals also included the fact that for all the grievous images that assail the eyes of young readers, there are barely "fifty lines of text" in the entire magazine.

Even here on the Catholic right, and particularly among those commentators and authors attached to *La Patronage*, the campaign against dangerous BDs was not specifically anti-American, at least not initially. Instead, it had begun even before the 1934 appearance of *Journal de Mickey*. In 1932, the writers of the journal warned against impertinent choices for children's reading and steered parents and concerned educators in the direction of their own *journal l'enfantine, Coeurs Vaillants*. Here they promised religious and social education as well as BDs they deemed more palatable like "Jim-Boum" or "Tintin et Milous."[88] The rather mild initial push to steer children toward *Coeurs Vaillants*—both of the BDs mentioned in the example just previous appeared there—grew more strident throughout the decade until it reached a near fever pitch by 1939. In a "Monthly Review of Children's Journals," the author wrote, "everyone says children do not like to read." This would not be the case if you "offer an illustrated magazine adapted for them"; but the onus was placed on the family to guide the choice of their young readers because "the faith and the innocence of the child are in play."[89] In the review of current popular journals that followed, titles such as the Sadoul edited *Mon Camarade*, and the socialist

Copain-Cop were cautioned against because their inspiration was Communist and antireligious and children who read them "poisoned their souls." More directly American-inspired journals like the *Journal de Mickey* and *l'Intrepide* were condemned for their perverse morality and the way in which they made sympathetic characters out of criminals. There were a number of journals that were described as "proper, honest, and educational," but the review ends with the best of the lot, *Coeurs Vaillants*, which parents were encouraged to purchase for their children if they wished to take an important and formative role in their child's education.

Sadoul also proposed a review of sorts of available illustrés. In a brief section titled "Healthy Publications," he predictably described *Mon Camarade*, along with *Copain-Cop* and *La Gerbe*, as being morally healthy and educational for young readers. *Mon Camarade*, in particular being a good choice as it took as an educating task the "diffusion of the work of great writers." He offered a long list of literary giants such as Victor Hugo, Swift, Rousseau, Edgar Poe, Kipling, and others.[90] Save for a fear of fascism, Sadoul's actually appeared to be more thoroughly foreign and less ideological than what appeared in *La Patronage*; but at the root of the matter their concerns were largely the same—the proper civic and moral education of the children of France, and in this, as in their criticism of the medium, their respective language was strikingly similar. At the end of his long article in *La Patronage*, Grosse noted that it had been argued by some—Winkler particularly—that these journals were a "healthy distraction of childhood! . . . Is this the case with these . . . drawings without originality . . . [which] accustom the child to intellectual laziness?"[91] Sadoul, in the beginning of his work, bemoaned the loss of direction in the presse enfantine that had been provided by artists like Töpffer and Christophe whose work was of a high "technical quality, moral, artistic, [and] educative."[92]

These criticisms of BDs in the 1930s were born not of a simple dismissal of childish fare or even principally, at this point, out of a fear and mistrust of America or American culture. Rather, they were the result of the larger contest between the left and right over the right to speak of and for the cultural patrimony of the nation during the tumultuous years of the run-up to WWII. It was in this decade that culture fitfully became political, if not simply politics, and few attempted to deny this reality. Tourism, be it colonial or simply within the Hexagon, took on a direct political dimension that made concrete by events like the International Colonial Exposition of 1931. Renoir was insistent on the social and educative role that cinema should play, and Sadoul, as well as those more officially a part of the Popular Front in 1936 to 1938, was

more than willing to second his intent. The protests across the political spectrum against BDs should be understood in the same light.

Jackson argued, in *The Popular Front in France*, that cinema was a particularly revelatory vehicle for examining this social phenomenon in France during these years because it is both a cultural art form and an industry.[93] While this is undeniably true, so are BDs. As an industry, *journaux des enfants* felt the pressures of modernization and the impact of foreign competition in a way that might well have eclipsed that of even the movie industry. And, even more than film, BDs are a truly mass medium given not just the huge numbers of journals printed weekly, but also their portability. Unlike film, where at least it was necessary to actually go to the theater to indulge in its consumption, BD journals could easily be toted about in the back pocket or knapsack of any child to be shared, traded, or simply read anew anywhere, at anytime.

Perhaps it was the portability of the popular journals that lent them an additional air of subversion—easily sported about and inexpensive, in procuring them the youth of France were often able to avoid negotiating with the familiar first-rank of societal authority, parents. This slightly uncontrollable element in the consumption of journals that might (additionally) not be truly *French*, then made them an easy target for authorities and social elites who had grown concerned over the nature and health of French culture and society in the interwar years. No doubt, the fantastical content of individual BDs, as we have seen, was always an obvious concern and an easily raised issue, particularly when the desire was to dismiss or diminish the medium. A point made even more complete when considered alongside the criteria that Sadoul insisted made for a great and timeless film. "The film directors who have created genuine and, therefore, lasting works," he wrote in the same year as *Ce que Lisent vos Enfants* appeared, "have relied on social reality." For a film to merit lasting consideration, it must take note of the society as it exists. "The fact is scarcely debatable," he insisted, "and it would be easy to multiply examples from Molière to Chaplin. The dazzling superstructure of a film has to rest on the firm terrain of social reality, or else risk almost immediately falling into ruin."[94] But there was ultimately more to the criticism of BDs than simply concern over the distressing *content* of their panels. When yoked to the, at least, century-old prejudice that images "speak" to the emotions and passions while print engages the higher faculty of reason, this leads to a presumption that BDs were tools ripe for the conveyance of base propaganda at best. Add to this the fact that there were more than three million copies a week of various *les journaux des enfants* being handed around by four million school-age

children by 1938 and the fear of critics of the medium quickly became that these weekly journals would come to express an unshakeable and stupefying hegemony over the youth of France, rendering them near illiterate and incapable of participation in the space of the national culture.

Too young a medium and too derisively thought of to be considered an art, it remained a form of popular entertainment laden with political baggage. In the modernization of BD that occurred in the late nineteenth century and the first decades of the twentieth, two things happened simultaneously. The first being the aesthetic development which has concerned most histories of the medium in France to date; the second was the gradual, though not always total, removal of the form from publications meant for adults and the relegation of it to journals intended for children. This literary quarantining, however, did little to free the medium of the condemnations and worry over the visceral power of the image that had dogged it since before the days of Philipon's journals in the mid-nineteenth century and left it in the awkward position of being seen as a dangerous influence on the only sector of society for which it was presumed suitable.

France, in the 1930s, was a nation enmeshed in a struggle over the very nature of what it meant to be French and in the lamentations over BDs, from those on the left and the right, the general commonality of the competing definitions of *True France* was laid bare. Whether rural peasant or urban worker, Communist or Catholic, the Frenchman was always thoughtful, deliberate, and rational; all the things, in other words, that BDs were presumed not to be. Soon enough, however, the decade's ideological civil war was brought to an abrupt end by the defeat of the country's army at the hands of the German Wehrmacht and the assumption of power by the aged WWI hero Marshal Henri Phillipe Pétain in May and June of 1940.

This was not the end of the political story for BDs, however. As will be seen in the following pages, the informal and public debate over BDs that the Catholics and Communists had engaged in during the 1930s will coalesce into a formal, if tenuous, alliance during the formative years of the Fourth Republic after the war as a theme of necessary cultural renewal is agreed upon by all parties. First, however, defeat at the hands of the Germans might have brought down the government, but it might also have saved French BDs.

Chapter Three

Notre Grand-Papa Pétain

The National Revolution and Bande Dessinée in Vichy

We read, when we do read, with the object of acquiring culture. I have nothing against that but it never seems to occur to us that culture can, and should, be a great help to us in our daily lives.

—Marc Bloch

Whoever has approved this idea of order ... will not find it preposterous that the past should be altered by the present as much as the present is directed by the past.

—T. S. Eliot

On June 17, 1940, after a winter of "Phony War" and little more than six weeks of actual fighting, the aged Marshal Pétain, named head of the government for barely a full day, announced his intention to seek an armistice with Germany in a radio address to the French people. The French nation had known defeat before, even on a grand scale as was the case in 1870, but this was different both quantitatively and qualitatively; this was a complete collapse and an utter humiliation of not the army so much as the entire Republic. The fighting along the ever-shifting front had been intense in some combat sectors, with the German army taking more than a million and a half prisoners and almost one hundred thousand servicemen killed; more telling however, were the million-plus sudden refugees who fled south, sometimes only barely ahead of the Nazi Werhmacht, clogging roadways and bringing with them their own versions of battlefield chaos and sense of despair in the face of the enemy.[1]

When Pétain informed the French people of his intention to pursue an end to hostilities with Germany, he famously insisted that he offered all that remained of himself for his beloved country: "the gift of my person to lighten her misfortune."[2] The elderly marshal—most comfortable as a soldier and still comparatively new to the role of diplomat and politician, dedicated to the *pays reel* if not the *pays legal*, and slightly vainglorious—believed that he could provide some protection for the people of France. As the French ambassador to Spain in 1939, according to the then Paris correspondent for the *Manchester Guardian* Alexander Werth, Pétain had "allowed himself to be flattered . . . by the Spaniards, and was ultimately persuaded by them that Hitler would offer him, the 'hero of Verdun,' an honourable soldier's peace."[3] If the German terms for a suspension of hostilities were mediated by a desire to accord Pétain and his new government the place of bested equal, it is difficult to discern such from the demands that were issued or the conditions under which the country was forced to labor for the bulk of the Second World War.[4]

If the last shabby threads of the national myth of Pétain's person providing the shield, while de Gaulle was the sword of France during World War II, have been laid bare, the fact that the old marshal's National Revolution was intended to be just that—a revolution—is sometimes too quickly passed over. Just short of a month after Pétain announced to the French people his intention to seek peace with Germany, his second, Pierre Laval, balefully insisted that the constitution of Pétain's government was not simply a renunciation of the Third Republic. "It is the repudiation," he charged, "not only of the parliamentary regime, but of everything that was and can no longer be."[5] From July 10 to 11 the Third Republic of France ceased to be and a new *État français*, settled in the spa town of Vichy and under the control of Pétain, now the chief of the French state, came into being. As if to underscore the dismissal of the Third Republic and its legacies, Article II of the Constitutional Act that established the new government began by declaring: "All provisions of the constitutional laws of February 24, 1875, and July 16, 1875, which are incompatible with this act are hereby abrogated."[6]

The physical realities of the Occupation and the shackling of the state that that necessarily forced certainly limited what Pétain and his cohorts could do in terms of fashioning a rigorous and autonomous identity for the Vichy regime. However, the fact that almost everyone had turned their backs on the past of the Third Republic is beyond dispute. In the days of actual fighting, the English newsman Werth detected what he thought a severe psychological formula when it came to defending the Republic: "avares du sang français."

Even the decision to flee, rather than defend, Paris a week before Pétain took power seemed to him pessimistically calculated. Provided some base survival of the (eternal) French people and the city not being razed, both might come to emancipate themselves and the French would be French again, just as Paris would again be Paris. Or as Werth put it, "Esclavage—plus or moins provisoir—plutôt que la mort."[7] The implication being that the Third Republic was not worth defending and, in some measures, was simply not *authentically* French enough for the sacrifice of French blood. Indeed, no less a figure than de Gaulle, who had abandoned his government post as decisions were being made to seek peace with Germany, fled to London, and established himself as the leader of the "Free French" and ostensible head of the collective Resistance, seemed less than desirous of any overt comparison between himself and the petty politicking that had burdened the last government for much of the previous decade. During the important first year of radio broadcasts for his movement, he avoided the slogan of the Republic (Liberty, Equality, Fraternity) and opened his messages with the earthier, though more amorphous, "Honour and Patrie," a banner which trucked a striking resemblance to that of Pétain's *État français* rallying cry of "Work, Family, Patrie."[8] Nor was the similarity an accident of political fate; across the political centers and touch points, be they *legitimate* or *resistance*, there was agreement that the *political* France of the 1930s must and rightly had disappeared.[9] Even before he was given the right of full powers by the Assembly, and the same day that the military was signing Hitler's onerous armistice demands, Pétain delivered a speech in Bordeaux insisting that honor had been saved and that a "New Order is beginning."[10]

Under the new regime in Vichy this meant a return to—or at least valorization of—what could be identified as *authentically* French and that was generally symbolized in Pétain's peasant-championing phrase of a *retour à la terre*.[11] However, the discourse of the rooted, resolute, and quietly dignified peasant was at its best simply antiurban, and at its worst xenophobic and anti-Semitic. The writer Henri Pourrat, a favorite of the regime for his rustically themed novels, wrote in 1940 that as opposed to the peasant, a man of honest instinct, "the banker, the man of calculation, is born of the Hebrew people, city-dwellers who never stick to the ground even when they live in the countryside. Yes, the Jew, the height of the intellectual, is by his race profoundly opposed to the peasant."[12] Consequently, even if overt, or at least crazed, anti-Semitism was cautioned against in some quarters of Vichy, ideologies of the modern age were warned off as concepts that had led France away from its strength. As Louis Salleron, chief theorist of agricultural corporatism for

Vichy, pointed out: "It is interesting to note that Ricardo and Marx are both Jews. This fact certainly explains . . . their contempt for the land—contempt that they bequeathed to their liberal and communist heirs."[13] As virulent and anti-Semitic as some of this rhetoric seems, it is worth considering Julian Jackson's admonition that "it would be as wrong to read the entire history of the Occupation through the prism of anti-Semitism as it would be to leave it out entirely."[14] It neither ignores nor overlooks the many grave decisions made by the regime in its treatment of Jews during the Occupation to suggest that in much of the Vichy-inspired discourse on the subject, the Jew played the role of duplicitous, cosmopolitan foil to the honest local peasant; an imagined *other* to the Vichy-constructed—and equally imaginary—*self* of the land-connected and communitarian peasant of *True France*.

Still, this portrayal of things might also muddle the waters of Vichy policy to some extent, for there are actually two (nearly) separate, but not wholly unconnected, wishes expressed in both these actions and sentiments. The most vitriolic actions of the government in terms of either the repression or round-up of Jews, points where French police troops willingly did the "dirty work of the SS," becoming "enthusiastic stooges of the German police," most often were bound up in its attempt to maintain a measure of physical and political autonomy.[15] The other side of this, however, is the adoption of one of Maurras's most ardent desires; "Vichy's desperate wish to believe the outside world did not exist."[16] And this wish formed the backbone of the National Revolution; a "revolution" that Werth scoffed at, but where the path was clear: just as "the Nazis [had] dismantled the [modernist] Bauhaus school . . . [and both] Italian fascism and German Nazism fought architectural rationalism, Pétainism rejected modernism for rural, regional motifs" in public design and social order.[17] Or, as Lebovics has succinctly put it, "the task of the future was to reclaim the past. Folklore had come home . . ." and nostalgia became law.[18]

The focus under Vichy was the creation and maintenance of an anachronistically traditional public sphere that could be put forward as authentically French. This was the reason for the regime's interest in fields as seemingly obscure as folklore and localized ethnography. The actions launched by Pétain's government in its attempt to locate a *true France* have been well documented, if not always stringently analyzed for their historical import, and here it should be sufficient to note that the cultural policies of Vichy were as wide-ranging and catholic, if sometimes scattershot, in their scope as they were earnest in their intent.[19] Indeed, in the process of recreating an anachronistically traditional public sphere, no detail was too small or insignificant; and in this,

even the aged chief of the French state served as an exemplar. All of his corre-
spondence, and much of the correspondence he came in contact with—at least
that from the two people with whom he spent the most time, his secretary and
personal physician—was written on specially designed and made "artisanal"
paper that had been crafted from bleached and pummeled rags and formed by
specially trained artisans, and thus possessed all the "qualities of tradition."[20]

These sorts of designs aside, the broader emphasis was placed on an affir-
mation and celebration of regional diversity and expressions of local culture.
Singing groups, dancing and acting troupes, garbed in regional dress and with
the additional stricture that troupe members must actually be from the region
they were representing, soon became a ballyhooed commonplace.[21] Here
we see the universal citizenship of prior republican traditions being thor-
oughly abandoned and a particularist trope of regionalism and local cultures,
sifted free of alien influences, being embraced. This, coupled with the politi-
cal assumptions that girded Vichy's cultural policies, constituted not simply
a desire to wish away the outside world, but, as Faure argued, "time [was]
immobilized by a double combination: resort to an anachronistic past, and
indisputable atemporality."[22]

As far as other cultural mediums were concerned, most everything was
bowed to the dictates of manufacturing this anachronistic past to varying
degrees of success. As Lebovics pointed out, beyond the regional singing
groups that were part of the general revival of folk culture, music "was not
one of the strengths of the National Revolution." The "goal" of detoxifying
"the musical culture of the sounds of Josephine Baker and Tino Rossi, of black
jazz and Latin rumbas," for instance, fell well short, as "jazz . . . did not die in
France" under Vichy.[23]

The plastic arts, however, were broadly and successfully sublimated to
the Pétainist project. This, despite the fact that the demonstrated interest the
régime held for the "artistic world" was weak.[24] Indeed the visual (high) arts of
painting and sculpture, that had for so long been a seminal part of the nation's
claims of cultural superiority, played little role in the direct plans of the
National Revolution. There was of course a general purging of the academy
and salon of foreign, decadent (Jewish) influences but generally, the "Salon
agenda on art and Vichy's did not mesh."[25] According to Michèle Cone, the
régime's principle interest in the high arts, at least those treasures already then
held in the nation's museums, was in their use as baubles coveted by both the
Germans and the Spanish that could be traded for prisoners of war or other
concessions from the former and continued neutrality in case of the latter.[26]

In general, there was no equivalent to the Nazi propaganda minister Joseph Goebbels, whose desire it was to make art an "instrument of political stewardship" in Pétain's government. The marshal's own interest in the arts extended little past ensuring that the striking blue of his eyes was properly captured in portraits. Cone relates the tale of an exchange between Pétain and Arno Breker; Breker, the official sculptor of the Third Reich, had offered to craft a bust of the French chief of state on his birthday only to be rebuffed by Pétain's reply that he would "rather own one of [Breker's] Venuses."[27] Nonetheless, this does not mean there was a complete dismissal of the importance of a proper (re)presentation of both Pétain and the régime's image. Under the direction of the Vichy-appointed ceramicist Robert Lallemant, there was a determined effort "to create over the long term an *Art Maréchal* that paid homage to [Pétain's] person but also, in line with his own wishes, celebrated eternal verities on the theme of country, the family, and work."[28]

In examples of "high" art this *imagerie du Maréchal*, as it was officially termed, often took on the visual formulas of early religious pictographs akin to the "Images d'Epinal," which had a flat style reminiscent of medieval art and distilled both Pétain's life and the message of Vichy into the simple didacticism of a fairy tale. The style and symbols of this plastic hagiography were carried throughout the unoccupied zone (at least) by youth groups like the *Compagnons de France*, who would sell calendars, almanacs, and other tchotchkes emblazoned with it, often in the most isolated rural zones, for charity drives for prisoners of war and their families. There was almost nothing that was not utilized in this manner as the slogans of Pétain and Vichy were printed on the covers of "matchboxes, packets of cigarettes and boxes of cigars, and railroad car advertisements" to mention only a few.[29]

Concomitantly with this explosion of the decorative arts under the direction of Lallemant came a re-valorization of the artisan, the trustworthy counterpart of the peasant without whose "industrious activity," according to Pétain, the "renaissance of [France's] farms" would be impossible.[30] Interestingly, despite the prevalence of forms reminiscent of the Images d'Epinal, the concern was not necessarily with either the restriction or imposition of certain styles. In fact, Lallemant's own contributions to the *imagerie du Maréchal* industry were often influenced by a very modern cubism. Rather, the limiting debate turned on poor technique and craftsmanship that quickly became more a question of honest village artisan versus the sloppy and decadent urban/cosmopolitan artist which easily converted the discourse into an essentialist debate not about competing styles but about what was authentically French.

When this was "translated into concrete effects," according to Cone, "such xenophobia . . . made Jewish artists into marginal figures and hunted prey."[31] Consequently, while there was no clear articulation of an official Vichy style, this bucolic "fascist realism," as Lebovics has called it, dominated much of the artwork that was produced during at least the first two years of the régime. Artists, sometimes actively sometimes tacitly, engaged in a purification and "Frenchification" of art, exploring themes consistent with Vichy policy and wishes while also engaging in exclusive exhibitions such as Salon de la Paysan-nerie Française hosted by René Henry in December 1941 at the Boëtie gallery in Paris, thereby giving such work the still valuable imprimatur of the Parisian art scene.[32]

In such a heated milieu there was no way that BDs could not have been drawn into the fray from nearly the start of the régime. Most immediately, the publishers of many BD journals were no different than the great multitudes of other French who were pushed into a southern exodus in the face of advanc-ing German armies—a disruption that affected some more directly than oth-ers. Paul Winkler, founder and director of Opera Mundi and publisher of the two most popular BD journals in the 1930s, *Le Journal de Mickey* and *Robin-son*, fled Paris along with thousands of others in the summer of 1940. Always and first a writer, publisher, and businessman, Winkler had organized the evacuation of his company's equipment and other materials along with his family and personal effects to the city of Marseilles. There, he contracted with a small imprint house and arranged for the continued printing of his *journaux l'enfantine*.

This, however, proved to be only a temporary move for the naturalized citizen and his three children. Among the first actions of the new régime had been the passage of restricting and exclusionary legislation intended to "single out what Maurras liked to call 'internal foreigners,' un-French French-men." After some forty years of conservative, Maurrasian-inspired discourse the "three parts of 'anti-France'" had, nearly by default, become "Protestants, Masons, and Jews."[33] Just one day after the reconstitution of the government under Pétain only a child born of a "French father could be a member of a ministerial *cabinet*." Days later "this exclusion was extended to public servants (including teachers), then to doctors, dentists, and pharmacists . . . and finally lawyers. In effect, these measures created a second class of French citizens whose families were deemed not to have been French sufficiently long."[34]

As almost a final note to this exclusionary coda, on July 22, 1940, the new government initiated a commission to investigate the great numbers of

"suspect" citizens who, since a "loosening" of the law in 1927, had been allowed "to become French too easily."[35] Heading this "Commission for the Revision of Naturalizations" was a failed businessman and "avowed monarchist," Raphaël Alibert, and under his leadership the commission reviewed the dossiers of roughly half a million people who had received French citizenship since August 1927. Of those, barely fifteen thousand actually had their citizenship revoked; still, and while the law was said not to be directed specifically at them as a "race," Jews made up nearly half of those whose citizenship was lost.[36]

Likely because of his prominence in the French publishing industry, Winkler became a subject of the commission's investigations as early as November 1940, with the manner of his naturalization, his activities, resources, and, particularly, "those elements which establish his Jewish qualities" all being questioned. Predictably perhaps, Winkler's French citizenship was stripped from him by official decree on June 10, 1941.[37] Luckily for the successful publisher, almost the entirety of this process was carried out in absentia.

A seasoned traveler before landing in France, the native Hungarian had become sensitive to the political winds of Europe after stays in Holland, England, and Germany during the decade of the nineteen-teens and was mindful of the xenophobic, and increasingly anti-Semitic, criticism of his publications throughout the 1930s. Shortly after the investiture of Pétain's government, Winkler obtained a divorce from his common-law wife Betty Dablanc, in an effort to spare her anti-Semitic reprisals, and secured for her, along with his business partner and secretary general of Opera Mundi Louis Ollivier, the authority to safeguard their business interests. With this quickly arranged, he used his now significant contacts within the Hearst and Disney media empires to arrange travel visas for him and his three children to the United States from the State Department. He had already left France, via Portugal, some months before the government stripped him of his legal rights as a French citizen. Only a few months after Winkler's departure, however, Dablanc joined him in New York after proving unsuccessful at securing permission to renew the sale of Opera Mundi's journals in the Occupied Zone from the German overseers, leaving the operation completely in the hands of Ollivier, who directed the business until Winkler's return after the war.[38]

While there were other "foreign" publishers affected by the upheaval of the French collapse and reorganization under Pétain, most notably the Italian-derived house Cino Del Duca that had been Winkler's principle rival before the war, the experience of Opera Mundi was, in many ways, illustrative of the course that BDs and la presse enfantine were forced to take during the war.

The German domination of the Occupied Zone of France brought with it a predictable censoring and prohibition of American (and American-inspired) products, which obviously included *Le Journal de Mickey* and *Robinson*. From the moment of the invasion and collapse, it was, at first, impossible to publish such journals, and after the Armistice, illegal. In the Southern, Free Zone, under the control of Pétain's Vichy government, American BDs continued to appear, if more limited in number, until the United States entered the war. However, the rationing of paper supplies had also made it easy to circumscribe the spread of Winkler's journals even when published legally. By the end of 1941, both *Journal de Mickey* and *Robinson* were appearing in alternate weeks and in a significantly smaller format than had been the norm for both publications. By the summer of 1942—with the United States now preparing to enter the war alongside the British on France's Mediterranean flank in North Africa—an already suspect product had become dangerous, and foreign BDs were steadily replaced by French examples. The last American BDs appeared in *Robinson* ("Popeye") at the end of June and the "Adventures of Mickey" disappeared from the namesake *Journal de Mickey* (now jointly published with a third Opera Mundi journal as *Le Journal de Mickey et Hop-là!*) the first week of July. With this purging of foreign content from *journals l'enfantine*, the "form" of the medium was made subject to the concerns of the National Revolution and many BDs took on the look of pre-1934—or pre-Mickey—examples; more Christophe or Töpffer than even Alain Saint-Ogan.[39] Opera Mundi's journals struggled along, sometimes appearing, in a thinned-out form, only once or twice a month, until July 1944, when they ceased publication altogether.

Using the fortunes of Winkler's company under Vichy as an example of what happened to *la presse enfantine* during the war years, it is easy to see why some commentators have called the brief era a pocket of salvation for the industry.[40] With the forced removal of syndicated American BDs from journals there were indeed new opportunities for young French artists, as editors looking to fill their pages turned to local talent out of necessity. The cost of in-house artists and production, a concern of the industry in the 1930s and a principle source of Winkler's market advantage because of his reliance on syndicated material, no longer mattered when everyone was forced to operate under the same constraints. The physical removal of the American product, however, did not necessarily force a replacement of the "American" style. Raymond Poïvet, one of the many young artists who got their start in the industry during Vichy, has insisted that "as we were faced by a problem both urgent and unforeseen, our only solution was to draw inspiration from, even

unfortunately plagiarize, the excellent American strips still available." Even if his "admiration for American models" was a shameful "stigmata" that he and his peers would bear "until the end of [their] careers" it is also pointed to as evidence by some that the burden BDs bore under Vichy was slight, if not always light.[41] Proof, in other words, that, for all else that might have occurred, the period of Pétain's government provided the space for a reeling industry to right itself before a foreign tidal wave and ensure that there would indeed be a French *presse enfantine* produced and published by Frenchmen. A few years that did much, in fact, to lay the seeds for the *age d'or* that was to come in the following decade where American products reappeared but never reclaimed their unchallenged place of supremacy and French BDs, arguably, took the lead in innovation and vitality.

There is undoubtedly some measure of truth to this relating of events. However, it glosses over the manner in which the "pocket" was made and maintained—often by way of racist and exclusionary government policies— and almost completely ignores the strictures under which the medium was forced to operate. As early as October 1940 the Ministry of Children and Sport (Ministère de la Jeunesse et des Sports) expressed concern over the content of children's journals; a policy memorandum written by a functionary of the ministry outlined a plan calling for reorganization, by decree, of the entire *presse enfantine* with the intent of "removing childhood from American influence" and insisting on the "total transformation of existing journals." The same memorandum also stressed the need to instill in France's youth the importance of "physical education, collective activity, country air, and manual labor," the ideological tenets of the National Revolution. The author of the memorandum also sought to secure from the "autorités des occupation"—as the Germans were blandly referred to in the missive—the authority to deny the publication and sale of any journal without prior approval of the secretary general of children in order to establish a uniform policy for the *presse enfantine* throughout the Hexagon.[42] Whether this policy memorandum ever amounted to more than a wish list of sorts is open to debate. There is, for instance, no obvious evidence that the occupying Germans ever granted authority to determine what was sold in the Occupied Zone. In fact, in at least one case, a publisher lobbied Vichy's Ministry of Information for permission to publish and sell his journal, *Fanfan La Tulipe*, in the Free Zone after German authorities had banned it in the Occupied Zone in early 1942.[43] However, as early as September 1940 paeans to *Le Maréchal* were already appearing in specialized sections of the *Journal de Mickey* and *Robinson* followed suit only a month later.[44]

Obviously—and similar to the case of high art and the bucolic "fascist realism" becoming the style *de rigueur* under Vichy—whether a particular policy regarding *journaux des enfants* was "officially" adopted and enforced from the start of the régime, they were quickly brought into the fold of the National Revolution. Their popularity among the children of France made them either too dangerous a weapon or too potent a tool to be left aside; and the value Vichy placed on the control of information and the power of propaganda is easily discernible. On September 24, 1940, barely two months after the reorganization of the government under Pétain, his second, Pierre Laval removed the "Service of the Censure (or Control of Press Information)"— referred to as simply "Censure" by Laval—from the Ministry of War and recast it as an "organ of the President of the Conseil." In truth, it was to be attached to the office of the Vice-Presidency of the Council, under Laval's personal control. "After the Armistice and the reform of the Constitution," he insisted, "the Censure ceased in fact to be a soldier and it is important, currently, in making the new conditions clear."[45]

The government was apparently aware of the demands that were now being put on the individual censors of the department in their role as guardians of the official message of the National Revolution. A memorandum issued the following year on October 24, 1941, titled "Note on the Insufficiency of the Treatment of Censure Personnel," recounted that the "task of censors is thankless and difficult." "They [must] claim general knowledge," it continued, "reliable judgment, a political direction, a spirit of responsibility and initiative, which one could, justifiably, require of higher placed and better remunerated civil servants. The Censure does not have the right to be mistaken but it notably has the duty to prevent the disclosure of errors."[46] In practice, the power accorded to the Ministry of Information and the Censure, in fact, served to lessen the need for an overt law or particular policy exclusive to children's weeklies; when an illustré ran too far—or too often—afoul of the messages articulated in the National Revolution, it was simply suspended from publication and sale. This was the fate of the journals *Tarzan*, *Jumbo*, and *Aventures* in September 1941, after Paul Marion, serving as the secretary general of information, criticized them for offering stories of kidnapping and violence "rather than trying to interest children in narratives that develop moral themes."[47] Marion was also more than willing to publicly recognize a publication when it served the cause of Pétain and the National Revolution. Only two months after censoring the offending children's journals, he was quoted in the pages of the regional journal *Corrèze* remarking that the review had answered one of

the dearest desires of the marshal: a return to the provinces within the nation and according the old leader the respect and recognition that "should never have stopped being given him."[48] Not only was this sort of public praise likely to appeal to those committed to the National Revolution among a journal's potential readership, but it could literally ensure its regular publication in those days of paper shortages and circulation difficulties by way of direct government *subventions*, or subsidies.[49] Consequently, even lacking a firm guide or directive, most publications, those meant for children among them, generally kept a cautious eye on the administration for any signs of displeasure.

After the defeat and the Armistice, the French nation found itself in a doubly awkward position. Pétain's government was possessed of a need to identify a rally-against-enemy but also an enemy that came—given the French collapse—from within rather than without; hence, the call for a renaissance and strengthening of the nation itself—in other words, the occasioning of the National Revolution. The easy anti-Semitism that so frequently draped the régime generally addressed the first "prong" of this problem; the second, revolutionary, "prong" lay in making the virtues of the honest and solid French peasant—the rhetorical antithesis of the vilified Jew—that of the entire nation. In this, in the actual renaissance of the nation, there was special emphasis placed on the role and importance of the youth of France.[50]

The criticisms of BDs that had been appearing in France from the 1920s had not simply adopted and adapted (adding the demonstrable xenophobic rhetoric post-WWI) concerns and rhetoric from a nineteenth-century parliamentarian's screeds against the emotive danger of *l'image*. They were also enveloped in a generalized natalist discourse that was concerned not simply with the low reproductive rate of the populace but, increasingly, with the health and welfare of the nation's existent children. Scattered concerns and random fears crystallized under the weight of events surrounding the fall of France, and the fate of children, and their role in society, took on a new sense of tangible urgency.

Within the government itself, concern about BDs and *journaux* was bound to the more general concern with the faith and future of the nation's children. Though derided in some quarters as too simplistic an explanation for France's collapse, the notion that "the education of courage had been overwhelmingly neglected, if not sabotaged and obliterated" in the school system was widespread.[51] Consequently, at the same time the new government was recasting who could be French, the secrétariat général à la Jeunesse (SGJ) was established and charged with the goal of "unifying young people, aged

14 to 21, and breathing a new mystique into them, because," so the thinking went, "youth is the essential and principal agent of any national restoration."[52] This "mystical" program, however, was going to take place, if it was to at all, within the framework of an ever-expanding state bureaucracy. After all, with a need to both explain the collapse and plot the terms and direction of national renewal, government "study groups were one of the few growth industries in France in the period after the defeat."[53] Indeed, that was one of the great ironies of Vichy. For all the ruralist rhetoric of faith, tradition, and balance, decentralized control and regional initiative, "the occupation years . . . moved France significantly toward the technicians' vision: urban, efficient, productive, planned, and impersonal."[54]

This was particularly true in the case of what would be generically called "social welfare." During Vichy, the welfare state that had begun under the Third Republic actually expanded, in many instances with the personnel and administrative structures remaining intact. Nonetheless, just as Pétain's government often looked to nongovernmental institutions to further its cultural agenda, here, too, Vichy turned to private charitable organizations to carry out their initiatives; the result, however, was a spread of state influence through bureaucratic growth.[55]

With Vichy's emphasis on the family generally, and children specifically, a network of government ministries, social workers, and experts was established to delineate the new realities of life imposed by the war and defeat on the nation's youth. Public schools afforded the state direct access to a large swath of the nation's young and, while Pétain (and much of his group of conservative experts like the eugenicist Alexis Carrel) believed the schools were to blame for corrupting France's youth under the Third Republic, the government's intention was to make them over into a place that carried the tenets of the National Revolution to the youngest, most impressionable, members of the French nation. Or, as one historian of education, Jean-Michel Barreau, has put it: "Schools under the Vichy government were 'Marshal, here we are" schools where children in classrooms sang, 'Before you, savior of France, we your boys, swear to serve and to follow in your footsteps.'"[56] The primary school system, however, could only account for France's children aged six to fourteen. Given that only a small fraction of students continued past legally mandated education to secondary schools, what was required was a way to continue the proper education and growth of just the fourteen to twenty-one segment of the population that the SGJ was established to unite and direct.

In this, an effort was made to replace the weak associational life of the Third Republic with a variety of socializing, and properly supervised, youth movements that would fill the day of this "in-between" category with wholesome and useful activity.

Likely, the most familiar of these youth organizations was the *Chantiers de la Jeunesse*. After the Armistice, all young men of twenty were "called to duty" for a term of six months (after January 1941 this was extended to eight months); at least initially, the organization was a success in terms of providing a place and mission for this group of France's "aimless" youth. Essentially military basic training with public works and agricultural harvesting, instead of combat and dependent on the local needs of the region where each camp was located, the general health of the first *Chantiers* to be discharged from the group in 1941 improved in terms of both healthy weight gain and "chest expansion." The communitarian and vaguely agrarian message of the movement also seemed to leave a mark on its charges as participation in organized sport increased in these first years, while "flight from the countryside to the towns" decreased.[57]

The *Chantiers*, however, accepted only twenty-year-olds. There remained the question of the great bulk of French youth between the ages of leaving primary school at fourteen and entering the adult world. The youngsters who were of this age group, early in the régime at least, fell into the *Compagnons de France*. Specifically designed as an admixture of military training and the ethics of the scouting tradition, the primary difference with the *Chantiers* being that it was voluntary. Nonetheless, there were a minimum of 30,000 members of the *Compagnons* as late as 1944.[59] As seen above, with their role in selling "Marshal memorabilia" the group was important, in a very material way, in spreading the message of the "cult of the Marshal" and counted far more teenagers than those who were registered on the full-time roll as, at least, part-time members.

While these two groups might have been the most prominent by virtue of their place of privilege in the régime, there were a number of other youth groups somehow sponsored or supported by Vichy—to say nothing of the myriad "private" youth organizations and movements, many of them Catholic in derivation, and no fewer than six different scouting organizations at the start of 1940. These were prodded into forming a loose confederation under the umbrella title of "Le scoutisme français" and put under the direction of a "chief scout," the elderly General Lafond, in September 1940.[59] Nonetheless,

the scouting groups remained largely regional or vocationally specific. The fragmentation of youth movements under Vichy was the result of a number of competing concerns from within and without the government.[60]

Limore Yagil, however, has argued that the "pluralism of the youth movements" was, at least in part, intentional and the program's "originality." Not only did it serve to assuage the fears of critics of a single youth movement in and outside of the government, but, by the variety of options in the scouting movement, the SGJ—and by extension, the régime—revealed to the young of France the rich diversity of the Hexagon and offered them the opportunity to explore the source of the nation's strength at its most obvious. Similar to the thinking that had underlined the 1932 Exposition, the "fundamental idea . . . is the restoration of the French community . . . [a] union in diversity and harmony in variety." In this way, Yagil contended, Vichy sought not to nationalize nor politicize France's young, but to forge "an organic national fusion."[61] To the extent that the success of such "mystical" missions can be measured, perhaps the refusal by scouting groups to be out-and-out collaborationists and resisting, at both the member and leadership levels, the dissolution of the *Eclaireurs israélites*, the Jewish scouting movement, in the winter of 1941 could be taken as evidence of an embrace of unity through diversity by the movement's participants.[62]

Whether or not the broad pluralism of the youth movement(s) under Vichy is evidence of a planned "originality," what it does reveal is not simply a concern for the well-being and proper formation of France's youth, but a shift in thought and policy concerning adolescence and the idea of juvenile delinquency. Under this multiplicity of options for children, there existed an extensive tissue of experts that cut across ministerial portfolios at the administrative level of Vichy, who all were concerned with the question of how best to care for and address the needs of France's younger population. The idea of adolescence, roughly the years twelve to twenty-one (there was considerable debate about its precise beginning and even more concerning when it ended), was a relatively new one in France and had just begun to gain broad acceptance as a critical and malleable stage of life that required "vigilant guidance" in the years prior to the start of WWII.[63] Building on work and research carried out during the Third Republic, under Vichy, and with the paternalistic Pétain's express blessing, educators, social workers, child psychologists, and even representatives from the Ministry of Justice renewed investigations into the causes and potential correctives for adolescent juvenile delinquency.

In spite of the prevalence of essentialist arguments concerning the nature of certain groups, under Vichy a child's environment came to be seen as the prime determinant of behavior by the majority of those involved with studies into childhood development. Predictably, for most psychologists, the family was the single most important "environmental factor" in this mix, and the form or status of the family became an important indicator in understanding, and perhaps even predicting, juvenile behavior. By the ending years of the war, many of the social experts engaged in evaluating juvenile crime and delinquency were arguing that upwards of three-quarters of young delinquents came from home and social situations described as "'broken,' 'disunited,' or 'divided' families." French defeat and the resultant starkly drawn Armistice had split families and torn apart the traditional social order in a way that no amount of legislation meant to protect the nuclear family alone could repair. Ultimately, both deprivation and a loss of family structure contributed to a trebling in juvenile crime in the first years of Vichy according to the government's own experts.[64]

With the vast majority believing that circumstance rather than inherent character deficiencies were the cause of most juvenile crime, the manner in which juvenile delinquents were dealt with under Vichy also underwent a sea change. In January 1941, Joseph Barthélemy, previously professor and dean of the University of Paris Faculty of Law, assumed the post of minister of justice and took as one of his central tasks in his first year reformation of law dealing with the issue. In September of the same year he insisted in a ministerial memorandum to his colleagues and staff that "of all the painful problems for which I carry the heavy responsibility, those of delinquent children occupy first place in my preoccupations. . . . It is a moral problem. It is a problem of justice. It is a problem of our future. It is, in the highest meaning of the word, a political problem."[65] The resultant Supreme Council of Penal Administration and Supervised Education Services (Conseil supériur de l'Administration pénitentiaire et des Services de l'éducation surveillée) ultimately passed off on proposed legislation that took to heart the concerns of environment when dealing with young criminals, particularly those involved in petty crimes. By some accounts, there was little to no discussion of inherent, or biological, degeneracy when accounting for the occurrence of delinquent acts, and rather a preponderance of care was taken to adumbrate "what factors pushed a young person into delinquency." Here again, Barthélemy's chosen "expert," Fernand Contancin, then director of Penal Administration, listed "poverty, 'the breakdown of households, debauchery.'" Contancin's report continued on

to insist that while the consequences of delinquent acts had to be dealt with by the Justice Ministry and specific courts and institutions to properly do just that should be created, the real issue that must be dealt with immediately were the causes of juvenile delinquency. "We must struggle against the causes . . . We must help raise the delinquent child back up."[66]

Though little of the law proposed by the "Supreme Council" was ever fully enacted, its legacy was to have turned the concerns of the justice system in France toward socialization and (re)education rather than strict penal sanction. Additionally, the belief that environment was the principal cause of untoward behavior in children, from crime to being what was termed "moral nonchalants," also meant the government had good reason—the future health of the French nation—for actively taking a part in shaping the environment of France's children. There was little that the state could do about rebuilding families that had been split by the effects of war and the Armistice. The socializing bonds of family and the masculine influence of a father figure would have to be left to the various youth movements and le scoutisme française. However, the public milieu of France's children was largely available for not simply the censor's pruning shears but also the active incorporation of material deemed appropriate for a child's proper development.

Following the traditionalist ethos of much of the National Revolution, apartment living was pointed to as an area of potential concern, for the prevalence of cramped and unsanitary quarters if nothing else. Department stores, for their display of flashy, tempting goods, were an unnecessary temptation to children, and flea markets, because they often served as fronts for the black market, came under suspicion. In essence, the typical conditions of urban living were made the subject of wary circumspection. There was one thing, however, that concerned nearly all who wrote on the subject of juvenile crime: the cinema. "Doctors, lawyers, social workers, and religious activists alike," Sarah Fishman wrote, "decried the evil influence of films on the minds of France's youth." Still, Fishman quickly pointed out, only one of the specialists whose work she examined actually tallied the number of minors he studied who regularly visited a movie theater. Of the one thousand children in his case study, "only 182 of them reported attending the movies at least once a week, hardly," she bitingly added, "an overwhelming number."[67]

Fishman's point that much of the concern over the influence of film on the impressionable minds of children being more the result of deep anxiety over a rapidly changing world is likely valid. However, she does not take the opportunity to look beyond her criticisms of these myriad "experts" to other points

where, by either their actions or expressed belief, concerns were delineated. Interestingly, the dossiers of various social workers that Fishman examined demonstrate that there was a concern with detailing not only the home life of children who they were sent to investigate, but also their school and work habits, and (extensively) their hobbies and other leisure time activities. Though she makes little use of the information in her own analysis of the juvenile justice system under Vichy, Fishman does point out that the reading habits of their charges were often of particular interest to social workers investigating delinquency. Additionally, there seems to have been a connection drawn between certain types of children, their disposition, and what they read.[68]

This concern with the reading habits of France's children should come as no real surprise; indeed, as should be apparent, in both official circles and the polemics of public commentators they were commonplace.[69] The ideological civil war that had engaged the politicized public in the 1930s and played out in the Catholic and Communist critiques of BDs had largely dissipated with the forcible removal of Communists from the public sphere under Vichy.[70] However, criticisms of the medium were renewed under the régime, often with even more damning and inflammatory rhetoric as well as an eye toward their propagandist role in not simply spreading the "cult of the Marshal" but in the moral reshaping of France's youth. Much of the most virulent anti-Semitic and anti-Masonic propaganda in France during the war years was produced by Henry Coston, the director of the Centre d'Action et de Documentation anti-maçonnique (CAD)—an organization not given to subtlety and at least familiar to a great number of functionaries within Pétain's government despite its being headquartered in Paris. Reigniting the criticisms of BDs and *journaux des enfants*, Coston was not simply more rabid in tone and tenor but also more pointed about their corrupting influence on France's children.

In a 1943 booklet titled "Les Corrupteurs de la Jeunesse: Main-mise judéo-maçonnique sur la presse enfantine" that was published as a special issue of a regularly appearing CAD publication, the *Bulletin d'information antimaçonnique*, Coston labeled both schools and some youth organizations as places where children were in danger of falling under a Jewish and/or Masonic spell.[71] However, given that previous Vichy policies were to have removed suspect teachers from the schools, Coston's primary focus was—as it had been for critics like both the Communist Sadoul and the Catholic Abbé Grosse in the previous decade—on BDs and the weekly journals that carried them. In his critique of those, he accuses Jews, Freemasons, and Communists in the 1930s of causing the demoralized, estranged, and apathetic spirit of French

youth that was evidenced by, first, France's defeat, and second, by their cur-
rent reluctance in taking on the "grand tasks offered to them by the National
Revolution."[72]

For the first effect of journal illustrés on children, the Communist *Mon
Camarade* (as well as *Copain-Cop*) came under fire from Coston—the journal
being particularly bad as it was written and published by way of a pernicious
trifecta of sorts—the editor being not only a Freemason but also the son of "le
Jérusalem muscovite." In describing those responsible for the current disaffec-
tion of the younger generations, Coston's accusatory net widened to include
the *Journal de Mickey* and "le trust judéo-yankee" of Disney and Winkler,
who, for good measure, was also identified as a Jew and a Freemason.[73] In an
interesting example of how malleable the identities of these perceived enemies
of France and corrupters of the young could be, depending on desire and envi-
ronment, Coston repeats the 1920s critique of the publisher Maison Offen-
stadt by Abbé Louis Bethléem but with one crucial distinction. Bethléem had
accused the press of being a "dispenser of pornography of German origin,"
but for Coston, while Maison Offenstadt was still "un abject pornographe" he
identified the publishing house now as Jewish rather than German.[74] None-
theless, he, too, was careful to give the young readers of these journals some
credit for being capable of discerning what appealed to them as consumers
of the product: "The goal of these children's journals is to distract, satisfy the
tastes and the aspirations of young people. What is necessary, is not to annoy
and tire the young clientele, but on the contrary to amuse while guiding them
by a sure and firm hand towards the ideals that are the strength of the nation."[75]
Whether it was the influence of Coston or not, it is clear that Vichy was also
concerned enough that officially sanctioned and published works be made
appealing to France's youth that even in the colonies editors included pages of
sports coverage and other leisure-reading in journal issues aimed at children
and adolescents.[76]

Judith Proud has detailed the effect that this wary and cynical atmosphere
had on the illustrated (young) children's storybook with the fairytale genre
being warped to fit the characters and desires of Vichy's National Revolution.
Even more than the BD, the fairytale has a long and distinguished literary
history in France with the "father" of the genre being Charles Perrault, the
seventeenth-century member of the Academie Française and author of *Stories
or Tales from Times Past, with Morals: Tales of Mother Goose*. In the north-
ern zone, particularly, the didactic fairytale was (often shabbily) usurped for
the most venal tales of anti-Semitism and fear-mongering as in the German-

supported retelling of "Little Red Riding Hood," *Doulce France et Grojuif*. In this reworking of the classic children's tale, the wolf was replaced by "Grojuif" (Fatjew) while "Doulce France" becomes the young girl of the title; mother and grandmother remained as they were in the original, though grandmother carried the additional burden of "appearing under the highly symbolic name of 'Vérité' or 'Truth.'" According to Proud, this racialized version still closely followed that of Perrault, replicating upwards of 40 percent of the original dialogue with the most significant deviation coming with an adaptation of the later Brothers Grimm ending—though the valiant woodsman was now, by his uniform and bearing, a French *Légionnaire*.[77]

This sort of crass politicking in children's literature was in the decided minority according to Proud, and "the majority," in fact, ". . . remained essentially unpoliticized." Nonetheless, there were a number of examples of the medium that were far more subtle, utilizing its conventions and forms to press the message of the National Revolution to France's youngest citizens. Two such examples were *Six petits enfants et treize étoiles* and *Il était une fois un pays heureux*. In the first story, six children from different social backgrounds (though still recognizably French) were "firm friends despite the envy and disdain that separate their parents." Their favorite activity together was to play about in a giant wood behind their village where the woodland fauna and flora embraced them while being suspicious of careless adults. On one of their trips through the woods they come upon an elderly solitary walker who surprisingly knows all their names and counsels them on the virtues they should cultivate and hold dear for their lives. Later, a great storm comes and destroys their village and as all the adults turn to run, the six friends turn to the forest and search out the old sage who calms the storm with a wave of his cane. When they ask him what they now should do, he takes six stars that had adorned his cane and tosses them to the fertile forest floor where they become farming tools and seeds—these he gives to the three young boys—and a small farm, a cooking range, and dress-making equipment—these he gives to the three girls. With their labor, they revitalize the village. After some time, the old man returns and instructs them to hold each other close as they did during the storm, and with their hard work and love the six of them, François, Rose, Anne, Noël, Clément, and Estelle, will save their homeland just as the first letter of each of their names spell it out.

In the second story, a peaceful, idyllic, and prosperous country was brought to near ruin by the machinations of an evil fairy whose spells make "the previously well-regulated citizens begin to show signs of complete

degeneracy." They abandon their beautiful farmland and move to cities where they fall further under the spells of dangerous foreigners while their formerly verdant farmlands lay ugly and fallow. As divine storm clouds sweep and rake the country with fire and blood, the people's false leaders, many who were foreign and put in place by the original evil fairy, encourage staying with their new "modern lifestyle" and "easy pleasures." Finally, an old and sage patriarch appears to lead the people back "onto the path of righteousness and increased birthrates. A new generation prepares to take up the challenge of the patriarch's example." As in most of these sorts of tales, Pétain is never explicitly named in either this or the first story. However, the fact that the sage old man in the forest, as well as the patriarch who leads the people away from the babel of bad advice of strange and foreign leaders, was indeed the marshal was made clear by the cut of the character's coat and trousers (he was seldom portrayed above the waist as most of the tales were illustrated from a child's point of view) and the cane or baton he always carried.[78]

That these sorts of saccharin and overtly propagandistic tales were intended for the youngest of France's readers was often made clear by digressions in a narrator's introduction to many of the tales. Here, children were reminded that the illustrations in the books were for the enjoyment of younger readers and older siblings should take care to make sure they were "neither dirtied nor torn."[79] When it came to *journaux illustrés* intended for older children and adolescents, publishers found themselves in a bind as to how and what to produce. Even without the elaboration of specifics as to what was acceptable or not under the watchful eyes of Vichy's Office of Censure, as was demonstrated above, publishers had to be wary of printing material that Marion and his compatriots in the ministry might possibly find objectionable. Unlike the official scouting newspapers that could fill pages with sporting news and the like in an effort to appeal to their young readers, BD journals did not have the same option. It was impossible to buffer less than exciting reports of food drives or physical training with soccer scores as the entire reason for purchasing the *Journal de Mickey* (or any BD journal) was the BD itself, the very thing that was then being trammeled by the state.

While critics like Coston were insisting on the need to ensure that BDs continued to amuse if they were to be used to guide children with a "firm hand" toward the "ideals" of the nation, the visual nature of the medium compelled publishers to adopt a reactionary style that forsook most of the innovations that had been the reason for the explosion in popularity of the journals among the children of France in the previous decade. Text was removed from

the panel and restored to its traditional place beneath a series of frames while also resuming the place of narrative primacy, and the aesthetic style itself returned to an archaic version of the earlier Images d'Epinal. As Crépin has put it, technique and innovation were sacrificed to ideology and little account was taken of the "taste" of young readers.[80] Indeed, there is at least some anecdotal evidence that children did not care for the changes that their favorite journals were pressured into making under Vichy. Recalling not only his own childhood experience but also that of many others, Maurice Horn has insisted that it was under Vichy, particularly after the 1942 ban on American BDs in the Southern Zone, that the "collection and preservation of . . . prewar 'illustrés'" began in earnest—a colorful reserve larded away in secret caches to be returned to and traded among friends who found little of interest in the journals that had made their way through the censor's hands.[81]

This, however, leaves the impression that Pétain's government had the power to enforce a single policy—unspoken or otherwise—on the *presse enfantine*, which was decidedly not the case. Publishers that, by their political and religious orientation, were régime favorites—like the Catholic house, l'Union des oeuvres (producers of *Coeurs Vaillants* before and during the war and *Ames Vaillantes*, a journal directed specifically at rural youths, under Vichy)—were able to continue at least a limited course of the modernist aesthetic innovation that they had begun the previous decade. In the Occupied Zone, where resources were, paradoxically, sometimes less scarce, there were a number of very modernist experiments with journals built around readers' letters and the costly inclusion of photography.[83] Nonetheless, and these exceptions aside, there was a general muting of innovation across the medium and a shackling of it to the traditionalist politics and aesthetics of Pétain's National Revolution. Moreover, among at least some publishers of BD journals—as well several members of the government—there seemed to have been an earnest belief that the medium could (and should) be used to fruitfully instruct children in the ideals that would strengthen the nation.

Such was the case with the journal *Fanfan la Tulipe*, published by the Paris-based Editions et publications françaises. The journal was unique in that it was a publication originating in the Occupied Zone that was entirely devoted, from its inception, to the cult of Pétain and the tenets of the National Revolution.[83] It began appearing in May 1941 and lasted nearly a year with the final issue—number 42—appearing in early March 1942.[84] Ultimately its dedication to the mission of the National Revolution forced cautious members of the German propaganda and information service in Paris, the *Propaganda*

Abteilung, to withdraw the journal's publishing authorization. In fact, in an undated questionnaire the journal's editors submitted to German authorities as part of their publishing authorization request in July 1940, the stated goal of the publication was "to combat the majority of children's journals published by Jews or foreigners that drew their stories and images from the files of Mr. Winkler and Opera Mundi."[85]

After German overseers quashed publication of the young anodyne title character's adventures in the months before the German occupation of the entire country, its publishers approached both the secretary of state and the commissaire générale à la famille in early 1943 to plead their case as to the value of the publication. The initial correspondence and administrative shuffling between governmental departments has apparently been lost, but the file held in the archives of the Ministry of Information includes a letter from the commissaire générale à la famille that recommended the journal be granted permission to publish because he was forced to "note each day the constant increase in juvenile delinquency" and this journal's "educational value is undeniable." Given the situation among France's youth, when such examples of an "educative press" such as *Fanfan la Tulipe* appear, the commissaire générale could only "recommend that you [the secretary of state and Ministry of Information] support it."[86] This was among the first instances of governmental recognition of BD journals having any educative value and potential as a useful tool in curbing the incidence of crime and delinquency among France's youth; it was also a consciously planned direction of the journal's publishers.

In a letter to the secretary of state, dated March 24, 1943, the publishers reminded the "honorable" secretary that he had earlier suggested he would "subordinate" his opinion to that of the secretariat à la famille who had, subsequently, assured all involved that the journal was of "excellent moral" character and would be of benefit in encouraging good behavior among the intended audience, children aged eight to twelve.[87] As further evidence of the high moral and educative standards kept by the journal, the publishers included with their letter a copy of the "broadsheet" insert called "Ce qu'en pense FanFan" (What FanFan thinks) to be a part of the first issue published upon receipt of approval from the government. In the, by then familiar, advice and editorial format that had become a part of many of the *journaux des enfants*, the column began by coyly reminding the requisite government officials of the journal's popularity by referencing the "several letters" received each day since the publication's suspension a year earlier, all expressing the same concern for *Fanfan*. This was heartening to *Fanfan*, the writers continued, as it "affirmed" that no one was

"forgetting us," and that they had "remained faithful to *l'Ideel Fanfan*, the good principles of union [and] friendship that equips our spirit."[88] The young fans of *Fanfan* were told to breathe easy as the "beautiful fire of 1941 had not died, it remained embers under ash," and when a "little wind suddenly blew . . . [and] a little paper was provided . . . it set out again, all the more beautiful, to bring warmth and light to us all."

Indeed, the "obstacle," or reason for the publication suspension, was explained to the journal's readers as nothing more than a shortage of paper in those difficult days. However, thanks to the wisdom and intervention of the Ministry of Families, and "thanks especially to our Marshal, who knew us well and who loves [Fanfan's] cadets like his own small children, we have received what was required to reappear." Interestingly, in spite of the often-treacly sentimentality and stretched metaphors of "What FanFan thinks," the broadsheet did not condescend to the journal's young readers. Rather, its authors openly discussed the war, among other difficulties, as the reason for the paper shortage and offered a sense of agency and responsibility to even their youngest readers. Every member of the family, "Fanfan" insisted, had a job to attend to in those heavy days. "There are, I know it," young readers were chidingly admonished, "families where little ones aggravate the older, where miseries are made, where nobody wants to obey, where the parents are tired, irritated; often enough it is the intervention of a child, girl or boy, who demonstrates good humor, kindness, cheerfulness, optimism that returns order and peace to these hearths." The job of the child in these days is just this—to "ease the strained atmosphere." Being light-hearted and obedient "is our way of preparing for after the war." And the way to "shorten" the "disorder," the "dramas caused by the war," the "misfortunes of France," is to hold to the "very simple" keys already offered by "notre grand-papa Pétain . . . Work, Family, Fatherland . . . LOVE YOUR WORK, LOVE YOUR FAMILY, LOVE YOUR FATHERLAND!"[89]

The design and intent of the journal impressed enough within the government that only six days after *Fanfan*'s publishers sent their letter of request, with supporting letters from the commissaire générale à la famille and the sample broadsheet, they were called to a meeting with the office of the secretary general of information in Paris.[90] The final decision, however, went against the journal and the Information Ministry ultimately withheld permission to publish it in the Southern Zone. Several within the ministry wrote in favor of *Fanfan*'s dedication to and articulation of both the National Revolution and Pétain, but concerns from two sides—those who remained wary

of the journal's Parisian (Occupied Zone) provenance and those concerned about incensing the increasingly agitated German overseers in the north—came together to work against approval of the publishing request.

Still, the example had been set and publishers began using the newly adumbrated concerns to their advantage. Support for the National Revolution and dedication to Pétain alone was no longer enough to receive publication authorization from the government; rather, the hebdomadaires strove to demonstrate (or at least claim) some manner of moral bearing and an educative mission. The BD journal *Benjamin*, founded in 1929 and subtitled (under Vichy) "journal intégralement français," was likely the most prominent example of a publisher successfully doing just that. While Coston less than playfully clucked that the journal had "an awfully Jewish name that gladly lent itself to confusion," along with *Fanfan la Tulipe* there was no other hebdomadaire so associated with the "cult of Pétain" though the treatment it received from the régime was far more indulgent.[91]

The reason for this likely had to do with the fact that in addition to a hagiography of Pétain and hazy lessons on the civic etiquette of good boys and girls, *Benjamin* consciously offered a program of history lessons on the glories of France. Here, they grounded their efforts not only in the simple virtues of the peasant and traditional life but also the vitality and strength the nation demonstrated (and drew upon) by its colonial empire. In doing this, the editors of the hebdomadaire tracked a very specific course that embraced the past in expressing the traditionalist ethos of the National Revolution and looked to the key to France's future (or so many within and without Vichy believed) in the empire while side-stepping much of the unsettling present.

The journal had another factor in its favor, the presence of Alain Saint-Ogan as an artist and writer, and finally editor after January 1942. Easily the leading figure in the *presse enfantine* field at the time and creator of the by-then famous *Zig et Puce* BD, he continued his aesthetic innovation and modernization of the medium with BDs such as *Mitou et Toti* and *Monsieur Poche* throughout the 1930s. In the second half of the decade, he joined the artistic and editorial staff of the BD journal *Cadet-Revue* while taking a lead with the UADF in fighting for government support for French BD artists and authors struggling against the "tidal wave" of syndicated foreign BDs.[92]

Even before Saint-Ogan took over as editor of the journal, however, it had tied its fortunes to the valorization of Pétain. Almost the entire first black-and-white four-page issue of July 1940 was spent reminding *Benjamin*'s young readers of the old marshal's great military victories in World War I,

his service to the nation in the interwar period, and the gift of his person to the people of France after the collapse. Under Saint-Ogan's direction, and likely buoyed by his contacts within both the publishing industry and the government, color returned to the journal's pages and its relationship with the régime became all the tighter. So much so that by December 1943, Saint-Ogan was writing the secrétaire général à la propagande under Marion suggesting that the ministry provide his journal some measure of "pecuniary assistance," as the Department of Colonies was poised to do for a special issue on the history of the colonies with a subsidy in the form of the purchase of 140 subscriptions. He even suggested what the ministry might do with any subscriptions they chose to underwrite, proposing that they be awarded to the "best pupils of unquestionable schools." Still, after making mention of the special educative issue on colonies (to appear the following month), Saint-Ogan insisted that *Benjamin* was not a "trade undertaking" but it was with the "aim of raising the moral standard [of children] that the [publishing house] French Social Editions assumes the expense of [the journal]." Consequently, "it goes without saying," he continued, even if the ministry did not believe it necessary to support the hebdomadaire, "*Benjamin* will always have a duty to publish in its columns . . . all information that you want to charge it with disseminating to the young public."[93]

The record is not clear on whether the Propaganda Ministry rewarded Saint-Ogan and his hebdomadaire with additional state underwriting but, as Crépin has asserted, there is little doubt that even before Saint-Ogan's letter the journal had become accustomed to carrying out the desires of Vichy. Not only were the hebdomadaire's young readers often "treated" to special messages from the marshal and told to hold to the mission of the scouting movement generally and the *Compagnons* specifically but, at its zenith in 1943, *Benjamin* sometimes resembled a government press release for children. Profiles of important Vichy functionaries were not uncommon and illustrated articles on current events, such as prisoner of war releases, and government initiatives that were likely to impact children appeared on both the front page and in special inserts. While comparatively rare, even the worst of Vichy ideology, anti-Semitism, disparagement of the English, and anticommunism, also made its way into the journal's colored pages. Ultimately, this all came together in a pleasant-enough faced political arithmetic that had the publication live up to its subtitle as a fully French (or perhaps better, Vichy) journal.[94]

Saint-Ogan and the rest of the editors and artists of *Benjamin* also had something of a plan to finally look to by the end of 1943 as the Ministry of

Information and Censure established guidelines for *journaux des enfants*. For the first time, and coming directly from Paul Marion's office, the October 13 directive, "Circulaire no32: Consigne Relative aux Journaux d'Enfants," pointedly instructed censors and publishers/artists as to what was expected and allowed. Marion's dictate carried across both the aesthetic sense and style of the medium as well as its content. Beginning with the look of BDs, Marion's office insisted that *journaux des enfants* would now be held to a higher technical standard in their appearance. "Generally . . . presentation will have to be clearer," both in terms of illustrations as well as any colors used. Like the drawings, text must "employ very legible characters" and, renewing an old argument about the dangerous physical effects of the garish medium on young and developing physiologies, the entire designs must assiduously avoid "any tiredness of the eyes." Finally, concretizing the return to a more traditionally French version of the medium, and attempting to remove any modern influences, the dictate insisted that, "except for the wordless cartoon," any "text will be placed outside the [borders] of the image." For good measure he added, "it will be necessary to avoid the formula of 'films' [which were] too often employed without utility and by rote."[95]

When it came to the acceptable content of BDs, Marion insisted that the *presse enfantine* "must play, above all, an educational part in preparing youth for the tasks they will face after the war." To that end, "it is necessary to put aside the puerility and silliness which have, up to now, too often characterized children's publications." "Principally," he admonished, it was "necessary to spark the interest of young readers with engaging stories where courage, the direction of honor [and] devotion to a satisfying and selfless ideal is exalted." In this, he called on the insular ethos of the National Revolution, insisting that the history of France should provide "an inexhaustible mine of subjects." The stories of France's great painters and authors, scientists and explorers, as well as the great events of the past and the glories of the colonies would all make "instructive and enthralling chapters," in a children's history while introducing them to the "primary elements" of a "general culture."

Concluding his general statements, he cautioned that all future BDs would be held to this standard and must "be put in simple and clear terms" presented in ways accessible to and "in the range" of young *clienté*. Marion then pointed to specific examples of things that must always be done and topics that would never be allowed. "Absurd and immoral stories" would be proscribed, and, "particularly," any story "likely to excite the morbid sensibility of young readers (torture, etc.)." Crime stories about either the police or

"gangsters or swindlers will be prohibited." Any language in the BDs must be correct and never use "slang." Journals should develop a "do-it-yourself" feature that considered both the range (and limitations) of abilities of their young clients as well as the "current lack of materials," while girls should be treated to the "various chapters of domestic education." Useful information and skills such as botany and gardening should be stressed while outdoor play should be portrayed as a "healthy distraction for children." And finally, the use of foreign stock or clichés was formally banned.

Immediately upon its issuance, Circulaire no32 was put into effect and circulated among the Censure department(s) with a memorandum from Jean Dufour, the sub-director of the Censure. Pursuant to the dictate, Dufour requested that an updated list of serialized children's publications be "urgently forwarded" to him and that all censors now consider the new guidelines when making approval recommendations for the Censure's Central Service.[96] Dufour's sense of urgency was not limited to either him or his ministry. They were symptomatic of the tenuous existence of Vichy itself by the end of 1943.

Eleven months earlier, the United States had joined British forces in an invasion of North Africa and Hitler ordered the occupation of the Southern Zone on November 9, 1942, taking control of the entire nation. Shortly thereafter, the Armistice Army was ordered disbanded to little opposition and nearly all pretenses to France being anything more than conquered territory was abandoned. Laval, once again heading the government since the previous April, had taken the post of prime minister from Pétain and was, in effect, the French government. The elderly marshal, whose age and stamina had for the first time proven problematic during the manic week of Allied invasion of North Africa and the complete occupation, was reduced to little more than a figurehead. There was little place for Laval to exercise any real control over subsequent events, however. While he privately confessed that he no longer believed in the inevitability of German victory in the war, that realization only meant that he was now working for a futile neutrality while caught in a vise of advancing Allied forces and stepped up collaborationist demands from Germany.

With good reason did Laval feel as if the nation itself was being in part ripped and in part melted away. Increased demands by Germany for labor sent nearly three hundred thousand French men and women out of the country by the mid-months of 1943 while thousands more disappeared into the countryside in an attempt to avoid Laval's Compulsory Labor Service that had been established in February, often becoming members of the Resistance along the

way. As external events tumbled all about the nation, each exerting some pull in one direction or another on the country's internal direction, Vichy continued to slide ever further down a slope of irrelevancy.[97] In response to this, all across governmental departments, wherever some utility and action could be enforced most Vichy officials grasped at any chance to make a French decision for France.

Despite his collaborationist tendencies, Marion's directive on BDs should also be read in this light. When considering everything that lay in the balance during that tremulous year, concern with the proper appearance and content of children's journals seems at first rather unimportant. However, even when the relationship between Vichy and the Nazis had been at its relative best, the situation had always been one where the political gaze of the government was fixed firmly on the future, and where the young of France today were expected to be the leaders of a reborn nation. Now, considering that hundreds of thousands of young French men and women were literally being commandeered by an occupying force while legions of others were scattering to the farthest reaches of the Hexagon and beyond, those younger children (adolescents and younger) became even more immediately important to the future of the nation and no chance could be squandered in their proper "French" education.

It is also possible that the October 1943 dictate came at least in part in response to the publication of a new journal, *Le Téméraire*, that began appearing in January of the same year. Published out of Paris after the Germans had stopped all other examples of the presse enfantine, the journal owed more to the approval of the occupying force for its appearance than it did Vichy. While it did not carry the authorization mark of the Propaganda Abteilung, that would have been little more than a formality after the occupation of the entire country, and the lushness of the journal's appearance in comparison to other journaux d'enfantine indicated that it was put out under the benefice of the Nazi overseers. It should nonetheless be noted that *Le Téméraire* was published by Frenchmen, for a French audience—and with a fortnightly circulation of between 100,000 and 150,000 copied per issue, it was one of the most widely distributed, if not demonstrably popular, journals of the entire Vichy period for the eighteen months that it was published.

The journal took its aesthetic inspiration from the most popular BD journals of the 1930s and has even been called "un véritable hommage" to Winkler's *Robinson* in terms of its layout and design.[98] Its content and guiding ideology, however, was almost entirely Nazi in derivation though with some subtle French nuances. The English were frequent targets with "Henry VIII . . . included in a gallery of ritual murderers, and Howard Carter, the

archaeologist who discovered Tutankhamun's tomb, was accused of 'grop-
ing the royal mummy' in a special issue on the Pharaohs."[99] Ireland's "'strug-
gle for freedom' from its 'protestant oppressors'" was the focus of a special
issue in May 1944 where an article on Sinn Féin described the group as
one "'whose tenacious and heroic actions have earned the admiration of
the civilised world.'"[100] The most common target of the journal, however,
was Europe's Jews. The principle BD of the journal was a near parody of
the American "Flash Gordon," "Vers les Mondes Inconnus" (Journey to
Unknown Worlds) and its blond, Aryan-styled hero, Norbert, was pictured
valiantly struggling against the typically Jewish-stereotyped underground
"Kingdom of the Marais"—Marais being easily recognizable as an area of
Paris known for its Jewish population. The "Maraisians" were drawn as
short, hook-nosed and big-eyed, vaguely greenish humanoids who wore
gold helmets adorned with a Star of David and were rapacious in their
appetites though easily distracted and detoured by bright and shiny things
like gold. This BD—and others in the journal—featured salacious illustra-
tions of "Jews torturing and butchering children; the accompanying text
extoll[ing] the superiority of the Aryan race."[101] Finally, in addition to the
BDs, Le Téméraire, like most other journals, also frequently featured sto-
ries and news items of interest. The difference in this instance being that
the journal specialized in "pseudo-scientific essays on ritual killings and
how blood transfusions could be used to achieve racial purity."[102] The jour-
nal's subtitle described it as the "journal de la jeunesse moderne" and, like
the two most politically engaged journals of the 1930s, Coeurs Vaillants and
Mon Camarade, had its own scout-like club, "Le Cercle des Téméraires."
While the organizational precedents for the journal's club was French, it
was styled after the Hitler Youth, and Nazi propaganda films were frequent
entertainment at the group's meetings.[103]

French scholars and commentators have been at pains for years to both
explain the appearance of the journal and insist that it had no impact or last-
ing influence in the BD field. Oftentimes this has been addressed as much by
silence, or gaps in the narrative, as anything else. Illustrative of this position is
the biographical entry on Raymond Poïvet in l'ABCdaire de la Bande dessinée,
a popular "pocket" encyclopedia on BD published by Flammarion with the
support of the CNBDI. Here, Poïvet's many accomplishments in the field, from
groundbreaking science fiction BDs to the founding of his own studio where
other well-known artists like Albert Uderzo (co-creator of "Le Aventures
d'Astérix le Gaulois") were to work after the war, were detailed and lauded.
Reference to his Vichy-era work for Le Téméraire, however, was limited to only

a brief mention of having worked at some point on "Journey to Unknown Worlds" with no discussion of the content or direction of the BD.[104]

The other tack has been double-sided. On the one hand it was asserted, work on *Le Téméraire* was nearly all that was available for authors and illustrators, particularly after the occupation of the entire country post-November 1942. On the other, many have insisted, following Pascal Ory's analysis of the journal, that it was not available for long enough to have made much of an impact. In response to the first assertion, Laurence Grove likely spoke for many commentators outside of France when he incredulously noted that "people say it was the only work going, but they didn't have to be so zealous."[105] François Cochet expressed the other side of this in his use of the "state" of BDs in France and the United States in examining what he called "two different cultural models" between the world wars. Here he insisted, again following Ory, that "even if bridges can be identified between this publication and that of the Liberation, [it] did not have sufficient enough time to be a real influence."[106]

The insistence that the journal had no developmental impact on the BD field post-WWII is, in some ways, simply disingenuous. If nothing else, many of the most significant authors and artists who worked on *Le Téméraire* went on to have quite an important role in the development of the medium in France's golden era of the BD. Poïvet has already been mentioned; however, the man who actually originated the BD "Journey to Unknown Worlds," Auguste Liquois, would, after the war, go on to develop another highly acclaimed science fiction BD "Guerre à la Terre" (War against Earth) that was serialized in the journal *Coq Hardi* from 1946 to 1947.[107] Three other artists who worked on the journal, at the end of the 1950s, would, with Poïvet, go to work with René Goscinny and Albert Uderzo in the early years of the influential BD journal *Pilote*.

Nonetheless, much of the analysis that *Le Téméraire* was either a singular occurrence within the field, or that it was little more than one piece in a long history, seems to carry with it something of the notion that, post-WWII, it has "been more important to give [BDs] a history than to worry about the exact nature of its pedigree."[108] Still, the very existence of this concern and debate over the journal also serves to indicate that during Vichy the medium of BDs in many ways politically came of age. If this were not the case, it would be unnecessary to either defend the journal's existence or deny its import and influence.

It has been said that American comics and comic books went to war in the 1940s right alongside the boys of the U.S. Army. Even Cochet noted in his

brief study of BDs in the two countries between the world wars that "Ameri-
can serialized heros were symbolically mobilized in defense of the country"
after the attack on Pearl Harbor.[109] Indeed they were, not least simply by
being carried in the knapsacks of soldiers as they canvassed Europe and the
Pacific Theaters. According to a 1944 survey of servicemen nearly 60 percent
of men in the armed forces aged eighteen to thirty read comic books at least
"occasionally," or up to six a month, and they "outsold the combined circula-
tion of *Reader's Digest*, *Life*, and *The Saturday Evening Post* by a ratio of ten
to one at post exchanges." The same year, the army distributed some one
hundred thousand copies of the *Superman* comic book each month, rep-
resenting roughly 10 percent of the publication's sale.[110] Inside the covers of
the American comic books the heroes of the illustrated works often engaged
in direct combat with Axis forces—the most obvious example of this being
Captain America, who made his appearance with a punch to Adolph Hit-
ler's jaw. The two most popular American comic book heroes, *Superman*
and *Batman*, were generally not written (or drawn) into stories where they
directly engaged America's wartime enemies in combat. However, they still
did their part by encouraging readers to buy war bonds and assuring their
audience that they were protecting the home front from gangsters and profi-
teers while the real heroes, the older brothers and fathers of the presumed
young audience, were taking care of business overseas. This sometimes took
the costumed crimefighters to relatively absurd lengths as Superman was
called on, in one story, to spend a wealthy doctor's fortune "where it would
do good." To that end he purchased lab equipment, saved a mortgage that
was near to foreclosure, and bid on art treasures at auction for a service
member's charity.[111]

 For most French scholars of BDs, at least, the presumption has typically
been that the situation in France was significantly different. While no small
measure of protection for the indigenous industry was afforded by the protec-
tionist policies of Vichy, the medium was not "mobilized" in a manner simi-
lar to that of the (at the time) other great BD-consuming culture, the United
States. There seems a strong likelihood that this reading of events was made
necessary at least in part by the apparent need to deny a future influence for
Le Téméraire on the industry by advocates of the medium. Even the broader
issues brought to bear on BDs under Vichy might seem easily looked beyond
with a focus squarely centered on what was to come. After all, the traditional-
ist aesthetics of BDs that were the begrudged norm for most of the industry
under Pétain did not last beyond liberation any more than the agrarian civics

or overt racism did in their content. However, this emphasis on future concerns slides over what actually did occur during the war years.

In his work *Capitalism and the State in Modern France*, Richard Kuisel revealed the cautious continuity in the economic development plans of Vichy's "National Revolution" advisors and those of the post-Liberation government.[112] More pointedly, Paxton marveled at a French judiciary that proved capable of performing "the extraordinary feat of enforcing the law of successive regimes virtually without personnel change."[113] Both of these examples of continuity, however, were not dependent on a rigid maintenance of structure or forms of government, but on a sense of continuity in the function of these two fields; or, as Kuisel so lithely phrased it, "a ripening of a nation's collective consciousness" as to the means and goals of both endeavors.[114] If we might be allowed an analogy here: over time, as fashions and technology changed, the design, or form, of the automobile has likewise changed; it has become safer, sleeker, more powerful, and so on. However, its function, the transport of goods and peoples, has remained constant. During Pétain's authoritarian regime, something similar happened with BDs.

In the first half of the twentieth century the medium underwent a number of fairly radical aesthetic changes ranging through the innovation of Saint-Ogan's thought and speech balloons in the 1920s to the brusque modernization of production as well as the form occasioned by the appearance of the *Journal de Mickey* in 1934. Under Vichy, vain attempts at rolling back technical and artistic development of BDs, that were often the issue here, were obviously common as was the yoking of it to the message of the National Revolution. The "function" of the medium likewise faced a change, development, revision, and, as has been seen here, even reviling. Unlike an automobile, the function of which is nearly universally manifest simply in its being, the function of a BD, or even the medium en toto, is derived from and ascribed by the interpretive community which takes it up. After the fervid debate in the public square over the dangers of the medium, during Vichy the *function* of BDs came to be an articulation of "French-ness" and the education of what that entailed. This function was concretized, if not guaranteed, in both public and governmental policy initially by what might be termed situational coercion and ultimately by way of Marion's dictate—the first of its kind in the political history of BD in France.

Admittedly, almost no individual Vichy-era BD (or BD journal) likely had a lasting effect on the medium or industry in terms of aesthetic design and appeal, nor even overt content.[115] In this, one could easily follow Ory's

conclusions and make reference to the period—and the journals and BDs that were common in it—being but one link in a long chain of the medium's history.[116] Cochet's "bridges" of influence on the medium were instead not the BDs themselves, but the policies of the Vichy government that looked to yoke them to a political goal. In the end analysis, BDs were legislated against and there existed an outright ban for some, after the Liberation, not simply because of the reemergence of American BDs in the marketplace (as is often the explanation), but because of the function of BDs as it was formalized during Vichy. Indeed, given the language of the "lamentable" July Laws of 1949, which levied certain strictures on the medium, it is likely that Marion's 1943 dictate served as a template for the later legislation. Simply put, the public sphere debates between the Catholics and the Communists of the 1930s were institutionalized during the era and made a part of official government discourse, ready to be picked up by members of the National Assembly in the early days of Provisional rule by de Gaulle and the establishment of the Fourth Republic; and, it is to these hurly-burly days that we now turn.

Vive la France!
Now Who Are We?

Reconstruction, Identity, and the 16 July Law

In France ideas are severely looked after; not allowed to stray, but preserved for the
inspection of civic pride in a Jardin des Plantes, and frugally dispatched on occasions
of public necessity.
—T. S. Eliot

The Frenchman cannot do without his daily newspaper, he is as hungry for it as he is for
bread, and he brings this appetite with him into this world. As soon as he can read, le
petit Français also wants his own newspaper . . .
—Marie Jade

In the first months after the Liberation, a curious illustrated album appeared
that intended to offer France's children an understandable and palatable his-
tory lesson on the country's experiences during the Occupation and the still
concluding war.[1] While *La Bête est morte!* drew on the tradition of anthro-
pomorphized animals to spin its tale, the illustrations of Edmund-François
Calvo owed as much to (the earlier and French) Rabier than to Disney's cata-
log of animal characters.[2] The principle belligerent nations were depicted as
specific animals, that is, the Americans were drawn as buffaloes and Russians
as bears, the English appeared as (very Churchill-like) bulldogs while the Jap-
anese were drawn as monkeys, and finally the Germans as particularly (and

FIGURE 4.1 Side-by-side panels from the first "chapter" of *La Bête est Morte!*, "Quand la Bête est Déchainée," showing the round-up and deportation of rabbits (serving in the tale as French Jews) and the machine-gun execution of a multi-animaled squad of resisters by German soldiers depicted as wolves. The two-part journal was first published in the first months after the liberation of France, images here are from a 2004 reissue of the work, copyright Gallimard.

cartoonishly) nasty wolves. The French, however, were portrayed as a broad community of animals; from the central characters of Patenmoins and his three grandchildren, Tit-Pat, Tiot-Pat, and Pat-Menue, who were chipmunks, to rabbits, sheep, frogs, owls, and even bees, who all lived in a prewar world marked most by a peaceful and harmonious existence with one another in the wooded glens they all shared.

In two brief volumes, subtitled "Quand la bête est déchaînée" and "Quand la bête est terrassée," respectively, the album drew out a tale of the previous five years as a "fantastic adventure," narrated by Patenmoins, who had lost a leg in the conflict between the kingdoms of Trottemenue (France) and Barbarie (Germany). Through both volumes the cunning and vicious wolves of Barbarie were portrayed as uncivilized brutes for whom the Trottemenue/French "laws of chivalry were always foreign." Central to this depiction of the immediate past was the notion that all that had occurred was brought by the invading Barbarie wolves and was equally foreign to true Trottemenue-ites. With this literal caricature of events the equivalences of Vichy policies were ignored and collaborators were depicted—when they were—as not simply traitors but as internal invaders and not really part of the resisting body-politic which was

« Cette déroute évidente des
Loups devant les forces Bison-
tines avait poussé au paroxysme
l'impatience des citadins de notre capitale qui brû-
laient du désir de secouer eux-mêmes le joug barbare
si péniblement enduré pendant un lustre. Et Brusque-
ment, sans qu'on sache exactement de qui venait l'ordre,
ce fut l'explosion ! Explosion de tout un peuple d'ani-
maux pacifiques que l'imminence de la libération galva-
nisait et qui voulait montrer au monde que l'apparente
soumission de quatre années d'esclavage n'avait rien
changé à sa foi, à son courage, à son patriotisme.
 « Nos rues se couvrirent soudain de Barricades où le
pistolet du Lapin futé de la zone côtoyait comiquement
l'arquebuse du Lapin cossu des quartiers Bourgeois, car le
soulèvement faisait l'unanimité chez nous et il n'était plus
question de tribus, de castes ou de naissances. Tous les
poils vibraient à l'unisson.
 « Je ne pense pas que dans l'Histoire notre capitale ait
jamais connu pareilles journées d'universelle exaltation ! »
Les drapeaux, frémissant d'impatience depuis quatre ans
dans un coin du terrier, avaient été sortis dès la première
heure et palpitaient aux fenêtres alors que les Loups
défendaient encore la chaussée. Déchaîné, un vent de
résistance soulevait la capitale et, de quartier en quartier,
Balayait sur son passage tout ce qui sentait le Barbare.

FIGURE 4.2 In depicting the liberation of Paris, the artist responsible for *La Bête est Morte!*, Calvo, took on some of most iconic depictions of French resistance since the inception of the Republic. Here he takes a direct cue from Eugène Delacroix's famous *Liberty leading the People,* painted in the midst of the July 1830 revolution that overthrew the Bourbon king Charles X. Copyright Gallimard.

portrayed as a unified front against the invaders.[3] Even the deportation of Jews was subsumed in this narrative and brought into the fold of the resisters, as at one point a depiction of Star-of-David-wearing rabbits (Jews) was placed alongside the murder of resisters at the hands of a vulpine Gestapo (fig. 4.1).

Buttressed by colonial forces (drawn as Orientalized African leopards) the unified resistance won the day as the most-hallowed images of France's tradition of resistance were brought to bear in detailing this, most recent, struggle (fig. 4.2). The moral of the tale seems to most readily be that it was now the task of the younger generation, here represented by Patenmoins's grandchildren, Tit-Pat, Tiot-Pat, and Pat-Menue, to take charge of this forged-anew unity of the nation, guard it and not betray it (as recently had been done) while also bearing witness to its enduring power. As such, the illustrated narrative of *La Bête est morte!* was an example of what Henry Rousso has called the "founding myth of the post-Vichy period": that France, true and eternal France, had never ceased to be, even in the darkest days of Vichy.[4]

From the start of the reestablished Republic the Provisional Government headed by General Charles de Gaulle engaged in a careful enunciation of the nation's immediate past, beginning with his famous speech upon the liberation of Paris. At Paris's famous Hôtel de Ville on August 25, 1944, the leader of the Free French and soon to be the uncontested "dictator by consent" of the nation, addressed a gleefully rumbling throng on the heels of the city's hard-fought liberation. "Why should we try to hide our emotion," the tall, earnest, and stoop-shouldered soldier opined, "which we all of us here, men and women, feel?"

> We are back home in Paris which is on its feet to liberate itself and which has been able to achieve it single-handed. No, we should not try to conceal this profound and sacred emotion. We are living through moments which transcend each of our poor lives. Paris! Outraged Paris! Broken Paris! Martyred Paris, but liberated Paris! Liberated by the people of Paris with help from the armies of France, with the help and support of the whole of France, of France which is fighting, of the only France, the real France, eternal France.[5]

Despite de Gaulle's penchant for rhetorical flourish there was much about the situation France found itself in at the time of his cautiously celebratory oratory that seemed to second his assertions of unity. Regarding the (technically) junior general and (officially) novice government official, de Gaulle had

succeeded, during the years of France's occupation, in rallying support from the colonies, shouldering aside other political alternatives, and welding the diverse resistance movements at least nominally into a single force capable of providing able assistance to the Allied invasion forces and the march eastward after the capital's liberation.[6] The various resistance groups had worked under de Gaulle's political umbrella since the mid-1943 creation of the National Resistance Council, even nominating and electing the moderate Christian democrat Georges Bidault to the council's presidency after de Gaulle's original designate, Jean Moulin, was killed by the Gestapo. By doing this, two things were assured: first, it guaranteed a centrist cant for the amalgamated resistance movement, and second, it helped to ensure a continuation of authority as the nation was liberated.

Indeed, the Provisional Government authorities swept into position and posts so quickly that there was little disruption between the Vichy administration and de Gaulle's. The American-born historian Crane Brinton, while serving in the United States Army's Office of Strategic Services, wrote a number of letters on his personal impressions of the progress of the liberated nation in the autumn of 1944, some penned only days after the speech at the Hôtel de Ville, that also supported this idea of the situation. Writing principally about Normandy and "throughout the West" of France, the governmental transition had occurred "with great smoothness." "Vichy has faded away," Brinton wrote, "like Lewis Carroll's Cheshire cat, but not even the leer has remained."[7]

He reported similar situations throughout the rest of France as he semiofficially toured the country in his partner's Citroën. The great bulk of the French he communicated with were concerned with reestablishing the day-to-day affairs of the nation—like a regular and sufficient supply of electricity. Many had, by the early autumn, begun acting as if life had returned to some semblance of normalcy complete with students returning to secondary school and concerned again with their examinations—as was the case with a young medical student who begged a ride to the university in Toulouse so that he might meet with his doctoral committee. Further, the fact that most simply intended to put the immediate past behind them as fully and quickly as possible was evinced by a scene in an Avignon auto garage: having stopped to have their engine checked over by a "young and capable garage mechanic," Brinton and his companion noted that he had "waved friendlily to a young lad who lounged in . . ." When the young man left a bit later, the mechanic related that the "boy's father was [the] leading local collaborator who had been disposed of weeks before." Taking this as a sign that the past was to be left in the

past, Brinton (an admitted Franco-phile) happily continued in his report that "nobody was ostracizing the boy."[8]

Perhaps the general populace was convinced by de Gaulle's announcement after being asked by Bidault to "formally proclaim the Republic" that there was no need, as the "Republic has never ceased to exist."[9] Whatever the case, Brinton remarked that everywhere he traveled he found little concern about the political future of the nation. "Ordinary Frenchmen in the regions we have traveled in," he insisted, "and I am sure in all of France, never think of the present government in terms of its legal basis. They accept it as simply as the ordinary American accepts our government."[10] When the situation was settled and "something like normal conditions are achieved," he continued, "[t]hey are all convinced . . . they will get a chance to vote and thus help to determine what the government does." Indeed, the general was regarded "as a symbol of continuity of France," not a führer. Nor, Brinton seemed to believe, would the great bulk of the French accept him if they believed de Gaulle had pretensions to become such.[11]

Nonetheless, that de Gaulle's Provisional Government was deeply concerned with both present appearances and control of the narrative surrounding the years of Vichy was also revealed in Brinton's letters. Among his first observations was that while there was little "spontaneous enthusiasm" for de Gaulle—at least in the rightist and Catholic Normandy—the "Gaullist 'machine'" was operating very efficiently across the country. Even in the heat of liberation, American and British intelligence officers were reporting "that somehow or other resistance people of direct Gaullist affiliations manage to get into key towns *ahead* of our troops, and clean up paper dealing with French politics."[12]

This controlling of the remnants of Pétain's régime was only the first, if necessary, step, however. De Gaulle's declaration of the endurance of the Republic in response to Bidault's request that the General proclaim it might well have been entirely political as Rousso has insisted, but there also was little doubt about the task of political reclamation and even re-definition that was to come. In this, Marc Bloch's posthumously published work on the causes of the French collapse at the hands of the Germans, *Strange Defeat*, was likely only the most famous of a chorus of texts and proclamations in other mediums that insisted the work of reconstruction must also be a period of examination and rejuvenation.

"What we need," wrote Bloch, "is that the windows should be thrown wide open and the atmosphere of our classrooms thoroughly aired."[13] The historian-

soldier's reference to the classroom was not by happenstance. Like many of his generation, concern for the youth of the nation and the broader question of demographics generally took a central position in any discussion of rejuvenation and renewal. As we have seen, the general pro-natalist discourse of the Third Republic crystallized under Vichy into an overt concern about not simply a low national birthrate but also the health and welfare of the country's existent children while a network of ministries and functionaries were tasked with reversing the trend of population stagnation and loss. Of the several administrative holdovers from Pétain's regime to de Gaulle's, one of the most significant was the retention of the administrative structure of Vichy's Commissariat Général à la Famille. Under the Provisional Government, however, it was renamed the Secrétariat Général à la Famille et à la Population and made part of the Ministry of Public Health and Population.

The name change was an expression of a change in the rhetoric that returned the issue to a discourse centered on the "ideal of national *grandeur*" and the "rights of individuals—as citizens or workers" rather than "the ideal of the family" and the rights of that social unit as it had been under Vichy.[14]

As Shennan has pointed out, "de Gaulle led the way with his call, in March 1945, for 'douze millions de beaux bébés' to restore French greatness." Nor were any across the political spectrum disposed to contradict him. Sounding very much like the right-of-center general, the "Communist Minister of Public Health, François Billous, declared that, barring a solution to the problem, 'It is . . . useless to speak of French greatness.'"[15]

This was, however, truly a change of rhetoric, and perhaps strategies, but not concern. Even if they were unclear on the specifics of the issue, or if the demographic details eluded them, the leaders of France—both in the government and not—were well aware of the gravity of a problem that had concerned the nation since the turn of the century and been made demonstrably worse by two severe wars. In a comparison of sheer numbers lost in the two conflicts, the demographic costs of WWII for France "were slight . . . but they represented a new phenomenon in the history of the West—a net population loss to a nation already declining."[16] Among the first actions of de Gaulle's Provisional Government was the appointment of an Advisory Committee on Population and the Family (ACPF) in April 1945, charged with examining "fertility trends, rural population, urban decentralization, and immigration." Family support programs that had started, or been extended, under Vichy were pushed further by de Gaulle: "Income tax schedules were further adjusted, costs of education reduced, and the protection of pregnant

women expanded."[17] It was in this concerned milieu that the call for millions of beautiful babies was made.

Even with all of these measures, however, government officials were realistic enough to recognize that the population increases they believed necessary for the nation to stay in the orbit of the first-world could not come from an increase in the native birthrate alone. Less than a year after the creation of the ACPF, the *New York Times* reported on April 7, 1946, that the government had crafted a plan to admit thirty thousand migrants, "primarily Italians, in 1946 as the first contingent of two million carefully selected immigrants to be admitted within the next decade."[18] The introduction of that many extra hands would likely be a boon for economic recovery in the coming years; however, it also made the elaboration of a specifically French identity and cultural rejuvenation all the more important. Consequently, the proper development of the nation's children became a point of immense concern as "youth and youthfulness [from necessity] became a key site around which France imagined and planned [its] future."[19] To this end, the country faced a decision concerning what was truly important for France's students and for the future of the nation. Or, as it had already been articulated by Bloch:

> A text-book which sets out to explain how the July Monarchy substituted "life peerages" for "hereditary titles" is not, I suggest, a very useful work to put in the hands of junior students. They have more important things than that to learn, things more closely concerned with human values, better calculated to mould the malleable imagination of youth, and more instructive for the future citizens of France and of the world.[20]

Here again, Bloch's reference to a textbook was both literal and metaphorical. The nation's educational needs at the rough onset of heavy industrialization had been addressed by the Ferry Laws of the 1880s and the introduction of compulsory (and mass) primary education; however, the more developed economy of the 1940s, and even a higher awareness of social concerns, required a more thorough-going educational system. Before even the ACPF was constituted, the Langevin-Wallon committee began meeting, charged with the "establishment of a comprehensive and detailed programme of [educational] reform."[21] Working from the premise that in a "modern democratic society the extent to which all human resources were developed and efficiently deployed determined the success or failure of a nation" the committee "proposed that education be made mandatory up to the age of

eighteen."[22] Few of the reforms from the Langevin-Wallon Report, as it has come to be known, were enacted, most falling to the wayside in the political twists and joustings of the Provisional Government and the early Fourth Republic. However, the concerns raised in the report, as well as the proposals it offered, demonstrate the government's desire to establish a "proper" milieu for the nation's youngest citizens.

More reformist headway was made in the legal arena. Working with remarkable zeal and administrative speed, the Provisional Government issued a new law on juvenile delinquency on February 2, 1945, that henceforth was to be "the founding act of juvenile justice" in the French legal system.[23] While members of the committee that drafted this legislation (referred to simply as the February 2, 1945, law) chastised the work of previous Vichy reformers and the never-enacted 1942 law on juvenile delinquency, the two statutes had at least two significant points in common. Each removed the judicial concept of "discretion" in the case of (particularly minor) crimes committed by those younger than eighteen, asserting, as Fishman has put it, "complete penal irresponsibility," and "privileged education over repression." The statute allowed judges on the "Children's Court" the judicial discretion to make final decisions on a case-by-case basis; however, Article 2 of the law stated that the "Children's Court will pronounce measures of protection, assistance, supervision, education, or reform" rather than corporeal punishment.[24] What is also revealed in this statute was the concrete shift begun during Vichy in the underlying assumptions concerning the origins, or reasons for, delinquent behavior in young children and adolescents. The social and legal presumption was now firmly that deficiencies in a child's surrounding environment rather than in their own character were the principle cause of most juvenile offenses. Like Vichy, where the public sphere became politicized fodder for those who would see in it what they wanted (or feared) and attempt to make of it what they desired, here again government functionaries looked to organize a proper "general culture," to use Paul Marion's phrase.[25]

Meanwhile, a great deal of evidence was being marshaled to demonstrate that the current "general culture" was plainly threatening to the nation's children. Liberation and the ending of the war did not bring an immediate end to the woes suffered by the average French family and many still confronted the same issues of dislocation and abandonment, now often compounded by the impact of war casualties and unemployment, that had plagued them during the Occupation. In an article that appeared in the September 1945 issue of the journal *Éducateurs* titled simply "L'Enfance en danger," René Duverne

recounted the conditions under which many of France's children now labored. On nearly all fronts, by Duverne's account, children were being poorly served in their development toward becoming good and productive citizens. All of this was the result of "negligence, ignorance, and the indifference of parents, the weakness of [protective] legislation, [and] . . . the insufficiency of disease prevention as well as therapeutic measures which one can truly say in this matter, and in spite of certain recent efforts, is the result of poverty, [governmental] inefficiency and, sometimes, an extraordinary [institutional] clumsiness." Children, Duverne continued, were too often allowed to become the victims of a "rapacious" economy and finally, citing a government report on the state of French families, "undoubtedly too many families are wracked by 'alcoholism . . . explosive passions and the availability of divorce.'"[26] What was being made explicit with Duverne's critique was a notion that the well-being of the children of France could not be considered in terms of physical health alone. Their social and mental health, the "general culture" of children had become as important as medical treatment in postwar France.

Finally, if the fracturing of French society had not disappeared with the end of the war, nor had the (now firmly decided) principle effect of the situation: juvenile delinquency. If measure was to be taken by the number of sensationalist stories that regularly appeared in the pages of the popular press, in the first years of the Fourth Republic the country seemed to be in the grips of a juvenile crime wave.[27] So dramatic did the situation appear to have gotten by January 1948 that Vincent Auriol, first president of the Fourth Republic, ordered the conseil supérieur de la magistrature to take up the issue of "juvenile criminality" and address its cause(s)—already presumed to be, at least in part, the influence of certain BD journaux and other illustrés as well as films.[28] Less than a month after Auriol's request was reported in the pages of *Combat*, the minister of justice, André Marie, announced on February 26, 1946, the creation of a new commission that would not only investigate the problem but also offer measures intended to at least curb, if not eliminate, the problem of juvenile crime.[29]

That the primary focus of the Commission Interministérielle de l'enfance délinquante (CIED) would be limiting the availability of illustrés deemed to have "deplorable repercussions on public morality" was of little surprise, and not only because, after the CIED's first meeting, reports of its sessions were titled simply "Commission Interministérielle (Presse et Cinéma)."[30] Preceding even Auriol's call to action, the Ministry of Youth and Sport had undertaken a study of juvenile delinquency and determined that one of its principle causes

was the prevalence of poor quality (in terms of both production and morality) illustrés that "exert a deplorable effect" on their readers.[31] Indeed, by mid-1948 many involved with the CIED specifically or the issue of delinquency generally were "uncritically" reporting that nearly 88 percent of all juvenile delinquents were "passionate readers of illustrés."[32]

It seems likely that the investigative "direction" of these officials was influenced by the recurrent and vociferous anti-BD/illustrés campaigns carried out in the press and public sphere by various newspapers, educational groups (both secular and religious), and organizations like the Cartel d'Action Morale & Sociale (CAMS). CAMS, in particular, was instrumental in keeping the debate about the questionable moral value alive in both the public and political spheres. The creation of prominent Catholic and rightist educators and public officials, it was formed in early 1946, after the leadership council of the La Ligue Française pour le Relèvement de la Moralité Publique (LFRMP) decided, in the spirit of renewal immediately after the war, to update and modernize their organization. Both the LFRMP and its sister organization, the Cartel d'Action Morale, had been influential on the Catholic side of the culture debates of the 1930s and the LFRMP had been one of the "private" organizations that worked closely with Vichy, principally on issues concerning the protection of the family. The Cartel d'Action Morale, formed within the LFRMP by Daniel Parker in 1936, was something of a documentation and informational clearinghouse for organizations sympathetic to the LFRMP's mission that also wanted to maintain their own independence of action. It was, in fact, one of the Cartel d'Action Morale's last publications in 1944, *La Démoralisation de la jeunesse par les publications périodiques*, co-produced (as much as written) by Parker and Claude Renaudy, that forcibly renewed the association of "les Petits Journaux illustrés" with "littérature pornographique" in the minds of the medium's critics. Indeed, so important did the Cartel believe reform and control of the presse enfantine to be that in a list of areas of concern on the inside front cover of the pamphlet/journal "publications périodiques" was listed after cinema but ahead of both prostitution and alcoholism.[33]

In 1948, just as the CIED was beginning its work on the issue of juvenile crime, CAMS published *Semences De Crimes*: La Démoralisation de l'Enfance et de la Jeunesse par les Publications Périodiques et par le Livre. The author/editor/compiler André Mignot followed the same tack as Parker and the earlier Cartel d'Action Morale in putting together a booklet that articulated the concerns of CAMS as they related to "la démoralisation de l'enfance." While doing this, Mignot provided a veritable handbook of what had been written

and said on the topic in the wider press and other organizations, includ-ing selective quotations from police and court reports and records, as well as references to popular texts by psychiatrists and other experts. In fact, the position of CAMS was most often articulated in frequent commentary asides wrapped around more developed writing on the issue from other authors and was neatly summed up by a small insert included after a section on juvenile crimes (supposedly) inspired by reading immoral BD journals titled "Les Imprudences Fatales":

> A child used a lighter to see whether the gasoline tank was empty.
> *It was not empty.
> A child stroked a large watchdog on the head to see whether it was aggressive.
> *It was aggressive.
> A child tried to cross a railroad crossing to see whether he could pass before the train.
> *He did not pass.
> A child touched a high-tension line to see whether the current had been cut off.
> *It was not cut.
> A child wished to read an obscene book to see whether it was poison.
> *IT WAS POISON![34]

This, in fact, summarized the argument of all those, no matter their politi-cal leaning, for whom the reading of BDs was an activity with (near to) no redeeming value. Simply stated, the consumption of BDs with improper con-tent was declared to be as dangerous to children (and those around them if the citations from juvenile court were to be believed) as any activity that would put them in the way of direct and overt physical harm.

From the former Resistance newspaper *Le Parisien Libéré* Mignot culled significant sections of a two-part article by André Fournel, "Alerte aux par-ents! Les publications enfantines ne doivent pas être une semence de démor-alisation pour les générations futures!," that appeared on July 17 and 18, 1946. In it Fournel spent several paragraphs relating a truncated history of "les publications enfantines" while lamenting the disappearance of examples from previous generations, and "éditées chez nous," that sought "to wake up [the readers'] curiosity and independence of his spirit, but with the constant con-cern to also ensure his moral balance." As for the examples available to young

readers today, "all the specialists will tell you," he insisted, "that there is no surer leavener of infantile criminality than the unhealthy reading with which our young people are watered daily." In a reference obviously intended to warn his readers that they already had evidence of the effects of these journals on the country as a whole, Fournel made specific mention of the Italian-derived journal *Hurrah*, published in France by the "Italian fascist Del Ducca." First appearing in 1936, "this journal with less than 5% French input and material" had its sales increase from 70,000 to 250,000 issues in only eighteen months "and began, on our children . . . the most disastrous moral intoxication ever suffered by youth the world over." The implication being that consumption of these (foreign) journals weakened the nation and, at least indirectly, contributed to France's humiliation in WWII. "France, which tends to its reconstruction in all other domains," he insisted, "needs to consider the moral reconstruction of its young generations."[35]

From the pages of *Combat* came a front-page editorial that demanded from the publishers of these "Journaux de Jeudi" (as they were sometimes called because they tended to land on kiosques shelves on Thursday) to know how many children they killed each week. "I counted," the author, Louis Pauwels, answered in response to his own rhetorical question, and found "on average: twenty-three assassinations for every eight pages, with busted guts, cut throats, strangulation, shootings, crushings." There were, he continued, five drawn and aimed revolvers, sixteen dirty tricks, and four grammar errors, and of the twelve BDs, "one in three ends in sentences like this one: 'This time, you will not leave my hands alive . . . !'"[36] Again, the deleterious effects of this on its young readers were easily identified. Citing the case of a young boy who had stabbed a washerwoman between the shoulder blades, Mignot quoted the court report stating that when asked by the judge where he got the idea for his actions, "the child pointed out the illustrated account of a similar crime."[37]

It was not simply exaggerated levels of violence that was risked by the reading of improper journals; rather the very future of France was actually at stake as the pornographic nature of many of them made a terrible example for young women and raised wild expectations in young men. "Reading these publications not only embarrasses teenagers," Mignot insisted, it causes "a loss of respect for the dignity of women, who become in [the readers'] eyes only an object of coarse pleasures, since any true love is banished in advance. Pornographic literature makes a normal and frank family life impossible . . . [and] makes an honest friendship between young boys and girls [just as] impossible." Adolescents who were not simply scared off from

normal sexual development were likely to become "devoted to excesses most dangerous to their physical health as well as their moral balance."[38]

Still, none of this was specifically concerned with, or directed toward, a total censure or complete removal of the *Journaux de Jeudi* from kiosques and newsstands. Rather, the concern remained an "idée éducatif." "The child," wrote Mignot, "this new creature that comes into the world, this tiny traveller with no baggage, will leave, thanks to what he reads, with a specific understanding of life. From all the beauty and ugliness that will be presented to him, he will choose that which enables him to build an ideal." Citing yet another writer, he continued: "it is important not to underestimate the role of the *journaux des enfants* in education—either education or contre-éducation, depending on what these journaux have to offer their young readers. It is a long held truth that 'the Frenchman cannot do without his daily newspaper, he is as hungry for it as he is for bread, and he brings this appetite with him into the world. As soon as he can read, le petit Français also wants his own newspaper, he loves it and believes—already—everything that it says! And that is the great danger.'"[39] Given this "long held truth," the issue was clearly not to deprive the children of France their own journals, rather it was more a matter of ensuring they had the proper *French* journals in which to indulge. Something of this concern was apparent in Fournel's lament for the illustrés of the previous generation(s). Even more, however, as we have already seen it was a consistent theme in the critiques of the *journaux des enfants* spearheaded by Sadoul on the side of the Communists and Abbé Grosse (and others) on the Catholic, conservative side during the culture wars of the 1930s.

In the postwar years, when the need for reclamation, rebuilding, and renewal was both immediate and obvious, the debate that had waged across the political divide in the decade prior seemed less hysterical to the average Frenchman and had merged into a single, if not tightly coiled, argument concerning the need to both protect and carefully guide and prepare the nation's youngest citizens. Just as de Gaulle's men had moved into Vichy offices and removed their archives during the Liberation, the general press was also put under direct control of former Resistance authorities. Among the first steps taken by the new authority was to ban all BD illustrés published during the Occupation. Then, using the dearth of equipment and material—primarily a paper shortage—as justification, the first two ministers of information in de Gaulle's Provisional Government, Jacques Soustelle (May 30, 1945–November 21, 1945) and André Malraux (November 21, 1945–January 26, 1946), prohibited the widespread renewal of the *presse enfantine*. There were exceptions to

this general prohibition; *La Bête est morte!*, as we have seen, was published in the first months after the Liberation of France, and journals of demonstrably Resistance-era provenance were able to skirt the regulations as Resistance newspapers were provided the lion's share of the available paper to continue publication in those first years.

Nonetheless, at the time of Malraux's posting as the minister of information in November 1945, a committee was formed within the Ministry to decide the merits of those who were applying to renew, or begin, publication of BD journals. Caught by the same spirit and call to rejuvenation that gripped the whole of the nation, the committee rejected most applications from either foreign presses or native publishing houses requesting permission to publish foreign BDs, generally on the basis that they were not educational (read French) enough.[40] Because of this, there was no immediate flooding of the newly liberated French marketplace with foreign—principally American and Italian—examples of BD as has been commonly held while new (and "reborn") French journals and BDs benefited from this lightly held monopoly both in terms of aesthetic development and the securing of niches among the journaux illustrée reading public.[41] In fact, while the censoring policies of both the German and Vichy authorities during the war years had banished foreign journals and BDs they had also, except for a few exceptions, muted innovation and development of the indigenous medium. The real, native, expansion and growth of the medium occurred under the "shaky protectionism" of the first years of the Provisional Government and the Fourth Republic.[42]

Likely, no publication benefited from this window of opportunity more than the Communist journal *Vaillant*. It was a continuation of the underground Republican/Resistance journal *Le Jeune Patriote* that had been published illegally for much of the war and served as the representative in print for the Front Uni de la Jeunesse Patriotique (FUJP), part of the Organisation de la Jeunesse Combattante du Front National during the Occupation. After the Liberation, but before the actual closing of the war, the journal continued to appear as *Le Jeune Patriote*. Recognized as a Resistance newspaper, it was protected, allowed to publish, and even allotted a scarce paper ration by the Provisional Government. Maintaining a stridently patriotic tone in the last days of the war, the journal continued its resistance to and "attacks on the Nazi Third Reich." After the conflict was finally past, however, the founders of the hebdomadaire recognized that there was a near vacuum in the "range of journaux being offered to the public": missing was a Resistance-informed journal illustré for children.[43] Using the paper allotment for *Le Jeune Patriote*,

Vaillant began appearing in June 1945, still bearing the subtitle, for the first few months of its publication, "Jeune Patriote" lest anyone forget its hard-won provenance.

Initially, the journal retained a rather hard-bitten and uncompromising style and sensibility better suited to the clamor of war than the calm of peace—an aesthetic point that the hebdomadaire's creators later conceded—perhaps due to the fact that the young, militant, Resistance fighters had now become slightly older, militant, Communists.[44] Just prior to the launching of *Vaillant*, the journal's staff joined the Communist-led Union de la Jeunesse Républicaine de France (UJRF) and, in the months following, founded the Union des Vaillants et Vaillantes, a secular (quietly Communist) children's movement.[45] Luckily for the future of the hebdomadaire, however, this also brought Madeleine Bellet, who would quickly assume the editorship of the journal, and Roger Lécureux, eventual author (though not illustrator) of some of the most imaginative and popular BDs of the postwar era, to the *Vaillant* office.

By his own account, Lécureux came to the journal after leaving an earlier job in print over political differences with his supervisors and was hired on to the *Vaillant* staff as head of subscriptions. Given that the new publication had no more than sixty active subscriptions for its first few issues, the position left him with much time on his hands and within weeks he was offering scenario suggestions and story ideas and was quickly made the head writer of *Vaillant's* first real BD success, "Fifi Gars du Maquis." Not long after that he teamed with the artist Poïvet and created the groundbreaking science-fiction BD "Les Pionniers de l'Espérance," which would go on to appear throughout the journal's many editorial shifts and permutations for nearly thirty years. Beyond any personal success as a BD writer, he has also been credited with developing the overall look and style of *Vaillant* in its first year. Originally, the gritty publication perhaps took itself too seriously to be a successful children's illustré and Lécureux, an admitted fan of Opera Mundi's *Robinson* and an admirer of the American style of BDs, encouraged a lighter and more accessible approach for the hebdomadaire generally.[46]

To many, he was guilty of having "Americanized" a French Resistance journal and in response he pointed to its quick success after the "remodeling." By early 1946, weekly sales of *Vaillant* had well surpassed 100,000 issues per week and were averaging just under 200,000 per week by 1948, while the size of the journal expanded from its original eight pages to thirty-two. This made it one of the top-selling (and largest in terms of pages) hebdomadaires of the 1940s and into the 1950s, even after the French marketplace was reopened to

competition from BDs and journaux illustrée from Italy, Belgium, and the United States.[47] Perhaps even more important however, *Vaillant* was also instrumental in shaping what Lécureux called a "school of truly French BD" that was self-consciously marked by a sense of social awareness and "development of ideas such as progress, justice, [and] freedom" without being heavy-handed or attempting to overly intellectualize the medium.[48] Particularly in the years immediately following WWII, this ethos informed the work of many who were producing journaux illustrées in France, no matter their political leanings. And if not always the publishers then certainly those who had made it their task to monitor the general culture as Lécureux's delineation of the French school of BDs closely mirrored the slogan of CAMS: "No social progress without moral progress, no moral progress without social progress."

The apparent allusion in the sentiments here was not accidental. There had been a weak attempt made at formalizing strictures on the *presse enfantine* made by the Ministry of Education at the same time that the committee in the Ministry of Information was unilateraly deciding the fate of those applying for publication authorization, but it quickly was forgotten as the Ministry was forced to focus more directly on its governmental portfolio of redesigning the education system in the first months after Liberation. However, two years later, in 1947 Pierre Bourdan, minister of youth, arts, and letters in Paul Ramadier's government, brought the project back before the government and formed a committee to draft a regulatory bill. Reflective of the widespread concern that the issue engendered, the committee included members from every Ministry that had some purview over either children or the press, as well as representatives from the Fédération Nationale de la Presse Française (FNPF), the Union Nationale des Associations Familiales (UNAF), the Communist Union Patriotique des Organisations de Jeunesse (UPOJ), and the Catholic Commission d'Etude des Journaux d'Enfants (CEJE). Despite the myriad specific interests and political concerns of this broadly constructed committee, by May 1947 it had brought two separate bills to the legislative table: Bills no. 1374 and no. 1375.

Though the underlying concern of protection and guidance of the nation's youth was apparent in both bills, they differed in their respective approaches. Bill no. 1375 was the more specifically protectionist of the two; directed at securing the French market for demonstrably French publishers as well as native BD authors and artists, it revived a proposal that had been advocated by the Union of French Artists and Designers (UADF) in the late 1930s. Foreign material and BDs would be limited to no more than 25 percent of any

journal and, in an attempt to level off the competitive economic advantage that journals reliant on syndicated BDs had enjoyed before the war, a tax and minimum price per BD "planche" or strip would be enforced. Finally, so that manifestly *French* products could be easily identified, a special stamp was to be created for all French BDs.[49]

Bill no. 1374 more completely reflected the direction of "the young and energetic" Bourdan, who had been active in the radio Resistance of de Gaulle in London, and, more generally, the ethos of the Resistance veterans who were looking to make an educational tool of the general culture.[50] For the committee, it was a simple enough proposition: children and teenagers, as a public, were easily influenced and "extremely . . . impressionable . . . [consequently] the press . . . intended for boys and girls younger than eighteen, can play a determining role in their moral and civic formation." Because of this, the issue of an appropriate press was not merely one of present-minded concern over a decayed social standard; rather it was a matter that struck at the heart of the country's future as the "contents and presentation of these publications [could] form much of the orientation of those who, tomorrow, will constitute the active part of the nation."[51] Therefore it was "important to take care that the presse enfantine is free from accounts or illustrations exalting banditry, idleness, theft and crime . . . [as well as] unhealthy reading or illustrations." Further, given the "dubious role of certain owners of journaux d'enfants (especially foreign)" before the war, "with regard to the morality and patriotism of the persons who wish to publish children's periodicals . . . [a]dministrative or judiciary sanctions must make it possible to restrict the harmful character of certain publications which are published with a purely commercial aim." Finally, in a reference to Bill no. 1375, the authors of no. 1374 demanded that to "ensure the national character" of the presse enfantine, it is also necessary to legislate control of publications and "bandes illustrées . . . of foreign origin." These additional "measures will make it possible to safeguard the interests of French professionals and increase the national wealth." Only by taking these actions, the members of the committee insisted in the bill, would it be possible "to give our children and teenagers, a press . . . worthy of them." Which will make them, as citizens, "conscious of the role they have [as well as] the role played in the world by the great democratic and progressive country that is France."[52]

The sentiments of Bill no. 1374 were widespread throughout France in the, still Resistance-informed, early years of the Fourth Republic; nonetheless, Bourdan's committee likely overreached in its attempt to guarantee a

press worthy of the nation's youth. Article 6 of the proposed law would have required that the management committee of any publication destined for children under the age of eighteen could not have been a publisher of a "legal publication during the occupation," and they must also "be of French nationality."[53] While the former restriction might well be considered admirable, the latter would have closed off the French market to foreign publications at a time when the Ramadier government was considering the merits as well as the dangers of U.S. Marshall Plan aid.[54] Bill no. 1374, consequently, never made it to the National Assembly while Bill no. 1375 made it only to a (failed) vote on the floor of the Assembly by dint of the strength of the Communist Party in Parliament.[55]

In many ways, Bourdan's appointment as minister of youth, arts, and letters, and the commissions and committees his Ministry initiated, marked the high point of the government's involvement with a project of shaping the general culture of the nation. Not long after these failed efforts, the portfolio for action in matters concerning youth and culture passed back to the Ministry of Education.[56] It has even been suggested that the entire question of journaux illustrées might also have passed had it not been for the influence of the general press—and other organizations like CAMS and the UPOJ—which continued to run sensational stories that tied the problem of juvenile crime to what children were spending their leisure time reading, keeping the issue current in the minds of the French people.[57] As part of a five-part series that ran through much of 1947 in Éducateurs, for instance, Bernard Bellande began the first installment, titled simply "Journaux d'Enfants," with an account of a violent crime committed by a fourteen-year-old:

> Before the Juvenile Court, the clerk read the bill of indictment: Leaving his parent's residence after night-fall, young B . . . , 14 years old, went to an old pensioner's [home], Mrs. Vve T . . . , from whom he succeeded in extorting, by threat of a revolver, a sum of 40,000 francs. Three days later, the culprit was found in Bordeaux, hiding in the hold of a cargo liner destined for the United States. During interrogation, the defendant stated that he was inspired . . . by the reading of an illustrated periodical entitled: Cartouche.[58]

The remainder of his nineteen-page article was filled with summaries of other stories and articles that had already appeared elsewhere—particularly Fournel's "Alerte aux parents" from the pages of Parisian libéré the previous

year—in an attempt to demonstrate to his own readers that there was indeed a widespread insistence that the journaux des enfants "should not be a seed of demoralization for future generations."[59] Renewing a tradition of "critical studies" of "principle journaux d'enfants" that had been common in the 1930s from both conservative/Catholic commentators and those on the left, Bellande offered an appraisal of several popular examples. Judging them by ten separate criteria ranging from their appearance, to humor, to their ideological and religious teaching, few of those on his list were deemed worthy of much respect for their content. Of the popular *Coq Hardi* (one of the first journaux illustrée to appear after the war), for example, he mustered only that it was a "very undistinguished journal, not precisely condemnable," though one of its BDs, "Lariflette," was poor enough itself to nearly classify the publication as "antiéducatif." Otherwise, it simply satisfied its readers taste for a "certain [minor] vulgarity."[60]

Interestingly, while much of the criticism of these hebdomadaires mirrored that which had occurred in the 1930s, one point of concern had decamped from the right and shifted to leftist critics of the journals. As the postwar years rolled on and resolution on the issue of the moral and ideological dangers of BD journals seemed never to come to pass, an increasingly strident anti-Americanism took root in the critiques of Communist commentators. Previously, when the criticism from the right was largely directed by the vitriolic voices of Abbés Bethléem and Grosse, a strong line of anti-American/ foreign xenophobia had marked it. Now, however, while there remained a certain—likely inescapable—amount of this in rightist commentaries, the worst that Bellande could muster concerning American BDs and journaux illustrées was reiteration of a (now) standard critique: "images of vice, chivalrous phantoms, gangsters toting machine-guns, and interplanetary flyers." In the final analysis, "their technical quality is rather good, their intellectual value poor."[61] This rather mild assessment of most American journaux illustrées actually left them with a higher mark from Bellande than several French examples of the weeklies, if for nothing else than their "technical quality," and it was a judgment more akin to Sadoul's critique in the 1930s of the medium as a whole than it was either Bethléem or Grosse. Meanwhile, the Communist position, by 1947, had taken an anti-American xenophobic stance that had previously been the purview of the Catholic ideologues. Take, for instance, the picture of a young boy reading a journal illustrée that appeared in an October 1947 issue of *L'Humanité* bearing the caption: "Will this little boy be the prey of Yankee journalism, assassin of young spirits?"[62]

The turn to an adamant anti-Americanism by the French Communist
Party (PCF) and its various spokespeople and sympathizers at the start of
the cold war has been a frequent subject of study as it related to a number
of topics and concerns, from economic development and Marshall Plan aid,
to political hegemony, and—most often—the threat of an insidious cultural
imperialism from a "civilization of bathtubs and Frigidaires."[63] The direct-
ing of this anti-Americanism at BDs and illustrated journals has previously
been understood as precisely a cold war phenomenon with the PCF, as well
as those who were sympathetic to its position, insisting that "danger came
from America and America only."[64] In the sense that for the average French
man and woman, postwar France seemed flooded by an American presence,
from GIs stationed in the country and Marshall Plan officials swarming gov-
ernment offices to American products and businesses, a "danger" alarm was
likely properly sounded. However, this was a fear of many and not just the
PCF and the association of the position by the Communist Party specifically
with the emerging cold war too easily leaves the impression that it was little
more than a counterposing of the United States with that of the USSR by
the party. That would seem too simple—and limited to the immediate situa-
tion—an explanation to a question that was itself only part of a much larger
and more complicated issue.

In fact, rather than a response without precedent, the anti-Americanism
of the PCF is better understood as a continuation of the party's "historic role
. . . as an important mediator of social promotion," as it has been described
by Lebovics.[65] In light of the 1946 Blum-Byrnes agreements, which had
opened the French market to American products in exchange for monetary
and economic concessions, the very ability of the French people to create and
enunciate their own cultural identity seemed to be in peril.[66] Because of this,
even with the dismissal of the PCF from Ramadier's government in the spring
of 1947, the party continued to assert its "determination to defend the interests
of the French working class."[67] In the current milieu, defending their interests
meant defending the integrity of a particularly French identity while a strident
anti-Americanism should be easily recognized as a potent—and potentially
face-saving—political strategy for a party forced out of the government but
still in command of 25 percent of the seats in the National Assembly.

None of this is to say, however, that there was not a certain ideologi-
cal bent to Communist criticism of American, or American-inspired, jour-
naux illustrées. The point here is simply that it is too easy a summation to
insist, "Communists were opposed to the American strips because they were

American and because they exalted individualism and the spirit of adventure, both contrary to Marxism."[68] Indeed, the anti-individualist and antiviolence critiques should not be seen as somehow uniquely Marxist in their derivation, as they easily had as much in common with attacks from the French right as they did the Cominform. Rather than PCF resistance to American BDs being read as coming from the notion that their ethos was "contrary to Marxism," it is just as likely that many French men and women, politically Communist or not, simply believed it to be contrary to the idea of France they wished to articulate in these years; and the party, well heeled in its traditional role, was reflecting that concern.

After all, concerns about an Americanized aesthetic had almost entirely disappeared from Communist critiques by the middle of the decade, and, as has already been discussed, their own principle journal, *Vaillant*, took its visual design from the earlier American-inspired *Robinson*.[69] If there was something to be taken at face-value from the anti-American rhetoric of Communists, it would be a sincere desire to protect the French print market and the livelihood of French writers, artists, and publishing houses from the American domination that had become all too apparent in other fields of cultural production like film. In his 1975 interview with Quiquère, Lécureux proudly pointed out the continued success of *Vaillant* after the market was reopened to foreign journals and it was this success, as well as that of other French (and increasingly Belgian) journaux that later scholars have pointed to as evidence of a dawning golden age for the French BD in the postwar years. Crépin, for instance, has argued that the success of *Vaillant* and *Coq Hardi* was proof that after the war, "children preferred truly French characters from the Resistance."[70] Pascal Ory has pressed even further to insist that these years in the history of the French BD, "in the heart of the period of deepest American penetration" into France, were "doubly provocative" precisely because it was actually a case of "désaméricanisation" or de-Americanization.[71]

Perhaps the distance provided by time, and a relatively recent shift in cultural appreciation for the medium, coupled with the undeniable aesthetic vitality of many French BDs of the period—and Francophone generally, if the dynamic work of the Belgian-born Hergé and his *ligne claire* drawing style are included, as is most often the case—has allowed some room for an assertion like Ory's. However, those dealing with the issue at the time, even the publishing board of *Vaillant*, while taking account of their modest success in maintaining sales rates in the face of heightened foreign competition, were confronted with the fact that the American-derived *Tarzan* was then the best-

selling journal, out-pacing their hebdomadaire by more than a hundred thousand issues weekly. Nor had the economic advantage that publishers who used imported or syndicated material, as Sadoul had first pointed out in the 1930s, dissipated while the children of France had admitted in 1947 that they, in fact, did prefer the protagonists of American BDs to their French counterparts.[72]

Without the traditional and well-entrenched community organizations that their Catholic counterparts could rely on to maintain a "subsidized" circulation of their journaux, it is also easy to suppose a certain self-interest in their expressed wariness and condemnation of American products. After all, the success of *Vaillant* stood in marked contrast to the weak performance of the PCF's first journal, *Mon Camarade*, in the 1930s but the party reasonably feared losing what they believed to be a powerful educational and ideological tool in the face of an out and out opening of the French market to popular foreign, read American, journaux. Nonetheless, even considering these facets of the situation and differences in rhetoric, the core issues raised by Communist commentators were still little different from those on the right.

Just as the CIED was formed in the first months of 1948, a commission whose "work was to be completed this time," André Mignot pointedly reminded all involved just what was presumed to be at stake.[73] "Since the Liberation, and in spite of the paper shortage," he lamented in a brief piece titled "Un Cri D'Alarme," "the press intended for Children and Youth has developed in an extraordinary manner." By the first of Decemeber 1946, there were already some forty journaux available in the kiosques and "five foreign journaux translated into French. On this same date, 189 requests for authorization to publish were submitted to the Ministry of Information." By 1948, there were more than sixty journaux available to children, according to Mignot, and they posed "a very serious problem: if the Government does not intervene with regulation and control of this press, we will pursue in the years to come a real battle with and a progressive victory over [the publishers] of unhealthy journaux." There was little doubt that Mignot's reference to publishers "that have powerful financial means and writers without scruples" was primarily directed at foreign syndicates like Winkler's Opera Mundi, which would, just that year, apply for permission to once again begin publishing the *Journal de Mickey*. And, if there were those who might not take his organization's threat to wage battle themselves if the government did not move to finally control the press enfantine seriously, he offered a thinly veiled reference to what some had done in the years which "précédé la guerre!"[74]

Whether due to Mignot's warning that CAMS stood ready for action if the government was unprepared to address the problem of immoral journaux illustrées or not, it is clear that by March 1948 the CIED was prepared to act with all due administrative haste to finally bring an end to this threat to public morality and decency. On March 8, just ten days after briefing the members of the National Assembly on the task and goals of the new commission, Minister of Justice André Marie addressed an official "Circulaire" to the attorney general of the Court of Appeals. In it, he informed the bureau that despite the already existent strictures on the publication of "photographs, engravings, drawings, [or] portraits" whose subject was "certain crimes" or moral "offences" he had been made aware "on several occasions that certain newspapers and periodicals have not hesitated in publishing, often on the first page and in large size, images which would fall under the abovementioned penal provisions." He continued on, seemingly chastising the attorney general for the failures of the entire French state for having allowed these injuries to public morals to happen: "You are well aware," Marie insisted, that these "intrigues . . . have a deplorable effect on public morality and are often one of the causes of delinquency in minors." He then directed the attorney general and his deputies to pursue a "strict application" of the relevant codes of law in prosecuting any violations of Article 38 of the law of July 29, 1881, on the press, modified by Article 128 of the decree-law of July 29, 1939. Finally, Marie informed the attorney general that while he intended to ask Parliament to pass legislation that would assure the complete repression of all those "intrigues likely to cause the demoralization of our youth," they were not to wait for it and should begin their work immediately.[75]

Precisely a month later, the minister of the interior, Jules Moch, followed Marie's "Circulaire" with his own directive to the Prefects of the Metropole, Algeria, and Overseas. His intent was laid bare by the subject line of his directive: "Publications dangerous for public morality." Like Marie, he relied on the modifications to the July 1881 law on the freedom of the press that were made by Article 128 of the seldom enforced July 1939 Decree-Law titled "Relative to the Family and French Natality," and even referenced "his colleague" in pursuing a strict application of the punitive articles of the July 1939 Decree-Law. There were issues of commerce and freedom of the press to be considered he counseled; however, this should not keep the prefect officials from aggressively removing, at least from easy public view, offending publications from kiosques no matter where they might be in the French Commonwealth.

Once again following the example of the minister of justice, he insisted that the "policing" of "dangerous publications" must begin immediately given the increasing problem of juvenile crime. He closed his directive with not only an elaboration of the legal justifications for any censoring action taken but also a list of publications that should be considered for immediate action. The list, however, was not to be presumed closed or "restrictive" and, he concluded, "it rests with you [the prefect officials] to modify it, taking into account local circumstances."[76]

Both Marie and Moch's directives began paying almost immediate dividends as publishers found themselves having to take account of a now active "policing" of circumspect journaux. The directors of various houses began contacting the Ministry asking for clarification on the relevant articles of the July 1939 Decree-Law, as well as review of their publication(s), particularly those that had been highlighted by Moch's list. Such was the case of André Beyler, president and general director of Editions "Nuit et Jour." In a letter dated less than two months after Moch's directive to the Department Prefects, Beyler pleaded the case for his journal *Qui?Détective*. Perhaps the journal had been particularly aggressively prosecuted but it was clear from his letter to the Ministry that Beyler was well informed of the grounds by which *Qui?Détective* was being removed from newsstands as he directly quoted from Moch's own directive. Begging all due deference, he relayed that he believed that Moch's principal concern was with "publications whose 'intrigues have deplorable repercussions on public morality,' or 'are a source of perversion for children.'" "Certainly," he continued, "*Qui?Détective* is a hebdomadaire of diverse stories and bits of news, but its compilation obeys precise and strict rules" and he did not believe that it should be classified among publications deemed to be a threat to "public morality." Interestingly, Beyler never suggested that it would be impossible for a magazine, no matter its "rédaction," to have "deplorable repercussions" on public morality or play a role in perverting the youth of the nation, though he did suggest that perhaps Moch's directive "unconsciously deviated" from the intent of "these rules" in its strict "application" of them. Nonetheless, if he or his staff had allowed harmful content to creep into the pages of their publication Beyler asked for clarification of the relevant articles of the law as well as review of material that he included with his letter. Concluding his request to the Ministry, he was careful to express solidarity with their concerns and signed his letter: "A. Beyler, Chevalier de la Légion d'Honneur, Croix de guerre, Médaille de la Résistance"—as if his own history as a hero of the Resistance should demonstrate that neither he, nor

his publishing enterprise, would consciously do anything to undermine the nation's future.[77]

Beyler's seemingly reasoned approach as a publisher who was in some ways working from inside the issue aside, three months before his letter to the Ministry, and at the start of the CIED's work, an article appeared in *Le Figaro* that counseled and reminded its readers as to what was presumed to be at stake. "Every day," the piece began, "brings new evidence of a frightening renewal of juvenile crime. The children kill . . . steal and one visits the courts and the lamentable procession of poor kids, filled with bravado or broken down, and parents who say: 'We do not understand!'" As has become apparent, just as it was for so many other commentators, for those at *Le Figaro* the responsibility lay with the proliferation of "bad" journaux des enfants; silly stories about cowboys, dangerous ones of war between gangsters and the police, space flights with no scientific basis, and the bestial Tarzan and his new partner the "pin-up girl." In almost all these stories, there are depictions of a "revolver" which "enters the scene with the first image . . . It acts simply as provocation to murder and not education, not even [honest] distraction." "It is on these grounds," the author François Mennelet continued, "that the Committee intends to carry out the fight." Of course, it is important to provide support for "healthy journaux" he cautioned, but "it is most important to stop the crimewave and the perversion of children's minds." Other bills had gestated in various ministries or even fallen dormant on the floor of Parliament, but this new committee had come together to design a bill with "clear language" designed solely "to prohibit the manufacture and the sale of these 'narcotics for children.'"[78] Mennelet's article was but one more example of a continued movement in the general press that kept this issue current in the minds of the French people, and reminded the members of the CIED, at the start of their work, just how serious an issue the entire nation had made of the question of *mauvais journaux d'enfant*.

The task before them seems one that the commission members took seriously, and we need not rely only on Marie and Moch's quickly produced and insistent directives as evidence of this. Convening nearly weekly, by May 11 the CIED had met eight times and the minutes of the commission's meetings, reflective of its interministerial make-up, rumbled across the problems of juvenile delinquency, child prostitution, the need for a noncommercial educative cinema, and the myriad work, commercial, and trade issues that would be involved in any market restrictions that might result from their work.[79] Before long, however, the CIED had settled into considerations of the issue that was

obviously believed to be the most significant—that of the pernicious influence of bandes or journaux illustrées.

The work of the CIED on the journaux illustrées was focused and directed by a report on the aesthetics, content, morals, and impact of BDs compiled earlier in the year by Jean Ballandras, vice president of the Groupement Départemental de l'Enseignement Laïc. Ballandras's report had been adopted by the Congrès des Oeuvres Laïques in Rhône at the end of May and the Prefect of the department thought highly enough of it—and apparently took Moch's earlier directive that his list of suspect journaux was not complete and should be detailed by local circumstances to mean that the work of the CIED itself was open to suggestion and support from the departments—that he submitted it to Moch's office on June 14, 1948. Ballandras's report was broken down into several sections with headings like "A Growing Danger," "Comment on the Presentation of the Majority of Publications Enfantine," "Misdeeds of the Presse Enfantine," "On Morals," and finally, "For Mastery of the Peril." As might be easily discerned, there was little in the six-page work that had not already been asserted about the dangers and deleterious effects of a great many BD journaux; indeed, if anything, he was sometimes given to even greater hyperbole in expressing his fears than the typical member of the Fourth Estate. "There are some thirty examples on my work desk . . ." the first sentence of his report began; he had been examining the journaux illustrées every evening for a week, but as he settled in to write his report, Ballandras had finally finished his review. "I am saturated with criminals . . . with gangsters and cowboys. Lepers and Martians, carnivorous plants and supermen, detectives and murderous burglars, [all] dance an unrestrained jig before Mammon and I am well afraid they will inhabit my dreams." Though he did not directly blame the hebdomadaires of the 1930s for France's humiliating defeat at the hands of the Germans, he did insist that an "occult Mafia endeavors to complete what five years of occupation started . . . [a]nd the majority of publishers are not unconscious accomplices of this harmful work."[80]

Ballandras's report brought together the salient, and most cutting, bits of criticism that had been heaped on BDs and journaux illustrées for the previous two decades while providing it all a patina of governmental surety and authority. The entire six pages read as an indictment of offenses that the medium had perpetrated on the youth of the nation. Nothing more than their consumption by young readers would, at the very least, lead to "a tiredness of the eyes," and "frequent insomnia" would often be the result of reading the garishly colored panels, which likely would end with the "balance" of a child's

"nervous system" being "broken." All of this would then make discipline of the (now) excited and unbalanced child difficult, imperiling its very education while the task of the schoolteacher was made impossible. More generally, according to Ballandras, the aesthetics of the medium were typically "perverted by the vulgarity of the engravings and coarseness of the drawings"; and while it was true that in most of the "histoires" good triumphed over evil in the end, evil was too often depicted in too seductive a manner. In sum all this could only mean that "it was above all on the moral sense that this criminal prose exerts its greatest damage."[81]

All of his own critiques of the hebdomadaires were based largely on a summary of publications easily available to all at nearly any kiosque. He freely named many of the journaux that he found to be most offensive while insisting that he was unconcerned by any personal repercussions because someone had to take a stand against this "public menace, enemy No1 of children." He apologized that his list was necessarily incomplete as "there are others," and he sarcastically lamented, "because if paper is in short supply for schoolbooks, it abounds for these works of perversion." Nor was this problem of perversion in the press limited to France, as both Belgium and Switzerland had also fallen prey to this "international deprevation!"[82]

Ballandras's report, however, concludes with a warning that makes it clear that the issue at stake went beyond even getting at the root(s) of juvenile crime and the demoralization of the nation's youth. The "ideal remedy" would obviously be for the government to adopt a law regulating the presse enfantine. However, he cautioned that it must be "extremely circumspect" in this arena. As dangerous as the journaux illustrées might well be, it would be wise to "not forget" that they represented only a small fraction of the "flourishing" market of journaux des enfants. More important, the "French hold tightly to the freedom of the press. A revolution might have no other cause than its defense . . . [and] it is often difficult to make the distinction between [the expression of] this freedom and its abuse."[83] In other words, though this was a dangerous plague that had to be controlled, it was just as important that the crafters of any censoring legislation not forget that the freedom of the press was one that lay at the heart of what it was to be French.

With Ballandras's report offering both vitriol and a cautionary note and the earlier bills, nos. 1374 and 1375, providing a framework of sorts, the CIED moved quickly through its work and by August 18 Paul Gosset, member of the moderate Mouvement républicain populaire (MRP) Party and head of the National Assembly's Press Committee, presented Bill No. 5305, Rapport, Projet

de Loi *sur les* publications destinées à la jeunesse, to the National Assembly. Developed largely from the commission's work, Bill No. 5305 predictably cast the issue of the "proliferation" of "magazines, journaux, and publications intended for youth" as one that had long "worried teachers" and imperiled the moral and educational health of the nation's children. It was now impossible, Gosset insisted, for any legislator to be "unaware of the gravity of evil caused by this [illustrée] form." "The duty of the Parliament is to establish a severe rule which definitively blocks the publication of texts and images not in conformity with morals and is the opposite of the principles which must preside over the training and education of French youth." In language that was reminiscent of the Ballandras Report, Gosset made it clear that the nation could not allow "the hearts of our youth . . . [to] be delivered to the tastes and inspirations of unknown paper merchants" interested only in profit and willing only to offer apologies to the "essential virtues that make men just and communities strong."[84]

Writing on behalf of the CIED, the Assembly's own Press Commission, and the general populace—from which he maintained there was a high level of public support for any regulatory action taken—the great surprise was, he insisted, not that there might still be some who would deny the deleterious effects of the journaux illustrées, but that the government had taken so long, and been so hesitant "in barring the road." The proposal of law that was then offered in the bill was similar to what had come before it, though this time public interest was higher and governmental support generally broader. Consisting of twelve articles, the proposed law would settle what was to be covered (demonstrably educational material would be excluded from the law and oversight by the Surveillance and Control Commission to be established, for instance); the fixing of the penalties for violation of the law (a combination of fines and potential prison sentences); the organizational composition of the commission to be charged with the surveillance and control of publications intended for children, and the requirements to be met by any enterprise wishing to publish "journaux destinés à la jeunesse." Articles 2 and 12, respectively and most importantly, of the proposed law would establish that no publication directed at children could favorably portray crime or any other immoral activity (including lying or idleness) and that 75 percent of all journaux be reserved for illustrations and stories of French origin and by French artists and authors.[85]

The support for Bill no. 5305 was initially remarkable for the broad base it managed across political lines, with the moderate MRP straddling the general

divide that separated those on the political right from the Communists and others on the left. Indeed, Pascal Ory has referred to the law that was the eventual result of these efforts, most commonly known as the 16 July Law, as "a beautiful example of how Western societies joined in the Cold War." The legislation was born of an "atmosphere of unanimous moralism representative of the consensus of the post-war" period. Even if the debate turned "sour" in its later stages, the underlying principles of freedom of expression and concern for the nation's children never wavered.[86] There is much to be said for this rosy depiction of the parliamentary maneuvers that resulted in the passage of legislation concerning BDs and journaux illustrées after years of near fruitless effort. However, like many descriptions of the legislative process, it leaves much to the side and slides past what was lost in making this "bel exemple" of lawmaking possible.

While other commentators in the press kept the supposed link between "unhealthy" hebdomadaires and juvenile crime ever-present in the minds of the French populace, Jean Polbernar, writing in *Ce Soir* just as the CIED was beginning to meet, dared to ask his readers if any such law would be effective. "One can doubt it" was his own answer; its "strict application would compromise too many powerful interests." His focus quickly turned to Winkler's Opera Mundi, which he predicted would be able to turn aside any real difficulties and secure allies and "defenders in official circles."[87] Whether it was the hunch of a well-practiced journalist or not, Polbernar proved more correct in his prediction than even he might have likely imagined. Two days before his article appeared in *Ce Soir*, representatives of both Opera Mundi and the Hearst publishing empire had already contacted the U.S. Embassy in Paris expressing their concerns over the proposed legislation on children's publications.[88] As the outlines of the proposed legislation became clear to interested American parties, Paul Winkler, having returned to Paris and attempting to relaunch the *Journal de Mickey*, along with others, actively beseeched American authorities in the country to intervene on their behalf.

Of principle concern to Winkler were Articles 2 and 12 of Bill no. 5305, as the former seemed obviously directed at what was often presumed by the French press to be the aesthetic concerns of American BDs while the latter would have simply made it impossible to publish his journals as they had appeared prior to the war. In his contact with embassy officials he assured them that Opera Mundi publications and "American comics in general, were of the highest moral character." While he and others stressed that the 25 percent limit on foreign content in the journaux was patently political and anti-

American "because foreign material from any other country . . . was negligible." Further, given the renegotiation of the Blum-Byrnes accords concerning film along lines more favorable to the French, similar strictures on American print media were reasonably presumed the next likely target.[89]

Before Gosset took control of the National Assembly's Press Commission, its president was Colonel Félix, a free-market and pro-American deputy. It seems also that he was the source of much of Winkler's, and others', information concerning both the drafts of the proposed legislation and its status within the Assembly.[90] Following information provided them by an "informant" in the Council of the Republic, the American ambassador, David Bruce, "filed an official 'verbal note' of protest" with the French minister of foreign affairs, Maurice Schumann. In it Bruce insisted that Article 12 of the proposed legislation was redundant given Article 2 which would regulate publications intended for children on the basis of their (im)moral content; moreover, it was also likely a "breach of the 1947 Geneva agreement concerning trade and informational exchange."[91] Marie had already taken the floor of the Assembly and warned of the possibility of economic reprisals against French products in the United States and soon after receiving the American ambassador's "protest," Schumann wrote the minister of justice demanding the removal of the article.[92]

The bill went forward, now without the restrictive article; Winkler's informant in the French Upper House had been correct in believing that the Assembly would not risk its majority over the issue. However, for those who recognized Winkler's hand in the whole process, debate grew ever more acrimonious as the issue, and Winkler himself, became a lodestone for criticism of U.S. influence in the French government. In the National Assembly much of it was loudly lead by the Communist deputy André Pierrard, who insisted that when one examined the organization of "the children's press in our country" nearly all roads "lead to Opera Mundi and to Mr. Winkler." Winkler, according to the Communist deputy, was the worst sort of capitalist who greedily profited from the corruption and demoralization of France's youth by way of the "great press of America, the Hearst press, instrument of the powerful financiers of the United States."[93]

His critiques continued, first, along very explicitly economic lines: Winkler, "who has operated in France for many years, is a specialist in dumping." His own "powerful hebdomadaire for children is 100% American . . . [b]ut Mr. Winkler resells to other publications, via his agency, huge quantities of planches and flans coming from America." The BDs that Winkler was reselling to other editors had already been published in North America. Consequently,

their production cost was "entirely amortized" so the "French editor" who makes use of Winkler's products "obtains it at a very low cost compared to that of his fellow publishers who use the services of French draftsmen and authors." The difference in production costs were immense; "without Mr. Winkler, a truly French and independent production, a healthy production instead of an unhealthy [one] of American comics, costs, for the same weekly edition, one million francs" versus the 200,000 to 300,000 franc cost of one reliant principally on syndicated BDs.[94]

Pierrard's larding of his specifically economic critiques with terms like "unhealthy" as it regarded American BDs tipped over into his explanation as to why the restrictive article was needed not simply for market-forces reasons. "All the unhealthy publications directed at our children come from America," he insisted, to applause from the (extreme) leftist deputies in the Assembly, "and exclusively America." Even considering the current dearth of journaux either originating, or derived, from American BDs, particularly in comparison to the mid-1930s, by Pierrard's estimate the French presse enfantine market was then proportionally at least "80 percent American." He went on to list a number of journaux that were 100 percent American in origin or derivation (*Tarzan, Donald*, and *Zorro*), and complained that even *Coq Hardi* regularly contained up to twelve pages of material that was likewise 100 percent American. Only *Vaillant*, the Communist deputy asserted, was completely French.[95] And for Pierrard, it was here where the real problem lay:

> This proliferation sets the tone across the entire children's press. It fosters questionable tastes among its clientéle. It imposes little by little the American formula that consists of many "cartoons," drawings and little text. Thus, the French journaux which try to fight are forced to reduce their written parts, i.e., ultimately, their educational part, at the same time as this invasion from the other side of the Atlantic brings unemployment to French draftsmen and authors.

Article 2 of the proposed law, he asserted, was indeed important. However, in itself, it was inadequate in protecting the sensibilities and morality of French youth, for with only a few small adjustments "Mr. Winkler" would be able to circumvent its intent. By its provisions Article 2 "will insist . . . that at the end of the [BD] the killer is punished and the gangster put behind bars, of course before his escape in the next episode!" "Throughout the story," he continued, "the methods of robbers and assassins will have been put on display,

with the precision of admiring experts, and, in spite of the provisions of your article 2, the exploits of the underworld will still populate the daydreams of our youth."[96]

While the record of the Assembly debate indicates at least murmuring support across the political divide for Pierrard's arguments, the MRP deputy Pierre Dominjon and the minister of justice, Marie, ultimately quieted the floor regarding Article 12. The issue, they both conceded, was loaded with more concerns than even Pierrard had raised; but they were also more complex than he allowed. Indeed, the spirit and even common sense that directed his ire was laudable; however, there were unavoidable questions of international trade that had to be considered as well as simply the freedom of the press, an issue that should cut to the heart of every honest Frenchman. In the end, Marie insisted, the Assembly had to restrict itself to legislation directed at protecting public health and the reduction of juvenile crime while the government had requested a vote on the proposal as it was then constructed.[97] This effectively ended debate on Article 12, generally an already decided issue anyway. However, a small group of socialist deputies more successfully pushed an amendment to Article 2 that would add the words "hatred" (la haine) and "cowardice" (la lâcheté) to the list of "things" or characteristics that would warrant the censure of a publication. As both the vice president of the CIED and the minister of justice, Marie initially resisted the addition of the terms to the article because neither cowardice nor hatred were crimes or recognized offenses. However, Solange Lamblin defended both the spirit in which the terms were suggested and the words themselves by referencing the ugly history of Europe no more than a decade old:

> I believed, when making this proposal, that in a country with a tradition of humanity and justice like ours, it explained and defended itself. While asking to include in the text the words "la haine," I do not [ask to] create a special case [or new offense]. Hatred is a very diffuse sentiment which colors the stories and tone of a publication so that it is impossible, in my estimation, to put it before the eyes of children. I would like to recall to the whole Parliament that it was while making an education of hatred, line by line, page by page, among the children of Germany and Italy, that one prepared for the advent of totalitarian régimes and the monstrosities they brought to be. This is why I ask that the attention of censures be attracted to the tone of publications as well, so that they do not offer to children the spectacle of violence.[98]

Drawing applause from the entire Assembly with this rhetorical point, and with Marie's acquiescence on the matter, what were quickly named the Bardoux and Cayeux amendment, after the two deputies who first proposed it, and the Lamblin amendment, were both adopted by the Assembly, the commission, and the government.[99] This was to be the only victory of those who wanted a legal hold and brake on the content of the children's press. The bill, with an amended Article 2 but without the trade restricting Article 12, went to a full vote in the beginning of July 1949 and passed, with the Communists—who had been instrumental in both crafting the proposal and getting it to the floor—actively voting against what they now considered to be a watered-down and useless piece of legislation.

On July 4, *Ce Soir* made special note of the actions of the Communists in the Assembly—particularly René Thuillier, who insisted the bill was the work of Winkler and his supporters—and reported that the vote was 402 for the bill and 181 voting against.[100] Five days later, on July 9, André Pierrard continued his tirade against both the legislation and the American press in the pages of *Humanité*. The new law, he insisted, would allow, "without contestation," "comics" intended for adults in the United States to be consumed by the youth of France, "contaminating the hearts of children and juveniles." Those who voted in the affirmative for the law "cannot claim to have cleansed children's publications."[101]

The sentiment of those on the political right was generally more optimistic in its tone. There was some concern that the new 16 July Law did not have sharper censoring teeth, recognizing that the "commission charged with oversight and control" was "in principle" more "consultative" than controlling. However, the broad make-up of the commission was of benefit in that it would "concretize the action of family associations, youth movements, Child Protection Organizations, the Juvenile Courts, and it will spur on the authorities." Moreover, though the commission was not truly a regulatory body, the public authority it wielded would ensure that "Ministers for Information and the Interior will be morally responsible before it."[102] Whether there were hurt political feelings on the left, or some on the right made more out of the "public authority" of the law's resultant commission than ultimately was there, the French state had—with its passage—positioned itself as the mediator of debates concerning a renewed national culture. And given that its locus was on the nation's youth—the purported and inescapable future of the country, as well as concerns with issues of Americanization and cultural competition, the 16 July Law allowed the Fourth Republic to place itself at the heart of an

increasingly important discourse of modernity as well. This was the case, even if many of the terms of this discourse were borrowed from the *neo*-conservative lexicon that had emerged from a twining of the discursive logics of the left and right that had been at work since the mid-1930s, a point made clear from an examination of the actual work of the law's commission.

The Commission at Work

*Saying "Non" to Microcephalic Hercules and
Determining What Makes for a Good French BD*

Exaggeration is the inseparable companion of greatness.

—Voltaire

The first task of the new commission, according to Jacqueline Meinrath writing in *Éducateurs* in the fall of 1949, would be to act wisely and moderately; "to attack . . . big scandals where it will find the most support, not only from 'specialists' in child development, but across the country." By doing this, "it will . . . gradually pull children" away from those exerting an undue "influence" over them, "not because they have a message to bring to [the nation's youth], but because [children] are a good bargain commercially." The task of those outside the government, but possessed of the necessary tools, was to not let the moment pass into history. Obviously, the country's newspapers devoted space to the issue when the law was first passed, but that was not enough; "each church, each teacher, every family association must devote several study meetings to it." They must bring not only offensive material to the attention of the commission but also point to educative examples of the presse enfantine as they were often easily lost and "choked by Zorros, Tarzans, and others."[1]

There was, nonetheless, one final attempt at amending and strengthening the law in 1950. On March 23, the Communist deputy Fernand Grenier presented the essential details of the Deixonne Proposition, named for one of the four socialist deputies who collaborated in its crafting, as well as the

Communist effort directed by Thuillier and Pierrard, Propositions of Law, nos. 7744 and 7796, respectively.[2] Grenier's summary of the two propositions demonstrated that in detail they both relied on figures and arguments similar to that already expressed in debate on the Assembly floor. Again, concern over the economic advantage that journals reliant principally on syndicated material had over those that made use of the work of French draftsmen and authors was made the crux of the issue. The situation being so dire that it was now possible to imagine a journal composed entirely of foreign images and stories, and it would be astonishing if the result were not a "devastating [level of] unemployment" being "pressed on our writers and draftsmen."[3] In what seems to have been a certain mock surprise, both proposals referred to a partial history of the debate that had surrounded the issue of limiting foreign material, noting that the vast majority of those in the government had been in favor of such regulations before they "reversed themselves at the last minute." If the reasons for the reversals, as the *JO* record seemed to indicate, were that the first proposals had been too broad, potentially circumscribing the rights of the press more than was their intent, the Deixonne proposal specifically limited itself to "periodicals intended for youth," while the Thuillier project defined its target as "hebdomadaires and illustrated albums intended for youth." Both would restrict foreign BDs and planches to no more than 25 percent of the total surface of any publication that fell into those categories, reserving the other 75 percent for demonstrably *French* material. At a moment in the nation's history, Grenier's summary insisted, when it had become a matter of "national interest" for publishers to continue their "meritorious" efforts at improving the quality of journaux des enfants, it would be at least "equitable" for the National Assembly to adopt these or similar measures.[4]

Once again, the Deixonne proposal particularly met with considerable support in the Assembly and, with the backing of the PCF, it was likely to pass in vote; once again, Winkler moved to have it stopped and received support from the "Council of the Republic, the American Embassy, and private groups." By inferring the origins of the proposal from the support it received from the Communists, Winkler was able to cajole J. Lovestone, head of the American Federation of Labor, into intervening "on his behalf with Léon Blum. 'The Socialist group of the French Assembly,' he explained, 'seems to be maneuvered, undoubtedly without its leaders being aware of it, by Communist interests.'" Meanwhile, the American Embassy reiterated it's "verbal note"

to the minister of foreign affairs and, like Article 12 of the 16 July Law previously, the Deixonne proposal "was rejected by the Council of the Republic."[5]

Still, by the time of the Assembly's consideration of the Deixonne proposal, the Commission for the Oversight and Control of Publications intended for Children and Adolescents (hereafter, Oversight Commission)—established by Article 3 of the 16 July Law—had already begun meeting and determining its direction and course. In many ways, the Oversight Commission occupied an amorphous position within the government. Not technically capable of banning or directly censoring a publication itself, it was supposed to serve as something of an intermediary filter between the juvenile press and its young "clientele." This was to be accomplished by way of the Oversight Commission's two principle tasks: identifying and preventing the sale of adult publications, like pornography, to minors under the age of eighteen; and improving the quality and content of publications intended for children. The first task seemed reasonably easy and straightforward to most members of the Oversight Commission; the second, like the commission's own place in the government, was far more ambiguous—though, it seems, generally directed at the many available journaux illustrés.

By the 16 July Law, the Oversight Commission itself drew its twenty-eight members from representatives from the Ministries of the Interior, Justice, the Press, Public Health and Population, Youth, and National Education, as well as representatives from youth organizations, family interest groups, local magistrates, and members of the press itself; and finally, and perhaps symbolically standing in for all the parents of France, a mother and father. Predictably, many of its first members were the same people who had been central in the debates surrounding the presse enfantine, both in and outside the government, for at least the years immediately after the war. Among the most notable were deputies Lamblin—who had successfully pushed the amendments to Article 2 of the 16 July Law—and Dominjon—who, with Minister of Justice Marie, had ended debate over Article 12 on the Assembly floor. It also included Jean-Louis Costa, director of "supervised education" in the Ministry of Justice; the vice president of the juvenile court, Michel Le Bourdelles; and Abbé Jean Pihan, head of the Catholic journaux illustrés *Coeurs vaillants* and *Ames vaillantes*; Madeleine Bellet, by then editor of the Communist *Vaillant* and head of the youth movement "Vaillant et Vaillantes;" Jean Chapelle, an independent Lyonnaise editor; Alain Saint-Ogan, "father" of the modern BD in France, former editor of the Vichy-era journal *Benjamin*, and head of the draftsmen's

union. There was also at least one interesting "substitute" serving on the commission; when Saint-Ogan was unavailable, his proxy was the creator of the notorious WWII BD "Journey to Unknown Worlds" (published in the Nazi-inspired journaux *Le Téméraire*), Auguste Liquois.[6]

The breadth of voices and concerns that seems in evidence by the catholic membership of the Oversight Committee was also apparent in the mission that it set for itself. When opening its first meeting on March 2, 1950, René Mayer, Keeper of the Seals, forcefully tied the purpose of the Oversight Commission to that of the rest of the government and the whole of the nation. Recounting the effect that a decade of war, deprivation, and simply the fracturing of society had wrought on the country's children—most obviously demonstrated by the persistent and growing problem of juvenile delinquency—he insisted that it had to take the lead in the creation of a healthy general culture. Beyond all other tasks, its focus was to be on "public welfare, which now turns to the interests of youth. You must help youth find the inspiration that will assure its fidelity to the ideals of a national and republican tradition."[7] In other words, it must work to ensure that the nation's children remained *truly French*.

However, at least initially, the forging of a single voice from the many interests and perspectives that the broadly constructed Oversight Commission brought with it—the expressed hope of Meinrath in the pages of *Éducateurs*—was not quick in coming; a problem clearly expressed by an exchange during a meeting late in its first year of existence between Lamblin and Saint-Ogan. Lamblin renewed the old concern over the literacy-dumbing effects of BDs by noting "the danger of the absence of text, replaced by the process of using balloons." Saint-Ogan, the first French author and draftsman to rely exclusively on the "balloon" to direct the narrative of a BD, found it necessary to defend "this modern technique," insisting that it "compared [favorably] with dramatic dialogue" in any other medium.[8]

It was the Lyonnaise publisher Chapelle who ultimately provided the Oversight Commission with some needed advice and perspective that reached beyond the hyperbolic or ideological and simply impractical. Writing to the body in mid-October 1950 Chapelle offered his own "observations" on what had occurred in the meetings of the Oversight Commission from March to October. In particular, his focus rested on a July 15 report delivered by the executive committee of the Oversight Commission entitled "Thèmes généraux inspirant des représentations et des recommandations aux éditeurs de journaux pour enfants." He had read the report with "sharp interest," and insisted that he shared "the ideas detailed by the author, but its philosophical analysis,

while of high inspiration, would be without much real range if it were to be used as the basis, as was certainly the author's intention, for the development of a series of practical recommendations."[9] Because of that, before he offered his own proposal of action for the Oversight Commission, as a working "commercial" publisher he felt it necessary first to "answer criticisms" and "to paint as accurate as possible a picture of [existent] realities."

It was first necessary to stop "measuring" all publications by the same criteria. "One cannot," for example, "require of commercial journals the same . . . moral, social, or educational" responsibilities of "journals sponsored by religious organizations, scholastic or political, whose means of diffusion enable them to impose their ideals." A journal wholly dependent on the market for its survival, after all, must place entertainment before all else if it is to be a success. This alone might be enough to excuse the "relative mediocrity" of much of the "commercial press" and, unless the Oversight Commission was prepared to chance putting all such publishers and editors out of work, it would do well to admit, and allow, the requirement to entertain. As a final cautionary note on this point, and reminiscent of the admonitions of both Paul Hazard and Henry Coston before him, Chapelle warned that if they were to push too hard with the educative mission of the presse enfantine, foregoing the need to entertain, children would ultimately retreat to reading publications intended for adults. "The remedy," he warned, "would be worse than the illness."[10]

As to the shoddy appearance of many examples of the commercial press, members of the commission would also do well to keep in mind the impact of the recent paper rationing. "French publishers" were not well treated, he wrote (presumably from experience), when it came to the "quality of inks and particularly the paper that is provided for them: they do not have a choice, the quality of their paper is imposed" on them by the government. This brought him to the final rasher of concerns that he believed those outside of the "commercial press" had to recognize. "Then there is the long-lived legend . . ." Chapelle wrote, "that the presse enfantine of the previous era was better than that of today: that is incorrect." According to the Lyonnaise publisher, the Oversight Commission members would do well to remember that the presse enfantine has had its critics for almost as long as it has been in existence. Nor were the stories proffered to children of bygone eras necessarily of higher quality in terms of the content of the tales told in their pages. One would have to look neither hard nor long to find adventure stories of children laying traps for their parents, pushing nails in the tires of automobiles, aiming various weapons at

the heads of respectable people, planting matches at the feet of their fellow citizens, "in short to obligingly expose a thousand ill deeds." The situation was such that, if this sort of reading material was the sole—or even primary— source of dangerous behavior in children, that he would expect "parents to predict their children's death on the scaffold if they continued reading similar illustrés." And yet, insisted Chapelle, "the majority of these children became conscientious citizens and not gangsters or criminals." Finally, those who would criticize the sometimes prominent place villains and gangsters have in many of the journaux illustrés would do well to remember that if "there is a hero, there is a villain, if not there is no more story."[11]

He would cap his *concerns of an actual publisher*, as the first half of his report might well have been subtitled, by noting the futility of criticizing the "current formula" of the BD. Children's journals "exist in their current form, and will continue to exist, because they answer the tastes of children in 1950 . . . accustomed as they are to cinema, to television, the rhythm of modern life. One can deplore it, but to resist this fashion, is to thrash against the current." Ultimately, Chapelle blandly pointed out, "the causes of bad behavior from young people are . . . more profound than merely the reading of magazines."[12] However, none of this was meant to infer that the presse enfantine should not be held to standards and kept to certain tasks. To this end, but only after having addressed all the practical concerns of the "commercial press" for the members of the Oversight Commission, he put forward his own "*Projet de Recommandations* aux Editeurs de publications pour Enfants."

His recommendations covered what he saw as the four principle parts of the modern BD: the story, the hero and villain, and the actual text. Taking each part in that order, Chapelle's report would insist that stories, "while making art of dreams, the fantastic and adventure," must "avoid the unexplained, improbabilities, and the mysterious." They had to, above all, "REMAIN LOGI-CAL." Not even a happy ending should be achieved without "effort, without work, without intelligence" and they must "avoid the abusive use of force . . . intelligence and ruse must triumph more often than brutality." Action should not be limited to only the struggle between two parties, "heros and rascals," a "larger part" of the story must include "labor, for the search of an ideal, the fight against the elements." And, finally, storylines should "avoid scenes of horror, torture, and blood; hideous, monstrous or deformed characters." Situations where the interactions "between men and women" could lead to "ambiguities" concerning their relationship and simply women with "provocative attitudes" were likewise to be avoided.

The hero of the story "should never commit a reprehensible act, should never kill" and he must always be "honest even with dishonest adversaries." He must also be "chivalrous with wounded adversaries or those unable to defend themselves" and he "should never take summary justice" and instead always "deliver culprits to the authorities." It should also go without saying that he always helps and defends the "weak" and "oppressed" and tries to set a "good example" and "counsels" those "who stray from the correct path" while availing himself "more readily to his intelligence than force." The villain, without whom there would be no story, must still never be "presented in a favorable light," nor should his actions be of so much interest that "the action and the story is likely to be carried by them." Finally, for the appearance of any BD, Chapelle's recommendations took the tone of Marion's Vichy-era directive, insisting that any text must be "well composed" and "caligraphied," in proper French "without [grammatical] fault or spelling errors" and, while the balloon was a modern necessity of the medium, whenever possible it must be "preceded or followed . . . by explanatory or descriptive text in order to give the child practice reading." He stopped short of insisting on a limit, or minimum of textual information, but insisted that a certain minimum and maximum level could be maintained on a case-by-case basis.[13]

It seems that Chapelle's reports were well received by the members of the Oversight Commission as, nearly word for word, his recommendations were adopted for its own "Recommandations élémentaires aux éditeurs" as they appeared in the official *Compte Rendu* of the commission's work in 1950, though its own "recommandations" went further in suggesting that publishers also avoid "shrill colors."[14] To carry out their work, the members of the Oversight Commission spent many of their meetings building their recommendations from the review of periodicals that all publishers were obligated, by law, to submit for holding in the commission's archive. In its first year, 42 publications were identified by it as restricted for adult consumption only and they reviewed 127 examples of the presse enfantine: 29 hebdomadaires, 20 bimonthlies, 78 monthlies or "irrégulières." The "classification" work of the Oversight Commission generally began with the designation of a publication as being of one of seven principal genres, themselves viewed as being discreet categories, though capable of "combining with" each other in their narratives. For example, the first genre, *policier*, typically had as its "heroes . . . a detective, a reporter, a film-maker, an aviator, a counter-espionnage agent, or even a child." No matter the hero, however, it was an "extremely widespread genre" and framed "all fights against robbers, bandits, or spies." It also, often combined with genres two, four, and six, *L'aventure*, *Le Western*, and *La*

guerre, respectively. The remaining genres (three, *Le Surhomme*; five, *Le récit historique*; seven, *Les séries enfantines proprement dites*) were described in an equally self-explanatory manner and were often, save perhaps for the last, just as malleable.[15]

After review of a publication, the Oversight Commission issued a report of its findings to the relevant ministries and the publisher of the journal, broken down along four classifications: praise for the educative worth and moral character of the journal; recommendations for general improvement; a warning to modify or improve the journal's quality (this could be in terms of appearance or content); and, finally, an official warning that extensive changes be made to the journal (or individual BD), publication of the offending journal be halted, and/or threats of prosecution under Article 2 of the 16 July Law. Generally, any publisher who received either of the former two reports was allowed a three-month window in which to bring their publication into compliance with the Oversight Commission's guidelines and was required to meet with the body to discuss the offenses as well as their plan for compliance with the law.[16]

The Oversight Commission archives regrettably do not contain many examples of these reports; however, there is at least one working report compiled and authored by Cotxet de Andreis, a member of the Oversight Commission as well as a prominent *juge des enfants* attached to the Seine Court. At issue was the classification of a journal published by the Paris-based house Éditions Mondiales titled *Bolero*.[17] As much as anything else, it seems that the journal's subtitle "le Journal pour tous" was the entry point of consideration for Andreis. "Is it really addressed to ALL readers," he asked in the beginning of his report, "or can it be regarded as mainly intended for children and teenagers according to the provisions of article 1 of the law of 16 July 1949? Such is the question which the Commission will have to decide."[18] In fact, it is Andreis's engagement with this question that makes his report so interesting as it revealed the machinations of, and assumptions held by, the Oversight Commission as it moved through its review of publications. After offering his understanding of the articles of the regulatory law, he determined that it was written in such a manner that the legislators "intended to fix at 18 years the limit of Adolescence . . . and . . . Youth" and that the legislation had not fixed "distinctive features of publications intended for Youth," meaning the "criteria rested on the presentation, character, and the object of the publication."[19] Consequently, the Oversight Commission should adopt certain terms as the basis of its own judgments. For instance, a "periodic publication intended

mainly for youth is characterized initially by its presentation." "On the cover: an image with sharp colors, representing a character or an animal, generally moving, more or less imaginary or fabulous, often mysterious . . . far from reality. Inside the publication: similarly decorated designs, contests, riddles, and games." Beyond the general presentation of the periodical, one intended for children also must be concerned with "adapting to the mental age of the child or teenager: no abstract ideas, but with subjects which, flattering the innate taste of the child for adventure, the plot, relies more on [the child's] sensitivity and [his/her] imagination than [their] reasoning." Finally, according to Andreis, "the object—here synonymous with the goal—consists in attracting the business of young people by proposing an educational or simply entertaining ensemble which satisfies their tastes."[20]

Given these parameters Andreis's report once again turned to the question of whether *Bolero* was truly a journal for all people: is it fit for, and even primarily directed at, children and adolescents under the age of eighteen? Here, he proffered two separate conceptions as to how to best view or understand the publication. The first intended to demonstrate how *Bolero* was designed for adolescents under the age of eighteen. Examining the cover illustrations of the first few issues of the hebdomadaire, he made note of the colorful illustrations that "correspond perfectly with the traditional presentation of journaux d'enfants." To demonstrate what he meant he cited a "cow-boy" in an "arresting costume," "indians aiming arrows at explorers," and a "horse neighing and bucking after throwing its rider." Themes hinted at by the cover illustrations were continued in the journal itself with tales of friendship between an Indian and a "young white orphan," all of which fit the "taste of a boy from 15 to 18." Thankfully, he added, the "scenes of violence (revolvers and arrows)" were buffeted by "acts of devotion," though "likely" of "allure [only to] young people" and of "interest [only] to them." Finally, an advertisement for the journal appeared in the pages of the journal *Tarzan*, "proving . . . that the editors of *Bolero*—Journal for all—believed that the new publication would be accepted by adolescents."[21]

Regrettably for Éditions Mondiales, his second "thesis" was a demonstration of why the journal was (also) apparently intended for those aged eighteen and above. There were, he noted, first no contests or games designed for children. Secondly, the technical articles he surveyed (on radar, African wildlife, and the Canadian Mounted Police) were obviously of interest only to older teenagers. Several of the stories/BDs—"The Island With No Name" and "Revenge of the Thugs" were two that he named—would obviously appeal

more to the older readers of *Confidences* (a popular true-crime and salacious story journal) than typical "readers of 'Tin Tin.'" Andreis would make several more references to additional "mature" illustrated stories, with particular emphasis on their heightened level of violence, scenes of banditry, "modern holdups," and "certain attitudes more or less lascivious" that "the Commission usually condemns." He ends by returning to the question as to which thesis— was it a journal for young adolescents or not—"to adopt?" For the juvenile court judge, it was a matter of appearance: "*Bolero* borrows the presentation of a publication *typically enfantine.*"[22] It was, in fact, just that which made the publication all the more dangerous. *Bolero* relied upon the appearance of a traditional children's journal while providing that particular audience a terrible example. For this reason, Andreis recommended that the Oversight Commission place *Bolero* "en demeure," or serve notice to Édition Mondiales that changes were necessary for the journal to continue to be sold as a publication intended primarily for children—the second strongest recommendation the Oversight Commission could levy.

The editors of *Bolero* had a choice, Andreis insisted: they could either remove the offending illustrated stories and "remain in the framework of a healthy publication enfantine, or, if they prefer to preserve the current character of their hebdomadaire, they will be constrained to modify its presentation completely." This particular publication was likely not the worst offender according to the judge; however, the sort of parsing that he had done in the report of his review of the journal was precisely the task of the Oversight Commission. If the members of the commission were seen as being "too liberal" in their "tolerance" of suspect publications, it would "discourage the publishers who give themselves willingly to the work of cleansing the presse des Jeunes."[23] As soft as a term like "healthy" might seem as an analytical lever for determining the worth of a publication, the members of the Oversight Commission had a clear understanding, themselves, of what would constitute just such an example of the presse enfantine.

Over the course of the commission's first year of existence, the reports and "observations" of members like Chapelle and Andreis crystallized into twenty-three "general considerations" of the current state of the journaux des enfants, the effect of journaux illustrés "on children's spirits" and what was expected from a "healthy" presse enfantine. Indeed, topping their litany of concerns was precisely the need to differentiate that which should be classified as adult rather than juvenile literature, just as Andreis had insisted on in his review of *Bolero*. "A segment of the presse enfantine," the commission

members insisted, "with its intrigues woven from perfidy, cruelty, and a lack of morals, puts forward a tableau of existence associated with 'noire' literature. The success of this literary genre among certain adults does not allow for its imposition on children." The effect of this was to create an overwhelming sense of "pessimism" among the nation's youth while the task of the presse enfantine, whether it be "educational" or merely of the "entertaining" variety, was to foster "a certain optimism which must be necessarily regarded as vital," even if some small "share of illusion" was allowed to creep into the journal's pages. It was "intolerable" that children were so often being sold a notion that the whole of existence was "consumed" by a struggle "to thwart criminals, overcome extreme perils, to rectify abominable wrongs, unceasingly fight against lies, iniquity and selfishness, without ever encountering truth and justice." To put it bluntly, the "somber colors" of the noire genre must never "darken the pages of publications enfantine. It is necessary that they inspire the primordial needs of the young heart, which yearns and hopes."

As the Oversight Commission understood it, the careful filtering and guarding of content of journaux illustrés was made all the more necessary by virtue of the nature of the modern BD as a medium of expression. An "irresistible suggestion" was "formed in the child's mind by the [intermarriage] of text and image, it [becomes] an obsession created by [garish] display and repetition." If it was impossible to do away with the popular format, it must then be carefully directed. The routine and "interchangeable" illustrated scenarios that were moved by "hate" and "greed" offered a "wrongly simplified and deformed" representation of human life that denied the place of "sympathy . . . generosity, sacrifice, fidelity," as part of the full human experience. When hatred is "called upon" as the "only engine" of action, "one thusly carries out an inversion which substitutes the moral for the immoral, or amoral."[24]

Indeed, in the view of most members of the commission, it seemed that too often the complexity of the human condition was ignored in the pages of most journaux illustrés as the "emotional atrophy of the characters" was matched only by an accompanying and "equal intellectual atrophy." They moved either as "automatons" or by "reflexes and uncontrolled impulse." The hero "springs" into pursuit of the "gangster" by way of the same "psychic mechanism" that "launches a dog after game." What little text there might be does "nothing but underline [the action]; it can not express a psychology that is non-existent" and often seems to be "used only to prevent confusion between the characters." The blurring of the distinction between right and wrong, good and evil, which occurred as a result imperiled the moral sensibilities and balance of

the nation's youth. These sorts of publications, the members of the Oversight Commission insisted, denied "human dignity" and brushed away "respect for human life" while conditioning readers "to accept human massacre as a normal incident of any endeavor."[25]

Given how few years the members of the Oversight Commission were removed from the ugly history of WWII on both France and the whole of the European continent, their heated concerns on this point in particular are understandable.[26] Nonetheless, their litany did not end with a simple articulation on the level of blurry brutality in many journaux illustrés. Rather, they also made issue of the "phantasmagoric accounts" in many of the BDs that left all "plausibility" behind, drawing young readers into an "absolutely false universe." Where Jules Verne, for instance, had "anticipated the development of science only by extending some [then] current developments, the imagination of the authors of children's literature too often was entirely free of concern regarding scientific data and deliberately improvises" what they require for their fantastic stories. This ultimately leaves young readers without the "minimum of scientific understanding" necessary to "enable" them to "distinguish between certainty and assumption, recent discovery and whimsical conjecture." "Under these conditions," the Oversight Commission continued, "the readers are inclined to ignore serious scientific teaching that will appear to them passé and out of date." The great irony of this "modern" medium would then be to leave its readers incapable of actually engaging with the everyday realities of modern life. Finally, just as the distinction between right and wrong was blurred by far too many examples in the pages of far too many journaux illustrés, traditional gender roles and relations between the sexes were also being imperiled. Too often, in the presse enfantine, women and girls were stripped of the "dignity of a fully developed human personality"; instead, the commission insisted, they must always be "treated as a subject and never like an object." In this, commission members conceded that the presse enfantine was only part of a general milieu that included the broader "informative press, posters, and cinema," which "saturated daily life with an eroticism . . . likely to exert a deplorable influence on children during puberty." However, "female characters" in journaux illustrés were too often "allotted" an "exaggerated 'sex appeal,'" and given the prevalence of the medium among the nation's youth they represented a particular threat to balanced physical and social development during their most formative years.[27]

There is likely little doubt that the experiences of WWII added a new sense of urgency to the entire issue of the influence of journaux illustrés on children. Indeed, some of the most vitriolic attacks on the medium levied the

charge that it was the heightened vulgarity and brutality that began appearing in their pages in the years prior to the war that made possible, if not palatable, the nation's collapse in 1940 and the succeeding years of Occupation and collaboration.[28] However, even this critique falls back on a continuation of much of the language and many of the concerns expressed during the 1930s.[29] Consequently, the work of the Oversight Commission should be recognized as the final evidence of the institutionalization of the public debates and entreaties of Sadoul, Grosse, and those sympathetic to them, on the nature of a "true France" in the decade before the war rather than simply a reaction to it in the years immediately after.[30]

Frankly, given the lack of any real repressive or censoring powers, the influence the Oversight Commission exerted over the presse enfantine in its first decade of existence would be difficult to explain if the slow coalescing of a broad consensus of opinion among a wide swath of politicians, intellectuals, and experts of all political stripes was not considered. The moral authority that Meinrath had hoped the body would hold over government ministers was likely better expressed in the generally one-sided dialogue the Oversight Commission engaged in with the publishers of the presse enfantine. In 1950, its first year of existence, the Oversight Commission issued reports with sixteen warnings and thirty-five sanctions that targeted fifty-one publications—more than a third of all those it reviewed that year—as being in violation of the new law. Additionally, they met with twenty-nine different editors (several of which, like those from Éditions Mondiales with more than one publication subject to sanction). Nor were either the warning reports or meetings with editors mere broadsides with little effect. By the end of the same year, twenty-nine publications had ceased appearing in the nation's kiosques, seven had been suspended from publication, and several others (including *Bolero*) were in the process of making the improvements necessary to pass the Oversight Commission's muster on subsequent review.[31]

Perhaps, when addressing the influence of the Oversight Commission in the first decade of its existence, the most important example comes obliquely rather than from a straightforward examination of the many journaux it reviewed. In disputing Ory's contention that BDs in France were an example of "désaméricanisation," McKenzie pointed to the strong return of *Le Journal de Mickey* on June 1, 1952. Within two years, the journal from Winkler's Opera Mundi (renamed Edi-Monde after the war), that Communist deputy Pierrard called a "powerful hebdomadaire" on the Assembly floor three years earlier, was selling more than six hundred thousand issues weekly. Handily eclipsing even its prewar circulation and once again placing it among the most popular

journals of the 1950s; and "hardly," according to McKenzie, "an indication of an aesthetic preference among consumers for French publications."[32] Even Crépin, whose analysis of BDs in the postwar period generally follows the parameters sketched out by Ory, allowed for the renewed success of Winkler's flagship journal. Nonetheless, his analysis continued to insist on an end to "American hegemony" in the presse enfantine while also insisting that this was the result of a growing preference for new graphic innovations in BDs among the French public, which Belgian publishers were often more responsive to, rather than the "effects of the 1949 law."[33]

As concerned as both are with overt American influence in the medium their analysis would seem to give short shrift to the influence of the Oversight Commission on this most American example of the medium. Winkler had been attempting to get authorization to begin printing the *Journal de Mickey* since 1948, and when it finally appeared in mid-1952 it had a new format, and smaller size, that was obviously in response to the pressure exerted on the presse enfantine by the work of the commission. Indeed, the journal already had something of a "tradition" of adaptation to concerns in the market. It has even been argued that the success of the *Journal de Mickey* in the (early) 1930s was nearly in spite of the BDs that appeared in its pages. In many instances, the American imports would have been "recognised linguistically" by young readers, given the skilled translations, "but the social satire would largely be as foreign as the cars [often] portrayed." According to Grove, the journal "broke new ground precisely because it was hybrid, it was Le Journal and not just Mickey." "The new techniques and prominence of the BD's provided the initial attraction," he continued, "but their success depended upon the surrounding journal that contextualised the stories for a French audience."[34]

This analysis seems shaded a bit too far to the side of the counterintuitive, and likely underestimates the importance of the novelty of both the (still fairly new at the time) medium and, perhaps even, Mickey's own American provenance. However, Grove was correct in noting that over the course of the 1930s the journal was adapted and better fitted to its French audience. For instance, the advice and information feature "Onc' Leon" (that addressed all the journal's readers as "mes chère nièces, mes chers neveux") appeared precisely because of sharpening laments over the loss of text in, and calls for an educative bent to popular journals in both the general and specialized press. This adaptive tradition would continue into the 1940s and the years of Occupation, even as the namesake BD character was forced from it pages, until it was finally banned from publishing in 1944.

Winkler was nothing if not a savvy businessman and his entire publishing career in France stood as evidence that he was sensitive to prevailing political winds. If the four years it took to secure a renewed publication authorization for his premier journal frustrated him, his intimate knowledge of the limits of the 16 July Law put him in good position for, once again, adapting to what was required to remain clear of any violations that the Oversight Commission might otherwise like to declare. The new, 1950s, *Journal de Mickey* was sixteen pages in length and strategically alternated between pages of colored BDs and (color-dappled) black-and-white text, and it was preceded by an official statement from Edi-Monde that insisted the hebdomadaire would "not imperil the educational efforts of parents and teachers" and would, in fact, "compliment them."[35] A typical issue of the hebdomadaire had six BDs juxtaposed with informational articles, a selection from a serialized novel, a puzzle and games section titled "pêle-mêle," and the regularly appearing advice and information column of "Onc' Leon" alongside reader participation contests that were always positioned on the first page of the journal. The front cover, meanwhile, now had a single well-designed scene on it that may or may not actually relate to anything inside the week's issue but was designed to be suitable for collecting by young readers. If, however, it had been the contextualizing tissue of the non-BD features of the journal obscuring the cultural disconnect of its BDs in the 1930s that, thereby, accounted for its success in that decade, in its later incarnation the BDs of *Journal de Mickey* had become fully French. The decision was made to drop some of the more phantasmagorical BDs in an attempt to ensure that it would never be classified by the commission as anything other than its own seventh genre: *Les séries enfantines proprement dites.* In addition, the regular BDs that remained mainstays, like "La Petite Annie" (the French version of the American "Little Annie Rooney"), were fully adapted to recognizable French settings and situations (fig. 5.1).

That this was a deliberative strategy to not run afoul of the Oversight Commission was clear to all who worked on the relaunch of the journal. Pierre Nicolas, a principal artist working on the journal at the Parisian studio of Disney that had opened after the war, has made note of the fact that the most difficult thing about publishing the new *Journal de Mickey* was that they "had to please a bit of everybody in France: left-wing parties, the Church, the patriotic parties, the Ministry of Education and many other people, to release a new magazine."[36] In fact, Nicolas was responsible for the greatest adaptive innovation of the new *Journal de Mickey*. Making its debut in the fifteenth issue of the hebdomadaire, "Mickey à Travers les Siècles" ("Mickey through

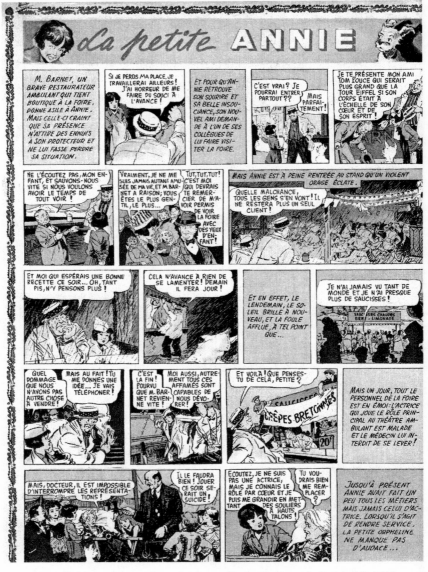

FIGURE 5.1 *Lil Annie Rooney* becomes *La petite Annie*. From *Le Journal de Mickey* #132 (December 5, 1954).

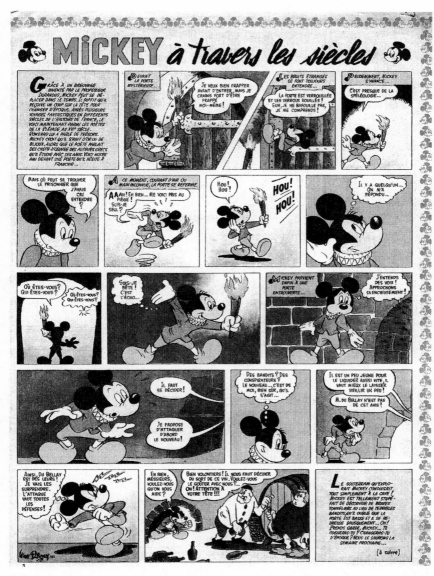

FIGURE 5.2 Mickey realizes the plot to overthrow the local lord is actually a discussion between loyal peasants discussing the readiness of that year's wine and knocks his head in surprise, sending him onto his next adventure through the ages. From *Le Journal de Mickey* #132 (December 5, 1954).

the Centuries") was a brilliant melding of the French historical novel and the graphic tradition of the BD. "Thanks to a potion invented by Professor Durandus," each weekly episode began, "Mickey can move through time. All he needs is a knock on the head to change époques."[37] Conceived in collaboration with an advisor from the National Education Ministry, the serial BD saw Mickey travel through France's history as a knight of the Crusades, a companion of Joan of Arc, and adventuring through nearly any conceivable parcel of the nation's past; each episode ending with the intrepid mouse inadvertently bumping his head in prelude to the following week's scenario. The story in figure 5.2, for instance, has Mickey confusing an overheard conversation among two loyal peasants for the intrigues of conspirators looking to overthrow their lord when what they were actually discussing was whether or not the previous year's wine was ready or not; one might be hard-pressed to find a more obviously French concern. Of course, when he realized his mistake, he stood straight in surprise too quickly knocking his head on a low doorframe, and set the stage for the following week's BD episode (fig. 5.2).

So extensive were the changes to Winkler's "powerful" foreign journal that it was now almost exclusively French with BDs on demonstrably French subjects and articles of particular French interest.[38] Moreover, with the Paris studio of Disney employing French draftsmen and authors, even much of the BD content of the *Journal de Mickey* was produced inside the country and was not simply the result of syndication. Winkler, with the rich resources of both Hearst's King Features Syndicate and Disney at his disposal, easily had the financial wherewithal to take on the project of *Journal de Mickey*'s redesign. No doubt, the quick success of the journal demonstrated his business acumen but also the influence of myriad concerns of the French made pointed and political by the Commission. Winkler's new Mickey might still be American born but he spoke perfect French and fit easily and naturally into his beret while attending art classes at the *Academie* (fig. 5.3).

Winkler had also likely watched the unfolding of *L'Affaire Tarzan* with keen appreciation. Prior to the relaunch of *Journal de Mickey*, Paris-based Éditions Mondiales published the best-selling journal d'enfant, the American derived *Tarzan*. As was seen above it outsold the Communist *Vaillant* by more than a 100,000 issues weekly and only the combined sales of both Catholic journaux, *Coeurs vaillants* and *Fripounet et Marisette*, even nearly approximated its success. Even the popular *Tintin*, with weekly sales of around 75,000 issues, managed only a quarter of *Tarzan*'s success. The popularity of the journal might well have been, at least in part, the result of the successful and wildly popular "Hollywood film series," as Jobs has argued.[39] However, as

FIGURE 5.3 How more French could he be? He speaks the language perfectly and studies art at the Academie! From *Le Journal de Mickey* #132 (December 5, 1954).

Raoul Dubois pointed out at the time, "Tarzan" had a "privileged place" in the French presse enfantine due to it having been introduced to the reading public by the Éditions Offenstadt journal *Junior*—nearly the only French publication that successfully competed with Winkler's *Journal de Mickey* and *Robinson* in the late 1930s.[40] It was this "privileged place" that allowed Éditions Mondiales to secure authorization to publish an entire journal with Edgar Rice Burroughs's famous ape-man at its center just two years after the Liberation. But, almost from the time of its successful launch in September 1946, *Tarzan* became a lodestone for criticism from across the political spectrum as one of the best examples of all that was the worst about the presse enfantine.

Tarzan featured prominently, for instance, in the 1947 five-part review of the presse enfantine in the journal *Éducateurs*; in the piece, "Savez-vous ce qu'il y dans les journaux d'enfants?," the journal was pointed to as particularly "dangerous" for the nation's youth.[41] This was only the beginning, however, as "the popular press thrashed *Tarzan* between 1949 and 1952," and it became a prominent target of the Oversight Commission in meetings its first year.[42] The journal was identified as particularly "dangerous because of its broad diffusion," and it was "allotted" the spot of "no1" concern because it was seen to be the "pilot journal of the bad press for children." "Devoted to the exaltation of the extraordinary physical qualities of a 'superman,'" commission members continued, "this illustré is a 'prototype' which more or less directly influences other publications for children."[43] In the official *Compte Rendu* of the Oversight Commission's work in 1950, there was little doubt that *Tarzan* was the inspiration for point seven in their list of twenty-three "general considerations" for the presse enfantine:

> The anatomy of these characters is in concert with their psyches: they are microcephalic hercules. Very often, their cranial capacity is, with respect to the size of the body, of a proportion much smaller than the average characteristics of the human race. The bestiality of the "type" continues in multiple detail: such supermen, or man-monkey, after each triumph over an adversary, launches an inarticulate cry of victory which can come only from purely animal instinct. It is necessary to banish this kind of character by remembering that the young reader is made to identify with the heros of his reading and moved to copy their attitudes; by also remembering that a presse enfantine, even if noneducational, can not make its ideal the apotheosis of physical force and animality.[44]

What damned *Tarzan* was not only its success and possible American provenance, but the fact that the title character was not sufficiently reasonable or

demonstrably intelligent. "Let Tarzan solve a problem of differential calculus," wrote one commentator, "or ask him to analyze a page of Valéry!"[45] His reliance on violence to solve problems that were already "made easier," or limited to artificial binary oppositions because his one-dimensionality made anything more complex impossible, marked him, for critics, not only as savage but simply not *truly French*.[46]

In the wake of this storm of popular criticism and the pressure that the journal was receiving from the Oversight Commission, Éditions Mondiales decided to make the May 3, 1952, issue of *Tarzan* the last one as well. Just as the editorial staff of *Les Belles Images* had done almost twenty years prior when that journal was forced to quit publishing because of the outcry over its addition of the American BD "Betty Boop," though with far less contrition, the editors of *Tarzan* addressed the journal's readers in an editorial "Adieu to Tarzan." In it, they defied "anyone to find a single attitude of Tarzan that was counter to the regulations . . . we will always consider Tarzan to be an honest, loyal, courageous, just, and irreproachable man."[47] There is little doubt that Winkler was well aware of the entire *L'Affaire Tarzan*, concluding as it did only a month before the reappearance of his own, often lambasted, *Journal de Mickey*.

By most measures, then, from its beginning and even without terribly sharp censorial teeth, the Oversight Commission should be counted as having succeeded in its mission of at least cleaning up the presse enfantine, if not "purifying" it. By 1955 many of the examples of the truly "bad press for children" had disappeared from the nation's kiosques; not only *Tarzan*, but also the journal that it had supplanted as being of preeminent concern to the commission, *Le fantôme du Bengale*. From 1951 to 1954, it was receiving and reviewing roughly two thousand issues a year from 23 hebdomadaires, 25 bimonthly, and 105 monthly or "irrégulière" publications; from review of this caché of journals the Oversight Commission issued reports with 135 recommendations for minor improvement, 45 warnings, and 41 actual sanctions.[48] The official record of the Commission also demonstrated that its members were sensitive to changing political and social concerns when they addressed the issue of racism that seemed to often be apparent in many journals. Too many BDs, according to commission reports, were notable only for their "at least implicit racism," and while it might be "generally unconscious," it remained "unacceptable."[49] At least in part because of the Oversight Commission's raising the issue, Article 2 of the 16 July Law was amended in November 1954 to include the phrase "to inspire or inflame ethnic prejudices."[50]

This sort of political "sensitivity," however, also underscored the fact that the members of the Oversight Commission saw their task as not simply aiding

in the curbing of juvenile delinquency, but also both the maintenance and normalization of a strict and specific social order. From the beginning of the commission's work, the maintenance, or in some instances the (re)creation, of the proper milieu/general culture for appropriate social interactions between the young and their elders, and (even more) between adolescent boys and girls had intertwined with its sense of mission and purpose. Early on, in July 1950, while the Oversight Commission was enmeshed in outlining its tasks and goals, Abbé Pihan presented to the body his own "observations" as to what the problems of the presse enfantine were and what the commission should submit as recommendations to the various publishers of "journaux destinées pour la jeunesse." Nearing the top of his list of concerns was the portrayal of the relationships between men and women, such as they were, across much of the presse enfantine. Too often, Pihan insisted, the only role a woman plays in many BDs is to be the "stakes" over which men fight. That is, of course, when she is not "herself a 'superwoman' who also fights against men, often with a cruelty and an absence of female sensitivity that should cause horror." "Almost never," he continued, "in certain journals, at least, is a female shown enjoying the behavior, [the] feelings of a normal woman." There is almost no real social interaction and seldom are "heroes" shown to be "dependent on" and functioning within a regular "social and family framework"; it went almost without saying that "mothers and wives hardly exist." This "deficiency," the churchman concluded, was "particularly serious" for women.

There were "very few" journals directed "specifically" at girls, Pihan noted. Generally, the "commercial journals, as a whole" were "indifferently addressed to boys and girls, though, in fact, they are ignorant of the psychology of young girls, of her needs, which should be exalted, and [are thus incapable] of presenting a good model." Nonetheless, their real failing, ultimately, was that because of the "false image" they gave of women to their principle audience, "they contribute, by their brutality . . . to an increase of coarseness, dismissive-ness, and the lack of courtesy that boys have regarding girls." "In an age" when commercial interests could get "Mother's Day" promoted to the level of a "national festival," Pihan lamented, "it would be regrettable" if a "directive of a familial nature" could not be issued to the presse enfantine.[51]

Following Pihan's observations, a subcommission (on which Pihan served) pursued an expansion of Article 14 of the 16 July Law, which had made the sale to minors of licentious or pornographic publications illegal in 1954 and again in 1958. The provisions of Article 14, the subcommission argued, have as their

"essential aim," the defense of "youth against early eroticism . . . sexual obses-
sion, sexual excesses, sexual deviations." Because of this, it was important that
"'suspect' points of view" be included in the understanding and application
of the article. These should include "accounts of mores 'contre nature,' homo-
sexuality and pederasty"; accounts of sado-masochism; descriptions of "the
life of prostitutes" or of "stripping (in nature or privately . . . or accounts of
striptease in the cabaret)"; or "descriptions of scandal (incest, bigamy, etc.)."[52]

On December 21, 1958, Article 14 was strengthened and expanded as the
subcommission had counseled and the "jurisdiction" of the Oversight Com-
mission was broadened to include all publications ostensibly directed at the
nation's youth and not simply illustrés or periodicals—granting members of
the commission even greater latitude to set the terms of debate of what was
and was not healthy for the country.[53] Given that France was in the midst of
a "bébé-boum" by the middle of the decade, the task of the commission not
only expanded but also took on increasing importance. After generations of
lagging behind the rest of Europe, by 1948 the country's "population of 44.5
million placed France demographically among the most dynamic nations of
Western Europe." Average life expectancy increased roughly six years during
the decade but the "old . . . found it increasingly hard to find a place in a rapidly
changing France." The nation was becoming a younger, more mobile, country
and by 1958, nearly a third of the population was under the age of twenty. "In
short," according to Rioux, "the old notion of . . . patrimony was being chal-
lenged, with the emphasis shifting away from the careful accumulation of past
generations towards . . . more immediate enjoyment . . . visible consumption
and more liquid forms of investment."[54] With these changes came changes in
the very nature of French identity, and it fell to the Oversight Commission to
determine what articulated that for the nation's children and by way of that,
for the nation writ large.

If the Oversight Commission's work is reviewed through the 1950s and
into the mid-1960s, records of meetings and concerns raised in reports issued,
it appears that little had changed for the body's members in the social and
political landscape of the nation in the turnover of decades. If anything, a
quick investigation of the commission's work would seem to indicate that it
had become even more assured of its task and the proper direction of the
presse enfantine. In 1962 a subcommission had been formed and charged with
"following the evolution of the publication *Detective*." This was the same jour-
nal from publishing house Editions "Nuit et Jour" that had been on Minister
of Interior Jules Moch's list of suspect journals in 1948, having only dropped

the *Qui?* from its title. Though the report of the subcommission indicated that the publication had undergone significant alterations since André Beyler's letter to Moch's Ministry there was much that was left wanting. Of particular concern for the members of both the subcommission as well as the general Oversight Commission was inclusion in the journal of serialized stories that were described as being of a "'série noire' style," which were, ironically for the commission, new to the journal since its "improvement." "The magazine," the subcommission concluded, had "certainly changed"; however, particularly given the broadened purview of Article 14 of the 16 July 1949 Law, the "opinion" of the body was that the journal still trucked too much with crime and depictions of a criminal lifestyle.[55] Over the course of the year, the Oversight Commission forced two separate government opinions against *Detective* and the journal was removed from sale by interdiction on October 3.[56]

When it came to the overall work of the Oversight Commission, the numbers of periodical journals examined (hebdomadaires, biweekly, and monthly) remained generally steady from 1958 (2,805 journaux and 16,960 examples reviewed) to 1964 (2,671 and 14,595); while a category of "Non-Périodiques," which had first appeared in the body's statistical breakdowns in their 1958 report, was expanded with 13 publications and 65 examples reviewed in 1958, steadily growing to 171 publications and 855 examples reviewed in 1964.[57] In what might be read as an example of the commission's continued influence on the publishing industry of the country, from 1958 to 1961 its members issued a total of 510 reports and recommendations without a single "mise en demeure" or warning of sanctions if changes to the publication were not made. From 1962 to 1963, 166 reports or recommendations were issued with only five warnings leveled against publishing houses (in 1962 two were issued to two separate houses, in 1963 three were levied against a single house); while in 1964 there were 127 reports with a return to no sanctions.[58]

This same block of years also marked a relative explosion in the commission's review of "publications étrangères distribuées en France." Following the same breakdown of "native" journals, from 1958 to 1964 the number of "foreign" journals reviewed steadily increased from 699 (3,456 examples) to 1,112 (5,558). The same held for the category of "non-périodiques," with 67 (268 examples) reviewed in 1958 increasing to 211 (844 examples) by 1964. Given that, by definition, these journals were not of French origin, the influence of the Oversight Commission over them and their content was generally weak. For that reason, rather than issuing "mise en demeure" warnings that French publications were subject to, the commission relied on issuing recommendations for the government to stop importation of any offensive

journals. Interestingly, in these years, very few of these "avis défavorables à l'importation" were issued. In 1958 there were only two issued (both for non-periodicals), with that figure apparently being a rough norm, though a high of eight (five for periodicals, three for nonperiodicals) was reached in 1962 and none in 1964.[59]

Finally, following the expansion of its purview in 1958, the commission also undertook review and evaluation of the broader field of all juvenile literature with a particular emphasis placed on the genre of "young romance" books aimed at adolescent girls known generally as the *presse du coeur* and crime magazines, or reviews, believed to be of appeal primarily to adolescent boys. Like the flurry of critiques that the Oversight Commission had issued regarding illustrés in the first years of its existence, the evaluation of this broader juvenile literature was similarly stark and hard-lined in its recommendations. In 1958, 34 reviews and 132 books were examined; of these 22 and 117, respectively, were recommended to the minister of the interior for interdiction for violations of Article 14 of the 16 July 1949 Law—21 of the 22 marked reviews and all 117 books actually were subjected to interdiction by the government. By 1964, with 34 reviews and 71 books evaluated, the number of publications marked for violations had dropped to 6 and 39, respectively, with 3 reviews and 28 books actually suffering interdiction.[60]

With just examination of the Oversight Commission's work and influence limited to these sorts of statistical breakdowns of its year-by-year activities, an argument could well be made that it was successful in forging a particular course for the nation's presse enfantine; particularly if its work not directly related to literature reviews is also included in an evaluation of the evaluators. In the mid-1950s, while still a member of the body, Lyonnaise publisher Jean Chapelle offered an unintentional demonstration of the commission's influence by forming and presiding over the Syndicat National des Publications Destinées a la Jeunesse. A formal letter held in the Oversight Commission's archives from Chapelle as president of the newly formed professional organization with members from across the country and political spectrum nearly begged the commission to make a formal, evaluative, distinction between what he called the Presse Idée and the Presse Récréative. Too many of the latter were disappearing from the nation's newsstands the publisher lamented, threatening to destabilize the entire industry or force it to make itself over in the image of the powerful Communist and Catholic publishing enterprises.[61]

At the same time, however, the work of Pierre Fouilhé, a social scientist from the CNRS Institute, was beginning to raise issue as one of the few voices to run counter to the prevailing sentiment regarding the dangers of journaux

illustrés. As early as 1953, Fouilhé was insisting in the pages of *Enfance*, just as Chapelle had earlier and directly to the Oversight Commission, that the good virtues of earlier examples of the presse enfantine were largely illusory and that the changes that had been forced in the industry since 1934 and the introduction of foreign BDs and journals, like the *Journal de Mickey*, were qualitatively no different than periodic developments that had regularly occurred since the nineteenth century. He chided government officials and even juvenile court judges who relied solely on anecdotal tales of corruption caused by journaux illustrés to gird their calls for their restriction with real evidence. "Only an empirical study," the sociologist insisted, would "make it possible to specify the nature and quality" of influence that journals "expressed" over children's behavior.[62]

Nonetheless, save for a handful of publishers and editors usually associated with Chapelle's Syndicat National, Fouilhé was nearly alone in his call for a more tempered evaluation of illustrés. Remaining more typical throughout the decade was the work and estimation of the medium by Henri Joubrel. Both psychologist and lawyer, as well as a magistrate, Joubrel was a widely regarded expert on juvenile delinquency whose work and research had carried him across Europe, the Middle East, North Africa, and the United States and Canada while he served as president of the International Association of teachers of misadjusted children. In his 1957 work *Mauvais Garçons de Bonnes Familles*, he soft-pedaled the overtly political assertion that illustrés were the single gravest threat to children and also placed much of the blame for the poor reading habits of the nation's youth on parents who had themselves become a society of magazine and "digest" readers. Still, in the current "civilization of the image," what he labeled "unhealthy readers" topped his list of secondary causes of juvenile delinquency, ahead of both the cinema and television. In what was to count as his own general examination of the field, his analysis swaggered freely across much that had been already insisted in the popular press, the National Assembly, and among the members of the Oversight Commission: "The monster, the 'pinup' and 'superman' contested for imaginations that need to be gradually directed towards reality, the taste for work and effort." The "press 'du coeur'"—that the commission would receive jurisdiction over the following year—meanwhile, did little to prepare young girls for what they would face in their normal adult lives. Instead, Joubrel insisted, it instilled in them an unslakable thirst for fame and its trappings of "furs, dresses and jewels . . . nightclubs, yachts, and deluxe hotels." It preached a life of "free love and adultery" and counseled that "suicide was the only 'noble' exit from a

broken love."[63] In an interesting turn of Americanization, the French expert noted that the French were not alone in recognizing the dangers of the juvenile press. Citing the work of American psychologists like Fredric Wertham, and his popular 1954 polemic *Seduction of the Innocent*, he even insisted that the French 16 July Law and the Oversight Commission were the envy of several countries, including the United States.[64]

There were attempts to address the lack of a formal investigation into the effects of juvenile literature on the nation's young in the 1950s; and again the Oversight Commission, having the influence and financial reserves of the government behind them, took the lead. In 1956, the commission empowered a subcommission to study the issue under the guidance of specialists from the prestigious Institut de Psychologie de Paris at the University of Paris. The study focused on the effects of depictions of violence in journaux illustrés on their young readers—in the context of the experiment, 280 girls and 630 boys. Not surprisingly, the results of the study were open to interpretation and argued by some—even on the Oversight Commission—to be inconclusive, though it did indicate a rough correlation between images of violence and violent behavior, particularly in young boys.[65]

Members of the commission, however, were able to parlay the very ambivalence of the report from the study to their advantage in staying generally relevant in a debate that in the broader public sphere was again gradually widening to a consideration of the entire general culture. Part of the problem with any study seeking to gauge the effects of a particular media or medium on its consumers are the ethical limitations that must be considered in the creation of any experiment. Consequently, in the study ordered by the Oversight Commission, rather than exposing the subject-pool of young readers to a series of "unfiltered" journaux illustrés riddled with violent images, researchers from the University of Paris devised a "simple and elegant test" wherein children were shown a series of images and asked to devise a story or history to go along with them and/or explain their sequenced action. While a link between exposure to violent images and subsequent violent behavior could not be conclusively demonstrated, what the study apparently did indicate, at least to the psychologists who fashioned it, as well as to members of the Oversight Commission, was that exposure to various images could either productively enrich a child's imagination or cause it to wither.[66]

With the results of its study as fodder, the Oversight Commission called for a formal course of study to be created at the École Nationale des Arts Décoratifs for those intent on fashioning a career as either a designer/artist or

scenario writer of BDs. Though the creation of what might be called a for-mal French School of BD design never came to pass (at least not in the way it was imagined here), the issue was picked up by the directorate general of arts and letters who then commissioned a study of its possibility in liaison with Chapelle's Syndicat National.[67] This increased governmental pressure, in turn, provided the commission additional ballast in forcing educational, or simply informative, scenario/story suggestions on various publishers. In particular, and in a move uncomfortably akin to issues raised by Vichy-era ministers, members of the commission expressed a certain "astonishment" that there were not more BDs centered around sports and athletics. Such seemed to the commission a waste of "vast resources" that could be profit-able to publishers while fostering a sense of appreciation for healthy activ-ity individually and of camaraderie collectively—both being "advantageous . . . for the country." Beyond these sorts of general recommendations, and in testament to "the eclecticism of its concerns, the Commission conveyed to publishers the desire of the 'Centre National d'Etudes Spatiales'" to see stories and BDs that exposed children to "scientifically undertaken space research," as well as express to adolescents the dangers of recklessly handling the explosives used in making fireworks and rockets. According to the commission's official record, these and other suggestions were met with such favor from publish-ers that some "even launched educational campaigns in other fields." And, it seemed with a measure of smugness that the commission reported that some of the campaigns had gone off so well that one "series of articles on the dangers of alcoholic drinks" caused the *Confédération nationale des industries et des commerces de vins, spiritueux et liqueurs de France* to bring a legal suit against the publisher—"fortunately in vain."[68]

The most important example of this sort of directional influence of the Oversight Commission, however, likely was also an example of the evolution of the production of journaux illustrés. In 1959, a small group of artists and authors headed most notably by the well-traveled René Goscinny launched *Pilote*, the first independent and privately funded journal in the country. Because it lacked the backing of established publishing houses and was also without the support of the powerful political and religious concerns that had been the mainstay of French journaux to then, its founders were forced to find other means and methods to ensure its popularity nearly from inception. The journal "compensated for its commercial isolation by allying itself to France's most popular radio station, Radio Luxembourg." This arrangement, "which guaranteed Radio Luxembourg a high profile in *Pilote* and *Pilote* promotional

exposure on the airwaves of Radio Luxembourg," allowed the creators of the journal to tap into the burgeoning youth market by tying it to the modest rebellion of the "rock and roll/yé-yé music culture that was to dominate youth entertainment in the early Sixties."[69]

Among the first journals to aim specifically for an adolescent audience—an audience that was in the process of becoming aware of itself as a distinct social unit apart from either children or adults—the BDs that appeared in its pages were "therefore . . . more satirical and characterized by well-thought-out adventure strips and humorous strips."[70] Unfortunately for the creators of *Pilote*, the securing of a niche in the journaux illustrés marketplace was only a part of the concerns they faced. Established publishing houses and the political and religious concerns that published their own journaux had, as we have seen, been intimately involved at nearly every level with the crafting and enforcement of the 16 July 1949 Law, which had afforded their product some measure of legitimacy. The artists that made up the editorial and publishing board of *Pilote* had not played a comparable role and thus were left needing to demonstrate the quality and value of the journal. To do this, *Pilote* was, almost from the start, aggressively associated with the "progressive attitudes towards education" that were apparent in France in the 1950s. According to Wendy Michallat, the most obvious indicators of this "progressive attitude" were the 1959 Berthouin Reforms that raised the "minimum school-leaving age from 14 to 16." "One consequence of the new enthusiasm for education," she added, "was the emergence of an adolescent concerned not only with leisure culture but also with how education might permit him access to it." Because of these society-wide concerns, she has maintained, *Pilote* directly entered into the "high-profile and long-running post-Liberation debate amongst educationalists about how bande dessinée publications could assimilate the pedagogical imperatives of the new Republic."[71]

Although the journal is likely most famous for the comic historic-adventure series created by Goscinny and his partner Albert Uderzo "Astérix les Gaulois," it was the pilot-hero strip "Michel Tanguy" that most completely demonstrated the conscious linking of an educational project with the products of leisure culture. Described elsewhere as "a carefully researched, minutely realistic strip not lacking in humor," Michallat has pointed out that the BD always appeared astride "'reportages' and 'documents' carrying themes that duplicate or anticipate the themes and subject matter fictionalised in the bande dessinée."[72] Thus, more than "the predictable and unquestionable qualities of honesty and integrity that one would expect of the traditional bande

dessinée hero" was learned and the "hero is reconstructed. He represents the values expressed in the text. The hero no longer perpetuates a traditional heroic stereotype but a range of values and concepts laid out in the supporting text."[73] By way of this maneuver, which Michallat likened to a "flaunting of [perceived] bande dessinée conventions," the producers of *Pilote* managed to avoid running afoul of the Oversight Commission.[74] And in doing so, like the *Journal de Mickey* earlier in the decade, demonstrated the persistent, reflexive influence of the commission over the direction of the industry.

Finally, the Oversight Commission managed to carve out at least a symbolic position in the burgeoning economic and cultural cooperation between European nations by pressing for, and ultimately securing, a meeting of editors and governmental officials in Luxembourg on March 4, 1960; a "European Association" of "specialized Editors from the six signatory countries of the [1957] Treaty of Rome." Mindful as it was that "French production must keep its national character," members of the commission also recognized that evermore examples of the presse enfantine were likely to come from outside the country. Consequently, the desire was the creation and adoption of a European-wide "Moral Code" to be followed by all publications that carried the "Europressejunior" label. In language reminiscent of the recently returned to power Charles de Gaulle and his goal of returning France, "the Madonna in the frescoes," to its rightful place as the spiritual and cultural leader of the continent, the commission now wrote of leading "one of the first examples 'of a European spirit,'" for the improvement of the presse enfantine and the benefit of all Europe's children.[75]

When considering the influence of the Oversight Commission on the French illustrated press in the first decade(s) of its existence there is an interesting comparison to be made with the Comisión Calificardora de Publicaciones y Revistas Ilustrades, an almost identical government body (in conception at least) established by the Mexican Republic in 1944. In her study of Mexican *historietas*, that country's popular version of the comic book, *Bad Language, Naked Ladies and Other Threats to the Nation*, Anne Rubenstein effectively argues that the Comisión was long on artful rhetoric but short on actual and effective power. Indeed, while the government, in response to public outcry similar to that heard in France, insisted that its role was to "purify" comic books, it had not invested the body with the necessary power to enforce its judgment on "immoral" publications. While it could levy fines, for instance, it could not impel the judiciary to enforce their collection and, as a consequence, the popular Mexican publishing industry did little to change. In her analysis,

Rubenstein went so far as to argue that actual "purification" of the medium was never the intention of the government. Instead, the comisión served a largely ceremonial, and obfuscating, function of allowing the government to claim to its critics that it was doing something to address their concerns while allowing the country's publishing industry to continue its economic growth relatively unfettered rather than have the industry turn its power to influence against the still new government.[76] There is something of this idea in the analysis of the 16 July 1949 Law of both McKenzie and (perhaps paradoxically) Ory. Even Crépin, with his emphasis on the reading tastes of French youth turning to realistic adventure stories inspired by the French Resistance as well as the responsiveness of Belgian editors to these tastes, would seem to limit the importance of the Oversight Commission or the influence of it on the presse enfantine particularly in the 1950s.

Instead, any determination of the commission's significance or discussion of its success cannot be measured solely in the direct impact it had on the country's publishing industry by way of limiting specific journaux illustrés or BDs—though, through the use of its political *bully pulpit* its influence was hardly insignificant in even that regard. Rather, its real success lay in the marshalling together the many ideologically disparate, though practically similar, voices of the decade as they regarded an articulation of fears over the country's future and direction of the nation's young into a single discourse of concern and course. In the years immediately after WWII, when the nation found itself needing to rebuild and repair after the crush (psychic as well as physical) of Occupation while caught between the bruising forms of the United States and the Soviet Union during the first chapters of the cold war, a distinct identity for the nation was articulated in the argument and reports of the commission's work. With its members drawn from across the political spectrum, as well as from the commercial press, the governments of the, occasionally unsettled, Fourth Republic managed to turn a potentially divisive issue into a point of stability. And, not inconsequentially, throughout the 1950s at least, the commission served to ensure that what appeared in the pages of the many available journaux illustrés reflected a demonstration and appreciation of what it was to be *truly French*. Even more, its members secured agreement on what that reflection should be. Once this issue had been settled and the greater mass of the journals could be counted on to do just that, it was a short trip to making part of being French an appreciation of the journaux illustrés—something that has been a near given since the commission's heyday in the first decades of its existence.

Chapter Six

Culture Becomes Policy

Bande Dessinée as Monumental Architecture

Culture is what responds to man when he asks himself what he is doing on the earth.
—Andre Malraux

L'Imagination au Pouvoir?
—Anonymous, May 1968

In 2009, the Oversight Commission remains an active governmental body and in recent years has been involved in the debate over Japanese-inspired manga-styled journals, pressing for a ban on some of the most violent examples of a genre known for near outrageous levels of violence and sexuality. The decade of the 1950s and the first years of the 1960s, however, should likely be recognized as the commission's acme point. Increasingly, from the 1960s on, its task became one of enforcement of a norm that was losing its relevance and cultural traction in the midst of the country's *les trentes glorieuses* and it was largely reduced to being a censoring body, a role for which it was ill-suited. Even members of the commission were well aware of the limits of their influence over publishers if they proved unwilling to accept its recommendations for change to their publications.

Only once had a publisher actually been charged and brought to trial for violating Article 2 of the 16 July 1949 Law and then with decidedly mixed results. Pierre Mouchot was an author, artist, and publisher from Lyon who worked under the pen name "Chott," and in 1953, after repeated refusals by

the Lyonnaise draftsman to submit to the commission's multiple "mises en demeure," the commission recommended prosecution of him to the attorney general. Because Mouchot had willingly removed an earlier journal from sale in 1949, his refusal to commit to the entreaties and mandates of the Oversight Commission in this instance was deemed a willful transgression of the law.[1] The state's case against Mouchot ran through the remainder of the decade as the Supreme Court of Appeals annulled each of his lower court victories over the charges.[2] It took nearly eight years but Mouchot was finally, tepidly, convicted of violations of Article 2 of the 16 July 1949 Law. But, the hollowness of the victory, and the lengthy legal wrangling that it required, served only to pull back the curtain on how toothless the commission was if a publisher chose to push the issue—and no prosecutions of violations of Article 2 have ever followed.[4]

The evaluative work of the Oversight Commission became far more circumspect after the Mouchot episode. At the end of the 1950s, while the Mouchot litigation was still awaiting its final judgment in the Angers court, a subcommission was formed and charged with review of all the publications of the fellow Lyon publishing house Imperia. Under review were all twenty-two of Imperia's journaux illustrés, most of which had a western or cowboy theme. The report that the subcommission issued in June 1962 was flatly condemnatory of most of the house's journals, the bulk of which were "without valor" and existed only to stream out scenes of "brawls, kidnappings, escapes, etc. . . . without interruption until a general lassitude of the reader was achieved." However, the authors of the report questioned whether the publications were truly any worse than that of Mouchot and admitted that the decisions in that case had made the successful pursuit of any "judicial action" against Imperia a "dubious" prospect at best. This sense of caution, if not futility, stands in marked contrast to the much more aggressive posture that the juvenile court judge and commission member Cotxet de Andreis had laid out in his commission reports a decade earlier and serves as notice that the commission was all too aware of its ultimate powerlessness. The fault lay not with its estimation of the journals, the subcommission insisted, but with the watery vagaries inherent in the "drafting of article 2 of the 16 July 1949 Law," which did not allow for "judgment" based on a "more exact understanding of childhood and adolescence."[4]

The members of the commission found themselves fighting a rearguard action against irrelevance at that point; to some extent the body was a victim of its own early successes. As we have seen, the support for the 16 July 1949 Law cut broadly across the political spectrum, and even the Communists who voted

against the legislation in its final form served willingly, and effectively, as members of the Oversight Commission. Still, the effectiveness of the commission depended far more on an agreement among all the involved parties, including the actual publishers of journaux illustrés, as to what the commission was overseeing and, to some extent, controlling than on any censoring teeth that the 16 July 1949 Law afforded the body. When the focus of the government shifted away from overt concern over the content of the nation's "general culture" the Oversight Commission lost the broad governmental support on which it had relied to give its "mises en demeure" the threat of a repressive bite.

The irony of this situation lay in the fact that it was with the return to power of General de Gaulle in 1958, and the foundation of the Fifth Republic, that culture became the "dominant language of politics."[5] Facing the immediate gory woes of the "war without a name" in Algeria and the ever-looming threat to national autonomy the two superpowers of the United States and the Soviet Union were believed to be, de Gaulle pressed toward his own middle way to modernization and political relevance.[6] "Now our great national ambition," he asserted, "is our national progress constituting a real source of power and influence."[7]

De Gaulle's ambition was to ensure the independence of France and while he sought the obvious accoutrements of military and economic power to guarantee the physical sovereignty of the nation, he understood that he also must unify and "regild" the nation's cultural identity to thwart the neocolonial effects of Americanization. "In the political sphere," he wrote, "we must . . . behave like Europeans."[8] And for de Gaulle, as for many of his countrymen, to be European was first to be French. This is what underscored the creation of the Ministry of Culture by de Gaulle in 1959, and made even more trenchant the appointment of his longtime political colleague, the novelist and former Resistance fighter André Malraux as its first minister. Some past analysis of the role of the Ministry in de Gaulle's Fifth Republic has cast it as an example of the conservative general's aversion and reaction to modernization, even that wrought by de Gaulle himself, but it should instead be recognized as a proactive element of his "middle way" to independence.[9]

Whether general or president, de Gaulle was personally "a powerful combination of principle and pragmatism" who saw in the state a "crystallization of social bonds" as important in the postwar world as the family and as deeply rooted as "instinct."[10] And in this, the Ministry of Culture was to serve as a "principal institution," necessary in the modern nation-state and capable of generating a unified "community" sturdy enough itself to repel the (mass) cultural invasion of America and restoring the great "mission" of France. As

Etienne Balibar has noted, "that is why there is a close historical correlation between . . . national formation and the development of . . . 'popular' institutions . . . serving to underpin the whole process of the socialization of individuals."[11] In this "technical epoch," de Gaulle wrote in the same year as the Ministry's creation, it is the state "which leads the entire country toward a better life," but its citizens must have a sense of themselves and their place within the world for that to be possible.[12] With a policy of jerky decolonization and a retreat largely to the boundaries of *l'hexagon*, de Gaulle and Malraux sought to "establish the cultural boundaries of the nation so that they may be acknowledged as 'containing' thresholds of meaning that must be crossed," or, conversely, could be more easily defended.[13]

For his part, Malraux spent his ten-year tenure as minister of culture in large part fulfilling his role as both guardian and promoter of France's culture almost exactly as de Gaulle had envisioned the post. Though he has been criticized as little more than a monument polisher and a dedicator of public buildings, these activities were not only what he was primarily called on to do publicly, but they were precisely what de Gaulle wished him to do in reestablishing and stabilizing the cultural identity of France. By giving the opening speech at the Joan of Arc festival in Orléans in 1961, Malraux consciously called attention to "the only face," in France's history that the whole of the nation could look on with "homage . . . [and] unanimous respect." For it was not simply the intrinsic "Frenchness" of Joan that commanded respect and provided her appeal, but rather the example of "firmness, confidence, and the hope" of the "girl of Orléans" that everyone in France could, "in these difficult times," admire and reach for.[14]

Much time and effort was also spent making it clear that French culture, always civilizing, was, now, also decidedly anti-imperialist. France was the home and celebrator of liberty—hence, Malraux's inaugural speech at the unveiling of the statue dedicated to Argentine general José de San Martín in Paris in 1960. Like de Gaulle, San Martín had freed his country from the specter of occupation and exploitation, and in this shared with France singing "the song . . . of the liberty of the world."[15] When it came to the actual development of "culture," however, his Ministry spent little time and less money on cultivating and nourishing the contemporary arts; instead, Malraux focused on the European masterpieces of the past as a sign of French *grandeur* and sought to make France, once again, *the* international authority on the arts.

Malraux's cultural plan within the Hexagon, known as *action culturelle*, similarly privileged *la culture cultivée*—artifacts of a transcendent high culture that would be spread about, and introduced to, the general populace by

way of his *Maisons de la Culture* (MC); his idea of "democratizing" culture.[16] There was little room in this conception of both culture and its role, for the valuation of contemporary cultural production, particularly that which did not lend itself to easy and traditional identification as demonstrably a product of high culture. The hoi polloi creations of what Malraux dismissively called "dream factories" had no more place in the cultural canon than the "public" did "in the management of the House of Culture"—little to none.[17]

The centralized and strictly hierarchialized structure of de Gaulle's government proved generally capable of dealing with the vicissitudes brought by the demands of decolonization and in tendering the appearance of a strong, even dynamic, nation in matters of foreign relations, but was too rigid and less than successful in addressing issues and growing demands from within the nation itself. By the end of the 1960s, both France and de Gaulle's Fifth Republic had become, in some measures, victims of their own successes, and the two no longer meshed quite as perfectly as the old leader presumed. At an ever-accelerating pace during *les trentes glorieuses* the country was modernizing, urbanizing, and also growing younger thanks to the *bébé-boum* that was encouraged and followed in the months immediately after WWII.

As seen in previous chapters, since before Pétain's Vichy government and the first days of the Fourth Republic, the youth of the nation had been made into a broad and detailed focus of both the general public and the state. The result of this was that by 1968 the nation's youth had a clear identity of themselves as a distinct social group with its own cultural tastes and political demands that often seemed to be treated with haughty disdain in regard to the former and simply went unmet in the latter case.[18] In the immediate, the issue with the latter took the form of inadequate university services for the more than half a million students that had entered the country's already overtaxed university system and attendant anxieties that even the successful completion of a degree would not result in gainful future employment.[19] More amorphously, there was a conflicted sense among many of the country's university-aged youth that while they had grown up in an environment where political and cultural rhetoric had continuously declared them the all-important future of the nation, they felt themselves shut out and dismissed by the imperious de Gaulle, who was at an equal loss in dealing with them (fig. 6.1).

For all the paroxysms of May 1968, however, and the eventual resignation of President de Gaulle, the broader populace of the nation ultimately demonstrated little desire to scotch the entirety of the government and begin anew once more by their general unwillingness to join young demonstrators

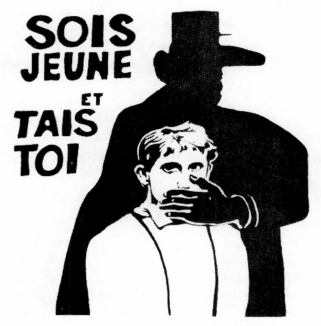

FIGURE 6.1 Popular anonymous poster during the summer
of 1968. Interestingly, certain groups during Nicolas Sarkozy's
presidency revived the image with President Sarkozy's face in
place of de Gaulle's profile. Anonymous.

coming out of the universities and their votes at the polls.[20] Nonetheless, the
government of new president Georges Pompidou accepted the analysis of
those like sociologist Michel Crozier, who declared that France was *une société
bloquée*.[21] Though Pompidou was nearly sixty by the time that he stood for the
presidency in 1969, he was seen as a vibrant and youthful alternative to the
craggy septuagenarian de Gaulle, and his actions during the '68 crisis when
de Gaulle seemed out of touch—and for a time simply missing—stood him in
good political stead among both those who sought radical societal change and
conservatives who more charily approached the issue. As a political animal,
Pompidou was personally wary of committing himself in either direction, but
he made a loosening of the central reins of government and a transformation
of social relations central themes in the 1969 elections.[22]

 Before the end of the year, Pompidou's first prime minister, Jacques Cha-
ban-Delmas, was forcefully addressing the National Assembly and calling
for a "new society" based on an open dialogue between various social forces

and camps. On the side of the government this was signaled by moves that afforded greater autonomy for the informational services of the Office de la Radiodiffusion—Télévision Française (ORTF) and, in a grand gesture of political openness that has been called "heavily laden with symbolism," the Ministry of Information was simply done away with.[23] Ultimately, though many of the structural reforms of the Pompidou presidency built on trends that were underway before the crisis of 1968, his government did push a decentralization of national population and industry outside of and away from Paris.[24]

The most obvious place of the loosening of control, and even of definitions of value, came in the cultural policy put forward by Pompidou and his minister of cultural affairs, Jacques Duhamel. Rather than the *action culturelle*, which had been articulated by the novelist-aesthete Malraux and privileged *la culture cultivée*, a transcendental artistic heritage marked by appreciation of classically high art to be spread throughout the Hexagon by way of MCs, a more amorphous ideology of *développement culturel* was being articulated in 1972 by Duhamel. Taken from the discourse of economics, influenced by the ideas of Structuralism and largely stripped of concerns with the isolated genius speaking for and to an age, *développement culturel* adopted a broader, more anthropological, approach. In something of a return to concern with the "general culture" of the nation that had been at issue during both Vichy and the Fourth Republic, *Culture*, now, was to be recognized as the very essence of quotidian existence and not simply the timeless classics of high art. Pluralism and expression in all forms were to be embraced as palpable and vital not only to life generally but for social and economic progress.[25]

This new cultural policy was further developed by the "Colloquium on the Future of Cultural Development." Directed by leading public intellectuals like Edgar Morin and Michel de Certeau and government experts such as Augustin Girard, the head of the Ministry of Culture's research unit, it was held at Arc-et-Senans in early 1972. The issue for all involved was not access to high culture but the "cultural alienation" and other "social costs" that were the consequences of development in advanced industrial societies. Economic growth, according to them, had wrought massive change and fostered urbanization and social mobility, but it had also brought with it social fragmentation and anomie. Because of this, while there could be "no question of arresting economic growth . . . culture must strongly assert itself in order to turn quantitative growth into an improvement of the quality of life."[26] The fact that the concept of culture was now to be recognized as something far broader and more organic than it had been conceived of by Malraux was here made evident.

"Nowadays," the *Arc-et-Senans Declaration* continued, "culture embraces the education system, the mass media, the cultural industries (newspapers, books, records, video-cassettes, the cinema, advertising, housing design, fashion)," while what was termed "bookish, academic culture" was "degenerating."[27]

In fact, established culture had not only become sclerotic and marginalized, but was "foreign to most sections of the population" while encouraging "certain forms of nihilism." At the same time, the cultural industries were moved by market forces and profit motives, the result of which was to subject the individual "to an indiscriminate barrage of information from the mass media." The individual, though, according to the *Declaration*, lacked the means to cope with this deluge that fostered conformism while turning them into mindless consumers. The corrective for this commercial "totalitarianism" was creating the "conditions for a decentralized and pluralistic 'cultural democracy' in which the individual can play an active part." One of the key features of any such decentralized "cultural democracy" was to provide "more direct links between cultural institutions and economic and social forces." All of this should be recognized as an immediate necessity as the "crisis in culture" was "symptomatic of the crisis in the established order." Ultimately, while no cultural policy alone would be capable of solving all the woes of the general crisis, "it can and must help every individual to cope with it and help society to 'manage' it." In short, any cultural policy must "embrace meaningful social practices" and foster "conditions favorable to creativity."[28]

It is not surprising to find Michel de Certeau as a founding member of the Arc-et-Senans Colloquium. Much of the *Declaration* reads as an insistent blueprint for bringing to life the theory that he outlined in his subsequent 1974 work *The Practice of Everyday Life*. When looking for sites of resistance to the culture industries, his injunction was to leave off "functionalist rationality" and to listen to the "murmuring of everyday practices," for it was there that the ordinary man engaged in his meaningful creativity, where he engaged in the art of "making do."[29]

In an attempt to embrace a global, pluralistic conception of culture while fostering individual, even regional, creativity, Duhamel established the *Fonds d'intervention culturelle* (FIC) in the early 1970s. With more than a nod to this catholic conception of *développement* rather than simple dissemination, while the Ministry of Culture administered the FIC, it received funds from departments as widespread as Defense, Health, Aménagement du Territoire, and Education. In the ten years after the FIC's establishment it supported roughly thirteen hundred projects, many of them very local, or regional in nature.

This, though, was the decided high-water mark for the Ministry and its expanded cultural ideology. Still trammeled by meager budgets and folded into other departments for much of the decade, it also had to combat a perception that it had become directionless, perhaps even listless, after the very public leadership of Malraux in its first decade. Ironically, this impression was, in part, the result of the hundreds of seemingly disconnected, particularized, projects that had been the FIC's focus. However, more than an apparent lack of policy focus, at least to outside observers, the real pall that hung over the Ministry came from within the government—the general lack of interest, and perhaps even vague ideological distaste, of Valéry Giscard d'Estaing.

A member of the Resistance during World War II, Giscard d'Estaing entered the government after the war as a civil servant, serving as finance minister in the 1960s. In the 1974 presidential election, precipitated by the early death of Georges Pompidou, he defeated François Mitterand and served as president of the Republic for the remainder of the decade. Aesthetically he was more classically inclined than his predecessor, and more classically liberal in economic ideology than his socialist opponent in the election; these two personal impulses developed into a more-distanced and "hands-off" policy as it related to culture. While the *développement culturel* of Duhamel and the Arc-et-Senans Colloquium was an expansion and adaptation of Malraux's earlier policy of democratization—itself a more pointed idea of cultural manufacture and maintenance than the defensive and protective measures of the Fourth Republic evident in bodies like the Oversight Commission of the 16 July 1949 Law—the central supposition of state intervention in culture had never been questioned; in fact, it had been, in some instances, strengthened and made more expansive, at least ideologically, with the adaptation. "Giscardian liberalism," though, "came close to questioning that dogma."[30]

Cultural policy played so minimal a role in how Giscard imagined his administration that he was "famously silent" on the subject in his 1976 book *La Démocratie française*. That is not to say that there was a complete policy vacuum during his tenure. Theater, a favorite of Giscard's and his first secretary of state for culture, Michel Guy, was granted a funding reprieve with the introduction of three-year contracts for the Centre Dramatique National (CDN), which freed them from the task of securing monies annually. "The effect of this," as was pointed out by David Looseley, "was to focus the CDNs on a more clearly defined, fixed-term creative plan, or 'project.'" But this governmental largesse was indicative of Giscard's more aristocratic sensibilities as they concerned culture. Rather than the policy of democratization and

"Nowadays," the *Arc-et-Senans Declaration* continued, "culture embraces the education system, the mass media, the cultural industries (newspapers, books, records, video-cassettes, the cinema, advertising, housing design, fashion)," while what was termed "bookish, academic culture" was "degenerating."[27]

In fact, established culture had not only become sclerotic and marginalized, but was "foreign to most sections of the population" while encouraging "certain forms of nihilism." At the same time, the cultural industries were moved by market forces and profit motives, the result of which was to subject the individual "to an indiscriminate barrage of information from the mass media." The individual, though, according to the *Declaration*, lacked the means to cope with this deluge that fostered conformism while turning them into mindless consumers. The corrective for this commercial "totalitarianism" was creating the "conditions for a decentralized and pluralistic 'cultural democracy' in which the individual can play an active part." One of the key features of any such decentralized "cultural democracy" was to provide "more direct links between cultural institutions and economic and social forces." All of this should be recognized as an immediate necessity as the "crisis in culture" was "symptomatic of the crisis in the established order." Ultimately, while no cultural policy alone would be capable of solving all the woes of the general crisis, "it can and must help every individual to cope with it and help society to 'manage' it." In short, any cultural policy must "embrace meaningful social practices" and foster "conditions favorable to creativity."[28]

It is not surprising to find Michel de Certeau as a founding member of the Arc-et-Senans Colloquium. Much of the *Declaration* reads as an insistent blueprint for bringing to life the theory that he outlined in his subsequent 1974 work *The Practice of Everyday Life*. When looking for sites of resistance to the culture industries, his injunction was to leave off "functionalist rationality" and to listen to the "murmuring of everyday practices," for it was there that the ordinary man engaged in his meaningful creativity, where he engaged in the art of "making do."[29]

In an attempt to embrace a global, pluralistic conception of culture while fostering individual, even regional, creativity, Duhamel established the *Fonds d'intervention culturelle* (FIC) in the early 1970s. With more than a nod to this catholic conception of *développement* rather than simple dissemination, while the Ministry of Culture administered the FIC, it received funds from departments as widespread as Defense, Health, Aménagement du Territoire, and Education. In the ten years after the FIC's establishment it supported roughly thirteen hundred projects, many of them very local, or regional in nature.

This, though, was the decided high-water mark for the Ministry and its expanded cultural ideology. Still trammeled by meager budgets and folded into other departments for much of the decade, it also had to combat a perception that it had become directionless, perhaps even listless, after the very public leadership of Malraux in its first decade. Ironically, this impression was, in part, the result of the hundreds of seemingly disconnected, particularized, projects that had been the FIC's focus. However, more than an apparent lack of policy focus, at least to outside observers, the real pall that hung over the Ministry came from within the government—the general lack of interest, and perhaps even vague ideological distaste, of Valéry Giscard d'Estaing.

A member of the Resistance during World War II, Giscard d'Estaing entered the government after the war as a civil servant, serving as finance minister in the 1960s. In the 1974 presidential election, precipitated by the early death of Georges Pompidou, he defeated François Mitterand and served as president of the Republic for the remainder of the decade. Aesthetically he was more classically inclined than his predecessor, and more classically liberal in economic ideology than his socialist opponent in the election; these two personal impulses developed into a more-distanced and "hands-off" policy as it related to culture. While the *développement culturel* of Duhamel and the Arc-et-Senans Colloquium was an expansion and adaptation of Malraux's earlier policy of democratization—itself a more pointed idea of cultural manufacture and maintenance than the defensive and protective measures of the Fourth Republic evident in bodies like the Oversight Commission of the 16 July 1949 Law—the central supposition of state intervention in culture had never been questioned; in fact, it had been, in some instances, strengthened and made more expansive, at least ideologically, with the adaptation. "Giscardian liberalism," though, "came close to questioning that dogma."[30]

Cultural policy played so minimal a role in how Giscard imagined his administration that he was "famously silent" on the subject in his 1976 book *La Démocratie française*. That is not to say that there was a complete policy vacuum during his tenure. Theater, a favorite of Giscard's and his first secretary of state for culture, Michel Guy, was granted a funding reprieve with the introduction of three-year contracts for the Centre Dramatique National (CDN), which freed them from the task of securing monies annually. "The effect of this," as was pointed out by David Looseley, "was to focus the CDNs on a more clearly defined, fixed-term creative plan, or 'project.'" But this governmental largesse was indicative of Giscard's more aristocratic sensibilities as they concerned culture. Rather than the policy of democratization and

dissemination that had been the focus of Malraux's *action culturelle*, much less the championing of everyday life proposed by Duhamel and the *Arc-et-Senans Declaration*, "giscardisme culturel" sought instead to bring into relief a clear differentiation between "professional creation and amateur creativity, art and *animation*."[31] The hierarchical distinction between high and low art, high culture and popular culture, was reified in Giscardian policy. The former was returned solely to recognized and professional artists freed from the need to explain themselves in terms of social activism, while the latter was more or less left to the vagaries of the "culture industries" decried earlier by the authors of the *Declaration*. In the process an explicit hierarchy among producers of culture was maintained by ministerial funding policies. In 1977, for instance, the annual budgets for all MCs and Centres d'Action Culturelle (CAC) outside of Paris was less than half that of the Opéra de Paris alone. Not even the prized, and heretofore privileged, written word was spared in Giscard's liberalization program. In 1979 the price of books, which had been regulated for 120 years, was unmoored from government protection and set adrift the shoals of the market while the administration offered a quiet approval of planned mergers between printing and industrial giants. These policies, for some on the left the most disastrous, signaled a regime gone too far and a "rejection of a long- standing acceptance that books had to be treated differently from other commercial products."[32]

In fact, it was on this front that a reconstituted Socialist Party (PS) struck out most loudly in the years leading up to the 1981 presidential election. Developing the concerns of the *Declaration* and taking aim squarely at President Giscard and his policies, they declared that such acquiescence to the market forces of capitalism both atomized the individual and offered only conformism. The global, and quotidian, conception of culture that the PS had nurtured throughout the decade brought along with it the parallel realization that capitalism was also a global force in its reach and required the continued de-differentiation of the world's populations to further the expansion of its markets. Hence, Giscardian policies, which would leave care of the popular culture to the whims of the market, imperiled the very identity of France as a distinct nation.

In response to this supposed threat to the Republic, in the months leading up to the 1981 presidential election, the PS campaigned on its "110 propositions pour la France," which proffered a decentralized approach to local culture meant to encourage regional creativity while providing a strong central program of spreading and protecting French culture around the globe.[33]

Specifically, the PS emphasized equal access to all cultural outlets for all citizens, and a bolstering of both history and philosophy in the primary education curriculum. In addition, the plan also meant to allow regional control of everything from the laying of streets to directing the development of community life, while the central government would foster the continued French identity of those living outside the Hexagon, most immediately by the creation of an "académie francophone" with the Canadian province of Quebec. Finally, the party swore to once again make books more than a simple commodity by reinstating pricing guidelines while placing "the cultural renaissance of the country" at the center of all socialist ambitions.[34]

In a contested election, the four primary candidates all essentially agreed on issues like the necessity of arts education in the schools and the need to increase state expenditure on culture generally.[35] There was also a consensus on the broader issue of making the more catholic, organic, and quotidian understanding of culture an official state policy at last. This general agreement had the effect of doing two things. First, it made culture an issue at the very heart of the presidential election. Second, it gave the PS a substantial advantage during the campaign as it was the socialists who had most thoroughly developed the global and malleable concept of culture that now was simply assumed, and also considered potential ways in which to institute any policy. With this as the political backdrop, and a skillfully crafted campaign that portrayed Mitterand as both a principal architect of socialism as "cultural project" and also "la force tranquille," the PS carried the May election.[36]

The role that culture was to play in Mitterand's administration was signaled almost immediately by the reconstitution of a stand-alone Ministry for the first time since 1974. Taking the helm as the minister of culture was the flamboyant Jack Lang, who had come up through the theater and played an important role in fashioning Mitterand's cultural identity during the presidential campaign. Though Lang was to some a polarizing figure in France's cultural scene he quickly set about enunciating an active plan that elaborated the concerns outlined by the *Arc-et-Senans Declaration* and the solutions proffered by the "110 propositions."

In 1958, André Malraux, while serving as the spokesperson for Charles de Gaulle's interim government, had declared that "the French will not forgive others, or themselves for becoming a people without a mission."[37] Lang now identified a grand mission for the Mitterand administration and the French people as a whole: the protection of regional and local cultures and heritages and the creation of vibrant cultural artifacts that were expressions

of the individual in the face of mass making culture industries.[38] The global reach of capitalism meant that the issues raised by Lang and others were not unique to France. Here again, Lang embraced the concerns of the founders of the Fifth Republic. This time it was none other than Charles de Gaulle, who had first made cultural policy an overt concern of the French state and culture itself a central part of his vaunted "Middle Way." President de Gaulle once declared that France had "been the soul of Christianity," and was now "the soul of European civilization," entrusted with the task of leader, arbiter, and protector of such.[39] Only six months into his first term as culture minister, Lang laid the foundation for the position his Ministry would stake out, and the role that culture should have in the modern world, in an address he delivered at a UNESCO House "Tribute to Picasso." The Picasso that Lang painted in his "tribute" was a subtle admixture of *la culture cultivée*, as appreciated and privileged by the first culture minister Malraux, and the *développement culturel* of Duhamel and the 1972 Arc-et-Senans Colloquium. He was, Lang insisted, "a painter apart . . . to be renowned for having left his stamp on this century," but it was also "Picasso's familiarity with everyday things that makes him a painter of his time." But, Lang continued, referencing the great artist himself on the role of art and culture, "'One does not paint in order to decorate apartments. Painting is an instrument of offensive and defensive war against the enemy.' The enemy," Lang continued in his own words, is "he who oppresses, he who helps to perpetuate injustice. This is the enemy against whom one must make a stand and must be seen to make a stand." The diversity of style, manner, and medium of Picasso's work demonstrated, Lang went on to argue, "a seething mixture of very diverse civilizations," and the appreciation and vitality of his work "offers us an antidote" "in these days when we are all exposed to cultural standardization." The world had entered a phase of false "internationalism" driven by the "world-wide profit system whose promoters seem . . . to have reduced our countries to a state of vassalage." "Neo-colonial cosmopolitanism," Lang spat out, "has the . . . effect of planing down distinctive features . . . and is the source of an impression of subordination and humiliation. We must say yes—and this is the significance of Picasso's work—to the intermingling of cultures and no to the spread of uniformity in the world."[40]

The following year Lang raised similar themes at a 1982 UNESCO organized conference of more than one hundred ministers of culture in Mexico City, this time in even more martial tones as he openly denounced "a certain invasion . . . an immersion in images manufactured from the outside and standardized music." Nations unable to offer alternatives had become

"vassals of an immense empire of profit." The only option was a "real cultural resistance" to this "financial and intellectual imperialism," which could only be realized by collaboration between "countries with similar [and similarly plagued] cultures," which made them "natural allies" in the struggle.[41] There was no doubt, however, after calls to strengthen ties with the French-speaking Canadian province of Quebec and, even more directly, addressing the Francophone countries of North Africa about the French language serving as a shield against cultural imperialism, that France was to lead in any resistance to the threat of cultural neo-imperialism.[42]

Within France itself, Lang turned to *irrigation* (arts education) and *développement*. Focusing on parts of the culture that had previously been ignored, and particularly those sectors that often seemed most mediated by the cultural industries, Lang stressed the need for cultivation and development in what was generally, and loosely, called "youth culture." This meant state recognition and valorization of rock and pop music, the circus, grafitti (*tagging* or street art), and BDs. Arguably, the popularity of these forms alone could well explain the new government's desire to associate itself with them.[43] And as has already become well apparent BDs in particular had become an undeniably popular form by the early 1980s, gaining in both critical notoriety and general consumption in the course of the previous two decades. In the six years between 1975 and 1981 alone BD had become the concern of big publishing houses like Dargaud and Casterman and witnessed its share of the publishing industry's total output double from 1.7 to 3.4 percent.[44] Rock and popular music, meanwhile, were shepherded in by an already existing tradition of promoting music of all styles and genres. Jazz, for instance, is particularly illustrative of the French habit of cultivating a nonindigenous cultural form and ultimately claiming it as their own by way of a complete embracing of the medium and a critical expertise concerning its specific merits.[45]

There was, however, ideologically, more to the valorization of BDs than simply the state appropriation of a popular cultural form by way of a flexible policy as guided by Lang. Whether it was always a conscious plan or a determined policy, "the special responsibility of France for the cultural heritage of Europe, and later the world, became an ever more self-evident part of the French *doxa*, the common sense of the land."[46] By the 1980s, the undeniable popularity of the medium, in France and around the globe, nearly demanded that it become part of the "official" culture if the French were to maintain the pretension of their "special responsibility." Moreover, considering Lang's sometimes too cavalier pronouncements of and against American cultural

imperialism, for some BD marked a point of victory for the French over their chief rivals in cultural matters post–World War II. In fact, the popularity of BD in France had been explained, at least in part, as being the result of the complete assimilation and mastery of the medium, marking a triumph over America and American culture. Correspondingly, by this analysis BDs represent a point of "désaméricanisation."[47]

While this argument implicitly allowed that the BD, at least its modern form, originated in the United States, it also provides for the fact that, given the implied developmental timeline, the medium was closely tied to the growth of a visual consumer culture, as that too was said to have originated in the United States of the late nineteenth and early twentieth centuries. BDs developed alongside and within that consumer culture; and what is recognized as the modern BD, not only in France but everywhere, is both a product of the mass circulation of the daily newspaper, or even BD journal, and an expression of the image-dependent nature of that culture. BDs have played an important role in the expansion of modern consumerism by not only mirroring it in their content but, often, actively promoting it.[48] In fact, the first modern comic book was produced in the United States as part of an advertising campaign.[49] As to their content, they have often offered the message that consumerist affluence can cure most ills, as is the case of the beleaguered Dagwood character and his monstrous sandwiches in the American strip *Blondie*—a practice that the Canadian social and communications theorist Marshall McLuhan characterized as "promiscuous gormandizing as a basic dramatic symbol of the abused and insecure."[50]

In short, BDs, in all their garish variety, are gleaming examples of products wrought by the culture industries so damningly adumbrated by the authors of the *Arc-et-Senans Declaration*. However, the elasticity of the medium also means that it was easily appropriated by de Certeau's "consumer-sphinx" and used to indicate individuality and resistance in the face of a de-differentiated mass society. Here, variegated and "clamorous production" is "confronted by an entirely different kind of production, called "consumption" and characterized by its ruses, its fragmentation (the result of the circumstances), its poaching, its clandestine nature, its tireless but quiet activity, in short its quasi-invisibility, since it shows itself not in its own products . . . but in an art of using those imposed on it."[51] In doing this, the consumer expresses an inventiveness and creativity that belies mindless conformism, and instead illuminates how the individual might appoint an environment to serve its own needs and interests.

When this meager, though nonetheless potent, agency does show itself in the marketplace it is often in the form of parody. BD, as a hybrid medium of text and image with recourse to the mocking grammar of caricature, lends itself particularly well to the lampooning manipulation of tropic stories and accepted dogma. Or as de Certeau wrote: received stories are upended, "reversed by a single 'circumstantial' detail. . . . [T]hese guileful tricks on the part of the storyteller . . . this extra element hidden in the felicitous stereotypes . . . makes the commonplace produce other effects."[52] These broadly iconoclastic practices, or "guileful tricks," are evident in many of the BDs that have been the most popular in France for the last two or more decades and have marked them as political as much as artistic creations.

The character *Super Dupont* (fig. 6.2) who first appeared in the BD journal *Pilote* in 1972—though he found his "home" at the more experimental and risqué journal *Fluide Glacial* three years later—is, for instance, a lampoon of many of the conventions of not only American superhero comic books, *Superman* most obviously, but also French national attitudes. Drawn as a stereotypical example of the hardy, barrel-chested peasant, whose love of wine was betrayed by a forever-reddened nose, Super Dupont's very appearance served to demonstrate that for the French there was more to life than the abstract causes of "Truth, Justice, and the American Way" that the far more physically chiseled Superman spends his days championing and protecting. Sometimes shown with a Gallic cock and armed with the ability to fly, some measure of superhuman strength and invulnerability, a mastery of the French martial art of savate, and the power to cure gonorrhea via a ray that he fires from his hands, he defends those things most typically associated with France—wine, cheese, and the reputation of romance and sensuality—against a secret organization called "Anti-France." Anti-France agents are all foreigners, meaning non-French, and consequently speak the language "Anti-Français," a jumbling of English, Spanish, Italian, Russian, and German.[53]

There are other, perhaps slightly more-subtle, examples of this sort of subverting humor in French BDs. The popular BD *Les Aventures d'Astérix le Gaulois* (fig. 6.3) created by the prominent BD author and artist team René Goscinny and Albert Uderzo for the groundbreaking BD journal *Pilote* in 1959, recounted the story of a small band of Gauls as they defend their village—the last one—from the imperial might of the colonizing Romans. With a particularly Gallic wit and cunning (and the helpful aid of a potion of invincibility), Astérix and his mountainous companion Obélix forever push back the invading Roman legions. Praised for the literary inventiveness on display in the

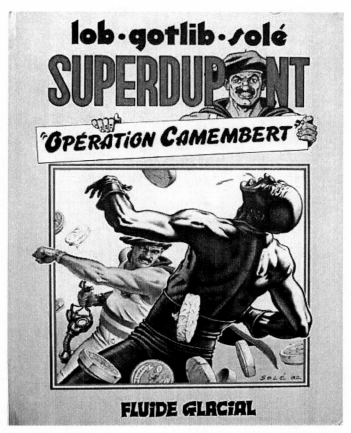

FIGURE 6.2 *Super Dupont*, the paysan Superman. Copyright Fluide Glacial–Audie.

speech balloons of the characters (Egyptians were drawn speaking in a stylized hieroglyphics script, for example), questions of political intent were also raised given the BD's appearance on the heels of the founding of the Fifth Republic and its policies of cultural protectionism.[54] Goscinny, the author of *Astérix* until his death in 1977, however, distanced himself from attributing more significance than simple entertainment to his BD, but did note that the "Romans" should not be seen as Italians but as "organizers" and bureaucrats.[55]

While it would be impossible to attribute any more intent to a specific BD than its creator publicly avowed, the general concerns and fears of a people (or nation) can be gleaned from the surrounding social and political milieu. The years between the ending of WWII and the end of the 1970s, the period

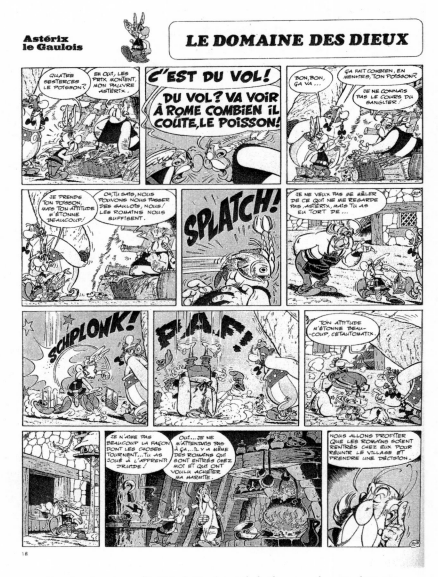

FIGURE 6.3 *Les Aventures d'Astérix le Gaulois.* Likely the second-most ubiquitous Franco-Belgian BD character, behind only *Tintin*. BD here from *Pilote*, no 606, June 17, 1971. Copyright Dargaud.

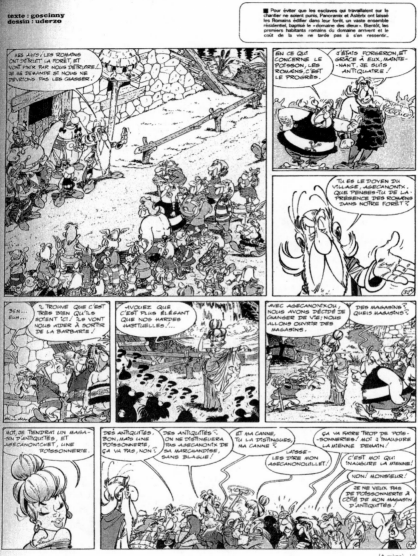

in which BDs not only proliferated but also became an increasingly accepted and acceptable popular culture product in France, witnessed the beginning and ending of the greatest period of economic growth and modernization in French history. *Les trente glorieuses* was marked by a rush so "headlong, dramatic, and breathless" that in ten scant years "a rural woman might live the acquisition of electricity, running water, a stove, a refrigerator, a washing machine, . . . a car, a television, and the various liberations and oppressions associated with each."[56] While BDs served as a site of victory over the threat of "Americanization" for the popular intellectual Pascal Ory, the fears and concerns roused by these radical changes brought to French life remained for the general populace.[57]

Americanization is a slippery and contentious term that has undergone a number of usage changes in its own history. However, as Richard Kuisel has written, it refers at least most generally to an idea of America being the model for "consumer society" or culture. Further, the term suggests not simply the "mass purchase of standardized products of American origin . . . [but also] a style of life that encompassed new patterns of spending, higher wage levels, and greater social mobility." More important, though, it also relied upon cultural practices that were "oriented" solely "around acts of purchase and a materialistic philosophy."[58] In truth, French society did undergo significant and substantial change during that thirty-year period.

Prior to WWII, barely half of the population of France was concentrated in cities and towns of any size, but in the years between 1946 and 1985 the population grew by nearly 15 million from 40.3 to some 55 million. This surge in population, coupled with a concerted program of modernization, served to shift the demographic and cultural make-up of the country from one that was predominantly rural to one dominated by cities and urban concerns. From necessity, then, the very identity of the French worker changed. In 1954 people describing themselves as farmers or agricultural laborers made up almost 27 percent of the active population while those describing themselves as management or office workers accounted for less than 20 percent. By 1975, this socioeconomic breakdown had more than switched, with the "white-collar" professions accounting for some 37 percent of the workforce in France while agriculture had fallen to just under ten.[59] Much of the (re)organization of society that Goscinny's testy Gaul fought against was occurring, with little hope of a magic potion to stave it off.

In this environment, BDs became not only an escapist and disposable time filler for the new breed of French "l'homme disponible" (available man)

who went by car or train to his job in an office somewhere and was "relatively indifferent to distances" he might travel to work, but also a tool for navigating consumer culture itself.[60] If the popularity of not just the form, but also specific journals can be said to indicate something of the concerns and desires of its consumers, often the content of many BDs reflected how deeply invested in, involved with, and even ambivalent toward the social and economic transformations affecting France many readers were.

In the post-68 world of rapidly modernizing France, the weekly journal *Pilote*, the first journal of its kind to be marketed to young adults rather than children, had developed into an ironical guide for its readers, typically young men in late adolescence to their midtwenties. While still bracketed by the form of journals similar to what most readers likely would have grown up reading, much of the content was now marked by satirical entries that addressed issues similar to "Exode rural," subtitled "comment retenir les jeunes" (fig. 6.4). After depicting farm life as being akin to a prison work-camp, this particular BD suggested adding pinball machines to plows and traffic lights for directing tractors in the fields and making those who had grown accustomed to driving cars in the city feel more comfortable on the rural machines. Short of these, and other changes, occurring, the direct suggestion was that more housing likely would be required in the cities. However, in the same issue and only a few pages after this was another BD, drawn in a style reminiscent of looser, less panel-dependent, designs prominent in the nineteenth century, titled "Saisons: Les Riches Heures Du Paysan." Here, in a free-flowing series of drawings framing a brief epigram noting how only peasants knew how to enjoy the seasons and commune with nature any longer while city-dwellers must be content to only "witness the simple and healthy happiness of rural populations," the individual cartoons told a story of a peasant both helping and laughing at an urban couple plagued by automobile and navigation trouble. Significantly, the primary-color cartoons are themselves hemmed by secondary, smaller, black-and-white, cartoons, reminiscent of the graphic inserts that were sometimes found in illustrated medieval examples of popular "Book of hours" texts, and which detailed the current woes of French farmers, from pollution to the ravages of insecticides (fig. 6.5).[61]

Encapsulated in these two BDs alone, many of the desires and concerns of a France caught in transition were highlighted. The advantages afforded by modernization and urbanization (social mobility and disposable income) were trumpeted while what had apparently already been lost (a connection with the traditional agrarian identity of the French peasant) and what was still

FIGURE 6.4 "Exode Rural"—Leaving the land behind. *Pilote*, no 607, June 24, 1971. Copyright Dargaud.

par duvic et alexis

ATTRAYANTE...

DING GELING TING : TING TILT

PRÉVOIR UNE VIE NOCTURNE.

THE OLD FOSSE À PURIN CLUB PRIVÉ

FAIRE ACCÉDER LES RURAUX AUX LOISIRS DES CITADINS COMME, PAR EXEMPLE, LES WEEK-ENDS À LA CAMPAGNE.

SORTIR EN A LE VENDREDI SOIR À 18 H ROULER PENDANT 200 KM SUR L'AUTOROUTE (C) POUR ARRIVER EN B (LA CAMPAGNE) VERS 21 H 30

AAH !... ON RESPIRE !

VOUS AVEZ DES ŒUFS FRAIS ?

DONNER AUX REPRÉSENTANTS DE LA LOI UN ASPECT PLUS MODERNE.

PÊCHE INTERDITE

NUL DOUTE QUE SI L'ON MET EN ŒUVRE TOUS CES MOYENS, LA POPULATION VA RAPIDEMENT AUGMENTER DANS LES CAMPAGNES, IL FAUDRA CONSTRUIRE DES LOGEMENTS ...

TEXTE DUVIC DESSIN ALEXIS

... ET LE PROBLÈME NE SERA PAS LOIN D'ÊTRE RÉSOLU DÉFINITIVEMENT... ②

9

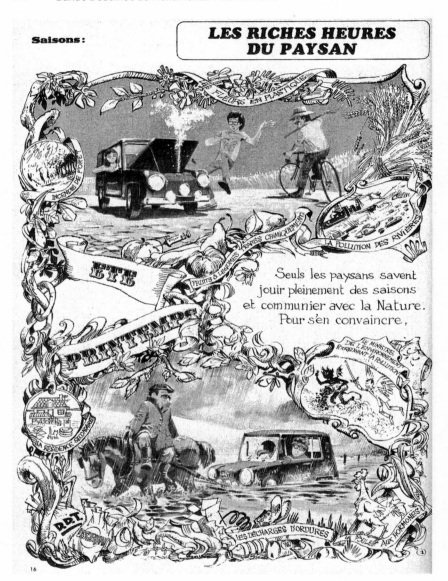

FIGURE 6.5 "Saisons: Les Riches Heures Du Paysans"—the little pleasures of the countryside. *Pilote*, no 607, June 24, 1971. Copyright Dargaud.

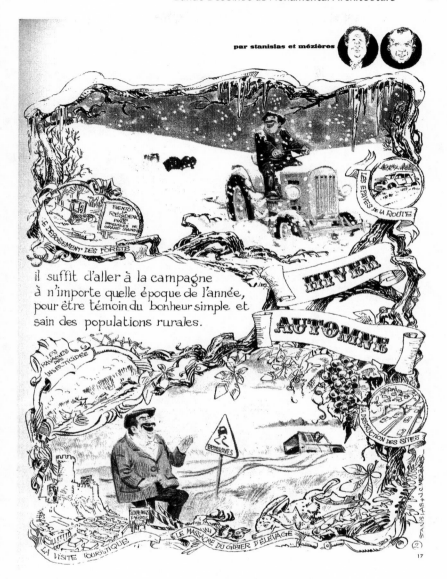

FIGURE 6.6 "Mr. Durand"—the typical modern Frenchman. *Pilote*, no 603, May 27, 1971. Copyright Dargaud.

par pélaprat et poppé

EN GOING AU BOULOT, HE IS REVING AU FUTUR TUNNEL UNDER THE MANCHE WHAT UN PLAISIR QUAND LE CÔTÉ FRANÇAIS, ÉTINCELING DE PROPRETÉ, FERA TERRIBLELY CONTRASTE WITH THE GRISAILLE OF THE CÔTÉ ANGLAIS TOUT POLLUED OF CRASSE! IT IS LÀ QU'ON VERRA THAT ON VERRA!

NOW, HE IS AU BOULOT. HE IS COMMERÇANT. A CLIENT ACHÈTE SOMETHING QUI COÛTE 5 FRANCS. THE CLIENT GIVES A BILLET OF 10 FRANCS. WHAT DOES M. DURAND FAIRE? M. DURAND REND THE MONNAIE!! NOT UNE SECONDE IL N'A PENSÉ KEEP ALL THE FRIC!

ENFIN, EN RENTRING CHEZ LUI, M. DURAND TAKE UN BAIN.

ALORS?

WHAT IL VOUS A PRIS, DEAR ANGLAIS FRIENDS? I CROIS UNDERSTAND. WHEN THE GÉNÉRAL CAMBRONNE SAID HIS FAMOUS WORD, IT WAS SIMPLEMENT BECAUSE IL ÉTAIT EN COLÈRE, BUT YOU MADE PEUT-ÊTRE UNE CONFUSION, THAT EXPLIQUE YOUR ERROR OF AUJOURD' HUI. WITH YOUR MANIE OF THE MONDANITÉS, YOU CROYED, WITHOUT DOUTE, QU'IL VOUS PRÉSENTED HIS ARMY. IT WAS NOT ÇA DU TOUT, DU TOUT, I HOPE, DEAR ENGLISH FRIENDS, THAT YOU HAVE ENFIN COMPRIS...

MERDE

AOH? MOI, C'EST WELLINGTON. HOW D'YOU DO?

BUT YOU WILL COMPRENDRE ÉGALEMENT QU'UN WORD D'EXPLICATION IS NECESSARY TO OUR FRENCH LECTORS; BECAUSE (DO NOT TAKE ÇA MAL) THERE ARE PAS DES MASSES QUI LISENT LA PRESSE ANGLAISE.

NOS LECTEURS FRANÇAIS DONC, AURONT BIEN VOULU NOUS EXCUSER. CEUX QUI NE COMPRENNENT PAS L'ANGLAIS ONT ÉTÉ UN PEU PERDUS; CEUX QUI LE COMPRENNENT AUSSI D'AILLEURS, QU'ILS SACHENT DONC QUE CETTE TRANCHE DE VIE, PROPRE, VERTUEUSE ET HONNÊTE N'EST QU'UNE RIPOSTE DIGNE, ENCORE QUE VITRIOLÉE, À LA PRESSE ANGLAISE QUI A DÉCLARÉ:
"LES FRANÇAIS SONT SALES, OBSÉDÉS SEXUELS ET MALHONNÊTES!"
NON, MAIS, HO!?...

TEXTE PÉLAPRAT — DESSIN POPPÉ ②

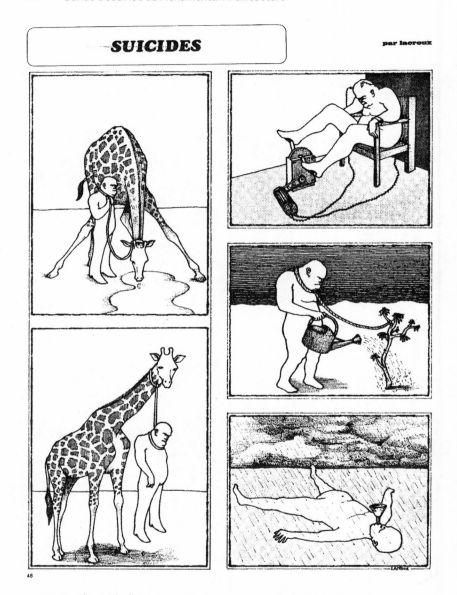

FIGURE 6.7 "Suicides," *Pilote*, no 605, June 10, 1971. Copyright Dargaud.

imperiled (the land itself) was lamented. In an issue that had appeared only weeks earlier the concerns of those unfamiliar with long-distance travel were lampooned while stereotyped assumptions that Americans and English were believed to hold of the French were lambasted in a mixed-language BD depicting a day in the life of Mr. Durand, who was honest, well groomed, and not sexually obsessed. In short he was, according to this particular BD, an example of the typical "français moyen" (fig. 6.6).[62]

Clearly many of the new realities of modern French life had become comedic fodder for BDs even as serious concerns were broached in their colorful panels. Still, while often making pointed jest of sites of significant change in French society, the journals themselves also served to not only colorfully detail what could be expected of modern life—ease of travel, variety in entertainment, economic opportunity—but also what was expected by a modern society of its participants/communicants. To this end, there always were a large number of advertisements for affordable consumer items like portable phonographs and tape recorders, disposable and electric razors, and motorbikes.[63] *Pilote*, however, went even further than simple advertising. In a semipermanent section at the back of the journal titled "Piloto-Flashes, Nouveautés," the editors offered suggestions of what the "New Man" should have at his disposal and in his wardrobe, thereby seeming to endorse not only particular products but a way of life.[64] Nonetheless, there always seemed to be an odd and awkward undercurrent of resistance even in these instances of apparent welcoming of modernization and urbanization. Ironically placed either immediately before or after this section, even the most macabre dimension of the distinction effacing and anomie fostering conditions of contemporary consumer society was reduced to humorous fare in a periodically recurring BD simply titled *SUICIDES* (fig. 6.7).[65]

Just as nineteenth-century readers of Balzac's serialized *La Comédie Humaine* had recognized their foibles and fears in his prose, by the 1970s readers of BD journals like *Pilote* witnessed their own being drawn out in fully realized illustration. Moreover, the work of *intellectualizing* the medium had already long been underway—if not completed—by a broad coterie of critics, artists, authors, and simply appreciators of the form since the 1950s. By the time that de Gaulle returned to power and refocused the government's interests specifically on the forms and products of *high culture*, the members of the Oversight Commission had been mucking about in the hazily defined world of popular culture and insisting on the significance of BD, in concert with other modern media to be sure, as an important part of the social milieu

of the nation's youth for the better part of a decade. Along the way, they had cultivated and relied on a broad web of "experts" whose purview was precisely the articulation of the roles popular media played in socialization. With the government's turn toward the embrace of expressions of high culture in the elaboration of a specifically French identity, evaluation of the merits of popular culture now fell squarely to this swath of (sometimes) quasi-official experts and academics.

This, in turn, happened at precisely the time that French "intellectuals," as Lebovics has noted, "were ready to make one of those daring and dazzling jumps in thinking that we have come to recognize as their method of attack on so thick-walled a culture."[66] While members of the Oversight Commission, and their sympathizers, fretted about *what* was being communicated in BDs and other popular media, another strata of the nation's intelligentsia was calling into question the nature of *communication* itself; in the process, interrogating "culture" in its broadest anthropological sense. Spurred by the swirled impulses of an increasingly embattled notion of what—precisely and "naturally"—constituted "Frenchness," the remnants of earlier political-aesthetic movements like surrealism, and the Saussurian linguistics that lent itself to the birth of structuralist theory, these intellectuals sought to lay bare the presumptions that held together the accepted *doxa* of the culture-nation.[67]

"Literature is *communication*," insisted the librarian, author, and reluctant philosopher Georges Bataille in 1957, and "[c]ommunication requires loyalty." For the inspired-by-the-esoteric author, this loyalty was the result of "complicity in the knowledge of Evil." "Literature is not innocent," he continued, "[i]t is guilty and should admit itself so." The guilt that Bataille was pressing for literature to admit, was in part, its failure to break nineteenth-century limitations "after the Great War" when it "seemed pregnant with revolution."[68] Instead literature, and by extension communication itself, fell short and was once again a force of constraint, not liberation.

At the same time, though in less florid prose, the structural semiologist Roland Barthes was undertaking an investigation of what he held to be "the falsely obvious." "The starting point of these reflections," he insisted, was his resentment at "seeing Nature and History confused at every turn, and I wanted to track down in the decorative display of *what-goes-without-saying*, the ideological abuse which, in my view, is hidden there."[69] For Barthes almost all media, and for Barthes most everything—from the fins on a Cadillac, to an "all-in" wrestling match, to an issue of *Paris-Match*—was media, engaged in a process of myth making in the construction of the "naturalness" of "the

bourgeois norm."[70] In this span of years when, according to Jean-Pierre Rioux, the "imperial mystique was . . . [often] carried to a level rarely equaled in the history of French colonialism," Barthes was casually confronted with a particularly duplicitous example of this myth making on the cover of an issue of the aforementioned journal.[71] "I am at the barber's," he wrote, "and a copy of *Paris-Match* is offered to me. On the cover, a young Negro in a French uniform is saluting, with his eyes uplifted, probably fixed on a fold of the tricolour." What is on display is "the *meaning* of the picture," but what it signified was that "France is a great Empire, that all her sons, without any colour discrimination, faithfully serve under her flag . . . French imperiality condemns the saluting Negro to be nothing more than an instrumental signifier, the Negro suddenly hails me in the name of French imperiality; but at the same moment the Negro's salute thickens, becomes vitrified, freezes into an eternal reference meant to *establish* French imperiality."[72] In other words, the image served to create myth. By simply stating "*the fact* of French imperiality without explaining it," without notice of its complexity, one gets "very near to finding that it is natural and *goes without saying*: I am reassured." And that is the role of myth, "it organizes a world without contradictions because it is without depth . . . it establishes a blissful clarity."[73]

For Barthes, the process of myth creation was laden with even more circumscribing tension when images and text were forced into interplay, as with a newspaper photo and its caption. In his later work "The Photographic Essay," he introduced a concept of context, noting that "a photograph can change its meaning as it passes from the very conservative *L'Aurore* to the communist *L'Humanité*," the very name of the paper "abstractly" informing readers as to what the image could mean. More than that, however, the caption of an image, by its nearness to the image—thereby appearing to be enveloped by its, *naturally* occurring, greater obviousness and truth—is "innocented" by it; all the while, "the text loads the image, burdening it with a culture, a moral, an imagination." Even more, "sometimes . . . the text produces (invents) an entirely new signified which is retroactively projected into the image."[74]

The work of Barthes and his fellow "68ers" ultimately nearly excluded the possibility of a stable *being*, free from interpellation, altogether.[75] Or, as Michel Foucault was to argue when describing his own project: "The search for descent is not the erecting of foundations: on the contrary, it disturbs what was previously considered immobile; it fragments what was thought unified; it shows the heterogeneity of what was imagined consistent with itself." Not even the individual body escaped the wrapping and warping presumed exposed by

the structuralist and poststructuralist project, for the "body is the inscribed surface of events (traced by language and dissolved by ideas)" and "nothing in man . . . is sufficiently stable to serve as the basis for self-recognition or of understanding other men."[76]

For all his work investigating the falsely obvious in the contours of automobiles, faux-sport, and popular journals, neither Barthes, nor any of his relative intellectual cohorts, spent much time with the surprisingly subtle and nuanced cultural product that likely lay in near piles at their feet on every newsstand—right next to the latest issue of *Paris-Match*.[77] Wading in the shallower ends of this theory pool, perhaps, a broad coterie of appreciators of BD was beginning to argue its merits on the very basis of its communicative structure as a hybrid medium of print and image. A construction that made it, they argued, a medium particularly well suited for appreciation and recognition in France in the current era of transition.

As early as 1951, when the still new Oversight Commission was likely at the apex of its influence, Marshall McLuhan was confident that within ten years the French would come to appreciate American comics, comic books, and comic magazines as a novel new art form.[78] Just over a decade later, and almost as if he were waiting on his properly timed cue, the Sorbonne professor and influential film critic Claude Beylie insisted that the French, "despite their innate cunningness, as a result of their humanist or pseudo-humanist prejudices have, as in other disciplines, arrived last on the scene. However, faithfully living up to their reputation, they have decided to make up for lost time: postulating immediately that *bande dessinée* is an art."[79]

Beylie was making reference most directly to the *Club des Bandes Dessinées* (CBD), founded in 1962, which coined the term le neuvième art (the ninth art)—the seventh art being cinema, and the eighth, television—for the medium at its inaugural meeting. Composed of sundry cultural commentators and critics, the CBD counted among its initial members New Wave filmmaker Alain Resnais and actor, screenwriter, and media critic Francis Lacassin, sociologist and early academic defender of the medium Evelyne Sullerot, creator of the adult-themed BD "Barbarella" Jean-Claude Forest, writer Pierre Couperie, and the Italian semiologist Umberto Eco. Given the CBD's membership roll, it would seem nearly impossible to craft a group more precisely fitted to the category of "new petite bourgeoisie" as classified by Bourdieu in his study of the judgment of taste, *Distinction*. For Bourdieu, the "members" of this group were those "who originate from the upper classes and . . . have had to reconvert into the new occupations such as cultural intermediary or

art craftsman." Often, despite not being formally a part of the traditional cultural elite (for whatever reason), they "possess a very great cultural capital of familiarity and a social capital of 'connections.'" Due to their "ambivalent relationship" with the traditional system, they are often inclined toward "forms of culture which are, provisionally, at least, on the (lower) boundaries of legitimate culture—jazz, cinema, strip cartoons, science fiction—as a challenge to legitimate culture." Even in this, however, "they often bring into these regions disdained by the educational establishment an erudite, even 'academic' disposition which is inspired by a clear intention of rehabilitation."[80]

There likely could be no better description of many of the CBD's members, and certainly not of their project for BD. In an attempt to provide their union more intellectual heft, the CBD quickly "rebaptized" itself the *Centre d'étude des littératures d'expression graphique* (CELEG) while its project of legitimation, or rehabilitation, of the medium was unfurled in the first issues of its journal *Giff-Wiff*.[81] Set as an early part of its agenda in the 1960s, the express concern of the CBD was to counter the "censure and prejudices that BD endures." To do this, to rehabilitate and legitimate the form, the intent of the members was to "define its aesthetics and the role which it plays in mass culture," while demonstrating that, in France at least, "BD no longer belongs to children and has conquered as wide a public as cinema has." Finally, as part of the project of rehabilitation, members sought to "study what BD owes to painting, to cinema and what BD itself can bring to other arts."[82]

While jazz—the other important twentieth-century cultural product saddled with the baggage of an American provenance—was receiving the imprimatur of the state by way of official promotion and (all-important) funding, BD received little to no recognition from the managers of France's "official" culture well into the 1970s.[83] Outside the work of the increasingly inconsequential Oversight Commission, the medium and the journals that relied on it seemed to seldom catch the attention of government officials. Unfortunately for those like the members of CBD/CELEG who sought its official legitimation as a recognized art form, when attention was paid to the medium the cause was often editors and publishers who had overstepped the "natural" bounds of decorum in their pursuit of satire, bringing the predictable result of censure on the part of the government.

Such was the case with *L'Hebdo Hari-kiri* after the death of Charles de Gaulle on November 9, 1970. The same journal that had been barred from sale in 1961 when it was a monthly, it had reappeared in 1966—becoming a hebdomadaire in 1969—and remained an oft-cited example of the immaturity and

dangerousness of the press illustrés. After the former president's death, and referencing a Paris discotheque fire ten days prior to his passing in which 146 people died, the journal's next issue appeared with an oversized headline that read: "Bal tragique à Colombey—un mort!" (Tragic ball at Colombey—one death!). Immediately, the Interior Ministry placed another interdiction on the publication and it was banned from sale.[84]

Beyond these sorts of overtly political interdicts, which periodically did occur and usually in immediate response to a specific incidence that did not rely on "review" by the Oversight Commission, the members of the CBD, and others like them, did succeed in slowly stimulating acceptance of the medium, if not of particular examples of BDs themselves. Through their own journals, festivals, and salons, an amorphous community of fans, authors, and even critics managed to create an informal infrastructure that kept itself and others up to date and informed about the medium in the years between (roughly) the founding of the CBD in 1962 and official government recognition of the medium that was to come in the first years of the Mitterand presidency. Along the way, this community, often spearheaded by (former) members of the CBD if not the club itself, managed several victories of recognition.

One of the first public exhibits of BD in France was held at the Paris Musée des Arts Décoratif in 1967; titled "Bande dessinée et narration figurative" it featured Franco-Belgian as well as American artists and, thanks in part to a prominent notice in the "Les Courants Actuels" section in the April issue of the popular culture and arts journal *Connaissance des Arts*, attracted a half million visitors over three months. The catalog that accompanied the exhibition would go on to be published as a groundbreaking (due in part to its nostalgia-tinged accessibility and popularity) stand-alone text titled *A History of the Comic Strip*. Organized by members of *la Société civile d'études et de recherches des littératures dessinées* (SOCERLID), a group lead by the writers Claude Moliterni and Pierre Couperie (who was the principal author of the exhibit catalog) that had broken away from the CBD, the rival organization aggressively sought to push awareness of the medium as a complicated and nuanced mass-cultural form. In addition to the exhibits the group organized (after Paris, the 1967 exhibition toured several European and world capital cities) SOCERLID published its own critical journal of the medium called *Phénix*. Though it would last only forty-seven issues, ending in 1977, the journal quickly became an influential model of the broad approach to the medium for which French fans (*bédéphiles*) would soon become well known. Often carrying reprints of old comics, deep studies of individual artists and authors,

and work from around the world, *Phénix* was emblematic of the catholic and international appreciation and subtle, even academic, analysis of the medium that has today become an accepted commonplace among both bédéphiles and even casual observers in the country.[85]

The 1960s and 1970s also witnessed BD becoming a suitable and fashionable topic for specifically academic discourse. A process that had begun with the work of founding CBD member Evelyne Sullerot, who authored *Bandes Dessinées et Culture* in 1966 with the express intent of fighting against the prejudices the medium faced. BD, she argued, represented and influenced vital "sub-cultures" and, as a mass medium, had become an important "reservoir of mythology" for the modern world.[86] Three years later, the art historian Gérard Blanchard published the *Histoire de la bande dessinée*, and signaled the beginning of what might be seen as official recognition of the form by the French Academy.[87] In 1976 the prestigious academic journal *Communications* devoted an entire issue to BD, with the semiologist Pierre Fresnault-Deruelle developing a structuralist-inspired narratology for the medium that argued its novel communicative form was the result of tension between the linear representation of a narrative sequence that required breakage or discontinuity and the surface representation that presented itself as a continuous whole.[88] Though it was not the first time that Fresnault-Deruelle had put forward this sort of argument regarding the novelty and ingenuity of the medium's communicative model, the fact that it appeared where it did seemed to serve notice that, at least in the academic realm, BD had arrived as a serious form.[89]

More than anything, however, it has been the annual BD festival in the ancient city of Angoulême that has raised the national profile of the medium within the Hexagon and the international reputation of the French themselves as true connoisseurs of the form. In the last several decades France has become a nation of festivals with official public holidays supplemented by vast numbers of "non- or semi-official *fêtes*." It has been estimated that in the summer of 1993 alone some five hundred festivals took place, and that number had grown to almost one thousand by the year 2000. Celebrating everything from music, cinema, food, and rallying to social causes like antiracism campaigns while supported by the government they have become an extremely visible way of "keeping debates about language, citizenship and 'Frenchness' itself at the front of the national agenda."[90] When it comes to the salon/festival at Angoulême, its history seems rather prosaic considering the major international event that it has become. Started by local businessmen and bédéphiles the first salon took place in January 1974 and included artist guests from both

France and internationally, most notably Burne Hogarth, artist/author of the ever-popular (and censured) "Tarzan," and the winner of the first *Grand Prix de la Ville d'Angoulême*—the award given to a single author/artist in recognition of their contribution to the BD medium—the Belgian artist André Franquin, creator of the magnificently indolent character "Gaston Lagaffe."[91] Over the course of the decade and into the 1980s, the salon/festival grew in size and reputation with both legendary international artists like Will Eisner (creator of the influential American BD "The Spirit") and the creators of landmark French BDs such as René Pellarin (also known as Pellos and likely most remembered for his groundbreaking 1930s BD "Futuropolis") being awarded the festival's increasingly recognized and coveted award.

It was into the swirl of this environment of increasing popular acceptance and cultural appreciation for the medium that Jack Lang stepped when he appeared at the 1982 festival, affording the growing meeting the imprimatur of Mitterand's new PS government, and addressed the excited but wary crowds. Lang was quick to decry the reputation that BD had as a *sous-produit littéraire* (second-rate literature), harmful to children and worthless for adults; he insisted instead that the medium deserved to stand alongside other literary and visual art forms beloved in France. In an echo of the *Arc-et-Senans Declaration* from a decade before, BDs, he asserted, had served to foster creativity and an aesthetic sensibility in just those segments of the population for whom "established culture" had become foreign. As part of the speech he also unveiled his "15 mesures pour la bande dessinée." Central to his plan for the medium was continuing and increasing state support of artists and producers and the founding of the *Centre National de la Bande Dessinée et de l'Image*, which was to be counted among Mitterand's prestigious *grands projets présidentiels*.[92]

The appearance of the minister of culture at the annual festival generated no small measure of ambivalence from the more committed bédéphiles around the country; though Lang was arguably the man most responsible for fitting an idea of "active culture" into the current government's agenda, the fact that most governmental attention as it related to BDs and journal illustrés had long been directed at forcing a level of control over the medium was not lost on either its creators or fans. In fact, much comment was made about the fact that for all his praise of the medium, none of Lang's "15 mesures" included the repeal of the 16 July 1949 Law. Nonetheless, as others have pointed out, there has long been a "close relationship between culture and politics" in France,

and it is understood to lay "at the very heart of the democratic state," for there "is an active engagement between creator and state, a constant cultural dialectic between government and the public which is, perhaps, unique to France."[93] In many instances this has resulted in a careful guarding and management (if not manufacture) of an "official" culture in/of the French state. Still, what remains undeniable is that the political fortunes and general acceptance of any cultural product or artifact is often mitigated and determined by official state attitudes concerning its value and importance. Hence, while the actual funding of BD artists and authors was met with some vague concerns over governmental control within that community, the medium rapidly ascended in terms of a broad, general cultural legitimation when President Mitterand declared in a television interview later in 1982 that he was a "constant reader of bande dessinée" and then attended the Angoulême Festival three years later.[94] This, as much as the actual funding of the medium by the Ministry of Culture, lead *Libération* to declare that BD had "made its lively entry to the Pantheon of socialist and republican culture," while the "discrete craftsmen of adventures on colored boards are promoted to artists of the regime."[95]

Though there has been, since the beginning of the state's *positive* recognition of the BD form, concern over the co-opting of the form by the government from those most intimately dedicated to the organic vitality of the medium, the building of the center was intended to demonstrate that BD had indeed ascended to the Pantheon of French culture as *Libération* had, and was to be numbered among such tokens and tomes of the culture as those held in the Louvre and the Bibliothèque nationale de France (BNF), both of which were significantly renovated as part of the same campaign. Particularly given that the interior focus of the formidable building designed by the noted French architect (and admitted bédéphile) Roland Castro was laid out as a gallery space rather than some sort of cartoon playland. It is instead a museum intended to preserve original *planches* (BD pages), thereby associating the medium with a sense of patrimony and heritage.[96]

Mitterand's *projets* are bound most immediately to Pompidou's Beaubourg Cultural Center and Giscard's Musée d'Orsay, both of which were intended to create and serve as official loci of collective identity, what Pierre Nora has called "sites of memory."[97] More generally, however, they belong to a long tradition in France of marking a historical cultural patrimony by way of physical construction of a state-sanctioned and -supported "site," while aiming to corral current discourse in order to direct it in the future. A tradition that

Mitterand was more than willing to reaffirm: "There is a direct correlation," he asserted, "between architectural grandeur, its aesthetic qualities, and the grandeur of a people. . . . For me," he continued, "architecture is first among all arts [because] . . . it is a useful art."[98]

From this position, cityscapes become symbol systems that mediate the manner in which individuals interact with one another, often defining their relationship through the character of the physical environment. Consequently, whoever defines the design of these spaces in large part defines the character of the society. Certainly, this was the case with Louis XIV's palace at Versailles, which became a focal point of aristocratic civilization during the seventeenth century, and perhaps, most apocryphally, Baron Haussmann's redesigning of Paris during the Second Empire; broadening the streets and boulevards, creating the "City of Light" but also making it more difficult for revolutionaries to build barricades across the wider avenues.[99]

However, there is much more to the cultural and artistic usefulness of architecture than simply this sense of subtle repression. The modernist architect Mies van der Rohe once declared that the role of the architect and modern architecture was to "express the will of the epoch . . . For the meaning and justification of each epoch, even the new one, lie only in providing the conditions under which the spirit can exist."[100] This is why "culture serves authority, and ultimately the national State, not because it represses and coerces but because it is affirmative, positive, persuasive."[101] In other words, it provides an attractive environment in which a certain idea or notion of oneself (or nation) can be anchored and cultivated, and it is with this prescriptive understanding of the role of architecture that Mitterand's *grand projets* must be considered.

The imagined community of France, the defining edges of *l'hexagone*, were frayed by some thirty years of rapid modernization, urbanization, and population growth, no small measure of which was the result of non-European and Muslim immigrants, many from former French colonies. The consequences of these far-ranging demographic changes in France during *les trente glorieuses* and after led *Le Monde*, in 1991, to declare that the French nation was exhibiting the "telltale signs" of a nation enmeshed in "an identity crisis." That France was, in fact, the "victim of a crisis in civilization."[102] Mitterand was well aware of this pervasive pessimism, as he had earlier insisted that with the *projets* "we are laying the basis for a new urban civilization."[103]

During (and since) construction, Mitterand's massive projects were subjected to sometimes withering critical scrutiny both within France and internationally, nearly always on points of aesthetics and the threat they were to

the traditional identity of France. An editorial appearing in the *Burlington Magazine* in 1989 cheekily noted that

> one of the most enjoyable sights in Paris at present is the twice-monthly scaling of I. M. Pei's pyramid by the team of *alpinistes* employed to clean its sloping glass sides, which have so far proved resistant to mechanical *nettoyage*. This conversion of a functional failure into a pleasurable tourist experience epitomises both the elegance and the refinement of Pei's design, and the whole-hearted determination of the French government to make a success of *le Grand Louvre*.

"The Pyramid," the editorial continued, "is not so much a building as the transparent lid of an underground system of crowd control—and as such it works brilliantly."[104] In some ways the most monumental of the projects, the BNF, was more thoroughly excoriated as the "scandal on the Seine," and declared "hostile to books, hostile to people and hostile to the city of Paris."[105]

Mitterand's response to these criticisms was to assert not simply the manufacture of an urban-centered civilization but one that was open, responsive, and inclusive in an increasingly cosmopolitan and multiethnic nation. "No monument," he insisted, "no facility is to be equated with its use alone. All of them inscribe, in space and time, a certain idea of the useful, the beautiful, of city life and the dealings of men and women among themselves. . . . [advocating] by example or discursive reasoning . . . certain values, certain virtues." Consistent with the PS cultural program, heading the list of virtues to be expounded in the elaborate details of the *projets* was a desire to "make this culture intelligible to the greatest number, to make it accessible to those other than the privileged."[106]

However, even more, the intention was to recast the very *idée d'France*, what constituted "Frenchness." The geometrical and avant-garde monuments that marked many of the projects were criticized not simply because of their brutish appearance but, as Michel Guy, Giscard's first secretary of state for culture, asserted in *Le Monde*, because the Louvre, for instance, had been virtually attacked "by a barbarian ignorant of its history and being."[107] In other words, Pei's massive glass pyramid struck at the very core of the Louvre's place in the crafting of France's traditional identity. But again, in the face of such conservative critiques, Mitterand insisted that even the disruption of the "finished" cityscape was both intentional and reflective of the heterogeneous state of modern France because they demonstrate "a true pluralism, in the

expression of images as well as in that of thought, because everything jostles together and lives together in the same age."[108]

Thus far, attention here has been focused primarily on the rhetorical scrum that surrounded the believed aesthetic, and even ideological, offenses perpetrated on two of the most visible symbols of French cultural identity.[109] But, while these examples have served as lodestones for criticism directed at Mitterand's cultural policies generally, they were only parts of his grander design to reshape and refix the identity of France at a time when the idea of *la nation française* was said to be under attack from both within and without. Moreover, they are examples of "sites of memory" weighted by a specific classical heritage, receiving, at most, grand makeovers in order to render their traditionalist countenance relevant to Mitterand's vision of contemporary France. It had been, after all, the PS and Mitterand's contention, since the 1970s, that cultural policy had atrophied and should be modernized just as any other governmental policy must to keep abreast of changing times and situations. Just as Lang had echoed the *Arc-et-Senans Declaration* in his 1982 speech at Angoulême, so to did Mitterand invoke its concerns in expounding the coherence of his *grand projets*. "A thriving culture reinforces the French national heritage," he insisted, "propagates knowledge and a spirit of invention, [and] creates centers of production."[110] To this end, the critical gaze must be refocused to include the CNBDI. For, it was with this piece in Mitterand's *grand projets* that the state most directly addressed the contemporary cultural landscape of France and looked to both lay bare and strengthen the ties between cultural and economic production.[111] Even more, it is the most obvious and demonstrable instance of the French state's attempt at structural flexibility in the articulation of a modern national narrative, one that is—in part at least—not directly in the hands of government ministries and originates from outside the panopticon of Paris and the Élysée Palace.

The choice to locate the CNBDI in Angoulême has not been without controversy however. Some argued that establishing the CNBDI well outside of Paris in the provincial city was a political move intended to assuage those insistent fans who were clamoring for official recognition of the cultural merit and worth of BD while relegating it to a secondary position in the official political culture of the nation. Thierry Groensteen, one-time director of the BD museum at the center, for instance, once called this situation a "first class burial" of the medium.[112] This, however, overlooks the important, if quiet, place that the city has held in the political and material culture of France for centuries. Proclaimed by local officials the "City of Festivals," it is still marked

as much by the twelfth-century Saint Pierre Cathedral and stunning views of the Charente River and surrounding valley, which lies some two hundred fifty feet below the remaining medieval walls of the original town, as it is by the modern Internet cafes that have opened in the last decade.[113] Nestled in the outer curves of France's historic southwestern wine region, and described as an entry point to "Cognac country," it is the préfecture of the Charente département, a reminder of the storied place that the hilltop town has held in the political history of France. The noble women of Angoulême have served as queens and consorts to both English and French monarchs. The sister of François I, Marguerite de Navarre, was born in the fortified castle, Hôtel de Ville, the remains of which still serve as the center of the city.

Even more than the city's place in the direct political history of France, it is the role it has played in the country's literary tradition that remains at its center. The city and its people have long appeared as reference points in the work of French authors, notably Alexandre Dumas, and as disparate a group of nonnatives as Henry Miller, Gabriel Garcia Marquez, and Mario Vargas Llosa.[114] Arguably, however, it was in the work of Honoré de Balzac that the provincial town and its inhabitants achieved their greatest recognition. Often appearing as a tropic example of what the critic Lionel Trilling once called the "Young Man from the Provinces," characters described as coming from Angoulême peppered his *La Comédie Humaine*.[115] The city itself appeared as a central character in Balzac's short work *Two Poets*, with homage paid to its position as a center of France's paper production and printing.[116] Balzac himself spent much of the summer of 1832 in Angoulême, the guest of the wife of the commander of the local armaments and powder works, Mme Carraud, who was an early appreciator of his work. Treated as a celebrity in Mme Carraud's salon as well as about town, his time there was apparently not simply literarily fruitful but also a balm for his confidence, for it was while in Angoulême that he first became aware of the growing power of his name and reputation.[117]

Home to such important literary salons and the inspiration for tropic figures in nineteenth-century prose, the most direct and physical link the city has with France's literary tradition is also impossible to overlook. Angoulême has long been at the center of France's paper producing and printing industries; sectors of the economy that have been revived in recent decades by the country's demand for BDs. Because of this, the city has also long held an important place in the centralizing policies of first the monarchy and later the Republic(s).[118] Among those who have been critical of the placement of the CNBDI in the city, one of the earliest and easiest critiques was that at least part

of the decision to place the CNBDI in Angoulême was meant to demonstrate that the mayor, Jean-Michel Boucheron, was an energetic and capable "jeune maire socialiste qui crée des enterprises."[119] Of course, Mitterand had a personal attachment to the city as well. At the age of nine he was sent to College St. Paul, a Catholic Christian Brothers' boarding school in Angoulême where his older brother, Robert, had been sent the year before. Among the brothers there he quickly became recognized as a "bon jeune homme catholique."[120] Still, it is also worth mentioning the obvious here; given the importance that was placed on the valuation of a variegated culturescape by Mitterand's government, the "demonstration" of Boucheron as an enterprising young socialist by way of locating the CNBDI in Angoulême is possible only if the cache and "cultural capital" of BDs as something more than simply an economic force is recognized and accepted—that the medium had "become natural . . . a habitus, a possession turned into being . . . [a] product that any reminder of the conditions and the social conditioning which have rendered it possible seems to be at once obvious and scandalous."[121]

In fact, the annual festival in Angoulême, since the inauguration of the CNBDI in 1990, regularly draws in excess of 200,000 visitors for the long weekend at the end of January and has become an annual destination for *bédéphiles* from around the globe while the *Grand Prix de la Ville d'Angoulême* has become a platform for the French state (by proxy) to demonstrate and display their critical mastery over a truly international art and literary form. Still, that point should be considered secondary to the festival itself for it has become a mass expression of de Certeau's "consumer-sphinx." Even while now state recognized and subsidized (in conjunction with other private and commercial interests), it marks an appropriation of public space directly for and by the participants of the festival where they engage in a process of culture making for themselves and on their own terms. For those few days, nearly the entire city becomes an *agora* in the full sense of the ancient Greek, a market place of both goods and ideas.

By way of its artistic and commercial evolution in France, BD had become at least part of the corrective that the authors of the *Arc-et-Senans Declaration* had called for in 1972. It is a cultural product not "foreign" to the ordinary man, that nearly anyone with a *crayon* could participate in producing; and its sheer popularity meant that it could not be ignored by a government so apparently consumed by cultural policy as Mitterand's. The question has been raised as to whether Lang in his 1982 speech, and Mitterand by extension with the CNBDI, intended to champion BD as an indigenous mass culture product of use in warding off the threat of American mass media, or "consecrate its status

as art."[122] However, the very concern presumes that the state's attitudes toward the medium can be judged in abstraction, separate from the whole of its cultural policy. Moreover, it indicates a misinterpretation of the cultural goals of Mitterand's presidency and the direction of Lang's Ministry as it relies almost solely on a continued distinction between high and low art, grand and mass (or popular) culture. Mitterand's policies subtly shifted that which had been France's grounding force since the founding of the Fifth Republic, its cultural policy. Under the guidance of Lang's Ministry the focus of state policy evolved from the conception of a single universal French culture to be disseminated to the masses to a notion, fully realized or not, of a multifaceted and universalist culture which everyone not only had access to but to which they also contributed by the daily art of "making do." As a hybrid medium of expression, BD is the nearly immediate and expressive embodiment of that principle. It straddles the divide between artistic creation and cultural product; and in the hands of its readers it effaced ethnic and social (if not always gender or economic) difference as evinced by the participants of the annual festival at the doorstep of the CNBDI.

"These new cultural instruments," Mitterand wrote in 1989,

born from the *grands chantiers* launched in Paris as in the provinces are akin to many communal houses which agree to a certain idea of the city, this form of collective life where, for the first time 2500 years ago, the Greeks outlined what we still name democracy. . . It depends on men, their choices, to inscribe, in space and time, the will to live together . . . the desire to connect or the resignation to what separates.[123]

The *grand projets* centered in Paris, the Louvre Pyramid and the BNF to name only those discussed here, sought to arrest the notion that the city was the "capital of the nineteenth century," as Walter Benjamin so ably and damningly put it, and mark it as the capital of a challenging present and vibrant future.[124] But the massive, geometrically dominated, designs could speak of and to the universalist virtues championed by Mitterand only obliquely and at an abstraction. By locating the CNBDI in Angoulême, already rich in political and cultural history, he sought to marry the official policy of the state to the diverse, organic, and popular community of cultural production that annually gathered in the city.[125] In this, when Mitterand felt called to "regild the nation's blazon" and settle it to contemporary realities, he turned not only to France's historic past but embraced one of its most dynamic cultural products in the present.

Epilogue

A Sous-Produit Littéraire No Longer

We still have the naivety to believe in certain things. We do not have the detachment
that characterises English humour, we are more militant. If we have a cause to protest,
however minor, we tear open our shirts, run into the street and shout "Shoot me!"
—Plantu

State recognition and valorization of BDs as an important part of a vital cul-
tural policy hardly ended with the construction and dedication of the CNBDI
in 1991. In the years after Lang's 1982 speech at the Angoulême festival there
was a broad celebration of the medium and fostering of other salons and fêtes
at both the national and local levels. Since 1984 the *Centre National du Livre*
(CNL) has maintained a specific commission dedicated to fiscally subsidizing
select(ed) BD artists and authors, the promotion of BD translations and "fan-
zines" and the development of the BD holdings of public libraries. The Minis-
try of Culture, meanwhile, has a section devoted to BD and in 1997, only two
years into the presidency of Jacques Chirac, and fifteen years after Lang's origi-
nal *15 Mesures*, the Ministry issued *15 Mesures nouvelles en faveur de la Bande
dessinée*, which stressed strengthening the ties between different departments
and ministries with an interest in the medium as well as the cultivation of a
better environment for the export of French BDs.[1]

The millennial turn brought with it a determined expansion of museums,
festivals and city salons dedicated to the medium in one form or another. The
CNBDI itself, in fact, neatly capped the first decade of the new century with its
own "modest expansion" when the center's museum reopened after nearly ten
years of retooling and redesign and under a new name, the Cité International
de la Bande Dessinée et de l'Image; a move that Jean-Marie Compte, CNBDI

director since 2005, "sees . . . as having an influence which [will] resonate both nationally and internationally." In spite of these decisions and designs that would seem to quite literally cement Angoulême as the *political* heart of official state recognition of the medium, an almost expected part of the BD-based cultural landscape that continues its struggle as a loose association of Paris-based *bédéphiles* still actively presses for a *Centre international de l'imagerie populaire* to be established in the capital to firmly—and to their mind, finally—demonstrate that the medium had truly become a valued part of the nation's cultural patrimony. Their efforts remain seemingly for naught, but others and other projects have met with much more success. The city of Épinal, home and namesake of the *Images d'Epinal* that were so nearly ubiquitous in the Revolutionary and Napoleonic eras, opened—legitimately so, as Groensteen has remarked—its own *Musée de l'Image* in 2003. The year 2006 saw the first stones being symbolically laid for a *Centre International du Dessin de Presse et d'Humor* at the twenty-fifth "Salon International de dessin et d'humor" in the Limousin city of Saint-Just-le Martel, the self-described "Capitale de la Caricature du Dessin de Presse et d'Humor." The year before, the town of Moulins, with support from the conseil général of the department of Allier, opened its own *Centre de l'illustration*, while 2005 might simply have been *l'année de la BD* according to the popular Ministry of Culture-supported cultural reporting website, *evente.fr*, in recognition of a near explosion in publishing, cinematic adaptations, and a new traveling, mid-year "Fête de la BD" that promised "un veritable voyage à destination de la 'République de la BD.'"[2]

The coherence of these myriad projects has been questioned by at least some commentators and critics but what cannot be denied is the vibrancy and even political currency of the medium in the years since the inauguration of the CNBDI in the early 1990s.[3] Still, this was perhaps not immediately apparent as the cultural correspondent for the *New York Times*, John Rockwell, noted when he visited the annual Angoulême festival in 1994. The scene he described was one of slight bewilderment as longtime participants negotiated the shifted and shifting social terrain of being not just an acceptable commercial product but a broadly recognized cultural artifact. As Rockwell pointed out, the festival's director, Jean-Paul Coumont, was keen to preserve its "slightly clubby status." "It is necessary to be very careful," Coumont pointedly stressed; "We are a little family. If we attempted to develop the festival . . . we would have to be very prudent not to antagonize the artists." This concern came, Rockwell noticed, after a "group of artists noisily withdrew . . . citing 'the fact that the festival has become prodigiously commercialized.'" And these issues came at a

time when the medium, as both a cultural product and industry, was seen as listing with articles appearing in *Le Monde* under headlines decrying a "Malaise in the Ninth Art" while publications of new BDs in 1993 fell by 23 percent compared to 1991.[4]

The commercial downturn, however, seems likely to have been more the result of a generally sluggish French economy in the first years of the decade while increasing production costs of the lavish and traditional albums and simple market saturation served to level off the huge leaps in sales that albums and BD journals experienced within the whole of the publishing industry in the 1970s and 1980s. Nonetheless, by the middle of the decade, BD albums were again to be counted as top sellers across the publishing market. In 1997, the single biggest seller of all BD albums sold some 490,000 copies with a total of BD albums sold for the year topping out at over thirteen million. In a year when total book sales came to almost 343 million, this represented a total share of nearly 4 percent for the entire book market, putting BDs ahead of such traditional literary fare as works of history (1.3 percent), current affairs, politics, memoirs and biographies (1.8 percent), and books on religion and art texts (1.9 percent).[5] In 1996, the best-selling book, again across all sectors of the literary market, with some 700,000 copies sold, was *l'Affaire Francis Blake*—a tale of Blake and Mortimer, an MI5 agent and professor of nuclear physics, respectively, characters that were reborn under the pens of new artists seven years after the death of their original creator, Edgar Pierre Jacobs; in 2000 alone more than 28 million albums, total, were sold.[6]

Large publishing houses such as Dargaud and Casterman (itself bought out by rival company Flammarion in 1999) continue(d) to dominate the BD market as they have since the 1980s and, consequently, a certain caution and conservatism often has a determining influence over what appears under the seal of the major houses. Traditionally popular work like *Astérix*, continued by the original artist Albert Uderzo alone since Goscinny's death in 1977, and specific serialized BDs that have a recognizable and stable market tend to not surprisingly predominate in the publishing mainstream; yet the creative dynamism of the medium remains very visible, with a sophisticated and growing audience. In the last two decades, evermore-personal works of individual trials and struggles have become extremely popular. So much so that one of the most popular BD albums of 1994 was a virtual graphic diary of the process of writing, drawing, and publishing a BD album by two of France's most popular BD artists, Charles Berberian and Philipe Dupuy, principally known as the authors of the "slice of life" BD *Monsieur Jean*. Published by L'Association, a

house and artist cooperative known for its avant-garde projects, their *Journal d'un Album* autobiographically detailed the creative pains and editorial struggles of completing the third issue of *Monsieur Jean*. Ranging across the worries of becoming a new father and the security of their chosen profession, the authors mockingly (and mawkishly) offered the continued ambivalence some still have for individual artists of BDs, if not the medium itself. In a series of panels from *Journal d'un Album* Berberian, drawn as a space alien, explains to a taxi driver what he does for a living only to have the burly driver reply: "Ah oui, je vois . . . vous faites des conneries, quoi . . ." (Oh yes, I see . . . you do that kind of bullshit").

The experiences of Berberian and Dupuy and the boutique press L'Association are likely the most visible examples of an aesthetic renaissance that has carried through the BD community for the last two decades. It is beyond the purview of this work to discuss with any detail or real authority the "radical restructuring of the comic book field in Europe" that has been born along largely on the "rise of small artist-run presses." However, it is generally accepted that when considering both the restructuring of the field and the aesthetic renaissance (and reconsideration) of the medium, among the artist-run presses "the most influential certainly has been L'Association."[7] Originally the vision of three gifted and experimental BD artists—Jean-Christophe Menu, Stanislas, and Mattt Konture—the small press began as an artists' collective with the self-important-sounding title of *l'Association pour l'apologie du 9e Art Libre*. When *LABO*, the progressive anthology where their work had found its best expression, stopped appearing after only one edition (a perhaps planned happening as the anthology was issued to accompany an exhibition at the 1990 Angoulême festival), the three men were nonetheless encouraged to invite in a number of other young cartoonists from the project (among them the idiosyncratic and now-popular Lewis Trondheim) and convert the collective into its own independent publishing house.[8]

Unlike their Anglo-American peers across channel and ocean who revitalized the medium among their own respective audiences beginning in the 1980s by stressing the storytelling, or more strictly *literary*, aspects of BD by way of the "graphic novel," the Francophone artists (as the project—if it might be loosely termed such—was not limited solely to France but came from Swiss and Belgian producers as well) of L'Association and other experimental groups pressed forward with an intention of stressing the medium's relationship to the high art methods and forms of a distinctly postmodern modernism. In practice this meant applying skills and methods traditionally recognized as

those of the high or *fine* arts such as painting, engraving, and even sculpting to the production of (often) highly personal BD albums. The early rumblings of this predated the artists of L'Association and were evident in the work of French artists like the Belgrade-born Enki Bilal and his 1980s science fiction BD *Nikopol*. In the creation of this still-popular work Bilal made use of the technique known as direct-coloring. Rather than relying on the industry-standard practice of a near-assembly-line-like production by teams of pencillers, inkers, and colorists, the technique emphasized an idea of production by a single artist as color is applied directly to the original art board by way of watercolors or gouache. The result, as Bilal's work continues to demonstrate, was a BD that could be both stark and sumptuous while offering a strong sense of the immediate.

More often than not, the artists who employed these techniques did not also work on BDs more obviously directed at children. This fact, and the history of even gouache itself, tied as it was most directly to the artistic tradition of painting *en plein air*, served as notice of an emerging, self-consciously aware, attitude among BD artists of themselves as *artists*. "By adopting a visual style that would be associated with artistic seriousness—and coupled with literary ambitions—these cartoonists," the BD critic and scholar Bart Beaty has noted, "helped to establish the terms by which their own work would be supplanted by the 1990s generations." Bilal, and those like him in the 1980s, "shifted European comics production towards the predominantly visual for the first time, rupturing the word/image balance and creating new spaces for innovation." Beyond even the use of fine arts techniques in the production of BDs in the next two decades, these new innovative spaces would also allow for radical experimentation with and re-conceptualization of presentation, layout, and even the notion of the page and album itself as in the case of the Geneva-based publishing house Bülb under the direction of owner-operator and artist Nicolas Robel.[9]

Though few projects have been as determinedly avant-garde as that of Bülb, what pushed at least those linked to the France-based L'Association was an attempt to "extrapolate into BD some of the basic principles of Surrealism." "L'Association," founding member Menu has insisted, "systematized the introduction of the dream into BD, applying all forms of collective experimentation, the *Cadavre Exquis* [Exquisite Corpse], raising even the idea of BD to a level that could be described as political and revolutionary."[10] In purposely adopting techniques and aesthetic structures (or the lack thereof) that came from the high arts generally and the socially charged and challenging

Surrealists specifically, L'Association and those that followed its path pushed for what Beaty, following Bourdieu, has called the "autonomous principle." Rather than the heteronomous priniciple, which "rests on the logic of financial success," the autonomous principle relies on a field of legitimacy and "prestige that is accorded to artists by other artists."[11] From this perspective the project of many BD artists in the past two decades has been to reclaim an aesthetic high ground for their chosen medium; in doing so they have managed to make the medium, in some measures, *unpopular culture* to use Beaty's own idea, eschewing commercial profitability in pursuit of Bourdieu-ian cultural capital.

However, in the process of engaging the aesthetic history of the Surrealists and collaborative techniques like Exquisite Corpse, they have also engaged with the political project of the early-twentieth-century modernist BD artists like Forain and others who made and contributed to *L'Assiette au Beurre* and other akin journals.[12] And as with them, the distinction between their aesthetic project and the political often times turns on a very thin cultural blade; or to again follow Bourdieu: "when one says 'popular culture,' one should know that one is talking about politics"; the addition here is that this realization holds even in the case of culture that has been made deliberately unpopular.[13] Indeed, adopting an artistic palette that had both the tools of high art and popular culture and included pastiche and a frequently self-consciously anachronistic nostalgia, the work of many of the BD artists that (figuratively) came of age in a (finally recognized) multicultural France of the 1990s could not help but be political.

By any measure, some of the most successful products to come out of L'Association have been both intensely personal and political. Likely among the best examples of this are the *Persepolis* albums by Marjane Satrapi— a roughly drawn, almost childlike squiggly-lined, autobiographical BD of the author's life as a young girl and woman in post-Revolutionary Iran and Europe.[14] While the albums were critically acclaimed in both the Francophone world and North America, many were unsure how to handle a work of obvious seriousness in a form most frequently associated with ephemera. Writing in the *New York Review of Books*, Patricia Storace likely echoed many when she insisted that while the first *Persepolis* album, which covered the author's life as a young girl, was visually undistinguished and the writing seldom little more than "serviceable," it nonetheless emerged as "memorable" and "an extraordinary achievement."[15] With the 2004 American publication of the second album, it was now author and reviewer Luc Sante, in the *New York Times*, who

detailed the significance not only of Satrapi's personal story but the medium in which she chose to tell it. "It would have made a stirring document no matter how it was told," he wrote, "but the graphic form, with its cinematic motion and its style as personal as handwriting, endows it with a combination of dynamism and intimacy uniquely suited to a narrative at once intensely subjective and world-historical."[16]

However, French BD artists have not held only to topics of broad universal appeal seen through the lens of intimate autobiography; they have directly addressed the immediate politics of France as well. If, as Menu has insisted, the ultimate project of L'Association, "registered in all conscience," was the continuation of the avant-garde traditions of the twentieth century, a project that was sure to have its derisive critics—"sniggerers," Menu has termed them— then it must also situate itself within the "professional context" of acceptable cartoons for adults.[17] Post-WWII, this history, he recognized, included not simply the post-68 "comic" (here meaning principally entertainment) journals of L'Echo des Savanes and Métal Hurlant (and others), but also those that, as entertaining as they might have been, were stubbornly political and used cartoons to take aim at the established political institutions of the day—be they the government itself, the church, political parties, or even prominent political or societal figures. As examples of the latter trend, Menu tellingly offered both Hara-Kiri and Charlie Hebdo, two journals with a twined history that (often one after the other, as both have been subject to periodic bans by the French government and sporadic publishing) have made a small cartoon-laced industry out of lampooning political (and more recently religious) hypocrisy.

The stance of Hara-Kiri was made clear from its beginning in 1960, if by nothing else its subtitle Journal bête et méchant (stupid and malicious journal), which pointedly recalled the characterizations of illustrated journals during the debates surrounding the passage of the 16 July 1949 Law only a decade prior. Consistently and deliberately provocative, the journal often ran afoul of the authorities and was known for a sometimes savage use of ironic parody, reprocessing the traditional print media's own language and images in describing one event into a frequently dada-ist collage to call sarcastic attention to another. The most (in)famous case of this sort was occasioned by the death of Charles de Gaulle in November 1970. The following issue of Hara-Kiri carried the headline "Bal tragique à Colombey: 1 mort," a reference not only to the home of the retired general and president but also to an earlier Paris disco fire that killed 146 people. Widely castigated as being incitingly distasteful, the journal was immediately banned by the minister of the interior. In order

to circumvent the journal's *interdiction*, however, its creator Georges Bernier quickly relaunched the publication under the new name of *Charlie Hebdo*. As political tastes changed over the course of the decade the circulation of the initially popular new journal flagged until it finally stopped publication altogether at the end of 1981 for want of a consistent public.

Though it was under new editorial leadership, *Charlie Hebdo* was revived in 1992. A political animal from the start, the journal took early aim at the first Gulf War but by the middle of the decade had found its stride in the internal politics of France itself. Following the eclectic and nonessentialist aesthetics of the artist-driven BD form in the 1990s, since the middle of the decade many of the BD artists and cartoonists that were at all overtly political also made frequent targets of the xenophobic politics of Jean-Marie Le Pen and his right-wing Front National (FN). Though founded in 1972, the FN only began to make serious political waves in France in the late 1980s and early 1990s as the party and its brusquely charismatic founder was able to harness both regional electoral success and national media attention after the 1985 introduction of proportional representation in electoral law had the effect of splintering the right-of-center vote and opening the Assembly door for extremist parties; Le Pen's well-organized political machine was among the big winners in the 1986 legislative elections as it won nearly 10 percent of the vote and sat thirty-five deputies.[18]

Electoral success did not necessarily translate into specific legislative success, as few political initiatives that have come directly from FN deputies have driven policy. Still, the extremist and essentialist positions that make up the platform of the party have led to the regular election of its members to prominent (if not particularly powerful) positions, often in the south of the country where the anti-immigrant rants that are the rhetorical staples of FN functionnaries tend to find a receptive if inchoate audience.[19] Consequently, even if specific legislative successes have eluded the party, since the late 1980s Le Pen and his faithful have done much to push the national dialogue and, by making the issue of immigration (along with other sometimes less-savory concerns) forever current, forced the political agendas of not simply the mainstream political parties on both the right and left but anyone with a political conscience.[20] And it was here that *Charlie Hebdo* stepped directly into the political fray when a prominent member of the FN, Jean-Marie LeChevalier, was elected mayor of the Mediterranean port city of Toulon, among the nation's largest metropolitan areas, in 1995. In November of that year a special issue of the journal was published in cooperation with the prominent Toulon-based

BD publishing house Soleil Editions titled simply *Charlie Hebdo Saute Sur Toulon*. The title brusquely translates to "Charlie Hebdo jumps on Toulon" and that is exactly what the cartoonists and writers did, while the journal's pages savaged the political positions of the city's new mayor, the cover art conveyed the position of those involved with little left to the imagination. A rough caricature of Le Pen has him dressed in a sailor's uniform, arm-in-arm with a bloated prostitute from the docks—who serves as both LeChevalier and Toulon itself—his right hand casually weighing her pendulous breast. This is done distractedly as both of their attention has been drawn to the upper-right-hand corner of the cover's frame where a small clutch of gangly, maniacally smiling protestors to the scene can be glimpsed heading directly for the ugly twosome, dropping in by way of parachute. The whole of it is an unsubtle reference to the city's place as home to France's Mediterranean fleet and the old (supposed) paratrooper having himself dropped into the nation's political scene as if it were an area held by an enemy.

When Le Pen claimed second place in the 2002 presidential election, *Charlie Hebdo* was joined by BD artists and cartoonists from across France in mobilizing in reaction to his early-round success. The June issue of *l'Echo des Savanes* (n216) included nine separate satirical BDs/cartoons, all with the same title of "Les mickeys contre Le Pen," by some of the country's most famous artists. Beyond the publication of various *contre* cartoons, and in an example of across-the-medium unity, a Web page with the straight forward title of "La BD dit NON à l'extreme-droite" was established to allow the nation's cartoonists and BD artists the chance to mark their opposition to Le Pen and the FN en masse. In a strident rebuke of the trademark xenophobia of the extreme right, at its start the site offered a churlish, if somewhat facile, reminder that "Your Christ is Jewish, your car is Japanese, your pizza pie is Italian, your rice is Chinese, your democracy is Greek, your watch is Swiss, your shirt is Indian, your radio is Korean, your holidays are American, your numerals are Arab, your writing is Latin and . . . your arguments with your neighbor are foreign!" Also including a short anthology of quotations from Le Pen at his worst over the course of his thirty-year political career the site concluded with a selection of cartoons and other work that had been donated to the site organizers for the purpose of drawing attention and support to the cause and a lengthy list of the notable figures from the world of French BD that had rallied to it.[21]

Le Pen had declared that his results in the first round of the presidential elections served notice that the FN was to be counted as a "mainstream conservative" party but French voters sent a resounding, if conflicted, message by

electing Jacques Chirac with over 80 percent of the vote.[22] In 2007, however, the BD community extended the FN the same left-handed symbol of recognition that all prominent French political personalities are expected to labor under when the publishing company Le Seuil produced a heavily satirical BD biography of Le Pen's youngest daughter, Marine Le Pen, whom he had chosen as his successor to lead the party. The BD-ography, *Les Malheurs de Marine*, is an often-tasteless detailing of the early life of Marine and her current struggle to take charge of her father's fractious and combative political machine.

A lawyer by profession, and like others who have received similar treatment in the illustrated press, she took legal action against Le Seuil and received some 5000 euros in damages for infringing on her private life and the misuse of her likeness. In addition, the publisher was forced to insert a "communiqué de justice" detailing the ruling between the second and third pages of the album, though the court dismissed Le Pen's request of seizure and withdrawal from sale of the BD, holding that any such measure would be "disproportionate to the infringements" suffered.[23] The ruling was distressing to some in the BD community who felt that even as comparatively meager as the ruling was, it nonetheless stood as a threat to their press freedoms. By this time, however, there were other political concerns to be dealt with in the illustrated pages of the French press, and *Charlie Hebdo* again charged to the front ranks.

In September 2005, the Danish newspaper *Jyllands-Posten* published a short series of single-panel cartoons done by different artists whose only theme was to depict the Islamic prophet Muhammad as an attempt, the newspaper's editors insisted, to further the then-current debate in Denmark concerning criticism of the Islamic faith and self-censorship. Though the immediate response to the cartoons was rather measured, the more the story was discussed, and the further it reached around the globe, the more intense reaction to the story by the world's Muslims became. What began in the global political community as diplomats from Islamic countries issuing a formal complaint to the Danish prime minister in mid-October 2005 shifted quickly to Saudi Arabia recalling its ambassador in late January 2006. And, from Muslim boycotts of Danish products to violence, with the burning of the Danish embassy in Beirut and at least eight killed in Afghanistan as reluctant authorities were forced into putting down violent protests on February 6 and 7, 2006.[24]

One day after the fatal riots, *Charlie-Hebdo* published the Danish cartoons, along with a number of originals from its own art staff, again claiming the need to defend the freedom of press and expression. To the credit of the journal's editors, they were at least more inclusive in their snickering

derision. On one double-page layout, a BD of stereotypical "representatives" from nearly all the world's religions asked, "how can you live normally if you have to worry about offending everyone from Sikhs to Scientologists, Jews to Jehovah's Witnesses?" Even with the potentially inflammatory issue of the journal sequestered behind newsstand counters, rather than on display in easy-to-reach racks, the 160,000 copies of the first print run reportedly sold out by midmorning and the publisher was promising another printing in similar numbers by early afternoon—that too apparently sold out. A BBC News report on the event made note of one newsagent "in an area with a large French north African community," who had sold at least two copies of the journal even before daybreak. The same article quoted a woman, identified only as a "well-known social commentator" who had burst into laughter when she saw the issue, saying that it was "a breath of fresh air," adding, "that it was like going back to the paper's heyday of the 1970s and 80s, before the tyranny of political correctness."[25]

Interestingly, writing in the *New York Times* on the same day, Michael Kimmelman had decried the original cartoons from *Jyllands-Posten* as little more than "callous and feeble," that they had been "cooked up as a provocation by a conservative newspaper exploiting the general Muslim prohibition on images of the Prophet Muhammad to score cheap points about freedom of expression." For many, the provocation had come in publishing the cartoons in a political and social environment still heated from the murder of polemicist author and documentary filmmaker Theo van Gogh at the hands of a young, Dutch-Moroccan Islamic radical, Muhammad Bouyeri, the previous year. In France, a similar concern came when considering the riots that shook the country, and particularly the banlieues of Paris, in the last months of 2005 and certainly remained tender in the first months of 2006. It was widely, if quietly, known that President Chirac condemned the publication as ill timed at least, but the threats of lawsuits from various leaders of the country's large Muslim community took almost the remainder of the year to grow any real teeth.

It was the following winter, in the midst of the presidential campaign and election, that the Grand Mosque of Paris and the Union of Islamic Organizations of France (UOIF) finally brought a legal suit against *Charlie Hebdo* on a complaint of "public injury to the dignity of a group of people on account of their religion."[26] That is no small offense in the French legal system; a finding of guilty would have left the journal's director, Philippe Val, risking a six-month prison sentence and a fine of up to 22,000 euros—while the two

complainants sought an additional 30,000 in civil damages. If reaction to the publication of the cartoons had originally been largely ambivalent, support for the illustrated weekly came quickly and from across the public and political spectrum. The two-day trial on February 7 and 8 was described by *Le Monde* as a "'medieval' complaint . . . which should never have taken place." The state prosecutor, Anne de Fontette—whose task in the courtroom (in this and cases like it) was to defend French law—argued in favor of the illustré: insisting that the caricatures published a year earlier were not an attack on the great majority of Muslims, the Islamic faith generally, or the prophet Muhammad, but rather a "denunciation of the terrorists who claim to act in his name."[27] In its March 15 verdict hearing, the Court agreed generally with the sentiments of the editors at *Le Monde*, and specifically with Prosecutor Fontette, insisting that the journal "showed no intention of insulting the Muslim community with the caricatures."[28]

Given all that has occurred in France in the last several years concerning the place, integration, and even the role of the country's sizable Muslim population in the public life of the nation, it is not surprising that the principle candidates for France's highest political office felt compelled to comment on the case. All three of the major candidates, or spokespersons from their respective political parties, came out in defense of *Charlie Hebdo* and in favor of a near absolute freedom of expression in the press. On the second day of the hearing, the centrist candidate François Bayrou insisted that he was sure "the arrow" fired by the hebdomadaire, "was directed at those who betray the teaching" of the Prophet, a statement that largely echoed that of François Hollande, leader of the Socialist Party and then partner of the Socialist candidate Ségolène Royal, who had spoken out the day before.[29]

Because of his tenacious image and official governmental history as the minister of interior, it was the future presidential winner and then right-of-center Union pour un Mouvement Populaire (UMP) candidate Nicolas Sarkozy who made perhaps the biggest impact on the hearing, however.[30] In a letter read to the court by the journal's lawyer at the start of the proceedings, Sarkozy, whose position as interior minister meant that he was also the minister for religious affairs in the nation, forcefully stated his own support for both Val and the tradition that served as *Charlie Hebdo*'s taproot. Making light of how often he had been pictured in the journal's pages—often as a night-stick wielding policeman, a rabid pitbull, or even a power-hungry Napoleon-esque figure—he freely noted that "I am one of the political leaders frequently and toughly caricatured over all manner of subjects, including my physique," and

further that no small part of his support for the journal came "in the name of the freedom to laugh at anything." *Charlie Hebdo* was an important example of "an old French tradition: that of satire, derision, and insubordination," Sarkozy insisted, and the candidate most known for his strong "rule of law" position offered in closing that he preferred "an excess of caricature to an absence of caricature."[31]

Wittingly or otherwise, the soon-to-be-elected president was echoing a position of support for the illustrated press that the government, through the Ministry of Culture, had begun articulating at an unprecedented reception for the *dessinateurs de presse* on March 15, 2006. In his comments that evening, the Minister of Culture Renaud Donnedieu de Vabres was effusive in his praise of not only the medium but the practitioners of the craft as well. Who better than the dessinateurs de presse, he asked, had so completely captured the sense of loss and sentiments of the nation at the death of Jean Paul Sartre and the passing of the great political oak de Gaulle? "Your drawings," he said to the gathered artists, "not only inspire, enlighten, our reading of political life or life at all, but they help make sense of it."[32] De Vabres concluded his brief speech that night by insisting that for all that was already done—making particular note of the annual festivals in Angoulême and other cities and exhibitions, for instance—there should be more done to clearly mark these images and BDs, as well as their producers and artists as a central part of the nation's political environment and cultural world. Turning to Georges Wolinski, he announced the artist's new charge, to head a commission whose task was to adumbrate the role of the illustrated press in the literal "animation of . . . ideological debate" in France. Counting such as both a given and an important part of the "national heritage" the commission was also charged with considering possibilities for not only its valorization but also its preservation.[33] Finally, the minister of culture was quick to assure the oftentimes polemical artist and occasional advocate of the medium that his new work would have the full support of all the experts of his Ministry, and the recommendations his team returned would be acted upon with all due haste and weighted with all the importance his task demanded.

The report that Wolinski and his commission team returned the following year, *Rapport sur la Promotion et la Conservation du Dessin de Presse* (*Report on the Promotion and Conservation of the Comic Press*, RPCDP) dutifully reported not only a catalog of the BD and comic political art holdings of the nation's museums, archives, and libraries, but also extended itself to include both observations on already existing festivals and events (as well as proposals

on coordination of current programs) and recommendations for projects to come. It is also worth taking note of the fact that after once again outlining the commission's various charges, Wolinski's fifty-page report began with a lengthy "Background" section that drew a "long history" of the aesthetic and political story of "satirical drawings and caricatures." The "first cartoon" appeared "in antiquity" and continued through "the Middle Ages and the Renaissance," the report confidently insisted. Leonardo da Vinci dabbled in the artistic expression of graphic exaggeration and it seemed, said Wolinski, that the Italians were masters of the form with the late-sixteenth-century artist Annibale Carracci, "considered by some to be the father of [modern] caricature." By the Enlightenment, the English, namely Thomas Patch and William Hogarth, had nearly perfected a "caricature of manners and . . . politics." But with the Revolution and Napoleon's empire, even if many appeared anonymously for fear of reprisal, the cartoon found its home in France.[34]

With the invention of lithography and its general adoption by the 1830s, the "relationship of drawing and printmaking" changed as the possibility of reproduction was almost exponentially multiplied; this alone "profoundly modifies the use of images and favors their diffusion on a much wider scale." It was with this technological advance that the press became the principle engine of illustrations and cartoons and the *caricature de célébrités*, particularly Louis-Philippe and his entourage, entered a golden age in the pages of Charles Philipon's two journals. Wolinski's report then appreciatively cited Jean Adhémar—the near-to-revered curator of the Cabinet of Prints at the Bibliothèque nationale de Paris for much of the middle twentieth century—who once wrote that it is in "crossing the four thousand planches of *La Caricature* and *Le Charivari* that we discover the true soul of 19th century France." The report's background history continued along already distinguished and now-familiar lines (some covered in earlier pages here as well), relating a past for cartoons, caricatures, BDs, and their authors and artists that was rich in political pith and aesthetic verve, even when it lacked the protections afforded the lettered press. By the twentieth century, Wolinski and his team insisted in concluding their background, the medium had come to occupy the place it does today, lodged at the nexus of politics and art, information and entertainment.[35]

After this history of the medium, the commission report offers a detailed listing of the various museums, archives, and libraries (including, in brief, international holdings) that exhibit or otherwise hold any *dessin de presse*, festivals, exhibitions, and associations, and finally schools and other institutions that specialize in teaching the craft and media research. However, the

report's real import for those with interest in the medium's future is not in the information it rather exhaustively had compiled but rather in its final section: "Possible Actions for the Promotion/Valorization of the Comic Press." For those who have called for more coherence in the state's projects, and even those who have wished for a place of study and recognition in the nation's capital, Wolinski's report here likely provided some relief and perhaps even a measure of vindication as the suggestions it made echoed many that have long been insisted upon by bédéphiles in and outside of government. They included, of course, the establishment of a central(izing) service as well as a new *Centre International d'imagerie populaire* dedicated to the preservation and promotion of the illustrated press, both located in Paris. In suggesting the BnF, the commission cited the then-current renovation of the Site Richelieu as a near-perfect opportunity to establish as comprehensive a structure—both physically and bureaucratically—as would be required within the institution while also holding that any new museum, even the proposed center, should be considered a secondary and complementary project, as that was how it was viewed even among artists and other specialists of the medium. Beyond these familiar offerings, Wolinski's report stretched out intriguingly into other areas with suggestions of support for authors and artists that extended beyond the merely financial with the creation of a *Centre d'accueil et d'hébergement* where artists who too often worked in isolation could engage in lively debate and discussion with peers. In addition, it could (should) be a place for professional events and workshops and have the facilities to temporarily lodge visiting artists and draftsmen from outside Paris and even France. Continuing this notion, the commission further suggested an amplification of the international dimension of the modern illustrated press by the establishment of a *Maison européenne du dessin de presse*, wherein the French producers of BDs and political cartoons might again take a lead in a dynamic European field of cultural production—an idea not unlike what the Oversight Commission had proffered with its exaltations in 1960 of leading an early example of "a European spirit"—this time, however, predicated on unfettered expression rather than censorship and a coerced fealty to an expected norm.[36]

Even though the collection of information and the detailing of museum and archive holding makes Wolinski's commission report of convenient interest, little of what is offered is truly new. What made it important is that the ideas and even demands that had long been made by many in the broad illustrated community of artists, appreciators, or specialists, experts, and even academics, by appearing in his report, now carried the imprimatur of the government at

a time when at least the edges of the illustrated press were being challenged in both the public and judicial spheres. Whether the report's recommendations will ultimately be adopted or forgotten remains an open question at present; however, it is evident that BD has now pierced the very heart of the nation's cultural patrimony.

With its opening in late January 2009, the Louvre, in cooperation with the BD publishing house Futuropolis, held a nearly four-month-long exhibition titled simply "Le Petit Dessein: Le Louvre Invite la Bande Dessinée" that offered the work of four Franco-Belgian artists and one manga artist in a display meant to demonstrate the vitality and diversity of contemporary BDs. The museum's own press release opened with a tinge of mock surprise, asking, "Who could have imagined one day the Louvre would display BD planches?" The "world of the museum," it continued, "and that of BD seem *a priori* hermetically sealed off from one another." But the two are not as different as they might at first seem, they both embrace "creativity and aesthetics to carry, each by its own means, the reader like the visitor on the path of visible—or invisible—knowledge and sensibility."[37] While he stressed that there was nothing incongruous about the presence of BD planches in the Louvre, the exhibition's curator, Fabrice Douar, was also quick to point out that the "initiative is not about 'modernizing' the Louvre, nor about 'validating' comic strips as an art, nor about engaging with the youth."[38] Yet, those involved recognized that both the medium and the institution would benefit: "the appropriation of the Louvre by the bande dessinée universe allows the 'dusting off' of its image to the casual public of the BD; and reciprocally, makes available to the museum going public a very contemporary form of artistic expression." Or, as Douar put it in an interview with the press, "Just like comics are not only fun or for entertainment the Louvre equally is not dusty and boring."[39] And if the Louvre is not dusty and boring and is instead modern, inclusive in its political and aesthetic definitions, and flexible, so then is France.

That is not to say that the French state's struggle with BDs and images, or indeed the very image the French have of themselves, is over—that the issues involved have somehow been entirely resolved. Indeed, in 2003 the role of the Commission for the Oversight and Control of Publications intended for Children and Adolescents created by the 16 July 1949 Law was once again raised for debate in the French Senate. Aware that the economic trends of globalization and the technological advances in communication, principally the Internet, had fundamentally altered the definition of what might be counted as "books for children" during the half century since the commission's creation,

Senator Jean-François Picheral, member of the Cultural Affairs Commission, requested that the body "consider a redefinition of its mission and capacities."[40] The 16 July 1949 Law has yet to be fundamentally altered; however, that does not mean that concern has disappeared from all quarters. In 1989 Ségolène Royal published a text, *Le ras-le-bol des bébés zappeurs*, in which she cautioned against too much unsupervised television watching. But she also pointed to the deleterious effect of Japanese *manga*, which was then just making its way into the reading consciousness of the French public.[41] Nor, apparently, were Royal's thoughts on the dangers of manga left behind in a previous election cycle; when she met with Fukushima Muziho, president of the Japanese Social-Democrat Party, in December 2006, Royal was reputed to have asked him if the issues surrounding the rights of women in Japan might not stem from the popularity of "the manga."[42]

If this were not enough, shortly after the Muhammad cartoon crisis made its torturous way through the French legal system and press, none other than *Astérix le Gaulois* came under attack. In the spring of 2007 Dominique Versini, the government's défenseure des enfants, opened a campaign that had the diminutive Gaul, who was forever fighting for the integrity of his village—and by extension, all of France—serving as a "special ambassador for the defense of children," promoting the United Nations' Convention of the Rights of Children in the country.[43] However, the Defense des Enfants International (DEI-France), under the direction of child advocate Jean-Pierre Rosenczveig, attacked the promotion, declaring that Astérix, was—for contemporary and multicultural France—*too French*. They insisted that his peculiarly "'gallic' vision was ignorant of the intercultural reality of contemporary French society and the universal character" of the rights of children.[44] When Astérix is open to criticism, it is obvious that the French take nothing for granted when it comes to their bande dessinées.

Etienne Balibar has argued that the nation is a narrative forever capable of reproduction, while Anthony Giddens has suggested that in the age of high modernity that the West (in particular) has been in for some time identity must continuously evolve. "A person's identity is not to be found in behaviour," he has insisted, "nor . . . in the reactions of others, but in the capacity *to keep a particular narrative going*."[45] The same is true of the character and identity of a nation-state; and the history of bande dessinée and the image in modern France demonstrates just how reactive and evolving the identity of both the state and its citizens as well as the relationship of one to the other must be. But it is also a history that demonstrates how ultimately flexible and absorptive the notion of French *civilization* truly is.

The traditional national cultural space of French civilization, rational and masculine with its reliance on a starkly important literary and literate print tradition, was scarcely able to accommodate the demands for inclusion made by another form of social communication that was seen as decidedly inferior, reliant on emotion, certainly juvenile and perhaps even feminine in its modus operandi. Resistance to BD and the image in the higher social categories and complete removal of them from the *idealized* image of the nation, however, were necessary parts in the cultivation of a national identity that stood in opposition to the more organic and visceral forms of nationalism that developed in much of the rest of Europe as well as the materialist concerns that dominated politics post-WWII. The French and their nation, it could be said, were both cleanly rational and republican when compared to the fascist states that developed in degrees around them but also understood the necessity of community in a way that the atomized economic politics of the United States did not allow.

The expanding physical comforts afforded by *les trente glorieuses* coupled with the pressures of decolonization and international political maneuverings—all made possible and necessary by the postwar world—forced a reworking of France's national identity; particularly after the system-shaking events of 1968 and the lethargy of the mid-1970s. The process of continuously reworking and redefining the political question of who should be counted among the nation's *citoyens* and the need to assess who possessed the amorphous but necessary cultural attribute(s) of *Frenchness* have been a part of the history of Republican France for as long as there has been a French Republic. Whether by design or not, BDs were soon located near the center of the most recent social-psychic-political overhaul, which has its beginnings in the 1980s and remains an unfinished project today. Most obviously, the form was simply made a part of the accepted national cultural space by the various (occasionally heavy-handed) attempts of the government to appropriate and incorporate the form into the nation's cultural patrimony, beginning with Lang's appearance and speeches at the annual Angoulême festival.

The barely articulated fear of some at the time that with government support would come at least some measures of government control of the medium has not come directly to pass, but there was another possibility that might actually be of graver consequence. In his work, *Bringing the Empire Back Home*, the cultural historian Herman Lebovics has laid out the political-cultural trickery, maneuvering, sidelong glances and silences that have been required to maintain the centralized policy of circumscription within the nation's folds by way of the creation of pockets within the national narrative in the form of archives,

centers of study, and (most important) museums. Unfortunately, Lebovics continued, for all the work, and sometimes the best of intentions, by creating institutionalized and static sites the end result is that it simply "updates the old 'we' and the 'other' of the colonial era."[46] However, the aesthetic renaissance the medium has undergone since the 1990s is demonstrative of its inherent plasticity, its resistance to simple categorization and, ultimately, its ability to escape the statis-making effect that has so often followed official recognition of cultural forms and artifacts. It's very openendness, the ability to apparently forever reimagine its attributes and form at one end of the creative spectrum, and its inherent accessibility to anyone with a *crayon* at the other would seem to offer the possibility that it will forever be a dynamic form.

The virtue of BD is that it is possessed of a recognizable and set, though both expansive and expanding, iconic lexicon while its structure lends itself well to situational manipulation in order to foster specific reactions on the part of its consumer. And yet, the things that allow for the medium's great range of expression also demand that there must be a contribution of meaning provided by the reader/consumer for the communicative loop to be closed. Because of this informational loose end, while evermore scholars of all stripes turn to cartoons and BDs as material to be analyzed for clues to how people of this time and that place understood their social milieu, they are bringing with them their own notes of caution. Writing about the use of cartoons in the field of international history Wolfram Kaiser has cautioned that "we often need a substantial amount of knowledge of historical facts and of contemporary images before we can interpret and use them for our historical research."[47] Though Kaiser's warning implicitly suggests that there is only one specific reading for any cartoon or BD, his is the lament of the scholar who desires to *know* the specific meaning of his subject of study. The other side of the coin is that of the censor who seeks to *control* its meaning. It was the difficulty of doing just that that drew the suspicion of those like Sadoul (to name but one) in the 1930s, for instance, who saw in BD journals a threat to the specific social narratives that they preferred. But it is the very interiority of the narrative structure of BD that makes it such a potentially powerful nodal point for the reimagining of a national narrative in France that takes an honest accounting of all its various faces and voices. Because it allows an individual to bring his own understanding and even his past to a collective and current event, the medium itself can become a site of what Jürgen Habermas has referred to as "post-traditional identity," wherein the past does not offer a model for behavior in the present, but a source of critical political self-understanding.[48]

In 2004, the American PBS news show *Wide Angle* aired a documentary titled "Young, Muslim, and French," which detailed the problems of integration that are all too often faced by young observant Muslims in the country, even those who are born French. One of the obvious angles explored by the film's producers was the issue of young Muslim women wearing the hijab in the nation's public schools, which has reopened an impassioned debate on the role of laïcité, or secularism in French society. The issue is one that remains an emblem of the nation's assimilationist difficulties and not one that has offered an easy solution. But when interviewing a young woman who, despite being a star student, had been expelled from her school for wearing a scarf, a near indelible mark of her own Frenchness was revealed: as they were talking with her in the family home, the camera panned around her room, and on her desk, beside her devotional copy of the *Qu'ran*, was a stack of *Tintin* albums. The significance of BD, it would seem, is something that all the French can agree on.

Notes

Introduction

Epigraphs. Françoise Rabelais, "To My Readers," *The Complete Works of Rabelais, Gargantua and Pantagruel*, xxxiii; and Charles de Gaulle, quoted in Raf Casert, "Famed Cartoon Character Tintin Turns 75," Associated Press (AP), January 8, 2004.

1. "A Very European Hero," *Economist*, December 20, 2008, 81.

2. Ibid., 82.

3. Ibid., 84.

4. Ibid., 82.

5. McCloud, *Understanding Comics*, 43.

6. Spigel, "Innocence Abroad," 34.

7. "A Very European Hero," 82.

8. De Gaulle, *The Complete War Memoirs*, 3.

9. According to some at least, it was Saint-Ogan who convinced a young Hergé to adopt the modern word-ballon for his BDs. See chapter 2 below for both Rabier and Saint-Ogan and the influence on Remi.

10. Harding, "Comic Icon Tintin turns 75."

11. *Le Nouvel Observateur*, Paris, August 29, 1986.

12. Cited in Maurice Horn, "Comics," 15. On the educational level of the readers of BDs, it is hardly a coincidence that there are a number of BD shops around the perimeters of Paris's university campuses. Medical students, in particular, have been identified as "notoriously avid consumers" of BDs. See Gildea, *France since 1945*, 195.

13. Those making this and similar arguments have often held the level of state funding for BDs alongside that allotted for support of French cinema; a comparison that decidedly does not fall in favor of the former with annual subsidies for the medium generally falling at roughly 1 percent of that granted cinema. See Miller, *Reading Bande Dessinée*, 66.

14. Reitberger and Fuchs, *Comics: Anatomy of a Mass Medium*, 193, 209.

15. Kemnitz, "The Cartoon as a Historical Source," 83, and Geertz, *Interpretation of Cultures: Selected Essays*.

16. See the epilogue of this work.

17. For an engaging analysis of why manga proved so nearly instantaneously popular among the French, see Bouissou, "Pourquoi le manga est-il devenu un produit culturel global?"

18. Johnson, "Astérix and the marauding manga-maniacs," *Financial Times*, February 3, 2004. In an ironic twist of timing the Japanese Defense Ministry announced the same year that in an attempt to increase the readership of its annual "defense white paper" it would release a manga version of the 450–page 2004 report. See *New York Times*, July 7, 2004.

19. Benoit Mouchart, the artistic director of the festival that year argued that "we can almost say that *manga* is in the process of saving the French publishing industry . . . with the profits from their *manga* bestsellers, publishers cross-subsidise all their other French language publishing activities." Quoted in Johnson, "Astérix and the marauding manga-maniacs."

20. On this, see Nyberg, *Seal of Approval: The History of the Comics Code*, and Hajdu, *The Ten-Cent Plague*.

21. "A Very European Hero," 81.

22. See Ory, "Mickey Go Home! La désaméricanisation de la bande dessinée (1945–1950)." "Americanization," as a useful term of analysis, has its own scholarly history, complete with both proponents of the concept and detractors. For a good discussion of this, see Brian McKenzie, *Remaking France*, 6–12.

23. On this "special responsibility" or mission, see Lebovics, *Mona Lisa's Escort*, 46.

24. For one of the clearest examples of this, see the work of Ory's former student, Crépin, *Haro sur la Gangster!* For the 16 July 1949 Law having little practicable effect on the illustrated press, see, for instance, ibid., 438. The general ineffectiveness of the law and its Oversight Commission in directly censuring many publications is a common enough theme in the work that examines the history of BD. However, Gérard Thomassian, editor and primary author of the influential multivolume *Encyclopédie des bandes dessinées de petit format*, has insisted that the general social pressure was so pervasive from the 1950s through to the 1970s that most publishers practiced a fairly extensive policy of self-censorship following the well-known guidelines of the Oversight Commission.

25. See Pells, *Not Like Us*.

26. "A Very European Hero," 81.

27. Lebovics, *Mona Lisa's Escort*, 30, 29.

28. See Anderson, *Imagined Communities*, wherein he argues that the ready dissemination of a monoglot allows, and in fact spurs, the imagining of large linked communities where none had previously existed. On the role of institutions helping forge national fictive ethnicities, see Balibar, "The Nation Form," 86–106.

29. Born, *Rationalizing Culture*, 70.

30. Mirzoeff, *Bodyscape: Art, Modernity and the Ideal Figure*, 62. See also his discussion on the shift of the political fetishism of the body politic from the king to the state during and after the 1789 Revolution, ibid., 75–83.

31. Robb, *The Discovery of France*, 41. See also Weber, *Peasants into Frenchman*. For a more developed and nuanced analysis of the development of national identity on the periphery of the nation-state, see Sahlins, *Boundaries: The Making of France and Spain in the Pyrenees*.

32. Balibar, "The Nation Form," 98–99, 97.

33. Yuval-Davis, *Gender and Nation*, 41. The concept of *hegemonization* also serves to better reflect the contested nature of the nation-building/maintaining process, see ibid. for more on this.

34. Armstrong, *Nations before Nationalism*, 8.

35. Bell, *The Cult of the Nation in France*, particularly chap. 6, "National Language and
the Revolutionary Crucible," 169–197. On L'Académie française and regional languages, see
Chrisafis, "Local language recognition angers French academy," June 17, 2008.

36. Levin, "Democratic Vistas—Democratic Media," 94.

Chapter One

Epigraphs. Töpffer, *Enter: The Comics*, 3. Philipon, *La Caricature*, no. 123, January 3, 1833.
Quoted in Goldstein, *Censorship of Political Culture in Nineteenth-Century France*, 33. Duhamel,
In Defence of Letters, vii.

1. Gordon, *Comic Strips and Consumer Culture*, 86, 92.

2. That is not to say that there has not also been a tradition of political "commentary" in
American graphic or figurative cartoon art. By way of only a few examples, one need think
only of Thomas Nast in the late nineteenth century and his damning portrayals of New York's
Boss William Tweed of Tammany Hall, or Joseph Keppler, the principle cartoonist of *Puck*
magazine from the same era. In the 1930s and into WWII, Theodore Geisel—better known as
Dr. Seuss—was the principle political cartooninst for the liberal New York magazine *PM* where
he challenged the stance of famous isolationists like Charles Lindbergh and Father Coughlin,
addressed anti-Semitism and racism, and harangued everyone from Hitler and Mussolini
to Pierre Laval and Marshal Pétain. His work did not escape all the ugly assumptions of the
day, however, and his cartoons seem to support the internment of Japanese Americans and
realized the fear of a Fifth Column element existing on the West Coast of the United States.
Fully formed BDs in the twentieth century have also blurred the line between entertainment
and politics, Walt Kelly's *Pogo*, for instance, and for the last four decades Garry Trudeau's
Doonesbury, which came under editorial fire in the first years of this century for his depiction
of President George W. Bush and the Iraqi conflict. See, for instance, Kahn, "'Doonesbury's
language gets some edits," *Boston Globe*, February 11, 2004. On Nast, see, for instance, Fischer,
Them Damned Pictures: Explorations in American Political Cartoon Art. On Keppler, see West,
Satire on Stone: The Political Cartoons of Joseph Keppler. On Geisel, see Minear, *Dr. Seuss Goes to
War: The World War II Political Cartoons of Theodor Seuss Geisel*. For a brief, if didactic telling
of both the current state of political cartooning in the United States as well as its general history,
see Lamb, *Drawn to Extremes: The Use and Abuse of Editorial Cartoons*.

3. For more on comic strips and newspaper syndication in the United States at the turn
of the twentieth century, see for example, Marshall, "A History of Newspaper Syndication,"
721–727.

4. For one of the more forceful statements of this argument, not just for the birth of the
medium in France (and Switzerland, of course) but generally, see Groensteen, "Töpffer the
Originator of the Modern Comic Strip," 107–114. Töpffer himself believed that he (along with
perhaps only the English artist/caricaturist William Hogarth) was creating a new, and definitive,
form of expression: "In passing, let us add that in the picture-story—a series of sketches where
accuracy is unimportant but, on the other hand, a clear, rapid expression of the essential idea
is imperative—nothing can compare for speed, convenience, or economy to the technique of
autography." Töpffer, *Enter: The Comics*, 5.

5. Töpffer, *Enter: The Comics*, 5.

6. Quoted in McCloud, *Understanding Comics*, 17.

7. Levin, "Democratic Vistas—Democratic Media," 94. See also, Hunt, *Politics, Culture, and Class in the French Revolution*, particularly chapters 2 and 3. Until the nineteenth century and the increased use of steel plates in the printing process, production of these prints was made all the more labor-intensive by the need for multiple engravings as the wooden planks were prone to "blunting" after as few as fifty pressings. The introduction of lithography about 1820 made possible the production of many more copies of any given image, even if they were of a slightly cruder quality.

8. *Archives parlementaires, de 1787 à 1860* (hereafter abbreviated as AP), v 34, 330, 31.

9. The best work on Philipon and his varied publishing interests remains Cuno, "Charles Philipon and La Maison Aubert: The Business, Politics and Public of Caricature in Paris 1820–1840."

10. Philipon, *La Caricature*, no. 30, May 26, 1831.

11. Bulwer, *France: Social, Literary, Political*, 71–72.

12. Philipon, *La Caricature*, no. 55, November 17, 1831. Because Philipon reported on his trials in the pages of his journal, as well as the fines and sentences he was assessed, it is possible to count that during this brief time his journals and caricatures were the subject of almost innumerable seizures, while he was sentenced to fines and prison sentences in excess of 4,000 francs and more than a year in prison. For more on Philipon's legal issues in the early to mid-1830s, see, for instance, James Cuno, "Charles Philipon, La Maison Aubert, and the Business of Caricature in Paris, 1829–41," 347–354.

13. For detail on specific design development—the printer's demon that began appearing in the masthead of the journal after a few months of publication and then in specific lithographs and caricatures, providing a recognizable (and defensible) print alter-ego for Philipon himself—see Kerr, *Caricature and French Political Culture, 1830–1848: Charles Philipon and the Illustrated Press*, 20–23.

14. Philipon, *La Caricature*, no. 30, May 26, 1831.

15. See *La Caricature*, no. 14, February 3; no. 18, March 3; no. 31, June 2; no. 43, August 25, 1831; and no. 74, March 29, 1832.

16. Spang, *The Invention of the Restaurant, Paris and Modern Gastronomic Culture*, 213.

17. Haine, "Café Friend: Friendship and Fraternity in Parisian Working-Class Cafés, 1850–1914," 607. See also his *The World of the Paris Café: Sociability among the French Working Class, 1789–1914*.

18. Wechsler, *A Human Comedy: Physiognomy and Caricature in the Nineteenth Century*, 20–41. For "interpretive communities," see the landmark text by Fish, *Is There a Text in This Class? The Authority of Interpretive Communities*, 303–321. On the "cultural phenomenon" of the *Cabinets de lecture* and their significance as an institution for the distribution and consumption of the graphic and written press, see Kerr, 130–131.

19. A lithograph by Honoré Daumier titled "I have three sous," which appeared in *Le Charivari*, August 11, 1839, plainly and simply reproduces the social dichotomy of success (of the patrons inside) and longing (of those who stand outside looking with desire for the exquisite foodstuffs and envy for the affluent patrons) that were an inevitable part of the restaurant scene in mid-nineteenth-century Paris.

20. Unfortunately, the one thing that the admirably complete collection of *La Caricature* held by the Print Collection of the New York Public Library seems to be missing is the

reproduction of this drawing that appeared in *La Caricature*, no. 56, November 24, 1831. The image included here is a copy of a more "finished" version of the caricature that appeared in Philipon's other journal, *Le Charivari*, January 17, 1832. Though it is more graphically developed, the morphing sequence is the same.

21. See, for instance, the published catalog by the National Archives for an exhibit devoted to Louis-Philippe at the bicentennial of his birth that, almost in spite of the author's apparent desire to foster respect, admitted "it was in the shape of a pear that the image of Louis-Philippe established itself in the popular consciousness." *Louis-Philippe, l'homme et le roi*, 132. It would be nearly impossible to list, much less detail, the vast number of works that have addressed Philipon's *poires* in one manner or another. The near ubiquity of the image was such that almost no history of the press in France looks past the "event"; see, for example, Henri Avenel, *Histoire de la Presse Française Depuis 1789 jusqu'à nous jours*, and Claude Bellanger et al., *Histoire Générale de la Presse Franise*, vII: de 1815 à 1871, as two of the most important such studies despite their age. Obviously the work of Kerr, already cited here, also references Philipon's *poires* as does Cuno's work. See also Childs, "The Body Impolitic: Censorship and the Caricature of Honoré Daumier," 155–158. Incidentally, Childs is one of the few commentators who get the timeline and reasons of the appearance of *Les Poires* correct; she does, however, continue a common mistake in insinuating that Philipon's point was that Louis-Philippe resembled a pear. For a more directly art historical, though from a decided polymath, take on Philipon's caricature, see, among many options, E. H. Gombrich, *Art and Illusion, A Study in the Psychology of Pictorial Representation*, particularly chap. 10, "The Experiment of Caricature." His essay on the physiognomic and psychological weapons of the caricaturist is also of interest; see "The Cartoonist's Armoury," in *Meditations on a Hobby Horse and Other Essays on the Theory of Art*, 4th ed., 127–142.

22. Gombrich, "The Experiment of Caricature," 344. Gombrich is here being used as a representative example of much of the typical quick history and analysis of the sketch. It is worth noting that Gombrich, among others, also pointed to this morphing caricature as an important point in the evolution of the modern BD by way of its sequential development. See ibid.

23. *La Caricature*, no. 55, November 17, 1831.

24. Ibid.

25. Ibid.

26. Philipon made these comments apparently in the courtroom but they were published with his drawing in *La Caricature*, no. 56, November 24, 1831.

27. *La Caricature*, no. 55, November 17, 1831.

28. Figure 1.3 is from *La Caricature*, no. 64, janvier 19, 1832, the auctioneer is calling for bids: "A quatorze millions! . . ."—a reference to the budgetary fight over the king's annual compensation which was then taking place in the Assembly.

29. Philipon, *La Caricature*, no. 115, November 8, 1832.

30. Quoted in Sandy Petrey, "Pears in History," 54. Petry's article is an interesting semiological analysis of the entire *les poires* "affair" which attributes the popularity of the pear image as a criticism of Louis-Philippe to the fact that it was as much an "invention" as the seemingly oxymoronic idea of a "citizen-king." He has continued and developed his analysis in his more recent text *In the Court of the Pear King: French Culture and the Rise of Realism*. Here, he links the near contemporaneous "events" of Philipon's "pears," George Sand's living and

writing as a man, and the development Balzac's fantastical realism. According to Petrey, taken together they served to demonstrate a culture-wide recognition of a society's ability to create and deny what was real.

31. Philipon, *La Caricature*, no. 115, November 8, 1832.

32. The pear image, however, remained politically charged and relevant for caricaturists for the remainder of the century. See, for instance, a cover illustration by the republicanist caricaturist Alfred Le Petit for the journal *L'Eclipse*, fevrier 14, 1871, titled simply *Fleurs, fruits et légumes du jour—La poire—M. Thiers*. Appearing on the very day that Adolphe Thiers was elected as head of the provisional government of the Third Republic, it showed the old politician, his own paunchy body and head shaped as pears, holding an oversized pear with a likeness of Louis Philippe in it standing before a shelf of pears with the likenesses of other prominent politicians fashioned similarly.

33. Quoted in *La Caricature*, no. 247, August 13, 1835.

34. AP (1898), v. 98, 258.

35. *Journal Officiel de la République Française*, June 8, 1880, 6212–6213.

36. The Affair remains a point of controversy in France even today. Between 1986 and 1988 a statue honoring Captain Alfred Dreyfus sat in the foundry which had cast it because no one wanted the memorial. See Fitch, "Mass Culture, Mass Parliamentary Politics, and Modern Anti-Semitism: The Dreyfus Affair in Rural France," 55–95. The best account of the Affair itself remains Bredin, *The Affair: The Case of Alfred Dreyfus*.

37. See Burns, *Rural Society and French Politics: Boulangism and the Dreyfus Affair, 1886–1900*.

38. Fitch, 63–65.

39. Zola's fiery polemic appeared in Georges Clemenceau's newspaper, *L'Aurore*, on January 13, 1898. It followed his more moderate "Lettre à la France," of January 4, 1898. In terms of sales and circulation, it was the exception in regard to the "market-popularity" of things pro-Dreyfus being the only one to sell in the hundreds of thousands of issues. Typically it was only the generally more virulent anti-Dreyfus journals that sold as many, and more, copies. See Bredin, *The Affair: The Case of Alfred Dreyfus*, 247.

40. *Psst . . . !*, no. 1, Février 5, 1898. Despite its age, Wilson's "The Anti-Semitic Riots of 1898 in France," 789–806, remains a thorough work on this part of the protracted Dreyfus Affair.

41. A worn but extant edition of this is held by the Prints Division of the New York Public Library.

42. In early 1890, the American novelist Henry James wrote a literary sketch of both caricature and Honoré Daumier, often presumed to have been the greatest of all the nineteenth-century French caricaturists. Here, rather than an easy lauding of Daumier and his work, it was "the wonderful, intensely modern Caran d'Ache" who became James's standard-bearer for the art/craft. See James in *Century Magazine*, January 1890. In 1999 the then director of the museum at the CNBDI, Thierry Groensteen, discovered what he purported to be a publishing plan and partially completed manuscript by Caran d'Ache for the first "graphic novel" free of text and driven solely by illustrations to be called *Maestro*. Published by the CNBDI as part of its "Bibliothèque de la Neuvième Art" collection, it has served to further cement his position in the pantheon of French BD artists.

43. *New York Evening Post*, "Art News," January 28, 1905, and *New York Tribune*, April 28, 1912, respectively.

44. Quoted in Eugen Weber, *Peasants into Frenchmen*, 336.

45. Eugène Morel, *Bibliothèque, essai sur le développement des bibliothèques publiques et de la librairie dans les deux mondes*, see particularly, vI, 7–10, 97–140, 161–192, 314–336, and vII, 123–172. On the introduction of the inexpensive reprint editions, each edition apparently being one thousand copies, see Byrnes, "The French Publishing Industry and Its Crisis in the 1890s," 234–236.

46. On this, as well as the evolution of this discourse from a position of literacy wariness to bemoaning a crisis of reading today as a dying activity, see Ann-Marie Chartie and Jean Hebrard, in collaboration with Emmanuel Fraisse et al., *Discours sur la lecture: 1880–2000*. On the fixation of the French on the personal individuation that literacy both promised and threatened, see Allen, *In the Public Eye*, particualry chap. 3, "The Politics of Reception," and chap. 5, "Artistic Images."

47. In the 1901 issue of the journal from which figure 7 was taken, for instance, there was an adventure story, a tale of a broken heart, a report on how messages were passed in the tangled wilds of French Indo-China, a geology sketch on rock quarries, an explanation of the "nouveau systéme décimal," and suggestions for child-friendly travel to a new children's museum and other educational trips.

48. See Trigon, *Histoire de la Littérature Enfantine, De Ma Mère L'Oye au Roi Babar*, 135.

49. The journal first appeared in the mid-1850s. The citations here are taken from the title page of the first issue wherein Philipon addresses potential readers in a section titled simply *Au Public*. Emphasis in original text. Journal collection is held by the New York Public Library Photographs and Prints Division.

50. Depending on a sequence of images to move along the "story" with text beneath which only elaborated on what was on display in the cartoons should mark *Le Musée ou Magasin Comique de Philipon* as an important step in the evolution and history of BD in France that has been strangely overlooked by most commentators and historians of the medium.

51. Philipon, "Aux Public," *Le Musée ou Magasin Comique de Philipon*.

52. The casual bigotry of Caran d'Ache and Forain's journal likely puts it closer, in both appeal and intent, to the anti-Semitic media baubles that proliferated in France during the Dreyfus Affair than to either of the two journals mentioned above, at least insofar as an intent to educate its/their readers was concerned. Though, that being noted, the supple skill of both artists, even when dealing in coarse material, was often in evidence. Furthermore, Caran d'Ache's sense for ferreting out essential and important political trends and concerns of the day extended beyond *L'Affaire*. See, for instance, issue no. 16, mai 21, 1898, of *Psst . . . !* which has a cartoon depicting a Gallic cock and Russian bear in council in a clearing in a forest while being spied on by a caricatured depiction of the British John Bull and the American Uncle Sam. John Bull asks Uncle Sam: "Ami Jonathan, what would you say to a leg of bear and this coq en broche?" Adolphe Thiers, "La République est le gouvernement qui nous divise le moins," *Discours à l'Assemblée Législative*, Février 13, 1850.

Chapter Two

Epigraphs. Quoted in Leighten, "*Réveil anarchiste*," 17. Quoted in James, "Lindbergh Does It," May 22, 1927. Aveline, "Films and Milieux," 246.

1. Unless otherwise indicated, the following telling of the night of Lindbergh's landing at Le Bourget field is reliant largely upon the already cited "Lindbergh Does It!"

2. See Apollonio, *Futurist Manifestos*. For the Futurists' as an artistic and aesthetic movement, see, for instance, Humphreys, *Futurism*.

3. On the automobile in the French imagination in the 1920s, see Harp, *Marketing Michelin*. See also, Lottman, *The Michelin Men: Driving an Empire*.

4. Kern, *The Culture of Time and Space, 1880–1918*, 242.

5. Wohl, *A Passion for Wings*, 63.

6. Orteig was a supporter of and believer in both technical and aesthetic "modernism." Not only did he offer the purse for the first nonstop transatlantic flight, but his Greenwich Village hotels, the Brevoort and the Layfayette, were well-known and chic hangouts for writers of the modernist era. For more on Orteig, see Turkel, "Raymond Orteig and 'Lucky Lindy': How a NYC Hotelier Helped Conquer the Atlantic," 72–74.

7. Eksteins, *Rites of Spring*, 245.

8. Ibid., 250.

9. On the phenomenon of Alfred, see Michel Pierre, "Illustrés, *Le Journal de Mickey*," 116–117.

10. See Eksteins, *Rites of Spring*, 251.

11. For an interesting recent biography that examines Lindbergh's role, and his awareness of being such, as a cultural icon, see Hixson, *Charles Lindbergh: Lone Eagle*.

12. See, for instance, Shaya, "The Flâneur, the Badaud, and the Making of a Mass Public in France," 70.

13. *L'Assiette au Beurre*, May 16, 1901.

14. Edward Verrall Lucas, *A Wanderer in Paris*, 27–30.

15. *The Masses* ran from 1911 to 1918 until it was forced from publication after running afoul of U.S. indecency laws. On Guilbeaux, see Goldberg, "From Whitman to Mussolini: Modernism in the life and works of a French Intellectual," 153–173. For an interesting and wide-ranging discussion on the influence of the illustrated press and *L'Assiette au Beurre* particularly from within the field, see Mouly and Weschler, "Covering the New Yorker: A Conversation between Françoise Mouly and Lawrence Weschler," 12–17.

16. It was from Rabier's work that Hergé got the name for his most famous BD character, the boy reporter Tintin. See Farr, *Tintin, The Complete Companion*, 18.

17. Couperie and Horn, *A History of the Comic Strip*, 11.

18. The action of the BD centered around a slightly stupid and self-absorbed bourgeois family and their exploits, which ranged from trips to the fair to round-the-globe adventures reminiscent of Jules Verne.

19. Maurice Horn, "American Comics in France: A Cultural Evaluation," 52.

20. Leighten, "*Réveil anarchiste*," 17–18. In discussing the work of modernist artists such as van Dongen, Leighten argues that while their cartoons "necessarily remain more narrative than abstract" they "exhibit the expressive freedom, bold simplification, violent deformation, and strikingly nonliteral composition associated with paintings by the same artists. Such correspondences reveal a strong formal relationship to the development of modernism." Ibid., 25.

21. Benjamin, "The Work of Art in the Age of Mechanical Reproduction," 224.

22. The term "field" here is being used in an expansive though similar sense to that intended by Pierre Bourdieu. See, for instance, Pierre Bourdieu, *Distinction*, particularly chap. 3, "The Habitus and the Space of Life-Styles," and chap. 4, "The Dynamics of the Fields," 169–256.

23. Office of Population Research, "War, Migration, and the Demographic Decline of France," 75.

24. On the idea of competing cultures being key to the outbreak of WWI, see Eksteins, *Rites of Spring*, 76–90.

25. On this see, for instance, Gordon Wright, *France in Modern Times*, 306–308. As he demonstrated, the concentration of industry and the urbanization of the country, which some have said were the most immediate consequences of the war, were already discernible trends. However, he notes that the impact of the war on the country's rural population was significant. Skilled laborers often found their way to deferments as their knowledge was required in the rapacious munitions factories that appeared in droves in the first months and years of the war. The unskilled sons of peasants whose only gifts were endurance and strong backs were seldom as lucky and often found themselves in the thick of combat in disproportionate numbers. By some estimates, almost half of the casualties France suffered during the year were drawn from rural stock and many of those who survived the war years were ambivalent about returning to land-bound toil after experiencing the easy pleasures of city life.

26. Fulcher, *French Cultural Politics and Music*. On the two referenced composers specifically, see 169–204.

27. Leighten, "*Réveil anarchiste*," 19. For more specific examples of this in the art world and the racialized nature of some of the debate, see Antliff, "Cubism, Celtism, and the Body Politic," 655–668.

28. Silver, *Esprit de Corps*, 388–389.

29. See Antliff, *Avant-Garde Fascism*.

30. Eksteins, *Rites of Spring*, 46. One need only think of the example of the loose coterie of American authors like Ernest Hemingway, Zelda and F. Scott Fitzgerald, Ezra Pound, whom Gertrude Stein deemed the "Lost Generation," to recognize the pride of place Paris continued to hold in the cultural imagination of the West. For an intimate look at this literary scene and the importance of Paris, see Hemingway, *A Moveable Feast*.

31. Office of Population Research, 76.

32. There has been a fair measure of work done on the social instability that has been associated with the experience of modernity. Generally, see for instance, Berman, *All That Is Solid Melts into Air*. See Wohl, *The Generation of 1914* for insightful work on the actions and reactions of various authors and intellectuals in the major European countries as they grappled both with the experience of WWI as well as the social and cultural aftermath of the interwar period. On the French experience specifically, see Mary Louise Robert's work on how the cultural shifting characteristic of the 1920s extended even to gender roles as relationships between men and women, metastasized by the experience of the war, became something close to combative while sexual difference was blurred. The French feminine world split between the good mother and/or daughter and *la femme moderne* or the *parisienne*, a "being without breasts, without hips" who was selfish and self-centered. See Roberts, *Civilization without Sexes*.

33. Jackson, *Making Jazz French*, 77–78.

34. See Duhamel, *America the Menace*, and Louis-Ferdinand Celine, *Journey to the End of the Night*.

35. Quoted in Gagnon, "French Views of the Second American Revolution," 433.

36. Siegfried, *America Comes of Age*, 167.

37. Duhamel, *America the Menace*, xiii. Interestingly, a 1926 guidebook by Félix Falck, the *Guide du touriste en Algérie*, described Arabs generally as having "elegant and vigorous appearances." However, it was only the Berbers, a group to which the Matmata belonged, who were afforded the "qualities of work, energy, and intelligence that one can recognize." Quoted in Furlough, "*Une leçon des choses*: Tourism, Empire, and the Nation in Interwar France," ff. 57, 457.

38. For a brief introduction to this, see Stovall, "Introduction: BonVoyage!" 415–422.

39. Furlough, "*Une leçon des choses,*" 443.

40. Ibid., 441.

41. Herman Lebovics, *True France: The Wars over Cultural Identity, 1900–1945*, 62–63.

442. Ibid., 55–56, 86, 79, and 93. Kristin Ross made the flipside of this argument as per the relationship of the metropole and the (former) colonies in the late 1950s. That being, if "Algeria is becoming an independent nation, then France must become a *modern* one." Ross, *Fast Cars, Clean Bodies*, 78.

43. Gagnon, "French Views of the Second American Revolution," 431.

44. Lebovics, *True France*, xiii. The art historian Mark Antliff has argued that it was in fact not simply the prevalence of this sort of Maurrasian-influenced "essentialist" discourse but its general acceptance in the years immediately prior to WWI that accounted for the racialized polemics of both the supporters and detractors of avant-garde artwork like Cubism and Fauvism. See "Cubism, Celtism, and the Body Politic."

45. Lebovics, *True France*, 143, 161, 140; italics in original.

46. "Tour d'Horizon. L'Osservatore Romano et la Réponse Communiste," *L'Aube*, June 16, 1936. Quoted in Hellman, "French 'Left-Catholics' and Communism in the Nineteen-thirties," 507.

47. Lebovics, *True France*, 158 and 159.

48. Felski, *The Gender of Modernity*, 59.

49. Ibid.

50. Lebovics, *True Frace*, xvi.

51. Weber, *The Hollow Years*.

52. Jackson, *The Popular Front in France: Defending Democracy, 1934–1938*, 114.

53. Fourment, *Histoire de la Presse des Jeunes et des Journaux d'Enfants (1768–1988)*, 409–416.

54. Crépin, "*Haro Sur Le Gangster!*" 26–27. Forton was one of the pioneers of the modern French BD, author of "Les Aventures Pieds Nickelés," which appeared in *L'Epatant* starting in June 1908 and "Bibi Fricotin," a popular series for *Le Petit Illustré*. Saint-Ogan had been the first to rely exclusively on the speech or thought balloon to carry the narrative of his strip but Forton had been the first artist to use it at all though, like the quality of his strip, its use was haphazard. See *l'ABCdaire de la Bande dessinée*, 83 for "Les Pieds Nickelés."

55. For an example of this, see *Le Journal de la Jeunesse*, which was an illustrated hebdomadaire but more often stories were simply begun by highly detailed illustrations that related only abstractly; e.g., if the story was a sea tale the opening paragraph would appear beneath a design of a ship on the water. See chapter 2 above. All material for Duhamel's *Les Jumeaux de Vallangoujard* taken from Duhamel, *Les Jumeaux de Vallangoujard*.

56. Pierre, "Illustrés, *Le Journal de Mickey*," 117. See also, Crépin, *Haro Sur Le Gangster!*, 38. The appearance of "Tintin" in this early, seminal, BD journal is one of the reasons that the French have adopted the Belgian-born Georges Remi as a co-father of the modern French (or at least Francophone) BD with Alain Saint-Ogan.

57. This is not to say that the "modernizing" process of the journal's BDs was without incident. When the first Tintin story, *Tintin au pays des Soviets*, first appeared the editors added additional explanatory text beneath the panels. See Khordoc, "The Comic Book's Soundtrack," 158.

58. Michel Pierre, "Illustrés, *Le Journal de Mickey*," 117.

59. Ibid., 118.

60. Georges Sadoul is one of those interesting figures in history who likely is significant enough in the history of twentieth-century France that he deserves a full critical biography, but not significant enough that the right scholar has thought enough of it to tackle such a project. He was the author of a number of works on the cinema that are still considered landmark standards, including a six-volume history published posthumously in 1973 and a work of historical synthesis entitled *Histoire du cinéma mondial: des origines à nos jours*, published in 1949. Demonstrating that his influence has not been forgotten, in her recent article on the filmmaker Jean Renoir, Janet Bergstrom called Sadoul "one of the most consistently intellegent supporter's of Renoir's work in the 1930s." See Bergstrom, "Jean Renoir's Return to France," 456. During his lifetime, he wrote not only his seminal histories of film but also about Arab and Asian cinema for UNESCO and carried on a protracted commentary and conversation with other cinéphiles in the short-lived American journal *Hollywood Quarterly*. Though there is no one complete biography there is a useful sketch in *Dictionnaire des intellectuels français: Les personnes, Les lieux, Les moments*, 1019–1021.

61. Fourment, *Histoire de la Presse des Jeunes et des Journaux d'Enfants*, 175.

62. Horn, "American Comics in France: A Cultural Evaluation," 50.

63. Crépin, *Haro Sur le Gangster!*, 26.

64. See advertisement at the end of Sadoul's best-selling 1938 polemic, *Ce Que Lisent vos Enfants: La presse enfantine en France, son histoire, son évolution, son influence*, 58.

65. Grove, "Mickey, *Le Journal de Mickey* and the Birth of the Popular BD," paragraph 1.

66. Pierre, "Illustrés, *Le Journal de Mickey*," 121–122. On Winkler, see also Groensteen's "La Mise en cause de Paul Winckler," 53–60. For an uncritical but thorough history and context of the *JdM* specifically, see Michel Mandry, *Happy Birthday Mickey! 50 Ans d'histoire du Journal de Mickey*.

67. Sadoul, *Ce Que Lisent vos Enfants*, 16–17.

68. Ibid.

69. For more on this, see Crépin, "Défense du dessin français: Vingt ans de protectionnisme corporatif," 26–30. See also, Crépin, *Haro sur le Gangster!*, 168–170, and the UADF's own journal *Echo-Dessin*, particularly no. 65, mars 1958.

70. Quoted in Pierre, "Illustrés, *Le Journal de Mickey*," 123.

71. On "Futuropolis" and its principle artist René Pellos, see *l'ABCdaire de la Bande Dessinée*, 81. See also, Lofficier and Lofficier, *French Science Fiction, Fantasy, Horror and Pulp Fiction: A Guide to Cinema, Television, Radio, Animation, Comic Books and Literature*, 133.

72. Horn, "American Comics in France: A Cultural Evaluation," 54.

73. Sadoul, *Ce Que Lisent vos Enfants*, 40 and 46–47. For Horkheimer and Adorno on Donald Duck and the "Culture Industry," see *Dialectic of Enlightenment*.

74. On the appeal of Duhamel's work across the political spectrum, see Gagnon, "French Views of the Second American Revolution," 438.

75. Jackson, *The Popular Front in* France, 114.

76. Herman Lebovics, "Open the Gates . . . Break Down the Barriers: The French Revolution, The Popular Front, and Jean Renoir," 11.

77. Jackson, *The Popular Front in France*, 114.

78. Ibid., 133–136, 131–132.

79. For an introduction and overview of the role of the cinema in France and French identity, see, for example, Harris, "Cinema in a nation of filmgoers," 208–219. On the "American Challenge" to European cinema in the years after both WWI and WWII, see Victoria de Grazia, "Mass Culture and Sovereignty: The American Challenge to European Cinemas, 1920–1960," 53–87.

80. Quoted in Jackson, *The Popular Front in France*, 141–142.

81. Lebovics, "Open the Gates . . . ," 14. Italics in original.

82. Sadoul, from "*La Marseillaise,* épopée populaire," *Regards,* 213 (February 10, 1938), in *French Film Theory and Criticism: A History/Anthology 1907–1939,* 239.

83. François Vinneuil, "Screen of the Week: *La Marseillaise,*" in *French Film Theory and Criticism,* 243.

84. Sadoul, "The Cinémathèque française," *Regards,* 150 (November 26, 1936), in *French Film Theory and Criticism,* 223.

85. Sadoul, *Ce que Lisent vos Enfants,* 12–13, 40, 33.

86. Ibid., 25, 33, 34, 26.

87. Grosse, "Les Illustres pour Enfants," 7–8.

88. *La Patronage,* September–October 1932.

89. Ibid., April 1939.

90. Sadoul, *Ce que Lisent vos Enfants,* 47, 53.

91. Grosse, "Les Illustres pour Enfants," 17.

92. Sadoul, *Ce que Lisent vos Enfants,* 11.

93. Jackson, *The Popular Front in France,* 18.

94. Sadoul, "Décors et société," *Regards,* 249 (October 20, 1938), in *French Film Theory and Criticism,* 255–256.

Chapter Three

Epigraphs. Marc Bloch, *Strange Defeat,* 151. T. S. Eliot, "Tradition and the Individual Talent," in *The Sacred Wood: Poetry and Criticism,* 50.

1. The August 22, 1940, issue of *Le Moniteur* called the May–June mass exodus from northern France "the largest population movement recorded in many centuries." The same issue of the newspaper also reported that "the population of the eight departments of central France had almost doubled because of the influx of 1.4 million refugees." Sweets, *Choices in Vichy France,* 6.

2. From Ferro, *Pétain,* 85–86. Excerpted in *The Third Republic in France, 1870–1940: Conflicts and Continuities,* 236.

3. Werth, *The Twilight of France,* 380. See also de Gaulle, *The Complete War Memoirs,* 31–32, where he noted that: "In all the parties, in the press, in the administration, in business, in the trade unions, there were influential groups openly favouring the idea of stopping the war. The well-informed said that this was the opinion of Marshal Pétain, our ambassador at Madrid,

and he was supposed to know, through the Spaniards, that the Germans would gladly lend themselves to an arrangement."

4. Not surprisingly, the historiography of the Occupation and Pétain's Vichy Regime is extensive and multivalenced. For a succinct listing of the terms of the Armistice agreement that is nonetheless more detailed than what is often found in general histories of the period, see Fishman, *The Battle for Children*, 51. On the Occupation and its management, see Jackson, *France: The Dark Years*; Gildea, *Marianne in Chains*; Oustby, *Occupation*; Le Betorf, *La Vie parisienne sous l'Occupation;* and Sweets, *Choices in Vichy France*. On the Vichy Regime, see Paxton, *Vichy France*, and, for a more sympathetic account, Dreyfus, *Histoire de Vichy*. On collaboration and survival under the Germans, see Burrin, *France under the Germans*; Gordon, *Collaborationism in France during the Second World War;* and Ory, *Les Collaborateurs*. For discussion of how the economy of the country was integrated into the larger German war effort and used to help pay for the Occupation, see Milward, *The New Order and the French Economy*. On the Resistance, see Kedward, *Resistance in Vichy France*, as well as his *In Search of the Maquis*; and Sweets, *The Politics of Resistance in France*.

5. Laval, Speech at a Secret Session of the National Assembly, Vichy, July 10, 1940, 22.

6. Constitutional Act No. 2, *Journal official de la République française* [hereafter *JO*], 1940, no. 168.

7. Werth, *The Twilight of France*, 379.

8. Jackson, *France: The Dark Years*, 43.

9. Shennan, *Rethinking France*, 10.

10. Quoted in Sweets, *Choices in Vichy France*, 31.

11. On the idea that Vichy's emphasis on an *authentic* France shifted the "focus of public life away from the 'abstract' ideas of citizenship and class to the 'concrete' fact of membership" in the communities of the family, workplace, profession, village, and region, see Shennan, *Rethinking France*, 24.

12. Quoted in Christian Faure, *Le Projet Culturel De Vichy*, 119.

13. Ibid.

14. Jackson, *France: The Dark Years*, 354.

15. Robert Gildea, *Marianne in Chains*, 255, 257.

16. Jackson, *France: The Dark Years*, 321.

17. Faure, *Le Projet Culturel*, 133. The reference here to modernist architecture is not to be overlooked. The Vichy government was interested in and concerned by the "messages" conveyed by the design of both public and private spaces. As Faure pointed out, a house of the appropriate design "is in effect a sign of the survival of traditional order." Indeed, he insists that during Vichy, the "architectural environment, opaque mirror of a reified human structure, becomes a symbol of permanence and an interruption of time." See ibid., 51–52. For more on urban planning specifically under Vichy, see, for example, Wakeman, "Nostalgic Modernism and the Invention of Paris in the Twentieth Century," 115–144.

18. Lebovics, *True France*, 171.

19. The most obvious examples where this has been done in varying degrees of depth, and with significant analysis of their import, are the two sources that have been relied on here for their narrative of events: Lebovics, *True France*, and Faure, *Le Projet Culturel*. For Vichy's folklore policies, and the important role of Georges-Henri Rivière in them, in Lebovics, see

ibid., 171–188. While there has been work on these topics completed since the appearance of Faure's extensive and penetrating study of the Vichy's cultural policies, it has often been of a particularized scope, focusing on individual components of Vichy's cultural policies. Ultimately, at least in terms of breadth and overall depth, little has changed since 1992 when Lebovics wrote that Faure's work thus far constituted "the most complete studies of the topic."

20. Faure, *Le Projet Culturel*, 161.

21. Lebovics, *True France*, 172–173.

22. Faure, *Le Projet Culturel*, 275.

23. Lebovics, *True France*, 173. On jazz "becoming French," see Beth Vihlen, "Sounding French: Jazz in Postwar France," and Jeffrey Jackson, *Making Jazz French*.

24. Faure, *Le Projet Culturel*, 174.

25. Michèle Cone, *Artists under Vichy*, 74–75.

26. Ibid., 73. Cone points out that Pétain had apparently had little concern about trading away the "national art patrimony," having, apparently, nonchalantly signed into law on 19 July 1941 an art exchange with Spain "in which France was the clear loser."

27. Ibid., 66, 72.

28. Laurence Bertrand-Dorléac, *Histoire de l'art: Paris, 1940–1944*, 42.

29. Faure, *Le Projet Culturel*, 158–159.

30. Quoted in Cone, *Artists under Vichy*, 75.

31. Ibid., 82.

32. See Lebovics, *True France*, 173. Cone makes an additional interesting point about the seemingly benign act of gallery displays of art of one's own apparent choice: "Through the simulacrum of freedom that the display of this art in official Vichy contexts provided, a sense of normality was being artificially maintained." Cone, *Artists under* Vichy, xix–xx.

33. Paxton, *Vichy France*, 171.

34. Jackson, *France: The Dark Years*, 130.

35. The population and labor shortage that had been among the most serious results of World War I on France had forced the French into an "audacious project" of liberalizing the nation's naturalization laws in 1927. The changes were more than effective in terms of bringing immigrants into the country. By 1931, the start of the most serious economic issues of the global depression for the country, recent immigrants made up almost 7 percent of France's population. See Weil, *Qu'est-Ce Qu'un Français?*, 76–81.

36. Paxton, *Vichy France*, 170–171. The more recent work of Weil has demonstrated, however, that the Vichy government's concern about immigrants and Jews particularly were directly the result of calls for national regeneration and took as their model the 1933 Nazi laws on race and citizenship. See Weil, *Qu'est-Ce Qu'un Français?*, 97–100; for Alibert and his "Commission," see ibid., 101–112.

37. The point of Winkler being a Jew was highlighted in a letter dated November 21, 1940, from the inspector general of the commission. See Crépin, *Haro Sur Le Gangster!*, 76.

38. Winkler was to spend the war years living in New York City where he started a second news agency, Press Alliance, and was the foreign political columnist for the *Washington Post*. He also became a fervent anti-German propagandist of sorts and is infamous in some circles for having authored and published the anti-Nazi book *The Thousand Year Conspiracy: Secret Germany behind the Mask*. With his wife, he ghost-wrote the U.S. best-seller *Paris Underground* in 1943.

39. See chapter 2 above.

40. See, for example, François Cochet, "La Bande Dessinée en France et aux Etats-Unis dans l'Entre-Deux Guerres: Deux Modèles," 200.

41. Raymond Poivet, quoted in Crépin, "Le Comité de Défense de la Littérature et de la Presse pour la Jeunesse," 133.

42. "Note on la diffusion des journaux d'enfants sur les deux zones," October 1940, Archives National (hereafter AN) F44, 2n.

43. "Fanfan La Tulipe," AN F41, 120, Presse Subventions. The example of *Fanfan La Tulipe* seems to actually have been a case that demonstrated Jackson's assertion that insofar as the rhetoric of the National Revolution, which the journal carefully hewed to, "encouraged the traditional values of French patriotism, the Germans were suspicious of it." Jackson, *France: The Dark Years*, 139.

44. See Crépin, *Haro Sur Le Gangster!*, 85–86. In *JdM* the calls for respect for the marshal and (shortly thereafter) notes on the importance of sport and duty to the nation appeared in a feature called "Votre Vieil Onc' Léon" (Your Old Uncle Leon), which had first appeared in the mid-1930s as an earlier attempt at making the journal more "French" according to Grove; see "Mickey, *Le Journal de Mickey* and the Birth of the Popular BD."

45. Laval, "Organisation Générale de la Censure," September 24, 1940, AN F41, 156: Organisation Générale de la Censure.

46. "Note Sur L'Insuffisance des Traitements Du Personnel de la Censure," October 24, 1941, AN F41, 156, Folder 4: Listes des Censures.

47. Marcel Gabilly, "Les Journées de Vichy: un assainissement qui s'impsait," *La Croix*, September 1941, 14–15. While there may not have been a direct equivalent to Joseph Goebbels in Vichy, according to Cointet-Labrousse's *Vichy et le fascisme*, Marion might well have been closest in temperament and desire to use the arts and media in building a new political culture. A longtime Communist who moved progressively to the right in the 1930s, Cointet-Labrousse wrote that he was "a bona-fide Fascist who was to place at the service of his latest convictions the talent he had acquired within the Communist party where he had held important responsibilities in the agitation and propaganda section." See Cointet-Labrousse, *Vichy et le fascisme*, 75–77. The man Pascal Ory described as "l'homme par excellence de la manipulation par la propagande" was particularly interested in the propaganda uses of film and newsreels in the formation of public opinion and actively sought a friendly, and actively collaborationist, relationship with Germany from within the Ministry of Information. See Ory, *Les Collaborateurs*. On Marion and film and newsreels, see Bowles, "Newsreels, Ideology, and Public Opinion under Vichy: The Case of *La France en Marche*."

48. Quoted in Faure, *Le Projet Culturel*, 240.

49. In September 1942, for instance, the government supported the publication of two other regionalist journals, *France-Pyrennees* and *d'Editions Bretonnes* (La Bretagne), with subsidies of 10,000 and 40,000 francs, respectively. An incomplete list of supported publications detailed more than thirty publications with a total subsidy for the month of September alone at well over two million francs. See "Article Unique," AN F41,120: Décision Ministrielle. This sort of government support for a publication was not a singular occurrence. In November 1942, the same month of the German occupation of the entire country, a directive from Marion himself raised the total amount of the monthly subvention for supported publications to 5,600,000 francs. It remained at, or near, this level for the remainder of the war years with the last

authorization examined dated May 17, 1944, and allocating 5,500,000 francs for subventions the following month. "Office Française d'Information," November 24, 1942, AN F41,120: Presse Subventions.

50. The touchstone for most Anglo-American scholars for this period regarding children in/ under Vichy remains Halls, *The Youth in Vichy France*. See also Giolitto, *Histoire de la Jeunesse sous Vichy*, and Yagil, *"L'Homme Nouveau" et la Révolution Nationale de Vichy (1940–1944)*, particularly, chap. 3, "La régénération de la jeunesse," 43–54.

51. Quoted in Halls, *The Youth of Vichy France*, 5.

52. Yagil, *"L'Homme Nouveau,"* 44.

53. Shennan, *Rethinking France*, 20.

54. Paxton, *Vichy France*, 352.

55. On the growth and expansion of the welfare state generally under Vichy, see Hesse and Le Crom, eds., *La Protection Sociale sous le Régime de Vichy*. The most important of the private organizations involved with both a spread of the social welfare safety net and "national regeneration" that became quasi-official organs of the government was the Secours National. According to Gildea the group "was a vast charity monopoly that launched waves of fundraising" and "was also a highly effective instrument of propaganda," particularly in continuing the spread of the "cult of the Marshal." See Gildea, *Marianne in Chains*, 124. See also Jean-Pierre Le Crom's essays "L'Assistance publique" and "De la philantropie à l'action humanitaire" in *La Protection Sociale sous le Régime de Vichy*.

56. Barreau, "Vichy, Idéologue de l'école," *Revue d'histoire moderne et contemporaine* 38 (1991), 592. Quoted in Fishman, *The Battle for Children*, 61.

57. Halls, *The Youth of Vichy France*, 284–307, 202.

58. Ibid., 65.

59. See Giolitto, *Histoire de la Jeunesse sous Vichy*, 499, and Yagil, *"L'Homme Nouveau,"* 45.

60. A unified youth movement raised concerns at nearly every level of government in Vichy as well as from the German administrators in the Occupied Zone where both the Chantiers and Compagnons were banned for fear that a unified movement might ultimately lead to "dissidence." Within the government there was a concern that a "jeunesse unique" would turn too openly fascistic while the Catholic lead movements feared losing their identity as (young) Catholics, their rallying cry being "Jeunesse unie? . . . Oui! . . . Jeunesse unique? . . . Non!" Halls, *Politics, Society, and Christianity in Vihy France*, 136–143. Even the delegates from the SGJ faced resistance at the local level as "teachers, clergy, Catholic youth organizers, and even municipalities resented the encroachment of these newcomers on their turf." Gildea, *Marianne in Chains*, 132–133, citation from 132.

61. Yagil, *"L'Homme Nouveau,"* 45–47.

62. On Le scoutisme française sharing the general themes of veneration of leadership, and loyalty of a traditionalist France with the National Revolution but not the collaborationist attitudes of some in Vichy, see Giolitto, *Histoire de la Jeunesse sous Vichy*, 502. General Lafond, in his role as "chief scout," according to Halls tried to shield the Eclaireurs israélites, from the Commissariat général aux questions juives, but could not stop its ultimate dissolution at the end of 1941. Halls, *Politics, Society and Christianity in Vichy France*, 295.

63. Kathleen Alaimo, "Shaping Adolescence in the Popular Milieu: Social Policy, Reformers, and French Youth, 1870–1920," 420.

64. Fishman, *The Battle for Children*, 136–137.

65. Quoted in ibid., 167.

66. Ibid., 169, 175.

67. Ibid., 145.

68. One adolescent was described as being of "good appearance . . . slightly severe facial expression. Answers a little too sharply . . . rarely goes to the movies . . . Reads little, maybe a few illustrated magazines of police novels." Another was described as enjoying serialized "detective novels" in the journal *Junior* "and other publications of doubtful morality." After listing his reading habits the report continued with "loves tobacco, hangs out in bars." Ibid., 98.

69. An interesting example of a prominent French intellectual in the interwar period who bridged what little divide often existed between the "official" educational circles and public commentators was the professor of comparative literature and historian of ideas, Paul Hazard. From 1925 through the 1930s, he was a member of the faculty at the Collège de France in Paris and a frequent lecturer in the United States, particularly at Columbia University. While his most famous work likely is the 1935 three-volume *La crise de la conscience européene, 1680–1715*, he also addressed the topic of children's literature and the growth of BDs. In his 1937 *Les Livres, les enfants et les hommes* he appears to be have been the first to draw cultural and political distinctions between Northern and Southern Europe by noting that the north far outpaced the south in the publication of children's literature. See Hazard, *Books, children & men*. He also entered into the debate, early on, about the educational development of children and resisted the notion that children were merely blank slates with no discriminating will of their own. Particularly in regard to overly didactic or ideological readings, Hazard insisted that children have an "early-flowering" or "precocious" skill for "jumping paragraphs, pages, chapters. A glance . . . and that is enough; they feel the sermon to come and dexterously pass it. It is the story they want to find; and if one is intent on taking advantage of them, so much worse for the book, it is condemned!" Hazard, "Comment lisent les enfants," 863.

70. On the fate of Communists under Pétain's government, see Jackson, *France: the Dark Years*, 151.

71. Coston, "Les Corrupteurs de la jeunesse." There is some difficulty in dating the first appearance of Coston's "Les Corrupteurs de la jeunesse." The date given here is for the copy/issue consulted; however, there is evidence that it appeared in either fragments or complete in either/both 1941 or/and 1942.

72. Ibid., 18.

73. Ibid., 23–24.

74. Ibid., 18. For Bethléem, see *Revue des Lectures*, March 15, 1923. Bethléem was a critical forerunner of much of the conservative right's attack on BDs, particularly (as might be expected) that of the conservative Catholic movement. Much of Abbé Paul-Emile Grosse's critique in the 1930s, for instance, was clearly influenced by Bethléem, and, at times, he seems to have simply parroted the earlier man's work as Coston appears to—save for his difference in identification—in the example cited here.

75. Ibid., 27.

76. See Ginio, "Vichy Rule in French West Africa: Prelude to Decolonization?" 210–211.

77. Proud, "Occupying the Imagination: Fairy Stories and Propaganda in Vichy France," 34–36. She makes the point that at least some of these stories that came out of the Occupied Zone obviously passed through and were passed on by the German *Propaganda Abteilung* service, as evidenced by the censorship office's mark. See also her longer work on the theme of

propaganda in children's storybooks, *Children and Propaganda. Il était une fois . . . ; Fiction and Fairytale in Vichy France*. Proud's work is particularly good in her discussion of the illustrated storybook for (very) young children; she is weaker, however, when she occasionally ventures into discussion more specifically related to BDs and journaux d'enfants—those publications intended for older children and adolescents—and their critics.

78. Proud, "Occupying the Imagination," 19–20, 40 n. 3.

79. Ibid., 40 n. 5.

80. Crépin, "*Il Était Une Fois Un Maréchal de France* . . . Presse Enfantine et Bande Dessinée Sous le Régime de Vichy," 79.

81. Horn went on to assert that it was with their secretive collection that "these stories for the first time were seen as representative of the best values America had to offer—freedom, individuality, democracy—and they stood out as so many beacons in the dark night of Nazi oppression. Horn, "American Comics in France," 51.

82. Crépin, "*Il Était Une Fois Un Maréchal de France* . . . ," 80–81.

83. Circulation figures for the journal have proven difficult, if not impossible, to accurately assess because many of the relevant archival material remains closed. However, Proud makes note of a small study of childhood recollections of life under the Occupation by Jill Sturdee, and *Fanfan la Tulipe* was one of only two BD journals from the time that any of her respondents remembered. Proud, *Children and Propaganda*, 69.

84. Letter from the publisher of *Fanfan la Tulipe* to the Secretary of State, March 24, 1943, AN F41 120: Press Subvention "Fanfan la Tulipe."

85. Quoted in Crépin, *Haro Sur la Gangster*, 90.

86. Letter from the Commissaire Générale à la Famille to the Secretary of State, February 26, 1943, AN F41 120: Press Subvention "Fanfan la Tulipe."

87. Letter from the publisher of *Fanfan la Tulipe* to the Secretary of State, March 24, 1943.

88. "Ce qu'en pense FanFan," AN F41 120: Press Subvention "Fanfan la Tulipe." Unless otherwise indicated, the following quotations also come from this source.

89. Emphasis and capitalization in the original.

90. Internal memorandum of the Ministry of Information, March 29, 2005, AN F41 120: Press Subvention "Fanfan la Tulipe."

91. Coston, *Les Corrupteurs de la jeunesse*, 22.

92. On the UADF, see chap. 2.

93. Alain Saint-Ogan au secrétaire général à la propagande, December 22, 1943, AN, F41, 269: propagande section jeunesse—marché pour les avonnements souscrits.

94. Saint-Ogan was so supportive of the *Compagnons* and the scouts that he has, for years, been lauded by the French scouting organization in a number of places and publications. On *Benjamin* under Vichy, see Crépin, *Haro Sur la Gangster*, 86–87.

95. Marion, "Ciculaire no32, Consigne Relative aux Journaux d'Enfants," October 13, 1943, AN F41, 156: Circulaires et Notes de Service, September 1930–August 1944. Unless, and until, otherwise indicated, quotations in the following paragraphs also come from this document.

96. Internal Memorandum, Censure Services, October 13, 1940, AN F41, 156: Circulaires et Notes de Service, September 1930–August 1944.

97. On the futility and vicissitudes of the Vichy administration for much of 1943, see, for instance, Jackson, *France: The Dark Years*, 226–231.

98. Crépin, *Haro Sur la Gangster*, 105.

99. Gary Anderson, "Nazi children's comic revealed." The following description, and discussion of content, of *Le Téméraire* is also dependent on correspondence with Laurence Grove, see his work, *Text/image Mosaics in French Culture: Emblems and Comic Strips* for more detail than is pursued here.

100. Grove, *Text/image Mosaics in French Culture*.

101. Halls, *The Youth of Vichy France*, 169. The images and storylines were sometimes so disturbing that even those sympathetic to the general politics and social sentiments of the journal occasionally were troubled by its vehement and visceral position. Halls referenced a letter from a parent to Pétain in July 1943 "complaining that the [journal] contained material not fit for his ten-year-old son." See ibid., n 441 n. 31.

102. Anderson, "Nazi children's comic revealed."

103. Halls, *The Youth of Vichy France*, 169.

104. *l'ABCdaire de la Bande dessinée*, 85.

105. Quoted in Anderson, "Nazi children's comic revealed."

106. Cochet, "La Bande Dessinée en France et aux Etats-Unis dans l'Entre-Deux Guerres," 200. Ory's short monograph on *Le Téméraire, Le Petit Nazi Illustre "Le Téméraire" (1943–1944)*, remains to date the most extensive work dedicated solely to the journal and its content. His work is unflinching in its demonstration of the virulent anti-Semitism that so frequently littered the journal's pages, but even in that he upholds, if not originates, the dual line of analysis that it was the available work and not long-standing enough to set a publishing example or be of influence. This, despite the fact that according to Ory *Vaillant*, the "first children's periodical to appear at the Liberation, offers obvious resemblances with *Le Téméraire*, in terms of both production and lay-out." His explanation however, veers into apologia and equivalence as he concludes his own work by insisting that the journal was not entirely anomalous, given that the entire field relies on a "masterly," "infallible," and "generic" didactic "orator" whether it is "Prince Téméraire, Jaboune, or Uncle Paul." Indeed, he asserted, the "whole of the media . . . takes part in a universe of order and hierarchy, conquering virility, and ethnocentrism." Given this, "*Le Téméraire* takes a seat in a very long history" and it "ceases to be a monstrosity." See ibid., 95–97. Ory's text was reissued in a new expanded edition in 2002 but with few changes to his analysis, and for many his work on *Le Téméraire* remains the standard-bearer. See, for instance, Crépin's text, *Haro Sur la Gangster!*, to date the most comprehensive work on the *presse enfantine* for the years between the appearance of *JdM* and the years immediately after the passage of the "July Laws" of 1949, largely echoing Ory's analysis; see particularly, 108–111.

107. Though "Guerre a la Terre" was not as explicitly racist as his effort for *Le Téméraire* had been, it remained reliant on some, now, disturbingly stereotypical images. The storyline of the BD was that the earth was engaged in a brutal war with Martians who were determined to enslave the earth. The Earth resistance was lead by a Frenchman, Captain Jean Veyrac, who was joined in his struggle by an international team of heroes, including an American flying ace, a Russian (though apparently not Soviet) pilot, and a British "rocketeer." The Martians, however, were large-eyed, brutish, and green-skinned, some with oversized heads—not all that different from the subterranean villains of "Journey to Unknown Worlds"—who were joined in the fight against the Earth champions by envious, renegade Japanese.

108. Grove, quoted in Anderson, "Nazi children's comic revealed." See also Grove, *Text/Image Mosaics in French Culture*.

109. Cochet, "La Bande Dessinée en France et aux Etats-Unis dans l'Entre-Deux Guerres," 200.

110. Ian Gordon, *Comic Strips and Consumer Culture, 1890–1945*, 139–140.

111. Ibid., 148.

112. Richard Kuisel, *Capitalism and the State in Modern France*, particularly 128–212.

113. Paxton, *Vichy France*, 339.

114. Kuisel, *Capitalism and the State in Modern France*, 280.

115. As alluded to above, however, the influence of artists likely remains an open question worthy of some interest and investigation.

116. See note 106 above.

Chapter Four

Epigraphs. Eliot, "Henry James," in *Selected Prose of T. S. Eliot*, 151–152. Jade. Cited in André Mignot, *Semences De Crimes*, 6.

1. *La Bête est morte!: La Guerre mondiale chez les animaux* was published three times by the Parisian publishing house Éditions G.P. in the years 1944 to 1946, while the cover of its first edition boasted that it was published "during the three months of Liberation." Despite the apparent popularity of the children's BD album, it was seemingly forgotten until it appeared as a reprint by Futuropolis in 1997 and Gallimard in both 1995 and 2002 at the peak of what Henry Rousso has called the "age of memory" as France was again rattled by the legacy of Vichy by the trials of Klaus Barbie and Maurice Papon in 1987 and 1997, respectively. See Rousso, *The Vichy Syndrome*. On the "persistence" of the memory of Vichy in the collective psyche of France, see Henry Rousso, *The Haunting Past: History, Memory, and Justice in Contemporary France.*

2. Calvo was widely regarded as one of the country's premier cartoonists and caricaturists from the mid-1930s, when he began publishing work in the Maison Offenstadt stable of journals, until his death in 1957. Though he was best known for his illustrated work in l'presse enfantine, and has been acknowledged as an influence on other popular artists like Albert Uderzo, he also published political and social caricatures and cartoons in more "adult" journals like *Le Canard Enchaîné*. For more on Calvo, see Lofficier and Lofficier, *French Science Fiction, Fantasy, Horror and Pulp Fiction*, 275.

3. Marshal Pétain was the only figure that really made this denoting difficult as he was portrayed as an old owl, an owl-faced oak whose roots had been exposed by the conflict and was subject to the evil winds that were blowing, and even as an owl in Bavarian lederhosen torturing a loyal Trottemenue-ite.

4. Rousso, *The Vichy Syndrome*, 16. Indeed, it seems logical to presume some credit for the persistence of this dual myth of resistance and unity that much of Rousso's work has been concerned with over the past two decades to narratives such as this. *La Bête est morte!* has recently been given a more complete analysis than appears here by O'Riley. See his "*La Bête est morte!*: Mending Images and Narratives of Ethnitcity and National Identity in Post–World War II France," 41–54.

5. de Gaulle, Speech at the Hôtel de Ville, Paris, August 25, 1944.

6. Rioux, *The Fourth Republic*, 3–4.

7. Brinton, Letter 3, "Letters from Liberated France," no. 1, 12.

8. Brinton, Letter 6, "Letters from Liberated France," no. 2, 141, 155.

9. For more on this exchange and its importance in the grounding of what Rousso calls the "Gaullist resistancialist myth," see *The Vichy Syndrome*, 16–19.

10. Brinton, Letter 6, "Letters from Liberated France," no. 2, 147.

11. Ibid.

12. Brinton, Letter 1, "Letters from Liberated France," no. 1, 4. Italics in original.

13. Bloch, *Strange Defeat*, 156.

14. Shennan, *Rethinking France*, 208.

15. Ibid.

16. Office of Population Research, 78. The total population loss due to the war was offset by the emigration of some three hundred thousand people to France in those years. However, the population (even considering emigrants) dropped from 41.5 million in 1939 to 40.4 million in mid-1945, or "2.7 per cent of the total prewar population of the country." Ibid.

17. Ibid.

18. Ibid., 78–79.

19. Jobs, *Riding the New Wave*, 24.

20. Bloch, *Strange Defeat*, 155–156.

21. Shennan, *Rethinking France*, 183.

22. Ibid., 184. For a more complete discussion of the Langevin-Walloon Committee, including its precedents in Vichy and later influence in educational reform, and the report it issued after two years of meetings, see 180–187.

23. *Le Monde*, February 7, 1995. Quoted in Fishman, *The Battle for Children*, 197.

24. Fishman, *The Battle for Children*, 200.

25. Marion, "Ciculaire no32, Consigne Relative aux Journaux d'Enfants."

26. Duverne, "L'Enfance en danger," 15–16.

27. Jobs, "Tarzan under Attack," 697.

28. *Combat*, January 31, 1948.

29. *JO*, Débats Parl., Conseil de la République (hereafter *JO*, Débats), 1948, 474–489.

30. Moch, "Publications dangereuses pour la moralité publique," April 8, 1948, Centre des Archives Contemporaines à Fountainebleau (hereafter CAC), 770130/article 32: Projet de loi sur la Press Enfantine.

31. *La Situation actuelle de la jeunesse française*, 20, AN F44, 52: Rapport du 9 juillet 1947 de la commission d'études des problèmes de la jeunesse.

32. Crépin, *Haro Sur Le Gangster!*, 229.

33. Parker and Renaudy, *La Démoralisation de la jeunesse par les publications périodiques*. My thanks to Laurence Grove for making me aware of this publication. See his informative essay on BD criticism, "BD Theory before the Term 'BD' Existed," 39–49.

34. Mignot, *Semences De Crimes*, 10.

35. Fournel, "Alerte aux parents! Les publications enfantines ne doivent pas être une semence de démoralisation pour les générations futures!," *Parisien Libéré*, July 17 and 18, 1946. Reprinted in ibid., 24–26.

36. Pauwels, Combien d'enfants tuez-vous par semaine?" *Combat*, December 30, 1947. Reprinted in ibid., 30–32.

37. Ibid., 8.

38. Ibid., 50–51. Here again, Mignot's assertions were buttressed by recourse to another expert. His reference here was to the work of a psychologist, Professeur Laverenne, who insisted

in his own work, *Do You Want Your Children to Be Good Students?*, that the increased use of contraceptives among young people and the veritable explosion in the number of "maisons de débauche" can be attributed mainly to the growth and availability of pornographic literature. Ibid.

39. Jade, in ibid., 6.

40. AN F41, 2047: Note of 1947: "La Presse enfantine depuis la Libération." Cited in Crépin, "Le Comité de Défense de la Littérature et de la Presse pour la Jeunesse," 134.

41. See, for instance, Jobs, "Tarzan under Attack," 693.

42. Couperie and Horn, *A History of the Comic Strip*, 95. Couperie and Horn use the phrase in relation to the BD industry in France after the passage of the July 1949 Law to be discussed below; however, it is more correct to say that the "shaky protectionism" began with this committe in Malraux's Ministry and was formalized, after much debate and reworking by the 1949 law four years later.

43. Quiquère, "30 ans de Bande Dessinée française."

44. Ibid.

45. Crépin, "Le Comité de Défense de la Littérature et de la Presse pour la Jeunesse," 134.

46. Quiquère, "30 ans de Bande Dessinée française." On Lécureux's role in moving the format of *Vaillant* stylistically closer to that of *Robinson*, see also Crépin, "Le Comité de Défense de la Littérature et de la Presse pour la Jeunesse," 134. Of course, given that "Fifi Gars du Maquis" was illustrated by André Liquois, creator of "Journey to Unknown Worlds" from *Le Téméraire*, and his collaborator on "Les Pionniers de l'Espérance," Poïvet, had worked with and replaced Liquois at the same journal, perhaps there is also something to Ory's contention that the journal took inspiration for its style and layout from there. See Ory, *Le Petit Nazi Illustre*, 95. It could also be the case that this amount of parsing concerning the aesthetic origins of the journal might well indicate that, by the 1940s, a generalized and recognizable aesthetic style and format for the modern BD, if not for the journal illustré, had made its way onto the French (popular) cultural palette, at least for most creators and consumers of the medium.

47. These figures are from Lécureux in his interview with Quiquère. They have been confirmed by Crépin, though he puts the number of weekly issues by 1948 more precisely at 182,500. This would still put it ahead of such "American" journals as *Donald* (109,800) and the other prominent journal with a Resistance heritage, *Coq Hardi* (156,500), and behind only the American/Italian-derived *Tarzan* (288,600), the Catholic *Coeurs vaillants* and *Fripounet et Marisette* (262,000), and the popular journal for young girls, *Lisette* (234,000). See Crépin, *Haro Sur Le Gangster!*, 131, 151.

48. Quiquère, "30 ans de Bande Dessinée française."

49. *JO*, Documets Parlemantaires, May 20, 1947, 983–984. On the UADF, see chap. 2 above.

50. See Rioux, *The Fourth Republic*, 436.

51. No. 1374, "Proposition de Loi portant statut de la presse enfantine," May 20, 1947, 2. CAC, 770130/article 32: Projet de loi sur la Press Enfantine.

52. Ibid., 2–3.

53. Ibid., 7.

54. McKenzie, *Remaking France*, 19.

55. Interestingly, the fact that Bill no. 1374 would remain, however, as inspiration for the later legislation of 1949 and the organization of the Oversight Commission that was created in

conjunction with that legislation is likely demonstrated by the fact that a copy of the proposal was found by the author in the archives of the CIED.

56. Rioux, *The Fourth Republic*, 436.

57. Crépin, "Le Comité de Défense de la Littérature et de la Presse pour la Jeunesse," 136.

58. Bernard Bellande, "Journaux d'Enfants," *Éducateurs* (January–February 1947): 30.

59. Ibid.

60. Ibid., 43.

61. Ibid., 34.

62. Monjo, "L'Offensive du dollar contre les cerveaux d'enfants," *L'Humanité*, October 25, 1947, 4. Cited in Crépin, "Le Comité de Défense de la Littérature et de la Presse pour la Jeunesse," 135.

63. Louis Aragon, "Victor Hugo," *Les Lettres françaises*, June 28, 1951. Quoted in Kuisel, *Seducing the French*, 38.

64. Crépin, "Le Comité de Défense de la Littérature et de la Presse pour la Jeunesse," 135.

65. Lebovics, *True France*, 158. See also chapter 2 above.

66. Rioux, *The Fourth Republic*, 84. Most often, the impact of the agreement has been discussed in terms of its impact on the French movie industry. See, for example, John Trumpbour, *Selling Hollywood to the World*. For a discussion of the impact of the agreement on the broader print media, see McKenzie, *Remaking France*, particularly 193–230.

67. Rioux, *The Fourth Republic*, 125.

68. Couperie and Horn, *A History of the Comic Strip*, 94.

69. Aesthetic critiques of the medium generally were more often the purview of right-of-center commentators, as they had been since the 1930s and into Vichy as demonstrated by Paul Marion's late-war directive. Nonetheless, concerns over an inferior "formule américaine" did become political fodder for some on the left in the Assembly debate that surrounded the passage of the July 1949 Law on BDs while the Oversight Committee that was created by the law would also raise these issues.

70. Crépin, "Le Comité de Défense de la Littérature et de la Presse pour la Jeunesse," 134.

71. Ory, "Mickey Go Home!" 77.

72. Young respondents to a survey indicated that they preferred *Captain Marvel Junior* and *Hopalong Cassidy* to French BD heros. "Résultats du concours," *Mon journal* no. 41, 1947, 7. Cited in Jobs, "Tarzan under Attack," 696. See also Jobs, *Riding the New Wave*, 322.

73. On the CIED not closing its sessions until the task of regulating dangerous publications was finally completed, see André Marie's address to the National Assembly, *JO*, Débats, 1948, 474–489.

74. Mignot, "Cri D'Alarme," *Semences De Crimes*, 13–14. Given some of the language that Mignot used in his "Cry of Alarm" it is likely that he was referencing the actions of Abbé Bethléem, who in March 1927 was fined eleven francs for publicly destroying several reviews and magazines he claimed were licentious and pornographic. He defended himself by asserting that the state no longer defended public morals and that he wanted to set an example to be followed by other concerned citizens. See *International Herald Tribune*, March 22, 1927.

75. Marie, "Circulaire: Le Garde des Sceaux, Ministere de la Justice à Monsieur le Procureur General près la Cour d'Appel," March 8, 1948, CAC, 770130/article 32: Projet de loi sur la Presse Enfantine.

76. Moch, "Publications dangereuses pour la moralité publique."

77. Beyler, "Letter to the Ministry of the Interior," June 3, 1948, CAC, 770130/article 32: Projet de loi sur la Presse Enfantine.

78. Mennelet, "On réclame une loi contre les journaux de gangsters 'stupéfiants pour enfants,'" *Le Figaro*, March 11, 1948.

79. The commission had representatives from not only the Ministry of Justice and the Interior, but also from Industry and Commerce and National Education, as well as members of the Press Commission. The breakdown of concerns raised in the CIED meetings here is based on the minutes from its sixth, seventh, and eighth meetings on April 20, May 4, and May 11, 1948, respectively. CAC, 770130/article 32: Projet de loi sur la Presse Enfantine.

80. Ballandras, "Deuxieme Enqueste sur les Journaux d'Enfants," 1. CAC, 770130/article 32: Projet de loi sur la Presse Enfantine.

81. Ibid., 2–3.

82. Ibid., 3.

83. Ibid., 5.

84. Gosset, No. 5305, "Rapport, Le Projet de Loi sur les publications destinées à la jeunesse," August 18, 1948, 1–2.

85. Ibid., 6–11.

86. Ory, "Mickey Go Home!" 80.

87. Polbernar, "L'Agoissante Question des Journaux d'Enfants Laisserons-nous corrompre notre jeunesse par les bandes illustrées made in USA: Gangsters, pin-up, superman and Co. . . ?," *Ce Soir*, March 24, 1948.

88. McKenzie, *Remaking France*, 218. McKenzie's text is the only work to date that addresses American involvement in the politicking that surrounded debate and ultimate passage of the 16 July Law on youth literature. It is therefore an invaluable source for a complete understanding and appraisal of what was presumed to be at stake and, perhaps even more, the extent to which the French nation was often constrained in making its own governmental policy in the years immediately after WWII.

89. Ibid. One point here that McKenzie could be overlooking is the fact that many American officials serving in France at the time likely might have been at least vaguely sympathetic to French concerns over the moral repercussions of BDs. These years after WWII also mark the beginning of overt and governmental concern about their effects on American youth, which would culminate in the formation of the Senate Sub-Committee on Juvenile Delinquency in April 1953; but only after the issue had been debated in Congress for several years. It seems highly unlikely that Winkler would have been unaware of his need to demonstrate even to American officials that his publications were in no way immoral or licentious. On the debates over "comics" in America, both in the public sphere generally and in the Senate, at this time, see Nyberg, *Seal of Approval*, particularly 42–135.

90. See McKenzie, *Remaking France*, 219.

91. Ibid.

92. Marie, *JO*, January 27, 1949; ibid.

93. Pierrard, *JO*, Débats, January 21, 1949, 91–92. Four days after this session of the Assembly, Winkler responded in writing to each of Pierrard's comments and accusations in a letter sent to each member of the Assembly, taking care to distance himself, Opera Mundi, and

the entire American press from any association with "Hitlerophile"-ism, Pierrard's strongest accusation, and one which Winkler found particularly distasteful. See Winkler, "Réponse aux accusations du député communiste André Pierrard," January 25, 1949, CNBDI. It is worth noting that Pierrard was repeating a claim first made by Sadoul in the 1930s in his *Ce que Lisent vos Enfants*, where he insisted that Mickey Mouse was a "great hitlerian fauvism" and extending it to the entire American press. On the Sadoul reference, see Sadoul, *Ce que Lisent vos Enfants*, 15.

94. Ibid. Pierrard was here again referencing Sadoul's earlier work on the economic/market advantage that journaux which used syndicated material had over those that did not. See chap. 2 above, and Sadoul, *Ce que Lisent vos Enfants*, 16–17.

95. Ibid. The MRP deputy Philippe Farine challenged him on this, asking if *Vaillant* was really the only 100 percent French hebdomadaire. Pierrard defended himself by saying: "I cite only some examples, but you can offer those which you know." To which Farine responded: "You would cite the weekly magazaine the title of which your party made a gift!" Ibid.

96. Ibid.

97. See Dominjon and Marie, ibid., 93–94.

98. Lamblin, ibid., 98.

99. Bardoux, with Cayeaux's support, first pressed for "la lâcheté," while Lamblin added "la haine." Ibid., 97–98. The final version of Article 2 of the 16 July Law reads in part that publications "should not contain any illustration, any narrative, any chronicle, any heading, or any insertion that favorably presents banditry, lying, thievery, idleness, cowardice, hatred, debauchery, or any criminal acts or misdemeanors of a nature demoralizing to youth." *JO*, Lois et Décrets, July 19, 1949, 7006.

100. "La Vent Aux Mineurs De Publications Licencieuses est Interdite, Mais la production américaine pourra envahir nous journaux d'enfants," *Ce Soir*, July 4, 1949.

101. Pierrard, "Les 'Comics' continueront-ils à contaminer notre jeunesse?" *Humanité*, July 9, 1949.

102. Meinrath, "La loi sur les publicaions destinées à la jeunesse," *Éducateurs* (September–October 1949): 453.

Chapter Five

1. Meinrath, "La loi sur les publicaions destinées à la jeunesse," 454.

2. Grenier, No. 9601, "Rapport, Au Nom De La Commission de la Presse Sur Les Propositions De Loi," March 23, 1950.

3. Ibid., 2.

4. Ibid., 2–3.

5. McKenzie, *Remaking France*, 220. See also, Ory, "Mickey Go Home," 83, and Crépin, *Haro Sur le Gangster!*, 314–315.

6. *JO*, February 14, 1950, 1734–1736. For Costa on the "reeducation" of juvenile delinquents, see, for instance, Jurmand, "De l'enfance irrégulière à l'enfance délinquante (1945–1950), itinéraire d'une pensée, naissance d'un modèle." See also Jobs, "Tarzan under Attack," 701–702.

7. Commission de Surveillance et de Contrôle des Publications Destinées à l'Enfance et à l'Adolescence, Séance du 2 mars 1950, procès-verbal, 2–3, CAC 900208/Articles 1 and 2.

8. Commission de Surveillance et de Contrôle des Publications Destinées à l'Enfance et à l'Adolescence, Séance du 16 novembre 1950, procès-verbal, CAC 900208/Articles 1 and 2.

9. Observations de Monsieur Jean Chapelle, "sur le projet de 'représentations et recommandations' aux éditeurs de journaux pour enfants présenté par le Secrétariate de la Commission, Suivi d'un projet de RECOMMANDATIONS," October 13, 1950, 1, CAC 900208/Articles 1 and 2.

10. Ibid., 3. For both Hazard and Coston on this point, see chap. 3 above.

11. Ibid., 2–3, 5.

12. Ibid., 4–5.

13. Ibid., 6–7.

14. *Compte rendu des travaux de la Commission de Surveillance et de Contrôle des Publications Destinées à l'Enfance et à l'Adolescence au cours de l'année 1950*, 31–34, CAC 900208/Articles 1 and 2.

15. *Compte rendu . . . 1950*, 12–15. The reference to the hero of the *policier* genre possibly being "even a child," was likely a result of the already immense popularity of the Belgian derived journal *Tintin*, and the intrepid cub reporter of the same name, which had begun publication in October 1948. Even among members of the Oversight Commission, the journal was considered a standard-bearer for its projected age group of readers of eight to fifteen.

16. Ibid., 8–9, 19–20.

17. "Rapport présenté à la séance du 29 Juin 1950 par M. Cotxet de Andreis, Juge des Enfants au Tribunal de la Sein, sur le cas de la publication "BOLERO" au regard des dispositions de l'article I de la loi du 16 Juillet 1949, CAC 900208/Articles 1 and 2. Éditions Modiales was also the publisher of the hugely popular journal *Tarzan*, which would also come under fire from the Oversight Commission.

18. Ibid., 1.

19. Ibid., 1–2.

20. Ibid., 2.

21. Ibid., 2–3.

22. Ibid., 3–4, emphasis in original.

23. Ibid., 4.

24. *Compte rendu . . . 1950*, 22–24.

25. Ibid., 24–27.

26. The crux of much of Jobs's analysis of both the 16 July 1949 Law and the work of the Oversight Commission, at least in its first years, is that both were attempts at refuting specifically the legacy of both Vichy and Nazi Germany, and it is here that his interpretation appears most trenchant. See Jobs, "Tarzan under Attack," particularly 703–704.

27. *Compte rendu . . . 1950*, 27–29.

28. See Dubois, "La Presse Pour Enfants de 1934 à 1953," *Les Journaux pour enfants*, Numéro spécial de la Revue *Enfance*, 9–17.

29. The Dubois essay, in fact, was preceded in the text by one written by Georges Sadoul and relies on the analysis of *Ce que Lisent vos Enfants* in his own work.

30. As intimated above this is generally the position of Jobs in his otherwise penetrating essay on the work of the Oversight Commission, see note 26 above. It also seems to be the tack of McKenzie's analysis of the political debate that surrounded the passages of the 16 July Law and

the subsequent work of that governmental body; though his general emphasis is directed more at the politics of the cold war than a reaction to the events of WWII. Still, he draws resistance to, particularly American, BDs back no further than 1948, which is a bit surprising given the centrality of Winkler and Opera Mundi to his narrative. See McKenzie, *Remaking France*, 220.

31. *Compte rendu . . . 1950*, 18–20.

32. McKenzie, *Remaking France*, 220.

33. Crépin, *Haro Sur Le Gangster!*, 439 and chap. 9: L'accommodement des éditeurs belges, 391–434.

34. Grove, "Mickey, *Le Journal de Mickey*, and the Birth of the Modern BD."

35. On the relaunch of *JdM* and Winkler's official statement on the goals of the journal, see "*Le Journal de Mickey / répond il à son programme publicitaire?*" 137–138.

36. Ghez, "Interview with Pierre Nicolas: Neuilly-sur-Seine; August 5, 1991."

37. "Mickey Through the Centuries" made its first appearance in issue #15, September 7, 1952, and ran continuously in the journal until #1362, August 6, 1978, making it one of the longest running BDs in French history. Figure 5.2 is from issue #132, December 5, 1954, as is the example of "La Petit Annie," figure 5.1.

38. Issue #132, for instance, contained a two-page article on the French mountaineer Bernard Pierre.

39. Jobs, "Tarzan under Attack," 705.

40. Dubois, "La Presse Pour Enfants de 1934 à 1953," 10. On *Junior* in the 1930s, see chap. 2 above. "Tarzan" continued to appear, for a short time at least, during the Occupation in the pages of the Italian publisher, Cino Del Duca, journal *Hurrah!*, see Crépin, *Haro Sur le Gangster!*, 75.

41. "Savez-vous ce qu'il y a dans les journaux d'enfants?" *Éducateurs* 11 (1947): 452.

42. Jobs, "Tarzan under Attack," 708. Jobs identified a broad swath of criticism across the political spectrum in the press with editorials appearing in *Le monde*, *Le Figaro*, *Éducateurs*, *L'éducation nationale*, *Rééducation*, *Enfance*, *Les temps modernes*, and *Combat*; and in books such as *L'enfant en proie aux images*; *Le monde étonnant des bandes dessinées*; *La presse, le film et la radio pour enfants*; and *La presse enfantine: Les surhommes, les gangsters, les bagarres, les comics et petit commerce*.

43. Sous-Commission chargée d'examiner les publications ayant fait l'objet d'une mise en demeure ou d'un avertissement de la Commission Plénière, Séance du 9 novembre 1950, Proces-Verbal, 8–9, CAC 900208/Articles 1 and 2.

44. *Compte rendu . . . 1950*, 24.

45. Vigilax, "Le mythe de Tarzan," *Éducateurs* 28 (1950): 397. Quoted in Jobs, "Tarzan under Attack," 711.

46. *Compte rendu . . . 1950*, 24. The irony of Tarzan is that in the Burroughs pulp-novels, the Earl of Greystoke, Tarzan's "real" identity, had been discovered in the wilds by a Belgian/French explorer and spoke English when in "society" with a French accent because of this. In addition, the storylines of the "Tarzan" BD had him visiting Paris on several occasions where he spoke with wonder and marvel at what the French people had achieved. On one of these occasions, he resorted to violence only when a great ape that had escaped from the Paris zoo threatened a clutch of women and children. Even in that case he attempted to "talk" to the primate in its own "language" before finally resorting to violence in order to subdue the animal.

47. "Adieu à Tarzan," *Tarzan*, May 3, 1952, 3. Quoted in Jobs, "Tarzan under Attack," 708. On the "Betty Boop" scandal of *Les Belles Images*, see chap. 2 above.

48. *Compte rendu . . .*, January 1, 1955, 8–9, CAC 900208/Articles 1 and 2. The figures in the years 1955–1957, show a slight increase with the number of received and reviewed journaux in 1955 being 2,299; 1956, 2,357; 1957, 2,587. However, there were no "sanctioning reports" issued in those years, but there were thirty-nine recommendations for improvement issued in 1955; thirty-three in 1956; and a large spike in 1957 to seventy-seven recommendations. See *Compte rendu . . .*, June 1, 1958, 10, CAC 900208/Articles 1 and 2.

49. Ibid., 10, 31. While it was to their credit that they forced this change to the law, the commission's members seem to have come to their sensitivity in the matter later than at least some. In his essay, "La Loi du 16 Juillet 1949," Dubois mentioned a letter from the Committee for North-African defense sent to Éditions Mondiales at the height of the "Tarzan Affair" raising the issue of race in *Tarzan*. They expressed disdainful surprise at the "racist poison so insidiously" distilled in a children's publication. See Dubois, "La Loi du 16 Juillet 1949," *Les Journaux pour enfants*, Numéro spécial de la Revue *Enfance*, 77.

50. Artcle 2 of the amending law also removed the legislative ambiguity of the original 16 July Law by extending it to the remaining French overseas territories, specifically Togo and Cameroun. Local regulations, however, were to determine the actual application of the law. *JO*, December 1, 1954, 11215.

51. Observations de M. l'Abbé PIHAN, "sur le projet de 'représentations er recommandation' aux éditeurs de journaux pour enfants, présenté par le Secrétariat de la Commission," July 1950, 3. CAC 900208/Articles 1 and 2.

52. "Notice sur l'application de l'article 14 de la loi du 16 Juillet 1949 sur les publications destinées à la Jeunesse," 1954, revised 1958, 4 & 6, CAC 900208/Articles 1 and 2.

53. *JO*, Article 42, Decembre 21, 1958, 11764–11765.

54. Rioux, *The Fourth Republic*, 351, 356, 361.

55. "Rapport établi par la Sous-Commission chargée de suivre l'évolution de la publication 'Detective,'" June 7, 1962, 1, 2, 4–5, CAC 900208/Articles 1 and 2.

56. *Compte Rendu . . . 1965*, 103. See also, *JO*, October 9, 1962, 9768.

57. *Compte Rendu . . . 1965*, 16.

58. Ibid., 17. In 1962 the two *mises en demeure* were issued to Editions "Nuit et Jour," for *Detective*; and to the publishing house éditée 4 for the still relatively new publication *Hari Kari*—perhaps best described as a French version of the American adolescent-to-young-adult-male-aimed satirical journal *Mad Magazine*.

59. Ibid., 25–26. Between 1955 and 1957, the Oversight Commission reviewed 672, 691, and 746 foreign journaux, respectively. *Compte rendu . . .*, June 1, 1958, 20.

60. Ibid., 34. The official statistical report here, however, issued the caveat that one of the three reviews subjected to interdiction had that ruling suspended after later evaluation. A complete list of all publications and publishers subjected to interdiction for violations of Article 14 of the 16 July 1949 Law from January 1, 1962, to December 31, 1964, can be found in Appendix VI, ibid., 101–114.

61. Chapelle, "A Monsieur le Président et à Mesdames et Messieurs les Membres de la Commission de Surveillance des Publications destinées à la Jeunesse," Mars 29, 1955, CAC 900208/Articles 1 and 2. Chapelle was joined in the National Syndicate by at least one other, perhaps surprising, member of the Oversight Commission, Abbé Pihan. Crépin, following the

analysis of others, has argued that the National Syndicate was created wholly in order to fashion a recognized code of good conduct among publishers of juvenile literature that would allow collective self-policing in the industry because of the success of the Oversight Commission. In this he, and others, have likened it to being "without doubt an imitation of the American system of the Comics Code Authority." See Crépin, *Haro Surle Gangster!*, 312.

62. Fouilhé, "Le Héros et ses Ombres," 27–33.

63. Joubrel, *Mauvais Garçons de Bonnes Familles*, 67–70.

64. Ibid., 67–68.

65. *Compte rendu . . .* , June 1, 1958, 13–16, 55–58.

66. Ibid., 14–15.

67. Ibid., 13–14.

68. *Compte Rendu . . . 1965*, 20.

69. Michallat, "*Pilote*: Pedagogy, Puberty and Parents," *The Francophone Bande Dessinée*, 83.

70. Reitberger and Fuchs, *Comics: Anatomy of a Mass Medium*, 191. On the growth and emergence of youth culture in France, see, for instance, Jobs, *Riding the New Wave*.

71. Michallat, "*Pilote*: Pedagogy, Puberty and Parents," 84.

72. Couperie, *A History of the Comic Strip*, 123.

73. Michallat, "*Pilote*: Pedagogy, Puberty and Parents," 89–90.

74. Ibid.

75. *Compte rendu . . . 1965*, 23. De Gaulle, *The Complete War Memoirs of Charles de Gaulle*, 3. On the Moral Code agreed to by Europressejunior and its emphasis on the protection of children, see Reinhold Reitberger and Wolfgang Fuchs, *Comics: Anatomy of a Mass Medium*, 185.

76. Rubenstein, *Bad Langauage, Naked Ladies, and Other Threats to the Nation*, 95–96.

Chapter 6

Epigraphs. Malraux, *La politique, la culture*, 323. Cited in R. W. Johnson, *The Long March of the French Left*, 64.

1. "Annexe 1: Décisions judiciares relativs aux poursuites intentées contre un éditeur de publications destinées à la jeunesse, pour infraction aux dispositions de l'article 2 de la lois du 16 juillet 1949," *Compte rendu . . .* , June 1, 1958, 39–54. Jobs also discusses the prosecution of Mouchot; see "Tarzan under Attack," 717–720, as well as his *Riding the New Wave*, 257–260.

2. Mouchot was acquitted by the original Lyon court on March 4, 1955; a decision that was upheld by the Lyon Court of Appeals in February 1956. January 1957, the Supreme Court of Appeals vacated both decisions and ordered a retrial in Grenoble. In December 1957, the Grenoble court also acquitted Mouchot and the Supreme Court again annulled the decision, sending it finally to the court in Angers. There, in January 1961, he had the nominal sentence of one-month imprisonment (suspended) and a 500-franc fine levied against him. See *Compte rendu . . . 1958* through 1968 for an overview of the Pierre Mouchot litigation.

3. Mouchot has become a martyr of sorts for French publishers who have faced censorship worries from the government. The publisher of the adult BD series "Elvifrance" maintains a Web site devoted solely to challenging the 16 July 1949 Law and the work of the commission. See http://poncetd.club.fr/CENSURE/EF_CENSURE.htm.

4. "Rapport de la Sous-Commission Chargee d'Examiner les Publication de la Maison IMPERIA," June 4, 1962, 5–6, CAC 900208/Articles 1 and 2. On Andreis, see chapter 5 above.

5. Fassin, "Two Cultures? French Intellectuals and the Politics of Culture in the 1980s," 11.

6. Though it is now slightly dated, John Talbott's work remains one of the better treatments of the Franco-Algerian conflict in English. See his *The War without a Name: France in Algeria 1954–1962*.

7. Charles de Gaulle, "Decolonization Is . . . Inevitable," *De Gaulle the Implacable Ally*, 93.

8. De Gaulle, "We Have Become Independent," ibid., 240.

9. For a brief example of this view, see Kuisel, "The French Search for Modernity," *The Transformation of Modern France, Essays in Honor of Gordon Wright*, 41. Consider the popular slogan from the 1950s and 1960s under de Gaulle, "Neither Ford nor Lenin." Referring to the automated production of the assembly line in America and the drabness of the Soviet leviathan, France was going to thread its own way to modernization, one that relied on the uniqueness of its culture.

10. Larkin, *France since the Popular Front*, 280.

11. Balibar, "The Nation Form: History and Ideology," 97–98. In 1958, Malraux, while serving as the spokesman for de Gaulle's new government, had publicly declared that "the French will not forgive others, or themselves, for becoming a people without a mission." Cited in "Foreign News," in *Time*, July 7, 1958, 20.

12. De Gaulle, "The Address at Dakar: You Can Have Your Independence," *De Gaulle the Implacable Ally*, 90.

13. Bhaba, "Introduction: Narrating the Nation," *Nation and Narration*, 4.

14. Malraux, *La politique, la culture: Discours, articles, entretiens (1925–1975)*, 275–283.

15. Ibid., 273.

16. On Malraux's "colonial" and "colonizing" sense of the role of culture in the Republic, see Lebovics, *Mona Lisa's Escort*, particularly, chap. 5, "Ministering to the Culture," and chap. 6, "Abolishing the Provinces," 87–131.

17. Ibid., 129.

18. This notion is a central part of the analysis of Jobs in his *Riding the New Wave*; see, particularly, "Epilogue: From Hope to Threat," 269–284.

19. See Larkin, *France since the Popular Front*, 318–319.

20. Despite its relative age the analysis of Stanley Hoffman on the events of 1968 remains among the best on offer. See Hoffman, *Decline or Renewal?*, 145–184.

21. See Crozier, *La Société bloquée*.

22. Kedward, *France and the French*, 441–442.

23. Kuhn, *The Media in France*, 127–128.

24. On the Pompidou administration, see Bernstein and Rioux, *The Pompidou Years, 1969–1974*.

25. There is a succinct description of the Ministry of Culture's policy of "développement culturel" on the Ministry's Web site, see http://www.culture.gouv.fr/culture/politique- culturelle/accueil.htm.

26. *The Arc-et-Senans Declaration* (April 7–11, 1972), 19. The "Final Statement" of the *Declaration* is available in pdf format on the Council of Europe Web site, www.coe.int. Complete internet address for Declaration: http://www.coe.int/T/E/Cultural_Co-operation/Culture/Resources/Texts/CDCC(80)7–E_AeS.pdf?L=EN. The Colloquium was an international affair with intellectuals and experts from most of the Western European nations as well as the American cultural theorist Alvin Toffler in attendance.

27. Ibid., 19, 20.

28. Ibid., 20.

29. De Certeau, *The Practice of Everyday Life*, 200.

30. Looseley, *The Politics of Fun*, 53.

31. Ibid.

32. Ibid., 54. For more on Giscard's cultural policies and the reactions they provoked, see ibid., particularly 53–58.

33. The "110 propositions pour la France" is available at www.lours.org/default.asp?pid=307. To see the development of the plan over the course of the 1970s, see *Nouvelle Revue Socialiste*, generally from 1974 to mid-1975.

34. Ibid. See particularly "propositions," 56, 57, 58, 83, 99, 100.

35. The president, Giscard d'Estaing, and the head of the PS, Mitterand, were faced by the leader of the Communist Party, Georges Marchais, and then mayor of Paris, Jacques Chirac.

36. For a more complete detailing of both the election and the central role of the issue of culture in it, see Looseley, *The Politics of Fun*, 61–65.

37. Malraux, "Foreign News," *Time*, July 7, 1958, 20.

38. The issue of regional recognition and protection of local cultures had long been an issue in France. As Lebovics has pointed out, in the 1960s "President de Gaulle and his culture minister, André Malraux, began to reel in the provincialism of the war years . . ." while the events of 1968 were "above all a protest against the top-down nature" of Malraux's "democratizing [of] the culture." Later, in the late 1970s and moving into the presidential election of 1981 the "Peasants of Larzac" refused President Giscard's late-round offer to limit the development of a military base that would have consumed most of the local farms, sparing many of them, because the Socialists had already promised that if they won the election the entire plan would be dropped. Lebovics, *Bringing the Empire Back Home*, 20, 42–43. 39. De Gaulle, in André Malraux, *Fallen Oaks, Conversations with de Gaulle*, 108.

40. Lang, *Address delivered at the opening meeting of the symposium "Tribute to Picasso,"* 2–3.

41. Lang, quoted in Looseley, *The Politics of Fun*, 78.

42. For more on the ideology of Lang and the PS cultural policy, see Ory, "La Politique du ministère Jack Lang: un premier bilan," 77–83.

43. In addition, the very concept of the *circus* in France is more expansive than might first be assumed, particularly by an American reader. The French state had stepped in to aid and protect the ailing family circuses of France in the 1970s creating the Association pour la Modernisation du Cirque, along with funding an École Nationale du Cirque where young artists could study "circus arts" as well as that most French of street arts, mime. Upon graduation from the institution there were at least three options for young performers: they could replenish the aging ranks of the traditional family circus; join the theater, which had become increasingly interested in the skills popular performers could bring to the stage; or go into street theater. For more on this, see Goudard, *Écrits sur le sable*. The valorization of grafitti might be harder to comprehend save simply for its prevalence in Paris and arguably was one reason for Lang's nickname among his critics being the derisive *le tout-culturel*, or everything-cultural. See, for instance, Finkielkraut, *La Défaite de la pensée* and Fumaroli, *L'Etat culturel*.

44. Starkey, "Bande Dessinée: the state of the ninth art in 1986," vi, 181.

45. See, for instance, Jackson, "Making Jazz French: The Reception of Jazz Music in Paris, 1927–1934," 149–170, as well as his text, *Making Jazz French: Music and Modern Life in Interwar*

Paris. For jazz in post-WWII France, see Beth Vihlen, "Sounding French: Jazz in Postwar France." Jazz remains quite popular in France, Angoulême, as the "City of Festivals," in fact hosts an annual fête celebrating the form.

46. Lebovics, *Mona Lisa's Escort*, 28. See also Looseley, "Cultural Policy," 128–131. Here, he notes that it is "not really appropriate to speak of a cultural policy at all" prior to 1959 and the formal establishment of the Ministry of Culture in de Gaulle's Fifth Republic.

47. See Ory, "Mickey Go Home!" 77.

48. Studies have shown, in fact, that minimalist cartoons or caricature may actually aid in both recognition and identification; something that might well more easily allow an individual looking at such to envision themselves in the described scenario or using the advertised product. See, for example, Sarah Stevenage, "Can Caricatures really produce distinctiveness effects?" 127–147.

49. Horn, *The World Encyclopedia of Comics*, 12.

50. McLuhan, *The Mechanical Bride: Folklore of Industrial Man*, 68. To that end, should it be counted as mere coincidence that, in the United States at least, the phrase "The Dagwood" has entered into the delicatessen vernacular and come to mean almost any variety of overstuffed sandwich depending on regional tastes?

51. de Certeau, *The Practice of Everyday Life*, 31.

52. Ibid., 89.

53. *Super Dupont* was created in 1972 by the BD team of Marcel Gotlib and Jacques Lob. For a more critical look at the nationalist tropes that are lampooned in the character of Super Dupont, see Ann Miller, *Reading Bande Dessinée*, 159–160. No matter the potential for misinterpretation of artist intent behind the character, so popular was he for a time that in 1982 two different songs referencing the character were produced in France and quickly became novelty favorites. One was recorded by the songwriting team of Dominique Pankratoff and Marc-Fabien Bonnard on the French Trema record label and is most notable for pointing to all the foreign products on the French market. The other was done by Le Grand Orchestre du Splendid on the multinational RCA record label, it is an ode to the hero who lets the French sleep comfortably knowing that someone is looking out for their interests. The lyrics for both songs respectively are available on the Internet at www.bide-et-musique.com/song/4846.html and www.bide-et-musique.com/song/1990.html. Accessed on August 15, 2004.

54. For a brief example of this, see Jill Forbes and Michael Kelly, "Politics and Culture from the Cold War to Decolonization," 134.

55. Quoted in Nye, "Death of a Gaulois: René Goscinny and Astérix," 190. However, he did say that he believed Astérix to be representative of the average Frenchman, chauvinistic and a bit boorish: "Most French are chauvinistic . . . but they're too modest to say so." Ibid., 185.

56. Ross, *Fast Cars, Clean Bodies: Decolonization and the Reordering of French Culture*, 4.

57. See note 47 above.

58. Kuisel, *Seducing the French*, 3. While the term is still used, it has lost most of its direct connection with America. More recently, scholarship has linked it to the concept of globalization, strengthening its analytical potential. Following Philip Gordon and Sophie Meunier, if globalization refers to "the increasing speed, ease and extent with which capital, goods, services, technologies, people, cultures, information, and ideas now cross borders," then Americanization refers to the frequent centrality of the United States in this process. Moreover, polls indicate that it is the threat of Americanization that makes the French most apprehensive

about globalization. See Philip H Gordon and Sophie Meunier, *The French Challenge: Adapting to Globalization*, 5 and 42 respectively.

59. Monneron and Rowley, *Histoire du peuple français: les 25 ans qui ont transformé la France*, 133. It is worth noting that the same statistical break-down also indicated that the percentage of those who described themselves as independent business men also fell from 12 to 8.7 percent in the same period; indicating a concentration of business and industry in the hands of fewer corporations and standardization of business culture for everyone.

60. Ross, *Fast Cars, Clean Bodies*, 22.

61. For these specific BDs, see *Pilote hebdomadaire, Le Journal Qui S'Amuse A Reflechir*, no. 607, 8–9 and 16–17 respectively."

62. *Pilote*, no. 603, 5 and 8–9 respectively. Perhaps it is worth noting that the BDs on pages 6 and 7 detailed what it was like to fly first class and the different traveling tastes of the English and Americans. The English preferred a classic and traditional grace in planes propelled quietly by Rolls-Royce motors, while the Americans were displayed surrounded at all times by the most modern and automated features possible with robots and mechanical arms which provided manicures, poured drinks, offered massages, and even held your cigar for you.

63. A typical journal of the time seemed to average no fewer than twelve advertisements, many not only very colorful but entire page layouts of obvious prominence. At least once, there was even an announcement on how to obtain information on a computer-training course at the "Advance Institute" in Paris, which took up the entire inside back cover. See *Pilote*, no. 606, 59.

64. Occasionally, this was made gender specific with the term "nouveautés" exchanged for the phrases, "fête des mères" or "spécial fête des Pères" but the intent remained the same and the range of products suggested to the readers moved through clothes for every situation to new kitchen and home "gadgets."

65. Figure 6 appeared in *Pilote*, no. 605, 48. In 1971, this BD appeared in at least one other issue of *Pilote* (no. 604). Strangely, the same artist, who went by the name Lacroux, drew an even more abstract BD with the same amorphous character called simply *Echasses* that was a series of cartoons with the character in various atypical situations on stilts. See *Pilote*, no. 611, 50.

66. Lebovics, *Mona Lisa's Escort*, 190.

67. Kuisel, *Seducing the French*, xii. Kuisel has further argued that it is unnecessary to determine the actual existence of this social and cultural construction, rather we need only recognize that it colored the way "our Gallic cousins viewed us [Americans/America]." Ibid.

68. Bataille, *Literature and Evil*, ix–x.

69. Barthes, *Mythologies*, 11.

70. Ibid., 9.

71. Rioux, *The Fourth Republic, 1944–1958*, 85.

72. Barthes, *Mythologies*, 116, 125.

73. Ibid., 143.

74. Barthes, "The Photographic Image," *Image Music Text*, 15, 26–27.

75. The appellation, "68ers," refers to the watershed moment in French political and cultural history of the 1968 revolts that forced de Gaulle (as well as his Minister of Culture Malraux) from power and the heady expectation of change and political innovation that, for many, followed. Its reference here was taken from Lebovics, *Mona Lisa's Escort*, 190.

76. Foucault, "Nietzsche, Genealogy, History," *Launguage, Counter-Memory, Practice: Selected Essays and Interviews*, 147–148, 153.

77. Pierre Bourdieu was nearly alone among the "68ers" in his recognition that "strip cartoons" played any role at all in French culture; even then, however, it was a point of moderate rebellion for the new "petite bourgeoisie who originate from the upper classes." Bourdieu, *Distinction*, 360. A point of clarification here, perhaps it is worth mentioning that Bataille, who died in 1962, is not here counted among the cadre of "68ers." Still, while significantly older than (even) Barthes, Foucault, Bourdieu, Jacques Derrida, and others, he did share at least one firm link with many of them as a contributor to, and collaborator in, the avant-garde journal *Tel Quel*.

78. See McLuhan, *The Mechanical Bride: Folklore of Industrial Man*.

79. Beylie, "La bande dessinée est-elle un art?" *Lettres et medecins*, January 1964, 9–14.

80. Bourdieu, *Distinction*, 360.

81. For an overview on the CBD, see Guillaume and Bocquet, *Goscinny*, 133.

82. Uncredited editorial prefacing the 1964 re-issue of Giff-Wiff, nos. 1 and 2 (unpaginated). See *Giff wiff!*: bulletin du club des bandes dessinées: deuxième anniversaire du club: réimpression des bulletins 1, 2, 3–4. The high cultural claims and hopes the members of the CBD had for BD aside, there was often friction between the group's members. Resnais, who frequently declared BD to be a kindred medium of cinema, ultimately left the group because he had tired of listening to Eco endlessly and ponderously lecture everyone else on the matter at the Club's meetings. McQuillan, "Trends in the BD critical field: A Brief History of Time."

83. Vihlen, "Sounding French: Jazz in Postwar France," 405.

84. *JO*, November 15, 1970, 10524. To circumvent the interdiction order, the publisher of the journal, Editions du Square, changed its name a few weeks later to *Charlie Hebdo*. It remained a leading satirical, left-of-center journaux illustrés until 1981. Reappearing in 1992, it has staked out an editorial position as an ardent, and some might suggest obnoxious, defender of leftist-liberalism and the freedom of the press. At the start of 2005, the journal put itself in the center of controversy by publishing a number of Danish cartoons ridiculing Islam and the prophet Mohammed (after there had already been demonstrations and violent riots in a number of Muslim and predominantly Muslim countries) with an original one on its cover of Mohammed, with head in hands, muttering, "It's hard to be loved by morons," as a declaration of the freedoms of speech and of the press. Not long after it was reported in the *New York Times* that the journal's editorial staff promised they would also publish Iranian-sponsored lampoons of the Holocaust. For the *New York Times* account, see Craig S. Smith, "The Islamic Flare-Up: France; Next Step by Weekly in Paris May Be to Mock the Holocaust," *New York Times*, February 9, 2006, Late Edition, Section A, 14. For more on this, see the concluding epilogue.

85. For a brief but informative take on the importance of both SOCERLID and *Phénix* in the push to cultural legitimation, see Pilcher and Brooks, *The Essential Guide to World Comics*, 157–160.

86. Sullerot, *Bande Dessinées et Culture*, 13, 24.

87. On Blanchard quickly, see Miller, *Reading Bande Dessinée*, 24.

88. Pierre Fresnault-Deruelle, "Du linéaire au tabulaire," 7–23.

89. Fresnault-Deruelle seems largely to have spent the great bulk of his professional life in the study of BD as a communicative form. See also his earlier *La Bande Dessinée: Essai d'analyse sémiotique*, one of the first serious works on the subject by a French academic.

90. Harris, "Festivals and fêtes populaires," 221.

91. For a quick review of both the Angoulême festival and its importance in English, see Pilcher and Brooks, *The Essential Guide to World Comics*, 161–163.

92. Miller, "Bande Dessinée," 136–137. See also "Les grandes dates du CNBDI" at the CNBDI Web site: www.cnbdi.fr. Interestingly, the Ministry of Culture set out a new version of Lang's "15 mesures" in 1997 entitled *15 Mesures nouvelles en faveur de la Bande dessinée*, which stressed strengthening the ties between different departments and ministries with an interest in the medium as well as the cultivation of a better environment for the exportation of French BDs. See www.culture.gouv.fr/culture/actual/misfred2.htm. See also the epilogue of this work.

93. Malcolm Cook, "Introduction: French Culture since 1945," *French Culture since 1945*, 2, 8.

94. Antenne 2, 1982.

95. *Libération*, February 2, 1982.

96. Roland Castro is a well-known and highly regarded architect in France who has designed buildings ranging from personal residences to government institutions like the CNBDI. To see the CNBDI, a modernist structure with a great deal of glass and evident steel, which also folds into the largely stone and medieval dominated cityscape, see www.chez.com/fransforarchitecture/AR/castro.htm.

97. Pierre Nora, *Realms of Memory: The Construction of the French Past*, see particularly volume 3.

98. Mitterand, quoted in Norindr, "La Plus Grand France," 242.

99. The most influential work on this topic/idea is likely that of the historian/social theorist Michel Foucault. See, particularly, his concept of the "Panopticon," which should not be "understood as a dream building: it is the diagram of a mechanism of power reduced to its ideal form . . . polyvalent in its applications; it serves to reform prisoners, but also treat patients, to instruct schoolchildren, to confine the insane to supervise workers, to put beggars and idlers to work. It is a type of location of bodies in space, of distribution of individuals in relation to one another, of hierarchical organization, of disposition of centres and channels of power, of definition of the instruments and modes of intervention of power, which can be implemented in hospitals, workshops, schools, prisons." Foucault, *Discipline and Punish: The Birth of the Prison*, 205.

100. Ludwig Mies van der Rohe, Detlef Mertins, and George Baird, *The Presence of Mies*, 76.

101. Edward Said, "Reflections on American 'Left' Literary Criticism," 170.

102. *Le Monde*, November 10–11, 1991, 9.

103. Mitterand, quoted in Norindr, "La Plus Grand France," 242.

104. "From the Pyramid to the Grand Louvre," 459. This is nearly the most gracious of the many commentaries on the American-born I. M. Pei's avant-garde entrance to the Louvre. The general criticism of the work has led the architect to declare that the "mixing of art, culture, and commerce is not possible," and he has sworn off any similar projects in the future. See "Pei's Palace of Art," *Time*, November 29, 1993.

105. Higonnet, "Scandal on the Seine," 32.

106. Mitterand, quoted in Norindr, "La Plus Grand France," 244–245.

107. Guy, "Le Louvre de la raison," *Le Monde*, December 7, 1984, 1.

108. Mitterand, quoted in Norindr, "La Plus Grand France," 243.

109. The modernist *Grande Arche de la défense*, designed by the Danish architect Otto van Spreckelsen, for instance, has also been the subject of attacks similar to those levied at Pei's

glass pyramid. For more on the general aesthetic and ideological critiques of Mitterand's *grand projets*, see Pierre Vaisse, "Dix ans de grands travaux," 310–328.

110. Mitterand, quoted in Norindr, "La Plus Grand France," 246–247.

111. Arguably, a similar assertion could be made about the Institut du Monde Arabe (IMA), which was also finished and dedicated during Mitterand's tenure as president. Created with the express purpose of fostering a greater understanding in France of Arab and Muslim culture and becoming a "true 'cultural bridge' between France and the Arab world," the IMA remains nearly a unique state institution in the West. See "Mission et organisation" at the IMA Web site: www.imarabe.org. However, its stated mission appears to reveal a breach, an uneasiness that remains in country as it seems to posit a disconnect, or remaining obstacle, between those who are French and those who are Arabic, and generally Muslim. France today has the largest Muslim population in Western Europe and the most recent political flurries surrounding the outlawing of overt religious symbols in state schools—while Jewish yarmulke and oversized Christian crosses are also banned, it is widely recognized that the law that went into effect on September 2, 2004, is aimed directly at the Muslim hijab or female headscarf—demonstrates that it remains a community still only awkwardly situated within the nation. Lebovics, however, has asserted that the legislation is more the reaction of "unitary republicans" to the racist and divisive political movement headed by Jean-Marie Le Pen's National Front than it is resistance to the nation's Muslim communities. Lebovics, *Bringing the Empire Back Home*, 186–187. For more on Le Pen and the National Front, at least through the mid-1990s, see Marcus, *The National Front and French Politics*.

112. His lament in full was: "l'implantation à Angoulême équivant à un enterrement de première classe." Quoted in Ann Miller, "Bande Dessinée: A Disputed Centenary," 85.

113. Angoulême's almost janus-faced nature has been discussed and praised by a wide range of commentators. See, for instance, the Trappist monk and multigenre author Thomas Merton, who wrote admiringly of the city's "strange fat Romanesque cathedral," in his spiritual autobiography *The Seven Storey Mountain*, and Richard Lehan, who argued that "with remnants of the medieval city still at the center and industry at the margins, a provincial city like Angoulême would be familiar even now to Balzac." Thomas Merton, *Seven Storey Mountain*, 48, and Lehan, *The City in Literature: An Intellectual and Cultural History*, 288, respectively.

114. The Duc d'Angoulême was a chief rival to the king in the famous Dumas work *The Three Muskateers*; in Gabriel Garcia Marquez's *Strange Pilgrims: Twelve Stories* the city itself served as a geographic marker of distance and place in the characters' journey; in the Vargas Llosa novel *The Way to Paradise: A Novel*, Angoulême served as a recognizable place of both repose from Parisian life and a place from which those wishing to make their mark came. In the semiautobiographical work of Henry Miller, Angoulême was of note mostly for being where a friend caught "the clap" from a local waitress. See *A Literate Passion: Letter of Anïas Nin and Henry Miller, 1932–1953*, 182.

115. Trilling, "The Princess Casamassima." On this phenomenon in Balzac, see, for example, *Pere Goriot*, where the lodging house of Madame Vauquer, an equally tropic figure of the aged and world-weary widow, who makes her way by letting rooms to boarders of all stripes had a room "occupied by a young man from near Angoulême who had come to Paris to study law, and whose numerous family submitted to the sharpest privations in order to send him twelve hundred francs a year." Honoré de Balzac, *Pere Goriot*, 14.

116. De Balzac, *Two Poets*. This work, the first part of a trilogy, was dedicated, with a lovingly crafted opening letter, to Victor Hugo.

117. The most compelling and entertaining account of Balzac's time in Angoulême remains Keim and Lumet, *Honoré de Balzac*. The authors make note of Balzac's near strident letters of instruction to his mother in dealing with potential editors and publishers that date from this time on as evidence of his emboldened spirit.

118. The 1539 Edict of Villers-Cotterêts, issued by François I, which required the use of French, in place of Latin, in official documents as well the Republican insistence that a standard French be adopted throughout the Hexagon for the well-being of the nation are obvious points of impact on the printing industries of France. More indirectly political events such as the revocation of the Edict of Nantes in 1685 by Louis XIV, convinced of the propriety of the principle of "One faith, one king, one law," had a near-devastating impact on the industry as many of the artisans in the field were Protestant Huguenots forced into exile.

119. Miller, "Bande Dessinée: A Disputed Centenary," 85.

120. See Tiersky, *François Mitterand*, 41.

121. Bourdieu, *The Field of Cultural Production*, 234.

122. Miller, "Bande Dessinée," 136–137.

123. Mitterand, "Preface," in "Grands Travaux" (special issue), *Connaissance des Arts*, August 1989, 5.

124. Benjamin, "Paris, Capital of the Nineteenth Century," in *Reflections*, 146–162.

125. Perhaps, given that the CNBDI is now at the center of the annual festival and that it was built on a site that was once an abbey, there is some measure of truth to the assertion that festivals in France are the "modern secular mode of the former religious ceremonies, uniting communities and diverse social groups in acts of commemoration, celebration and (more or less spontaneous) festivity." See Harris, "Festivals and fêtes populaires," 222.

Epilogue

Epigraph. The French political cartoonist Jean Plantureux (professional name, Plantu), explaining the difference between French and English humor in the pages of the *Economist*. Plantu has had firsthand experience with this lack of detachment as he describes it. His political cartoons have appeared on the front page of *Le Monde* for roughly twenty years, and before 1995 he was left to his own devices in choosing what his daily cartoon would address. However, because of his willingness to be controversial, since then the newspaper's editors have limited his work to being related to the day's top story. In 2003, the artist seriously clashed with the management of *Le Monde* when he "published" a cartoon on his personal Web site showing his trademark mouse gagged while reading *La Face Cachée du Monde*, a best-selling polemic about the arrogance, obstinance, and political aspirations of the newspaper's editors. See "Very Droll," *Economist*, December 20, 2003.

1. Though completed under the umbrella of the Ministry of Culture, the project that produced the "15 Mesure nouvelles" was done jointly with the CNL and its BD commission. For the new measures as well as a summary of the report from the committee that generated them, see http://www.culture.gouv.fr/culture/actual/misfred.htm.

2. See Miller, *Reading Bande Dessinée*, 66, and Groensteen, *Un objet culturel non identifié*, 149. On *l'année de la BD*, see http://www.evene.fr/livres/actualite/l-explosion-des-bulles-128.php.

3. See, for instance, Groensteen, *Un objet culturel non identifié*, 149. Groensteen is even more forceful and dismissive of the "treatment" of the medium over the course of the entire twentieth century earlier in his text; see ibid., 18.

4. Rockwell, "In a Venerable French City, the Comic Book Seeks a Future," January 29, 1994.

5. Novels, at 26.4 percent, continued to account for the single largest share of the market, followed by non-BD children's books (18.6 percent) and school texts (17.9 percent). See *L'Edition de Livres en France* 1998: report for 1997. It should be noted that these figures do not take into account *journals d'hebdomadaire*, or even monthly American-style comic books. Since the late 1980s French publishers and distributors of these products have adopted the secretive policies of American publishers like *Marvel* and *D.C. Comics* and relatively closely guarded their circulation figures. Rough, and likely conservative, estimations would put yearly consumption of these products also into the millions of copies.

6. Groensteen, "Genres et series," 78–87.

7. Beaty, *Unpopular Culture*, 21.

8. For an informative primer on L'Association and other actors in the independent BD and publishing scene, see Pilcher and Brooks, *The Essential Guide to World Comics*, 164–173.

9. Beaty, *Unpopular Culture*, 26, 65.

10. Jean-Christophe Menu, cited in Björn-Olav Dozo, "La bande dessinée francophone contemporaine à la lumière de da propre critique."

11. Beaty, *Unpopular Culture*, 20.

12. See chapter 2 above on *L'Assiette au Beurre*.

13. Bourdieu, "La sociologie de la culture populaire," 118.

14. From 2000–2003 Satrapi published four *Persepolis* albums in France; thus far, only two have been translated and made available in the United States.

15. Patricia Storace, "A Double Life in Black and White," April 7, 2005.

16. Luc Sante, "She Can't Go Home Again," August 22, 2004. It is perhaps worth noting, that among the English-language press, Sante was hardly alone in his observations. See also, "A Life in Pictures: How to say a lot without a lot of words," *Economist*, October 28, 2004.

17. See Björn-Olav Dozo, "La bande dessinée francophone contemporaine à la lumière de da propre critique."

18. See McMillan, *Twentieth-Century France*, 216.

19. On the idea that the populist success of the National Front has at least in part been a result of the difficulties the French populace have faced as a consequence of market globalism and postcolonial and postnational politics, see, for instance, Jenkins, "The Once and Indivisible Republic," 5.

20. See Schain, "The National Front and the French Party System," on immigration and political dialogue in France; for an interesting examination of how Le Pen and the rise of xenophobic politics effected the PCF in the 1990s, see Marcus, *The National Front and French Politics*.

21. "Extrême-droite: le réveil des auteurs de BD," Avril 15, 2002. When it came to mobilizing BDs to political use Le Pen was not entirely left behind. As the BBC profile of him from 2002 made mention, there was an "adulatory comic-strip biography" available from the FN headquarters that made much of his youth and military service. See "Profile: Jean-Marie Le Pen," April 22, 2002.

22. On the electoral results of 2002, see Durand, "The Polls in the 2002 French Presidential Election: An Autopsy."

23. "Le Seuil condamné pour une BD sur Marine Le Pen," June 24, 2008.

24. "Four Die in Afghan cartoon riot," February 8, 2006.

25. Sanford, "French magazine sells quickly," February 9, 2006.

26. *Le Monde*, February 3, 2007.

27. *Le Monde*, February 10, 2007, and February 8, 2007.

28. Chrisafis, "Cartoons did not incite hatred, French court rules," March 23, 2007. It is perhaps worth pointing out that the original complaint brought against *Charlie Hebdo* included only three of the original twelve published cartoons, including the image of Muhammad cradling his head in his hands crying out, "It is hard to be loved by fools," by the French cartoonist Cabu that had been the cover page of the original February 9, 2006, issue. This and another cartoon published originally in the Danish journal *Jyllands-Posten* were argued by the court to be "well within the acceptable limits of freedom of expression." The final caricature, one depicting the Prophet Muhammad as wearing a bomb-shaped turban, however, elicited a more-nuanced ruling. Admitting that the caricature, on its own, could well be taken as shocking if not offensive by followers of Islam, it must be understood in the context of its presentation in an issue of *Charlie Hebdo*, which had as its goal a satire-laced investigation of religious fundamentalism. For more on the entire ruling, see, for example, Bell, "Victory for editor over 'offensive' cartoons," March 23, 2007.

29. "Relaxe requise par le parquet pour Charlie Hebdo," December 2, 2007.

30. Sarkozy's history—from his "racaille" comments during the riots in *les banlieues* in the fall of 2005, to his commissioning of the Machelon Report, which recommended an updating of the 1905 law on the separation of church and state in his second term as the interior minister and overseeing the creation of the Conseil Français du Culte du Musulman in his first, to his continued insistence that Turkey not be admitted to the EU, mixed with his sometimes quarrlesome relationship with the press, all coupled with his "front-runner" status as a presidential candidate—meant that his response to the case was regarded with particular interest.

31. See *Libération*, February 8, 2007; *Telegrah.co.uk*, February 8, 2007; and *Le Figaro*, February 7, 2007.

32. De Vabres, "Réception en l'honneur des dessinateurs de presse," March 15, 2006.

33. Discours et communiqués, "Renaud Donnedieu de Vabres a confié une mission sur la conserc ation et la valorization du dessin de presse à Georges Wolinski lors d'une reception en l'honneur des dessinateurs de presse le mardi 15 mars," Mercredi, March 16, 2006.

34. Wolinski, "Rapport Sur La Promotion et La Conservation Du Dessin De Presse," 5.

35. Ibid., 5–6.

36. See Section III, ibid., 35–40; on the Oversight Commission and the Europressejunior label, see chap. 5 above.

37. Louvre, "Le Petit Dessein: Le Louvre Invite la Bande Dessinée," Communiqué de Presse, January 1, 2009.

38. "The Louvre embraces comics for the first time," *International Herald Tribune*, January 1, 2009.

39. Ibid. and Louvre, "Le Petit Dessein: Le Louvre Invite la Bande Dessinée."

40. Jean-François Picheral, Séance du jeudi, January 30, 2003.

41. See Royal, *Le ras-le-bol des bébés zappeurs*, 1989.

42. This was quite an issue in the Japanese press, as was the French presidential election generally. See, for example, "Aso urges French presidential candidate to read 'manga,'" *Japan Times Online*, April 21, 2007.

43. See, "Asterix, Ambassadeur exceptionnel de la défenseure des enfants."

44. Jean-Pierre Rosenczveig, "DEI Communiques Commentaires," May 5, 2007.

45. Giddens, *Modernity and Self-Identity*, 54, emphasis in the original.

46. Lebovics, *Bringing the Empire Back Home*, 172–176.

47. Kaiser, "The Rat Race for Progress," 248.

48. Habermas, "Historical Consciousness and Post-Traditional Identity," 249–267.

Bibliography

Archival Sources Consulted
Archives Nationales, Paris (AN)

Ministère de l'Information
F41, 120: Subvention à des organismes de presse.
F41, 156: Circulaires et Notes de Service, Sept 1930–Août 1944.
F41, 269: Propagande section jeunesse—marché pour les abonnements souscrits.

Ministère de la Jeunesse et des Sports
F44, 2n: Note sur la diffusion des journaux d'enfants sur les deux zones.
F44, 52: Rapport du 9 juillet 1947 de la commission d'étude des problèmes de la jeunesse.

Bibliothèque Nationale de France, Paris (BnF)
Centre des Archives Contemporaine à Fountainbleue, Seine-et-Marne (CAC)

Ministère de l'Intérieur
770130: Article 30: Contrôle des Publications Étrangères.
770130: Article 32: Projet de Loi sur la Presse Enfantine.

Ministère de la Jeunesse et des Sports
860430: Article 16: Correspondence et Pieces Diverses Concernant la Développment de la Culture et des Arts: Presse Enfantine, 1945–1959.
900208: Articles 1 et 2: Procès-verbaux des Commissions et Sous-commissions de surveillance et de contrôle des publications destinées à l'enfance et à l'adolescence, 1950–1967.

Centre Nationale de la Bande Dessinée et de l'Image, Angoulême

Crépin, Thierry. "Défense du dessin français: Vingt ans de protectionnisme corporatif." *Dessin Français*.
Winkler, Paul. "Réponse aux accusations du député communiste André Pierrard." January 25, 1949.

Print Collection, Miriam and Ira D. Wallach Division of Arts, Prints, and Photographs, New York Public Library, Astor, Lenox, and Tilden Foundations, New York

La Caricature. Paris: La Maison Aubert, November 1830 to August 1835.
Le Charivari. Paris: La Maison Aubert, January 17, 1832.
Le Musée ou Magasin Comique de Philipon. La Maison Aubert.
L'Assiette au Beurre. Paris: n.p.
Psst . . . ! Paris: Plon, February 5, 1898, to September 16, 1899.

Journal Officiel de la République française

J.O., Débats parlementaires, Assemblée nationale

Séance du 21/22 janvier 1949: 90–98.
1re et 2e séances du 27/28 janvier 1949: 141–154 and 172–182.
Séance du 2/3 juillet 1949: 4092–4102
Séance du 22/23 décembre 1950: 9472.

J.O., Débats parlementaires, Conseil de la République

Séance du 26/26 février 1948: 474–489.
Séance du 4/5 mars 1949: 529–548.
Séance du 31 mars/1 avril 1951: 753–755.
Séance du 18/19 novembre 1954: 1845.

J.O., Documents parlementaires, Assemblée nationale
No1374, 1947: 983–984.
No1375, 1947: 984.
No3838, 1947: 597–598.
No5305, 1948: 1962–1964.
No7365, 1949: 1000.
No7744, 1949: 4171.
No7796, 1949: 4396.
No9601, 1950: 2330.
No4296, 1952: 2114.

J.O., Lois et décrets

Lois no49–956 du 16 juillet 1949 sur les publications destinées à la jeunesse, 18–19 juillet 1949: 7006–7008.
Décret no50–143 du qer février 1950 portant règlement d'administration publique pour l'exécution de la loi du 16 juillet 1949, 2 février 1950: 1193.
Arrêté du ministre de la Justice du février 1950 concernant l'application de la loi et de son règlement d'administration publique, 13–14 février 1950: 1734.

Arrêté du ministre de la Justice du 4 février 1950 concernant la composition et l'organisation du secrétariat de la commission de surveillance et de contrôle des publications destinées à l'enfance et à l'adolescence, 13–14 février 1950: 1735.

Other Sources

"15 Mesures nouvelles en faveur de la Bande dessinée." www.culture.gouv.fr/culture/actual/misfred2.htm.

"110 propositions pour la France." www.loursorg/default.asp?pid=307.

"A Life in Pictures: How to say a lot without a lot of words." *Economist*, October 28, 2004, Online at: http://www.economist.com/books/displayStory.cfm?story_id=3329029.

Abel, Richard. *French Film Theory and Criticism: A History/Anthology*, vII: 1929–1939. Princeton, NJ: Princeton University Press, 1993.

Ahearne, Jeremy. "Questions of Cultural Policy in the Thought of Michel de Certeau (1968–1972)." *South Atlantic Quarterly* 100, no. 2 (Spring 2001).

Alaimo, Kathleen. "Shaping Adolescence in the Popular Milieu: Social Policy, Reformers, and French Youth, 1870–1920." *Journal of Family History* 17, no. 4 (1992): 419–438.

Alexandre-Bidon, Danièle. "La bande dessinée avant la bande dessinée: narration figurée et procédés d'animation dans les images du moyen âge." *Les Origines de la bande dessinée*. Paris: Association de la revue Le collectionneur de bande dessinées, 1996.

Allen, James Smith. *In the Public Eye: A History of Reading in Modern France, 1800–1940*. Princeton, NJ: Princeton University Press, 1991.

Anderson, Benedict. *Imagined Communities: Reflections on the Origin and Spread of Nationalism*, Revised ed. London: Verso, 1996.

Anderson, Gary. "Nazi children's comic revealed." *The Sunday Herald*, September 19, 2004.

Antliff, Mark. *Avant-Garde Fascism, the Mobilization of Myth, Art, and Culture in France, 1909–1939*. Durham, NC: Duke University Press, 2007.

———. "Cubism, Celtism, and the Body Politic." *The Art Bulletin* 74, no. 4 (December 1992): 655–668.

———. *Inventing Bergson: Cultural Politics and the Parisian Avant-Garde*. Princeton, NJ: Princeton University Press, 1993.

Apollonio, Umbro. *Futurist Manifestos*. Boston: MFA Publications, 2001.

Archives parlementaires, de 1787 à 1860. Paris: Paul Dupont, 1876.

Armstrong, John Alexander. *Nations before Nationalism*. Chapel Hill: University of North Carolina Press, 1982.

"Aso urges French presidential candidate to read 'manga.'" *Japan Times Online*, April 21, 2007. Online at: http://search.japantimes.co.jp/cgi-bin/nn20070421a9.html.

"Asterix, Ambassadeur exceptionnel de la défenseure des enfants." Online at: http://www.asterix.com/droits-des-enfants/.

Austin, James C., and Daniel Royot. *American Humor in France: Two Centuries of French Criticism of the Comic Spirit in American Literature*. Ames: Iowa State University Press, 1978.

Aveline, Claude. "Films and Milieux." In *French Film Theory and Criticism: A History/Anthology*, vII: 1929–1939, ed. Richard Abel. Princeton, NJ: Princeton University Press, 1993.

Avenel, Henri. *Histoire de la Presse Française Depuis 1789jusqu'à nous jours*. Paris: Flammarion. 1900.

Balibar, Etienne. "The Nation Form: History and Ideology." In *Race, Nation, Class: Ambiguous Identities*, ed. Etienne Balibar and Immanuel Wallerstein. Translation of Balibar, Chris Turner. London: Verso Books, 1991.

Balibar, Etienne, and Immanuel Wallerstein, eds. *Race, Nation, Class, Ambiguous Identities*. Trans. Chris Turner. London: Verso, 1991.

Balzac, Honoré de. *Pere Goriot*. Trans. Henry Reed. New York: New American Library, 1981.

———. *Two Poets*. Trans. Ellen Marriage. Champaign, IL: Project Gutenberg, 1998.

Barker, Martin. *A Haunt without Fears*. London: Pluto Press, 1984.

———. *Comics: Ideology, Power, and the Critics*. Manchester, England: Manchester University Press, 1989.

Barreau, Jean-Michel. "Vichy, Idéologue de l'école." *Revue d'histoire moderne et contemporaine* v38, 1991.

Barrot, Olivier, and Pascal Ory, eds. *Entre deux Guerres: La Création Française entre 1919–1939*. Paris: Éditions François Bourin, 1990.

Barthes, Roland. *Image Music Text*. Trans. Stephen Heath. New York: Hill & Wang, 1977.

———. *Mythologies*. Trans. Annette Lavers. New York: Hill & Wang, 1972.

Bataille, Georges. *Literature and Evil*. Trans. Alistair Hamilton. London: Marion Boyars, 2001.

Beaty, Bart. *Unpopular Culture: Transforming the European Comic Book in the 1990s*. Toronto: University of Toronto Press, 2007.

Bell, David A. *The Cult of the Nation in France: Inventing Nationalism 1680–1800*. Cambridge, MA: Harvard University Press, 2003.

Bell, Susan. "Victory for editor over 'offensive' cartoons." *Scotsman International*, March 23, 2007. Online at: http://thescotsman.scotsman.com/international.cfm?id=445892007.

Bellande, Bernard. "Journaux d'Enfants." *Éducateurs* (January–February 1947): 30–49.

Bellanger, Claude, et al. *Histoire Générale de la Presse Franise*, vol. 2: de 1815 à 1871. Paris: Presses Universitaires de France, 1969.

Benjamin, Walter. *Reflections*. Ed. Peter Dementz. New York: Schocken Books, 1986.

———. "The Work of Art in the Age of Mechanical Reproduction." *Illuminations*. Ed. Hannah Arendt, trans. Harry Zohn. New York: Schocken Books, 1969.

Bergstrom, Janet. "Jean Renoir's Return to France." *Poetics Today* 17, no. 3 (Fall 1996): 453–489.

Berman, Marshall. *All That Is Solid Melts into Air: The Experience of Modernity*. New York: Simon and Schuster, 1982.

Berstein, Serge, and Jean-Pierre Rioux. *The Pompidou Years, 1969–1974*. Cambridge: Cambridge University Press, 2000.

Bertrand-Dorléac, Laurence. *Histoire de l'art: Paris, 1940–1944: ordre national, traditions et modernités*. Paris: Publications de la Sorbonne, 1986.

Bethléem, Abbé Louis. *Revue des Lectures*, March 15, 1923.

Beylie, Claude. "La bande dessinée est-elle un art?" *Lettres et medecins* (January 1964): 9–14.

Bhaba, Homi K., ed. *Nation and Narration*. London: Routledge, 1990.

Bibliothèque nationale de France. www.bnf.fr.

Bloch, Marc. *Strange Defeat: A Statement of Evidence Written in 1940*. New York: W. W. Norton & Co., 1999.

Bouissou, Jean-Marie. "Pourquoi le manga est-il devenu un produit culturel global?" *Esprit*, July 2008. Online at Eurozine: http://www.eurozine.com/articles/2008-10-27-bouissou-fr.html.

Bourdieu, Pierre. *Distinction: A Social Critique of the Judgement of Taste*. Trans. Richard Nice. Cambridge, MA: Harvard University Press, 1984.

———. *The Field of Cultural Production, Essays on Art and Literature*. Ed. Randal Johnson. New York: Columbia University Press, 1993.

———. "La sociologie de la culture populaire." *Le Handicap socioculturel en question*. Paris: Editions ESF, 1978.

Bourdieu, Pierre, and Loïc J. D. Wacquant. *An Invitation to Reflexive Sociology*. Chicago: University of Chicago Press, 1992.

Bowles, Brett. "Newsreels, Ideology, and Public Opinion under Vichy: The Case of *LaFrance en Marche*." *French Historical Studies* 27, no. 2 (Spring 2004): 419–463.

Bredin, Jean-Denis. *The Affair: The Case of Alfred Dreyfus*. Trans. Jeffrey Mehlman. New York: George Braziller, 1986.

Brinton, Crane. "Letters from Liberated France." *French Historical Studies* 2, no. 1 (Spring 1961): 1–27.

———. "Letters from Liberated France (Concluded)." *French Historical Studies* 2, no. 2 (Autumn 1961): 133–156.

Bulwer, Henry Lytton. *France: Social, Literary Political*, 2 vols. New York: Harper & Bros., 1834.

Burns, Michael. *Rural Society and French Politics: Boulangism and the Dreyfus Affair, 1886–1900*. Princeton, NJ: Princeton University Press, 1984.

Burrin, Philippe. *France under the Germans: Collaboration and Compromise*. New York: New Press, 1998.

Byrnes, Robert F. "The French Publishing Industry and Its Crisis in the 1890s." *Journal of Modern History* 23, no. 3 (September 1951): 232–242.

Calvo, Edmund-François. *La Bête Est Morte! La Guerre Mondiale Chez Les Animaux*. Paris: Éditions Gallimard, 1995.

Captain Euro. www.captaineuro.com.

Caser, Raf. "Famed Cartoon Character Tintin turns 75." *Seattle Times*, January 8, 2004.

Celine, Louis-Ferdinand. *Journey to the End of the Night*. Trans. Ralph Manheim. New York: New Direction, 1983.

Childs, Elizabeth. "The Body Impolitic: Censorship and the Caricature of Honoré Daumier." *Suspended License: Censorship and the Visual Arts*. Ed. Elizabeth Childs. Seattle: University of Washington Press, 1997.

———, ed. *Suspended License: Censorship and the Visual Arts*. Seattle: University of Washington Press, 1997.

Chrisafis, Angelique. "Cartoons did not incite hatred, French court rules," *Guardian Unlimited*, March 23, 2007. Online at: http://www.guardian.co.uk/print/0,,329755394–119664,00.html.

———. "Local language recognition angers French academy." International Section, *Guardian*, June 17, 2008: 21.

Cochet, François. "La Bande Dessinée en France et aux Etats-Unis dans l'Entre-Deux Guerres: Deux Modèles Culturels en Action." *Les Américans et la France 1917–1947. Engagements et Représentation*, ed. François Cochet, Maire-Claude Genet-Delacroix, and Hélèe Trocmé. Paris: Maisonneuve et Larose, 1999.

Cochet, François, Marie-Claude Genet-Delacroix, and Hélèe Trocmé, eds. *Les Américans et la France 1917-1947. Engagements et Représentation*. Paris: Maisonneuve et Larose, 1999.

Cohen, William B., ed. *The Transformation of Modern France, Essays in Honor of Gordon Wright*. Boston: Houghton Mifflin Co., 1997.

Cointet-Labrousse, Michèle. *Vichy et le fascisme*. Brussels: Editions Complexe, 1987.

Combat, January 31, 1948.

Cone, Michèle. *Artists under Vichy: A Case of Prejudice and Persecution*. Princeton, NJ: Princeton University Press, 1992.

"Connaissance, Les Courants Actuels." *Connaissance des Arts* 182 (April 1967).

Cook, Malcolm, ed. *French Culture since 1945*. London: Longman Publishing, 1993.

Coston, Henry. "Les Corrupteurs de la jeunesse: La main-mise Judéo-maçonnique sur la presse enfantine." *Bulletin d'information antimaçonnique*, numéro spécial, Paris, 1943.

Couperie, Pierre, and Maurice Horn. *A History of the Comic Strip*. Trans. Eileen Hennessy. New York: Crown Publishers, 1968.

Crépin, Thierry. *Haro Sur Le Gangster!: La moralisation de la presse enfantine 1934-1954*. Paris: SNRS Editions, 2001.

———. "*Il Était Une Fois Un Maréchal de France* . . . Presse Enfantine et Bande Dessinée Sous le Régime de Vichy." *Vingtieme Siècle, revue d'histoire* 28 (October–December 1990): 77–82.

———. "Le Comité de Défense de la Littérature et de la Presse pour la Jeunesse: The Communists and the Press for Children during the Cold War." *Libraries and Culture* 36, no. 1 (Winter 2001): 131–142.

Crépin, Thierry, and Thierry Groensteen, eds. *On Tue à chaque page: La Loi de 1949 sur les publications destinées à la jeuness*. Paris: Éditions du Temps, 1999.

Crozier, Michel. *La Société bloquée*. Paris: Seuil, 1971.

Cuno, James. "Charles Philipon, La Maison Aubert, and the Business of Caricature in Paris, 1829–41." *Art Journal* 43, no. 4 (Winter 1983).

———. "Charles Philipon and La Maison Aubert: The Business, Politics and Public of Caricature in Paris 1820–1840." Ph.D. dissertation, Harvard University, 1985.

Dauncey, Hugh, ed. *French Popular Culture*. London: Arnold, 2003.

Davis, Allen, ed. *For Better or Worse: The American Influence in the World*. Westport, CT: Greenwood Press, 1981.

De Certeau, Michel. *The Practice of Everyday Life*. Trans. Steven Rendall. Berkeley and Los Angeles: University of California Press, 1984.

De Gaulle, Charles. *The Complete War Memoirs of Charles de Gaulle*. Trans. Jonathan Griffin and Richard Howard. New York: Carroll & Graf Publishers, 1998.

De Grazia, Victoria. "Mass Culture and Sovereignty: The American Challenge to European Cinemas, 1920–1960." *Journal of Modern History* 61, no. 1 (March 1989): 53–87.

Descartes, René. *Descartes: Meditations on First Philosophy: With Selections from the Objections and Replies*. Trans. John Cottingham. New York: Cambridge University Press, 1996.

de Vabres, Renaud Donnedieu. "Réception en l'honneur des dessinateurs de presse," Discours et communiqués, Mardi 15 mars, 2006. Online at: http://www.culture.gouv.fr/culture/min/index-archives.htm

Didier, Ghez. "Interview with Pierre Nicolas: Neuilly-sur-Seine; August 5, 1991," http://www.pizarro.net/didier/_private/interviu/nicolas.html.

Dierick, Charles, and Pascal Lefèvre, eds. *Forging a New Medium: The Comic Strip in the Nineteenth Century*. Brussels: VUB University Press, 1998.

Discours et communiqués, "Renaud Donnedieu de Vabres a confié une mission sur la consercation et la valorization du dessin de presse à Georges Wolinski lors d'une reception en l'honneur des dessinateurs de presse le mercredi 15 mars," Mercredi, 16 mars, 2006. Online at: http://www.culture.gouv.fr/culture/min/index-archives.htm.

Dozo, Björn-Olav. "La bande dessinée francophone contemporaine à la lumière de sa propre critique: Quand une avant-garde esthétique s'interroge sur sa pérennité." *Belphégor*, vVI n2, Juin 2007. Dalhousie University Electronic Text Centre. Online at: http://etc.dal.ca/belphegor/vol6_no2/articles/06_02_dozo_bande_fr.html.

Dreyfus, François-Georges. *Histoire de Vichy (Vérités et legends)*. Paris: Perrin, 1990.

Dubois, Raoul. "La Presse Pour Enfants de 1934 à 1953." *Les Journaux pour enfants*. Ed. Henri Wallon. Numéro spécial de la Revue *Enfance*. Paris: Presses Universitaires de France, 1954.

Duhamel, Georges. *America the Menace: Scenes from the Life of the Future*. Trans. Charles Miner Thompson. New York: Houghton Mifflin Company, 1931.

——. *In Defence of Letters*. Trans. E. F. Bozman. New York: Greystone Press, 1989.

——. *Les Jumeaux de Vallangoujard*. Illustrated, Berthold Mahn. Ed. Mary Elizabeth Storer. Boston: D. C. Heath and Company, 1940.

Durand, Claire, André Blais, and Mylène Larochelle, "The Pools in the 2002 French Presidential Election: An Autopsy." *Public Opinion Quarterly* 68, no. 4 (2004).

Duverne, René. "L'Enfance en danger." *Éducateurs* (September 1945).

Eisner, Will. *Comics and Sequential Art*. Tamarac, FL: Poorhouse Press, 1985.

Eksteins, Modris. *Rites of Spring: The Great War and the Birth of the Modern Age*. New York: Anchor Books, 1990.

Eliot, T. S. *The Sacred Wood: Poetry and Criticism*, 7th ed. London: Methuen & Co., 1950.

——. *Selected Prose of T. S. Eliot*. Ed. Frank Kermode. New York: Harvest Books, 1975.

"ElviFrance et la Censure." http://poncetd.club.fr/CENSURE/EF_CENSURE.htm.

"Euro Hijinks." http://www.theyesmen.org/hijinks/euro/.

"Extrême-droite: le réveil des auteurs de BD," actuabd.com, April 15, 2002. Online at: http://www.actuabd.com/Extreme-droite-le-reveil-des-auteurs-de-BD,279.

Farr, Michael. *Tintin, The Complete Companion*. San Francisco: Last Gasp, 2001.

Fassin, Eric. "Two Cultures? French Intellectuals and the Politics of Culture in the 1980s." *French Politics and Society* 14, no. 2 (Spring 1996): 9–16.

Faure, Christian. *Le Projet Culturel de Vichy: Folklore et révolution national 1940–1944*. Lyon: Presses Universitaires de Lyon, 1989.

Felski, Rita. *The Gender of Modernity*. Cambridge, MA: Harvard University Press, 1995.

"Final Statement." *The Arc-et-Senans Declaration*. Council of Europe. http://www.coe.int/T/E/Cultural_Cooperation/Culture/Resource s/Texts/CDCC (80)7–E_AeS.pdf?L=EN.

Finkielkraut, Alain. *La Défaite de la pensée*. Paris: Gallimard, 1989.

Fischer, Roger. *Them Damned Pictures: Explorations in American Political Cartoon Art*. North Haven, CT: Archon, 1996.

Fish, Stanley. *Is There a Text in This Class? The Authority of Interpretive Communities*. Cambridge, MA: Harvard University Press, 1980.

Fishman, Sarah. *The Battle for Children: World War II, Youth Crime, and Juvenile Justice in Twentieth-Century France*. Cambridge, MA: Harvard University Press, 2002.

Fitch, Nancy. "Mass Culture, Mass Parliamentary Politics, and Modern Anti-Semitism: The Dreyfus Affair in Rural France." *American Historical Review* 97, no. 1 (February 1995): 55–95.

Forbes, Jill, and Michael Kelly. "Politics and Culture from the Cold War to Decolonization." In *French Cultural Studies, an introduction*, ed. Jill Forbes and Michael Kelly. New York: Oxford University Press, 1995.

Forsdick, Charles, Laurence Grove, and Libbie McQuillan, eds. *The Francophone BandeDessinée*. Amsterdam: Rodopi, 2005.

Fortescue, William, ed. *The Third Republic in France, 1870–1940: Conflicts and Continuities*. London: Routledge, 2000.

Foucault, Michel. *Discipline and Punish: The Birth of the Prison*. Trans. Alan Sheridan. New York: Vintage Books, 1995.

———. *Language, Counter-Memory, Practice: Selected Essays and Interviews*, ed. D. F. Bouchard. Ithaca, NY: Cornell University Press, 1977.

Fouilhé, Pierre. "Le Héros et ses Ombres." *Les Journaux pour enfants*, ed. Henri Wallon. Numéro spécial de la Revue *Enfance*. Paris: Presses Universitaires de France, 1954.

"Four Die in Afghan cartoon riot," BBC News, February 8, 2006. Online at http://news.bbc .co.uk/go/pr/fr/-/1/hi/world/south_asia/4692172.stm.

Fourment, Alain. *Histoire de la Presse des Jeunes et des Journaux d'Enfants (1768–1988)*. Paris: Editiocs Eole, 1987.

Fraisse, Emmanuel, et al. *Discours sur la lecture: 1880–2000*. Paris: Fayard and Bibiliothèque publique d'information—Centre Pompidou, 2000.

Fresnault-Deruelle, Pierre. "Du linéaire au tabulaire." *Communications* 24 (1976): 7–23.

———. *La Bande Dessinée: Essai d'analyse sémiotique*. Paris: Hachette Littérature, 1972.

"From the Pyramid to the Grand Louvre." *Burlington Magazine* 131, no. 1036 (July 1989): 459.

Fuchs, Wolfgang, and Reinhold Reitberger. *Comics: Anatomy of a Mass Medium*. Boston: Little, Brown and Co., 1972.

Fulcher, Jane. *French Cultural Politics and Music: From the Dreyfus Affair to the First World War*. New York: Oxford University Press, 1999.

Fumaroli, Marc. *L'Etat Culturel: Essai Sur Une Religion Moderne*. Paris: Le Fallois, 1991.

Furlough, Ellen. "*Une leçon des choses*: Tourism, Empire, and the Nation in Interwar France." *French Historical Studies* 25, no. 2 (Summer 2002): 441–473.

Gabilly, Marcel. "Les Journées de Vichy: un assainissement qui s'impsait." *La Croix*, September 14–15, 1941.

Gagnon, Paul. "French Views of the Second American Revolution." *French Historical Studies* 2, no. 4 (Autumn 1962): 430–449.

Geertz, Clifford. *Interpretation of Cultures: Selected Essays*. New York: Basic Books, 1973.

Ghez, Didier, and Alain Littaye. *Disneyland Paris: From Sketch to Reality*. Paris: Nouveau Millenaire, 2002.

Giddens, Anthony. *Modernity and Self-Identity: Self and Society in the Late Modern Age*. Stanford, CA: Stanford University Press, 1991.

Giff wiff!: bulletion du club des bande dessinées: deuxième anniversiare du club: réimpression des bulletins 1,2,3–4. Paris: Centre d'étude des littératured d'expression graphique, 1964.

Gilbert, James. *A Cycle of Outrage: America's Reaction to the Juvenile Delinquent in the 1950s*. New York: Oxford University Press, 1986.

Gildea, Robert. *France since 1945*, 2nd ed. Oxford: Oxford University Press, 2002.

———. *Marianne in Chains: Daily Life in the Heart of France during the German Occupation*. New York: Picador, 2002.

Giolitto, Pierre. *Histoire de la Jeunesse sous Vichy*. Paris: Librairie Académique Perrin, 1991.

Ginio, Ruth. "Vichy Rule in French West Africa: Prelude to Decolonization?" *French Colonial History* 4 (2003): 202–226.

Goldberg, Nancy Sloan. "From Whitman to Mussolini: Modernism in the Life and Works of a French Intellectual." *Journal of European Studies* 26 (June 1996): 153–173.

Goldstein, Robert Justin. *Censorship of Political Culture in Nineteenth-Century France*. Kent, Ohio: Kent State University Press, 1989.

Gombrich, E. H. *Art and Illusion, A Study in the Psychology of Pictorial Representation*, Millennium ed. Princeton, NJ: Princeton University Press, 2000.

———. *Meditations on a Hobby Horse and Other Essays on the Theory of Art*, 4th ed. London: Phaidon Press, 1985.

Gordon, Bertram M. *Collaborationism in France during the Second World War*. Ithaca, NY: Cornell University Press, 1980.

Gordon, Ian. *Comic Strips and Comsumer Culture 1890–1945*. Washington: Smithsonian Institution Press, 1998.

Gordon, Philip H., and Sophie Meunier. *The French Challenge: Adapting to Globalization*. Washington: Brookings Institution Press, 2001.

Goudard, P. *Écrits sur le sable*. Paris: Artistes Associés pour la Recherche et l'Innovation au Cirque, 1993.

Groensteen, Thierry. "Genres et séries." *9e Art: Les Cahiers du Musée de la Bande Dessinée* 4 (1999): 78–87.

———. "La Mise en cause de Paul Winckler." In *On Tue à chaque page: La Loi de 1949 sur les publications destinées à la jeunesse*, ed. Thierry Crépin and Thierry Groensteen. Paris: Éditions du Temps, 1999.

———. *The System of Comics*. Trans. Bart Beaty and Nick Nguyen. Jackson: University Press of Mississippi, 2007.

———. "Töpffer the Originator of the Modern Comic Strip." In *Forging a New Medium*, ed. Charles Dierick and Pascal Lefèvre. Brussels: VUB University Press, 1998.

———. *un objet culturel non identifié*. Angoulême: editions de l'an 2, 2006.

Grosse, Abbé Paul-Emile. "Les Illustres pour Enfants." *La Patronage* 104 (June 1939).

Grove, Laurence. "BD Theory before the Term 'BD' Existed." In *The Francophone BandeDessinée*, ed. Charles Forsdick, Laurence Grove, and Libbie McQuillan. Amsterdam: Rodopi, 2005.

———. "Mickey, *Le Journal de Mickey* and the Birth of the Popular BD." *Belphegor* 1, no. 1 (November 2001). Dalhousie University Electronic Text Centre. www.dal.ca/~etc/belphegor/vol1_no1/articles/01_01_Grove_Mickey_cont.html.

———. *Text/image Mosaics in French Culture: Emblems and Comic Strips*. London: Ashgate Publishing, 2006.

Guillaume, Marie-Ange, and José-Louis Bocquet. *Goscinny*. Arles: Actes Suc, 1997.

Guy, Michel. "Le Louvre de la raison." *Le Monde*, July 12, 1984: 1.

Habermas, Jürgen. *The New Conservatism: Cultural Criticism and the Historians' Debate*, ed. and trans. Shierry Weber Nicholsen. Cambridge, MA: MIT Press, 1990.

Haine, W. Scott. "Café Friend: Friendship and Fraternity in Parisian Working-Class Cafés, 1850–1914." *Journal of Contemporary History* 27 (1992): 607–626.

———. *The World of the Paris Café: Sociability among the French Working Class, 1789–1914*. Baltimore: John Hopkins University Press, 1996.

Hajdu, David. *The Ten-Cent Plague: The Great Comic-Books Scare and How It Changed America*. New York: Farrar, Straus and Giroux, 2008.

Halls, W. D. *Politics, Society and Christianity in Vichy France*. Oxford: Berg Publishers, 1995.

———. *The Youth of Vichy France*. New York: Oxford University Press, 1981.

Hanna, Martha. "A Republic of Letters: The Epistolary Tradition in France during World War I." *American Historical Review* 108, no. 5 (December 2003): 1138–1161.

Harding, Gareth. "Comic Icon Tintin turns 75." *Washington Times*, January 9, 2004.

Hargreaves, Alec G., and Marck McKinney. *Postcolonial-Cultures in France*. New York: Routledge, 1997.

Harp, Stephen. *Marketing Michelin: Advertising and Cultural Identity in Twentieth-Century France*. Baltimore: Johns Hopkins University Press, 2001.

Harris Sue. "Cinema in a Nation of Filmgoers." In *Contemporary French Cultural Studies*, ed. William Kidd and Siân Reynolds. London: Arnold, 2003.

———. "Festivals and fêtes populaires." In *Contemporary French Cultural Studies*, ed. William Kidd and Siân Reynolds. London: Arnold, 2003.

Harvey, Robert. *The Art of the Comic Book: An Aesthetic History*. Jackson: University Press of Mississippi, 1996.

Hazard, Paul. *Books, children & men*. Trans. Marguerite Mitchell. Boston: The Horn Book, 1944.

———. "Comment lisent les enfants." In *Revue des deux mondes* 42 (1927): 860–882.

Hellman, John. "French 'Left-Catholics' and Communism in the Nineteen-thirties." *Church History* 45, no. 4 (December 1976): 507–523.

Henley, Jon. "A Book Emergency? No problem." *Guardian Unlimited*, August 22, 2005. Online at: http://www.guardian.co.uk/france/story/0,11882,1553812,00.html.

Hesse, Philippe-Jean, and Jean-Pierre Le Crom, eds. *La Protection Sociale sous le Régime de Vichy*. Rennes: Presses Universitaires de Rennes, 2001.

Higonnet, Patrice. "Scandal on the Seine." *New York Review of Books*, August 15, 1991: 32.

Hinds, Harold E. *Not Just for Children: The Mexican Comic Book in the Late 1960s and 1970s*. New York: Greenwood Press, 1991.

Hixson, Walter. *Charles Lindbergh: Lone Eagle*. New York: Longman Press, 2001.

Hoffman, Stanley. *Decline or Renewal? France since the 1930s*. New York: Viking Press, 1974.

Horkheimer, Max, and Theodor Adorno. *Dialectic of Enlightenment*. Trans. John Cumming. New York: Continuum International Publishing Group, 1976.

Horn, Maurice. "American Comics in France: A Cultural Evaluation." In *For Better or Worse: The American Influence in the World*, ed. Allen Davis. Westport, CT: Greenwood Press, 1981.

———. "Comics." In *Handbook of French Popular Culture*, ed. Pierre L. Horn. New York: Greenwich Press, 1991.

———, ed. *The World Encyclopedia of Comics*. New York: Chelsea House Publishers, 1976.

Horn, Pierre L., ed. *Handbook of French Popular Culture*. New York: Greenwood Press, 1991.

Hughes, Alex, and Keith Reader, eds. *Encyclopedia of Contemporary French Culture*. London: Routledge, 2002.

Humphreys, Richard. *Futurism*. Cambridge: Cambridge University Press, 1999.

Hunt, Lynn. *Politics, Culture, and Class in the French Revolution*. Berkeley and Los Angeles: University of California Press, 1984.

Inge, Thomas. "The Comics as Culture." *Journal of Popular Culture* 12, no. 4 (Spring 1974): 631–652.

International Herald Tribune. March 22, 1927.

Jackson, Jeffrey H. *Making Jazz French: Music and Modern Life in Interwar Paris*. Durham, NC: Duke University Press, 2003.

———. "Making Jazz French: The Reception of Jazz Music in Paris, 1927–1934." *French Historical Studies* 25, no. 1 (Winter 2002): 149–170.

Jackson, Julian. *France: The Dark Years, 1940–1944*. New York: Oxford University Press, 2003.

———. *The Popular Front in France: Defending Democracy, 1934–1938*. Cambridge: Cambridge University Press, 1988.

James, Edwin L. "Lindbergh Does It! To Paris in 33_ Hours; Flies 1,000 Miles Through Snow and Sleet; Cheering French Carry Him Off Field." *New York Times*, May 22, 1947: 1.

James, Henry. *Century Magazine*, January 1890.

Jay, Martin. *Downcast Eyes: The Denigration of Vision in Twentieth-Century French Thought*. Berkeley and Los Angeles: University of California Press, 1994.

Jenkins, Brian. "The One and Indivisible Republic: French Identity and Identities." In *Multicultural France*, ed. T. Chafer. Portsmouth: Working Papers on Contemporary France, 1996.

Jennings, Eric. *Vichy in the Tropics: Pétain's National Revolution in Madagascar,Guadeloupe, and Indochina, 1940–1944*. Stanford, CA: Stanford University Press, 2001.

Jobs, Richard Ivan. *Riding the New Wave: Youth and the Rejuvenation of France after the Second World War*. Stanford, CA: Stanford University Press, 2007.

———. "Tarzan under Attack: Youth, Comics, and Cultural Reconstruction in Postwar Postwar France." *French Historical Studies* 26, no. 4, (Fall 2003): 687–725.

Johnson, Isabel Simeral. "Cartoons." *Public Opinion Quarterly* 1, no. 3 (July 1937): 21–44.

Johnson, Jo. "Astérix and the marauding manga-maniacs." *Financial Times*, February 3, 2004: 4.

Johnson, R. W. *The Long March of the French Left*. London: Macmillan, 1981.

Joubrel, Henri. *Mauvais Garçons de Bonnes Familles: Causes, Effets, Remèdes de L'Inadaptation des Jeunes a la Sociéte*, Préface d' Andre Le Gall, Inspecteur Général de l'Instruction Publique. Paris: Aubier Editions Montainge, 1957.

Julliard, Jacques, and Michel Winnock, eds. *Dictionnaire des intellectuels français: Les personnes, Les lieux, Les moments*. Paris: Éditions du Seuil, 1996.

Jurmand, Jean Pierre. "De l'enfance irrégulière à l'enfance délinquante (1945–1950), itinéraire d'une pensée, naissance d'un modèle." *Le Temps de l'histoire, revue d'histoire de l'enfance "irrégulière,"* no 3, 2000, special issue, "L'enfant de justice pendant la guerre et l'immédiat après-guerre." Online at: http://rhei.revues.org/document.html?id=76.

Kahn, Joseph P. "Doonesbury's language gets some edits." *Boston Globe*, February 11, 2004.

Kaiser, Wolfram. "The Rat Race for Progress: A *Punch* Cartoon of the Opening of the 1851 Crystal Palace Exhibition." In *Culture and International History*, ed. Jessica C. E. Gienow-Hecht and Frank Schumacher. New York: Berghahn Books, 2003.

Kedward, Rod. *France and the French, A Modern History*. Woodstock: Overlook Press, 2007.

———. *In Search of the Maquis: Rural Resistance in Southern France 1942–1944*. Oxford: Clarendon Press, 1993.

———. *Resistance in Vichy France: A Study of Ideas and Motivation in the Southern Zone, 1940–1942*. New York: Oxford University Press, 1978.

Keim, Albert, and Louis Lumet. *Honoré de Balzac*. Trans. Frederick Taber Cooper. New York: Haskell House, 1974.

Kemnitz, Thomas Milton. "The Cartoon as a Historical Source." *Journal of Interdisciplinary History* 4, no. 1 (Summer 1973): 81–93.

Kern, Stephen. *The Culture of Time and Space, 1880–1918*. Cambridge, MA: Harvard University Press, 1983.

Kerr, David S. *Caricature and French Political Culture, 1830–1848: Charles Philipon and the Illustrated Press*. New York: Oxford University Press, 2000.

Khordoc, Catherine. "The Comic Book's Soundtrack: Visual Sound Effects in *Asterix*." In *The Language of Comics: Word and Image*, ed. Robin Varnum and Christina T. Gibbons. Jackson: University Press of Mississippi, 2001.

Kidd, William, and Siân Reynolds, eds. *Contemporary French Cultural Studies*. London: Arnold, 2003.

Kimmelman, Michael. "A Startling New Lesson in the Power of Imagery." *New York Times*, February 8, 2006: E1.

Kuhn, Raymond. *The Media in France*. London: Routledge, 1994.

Kuisel, Richard. *Capitalism and the State in Modern France, Renovation and Economic Management in the Twentieth Century*. Cambridge: Cambridge University Press, 1981.

———. "Modernization and Identity." *French Politics and Society* 14, no. 1 (Winter 1996): 45–50.

———. "The French Search for Modernity." In *The Transformation of Modern France, Essays in Honor of Gordon Wright*, ed. William B. Cohen. Boston and New York: Houghton Mifflin Co., 1997.

———. *Seducing the French: The Dilemma of Americanization*. Berkeley and Los Angeles: University of California Press, 1996.

Kunzle, David. *History of the Comic Strip: Vol. 1, the Early Comic Strip*. Berkeley and Los Angeles: University of California Press, 1973.

La Patronage. September–October 1932.

"La Vent Aux Mineurs De Publications Licencieuses est Interdite, Mais la production américaine pourra envahir nous journaux d'enfants." *Ce Soir*, April 7, 1949.

Lamb, Chris. *Drawn to Extremes: The Use and Abuse of Editorial Cartoons*. New York: Columbia University Press, 2004.

Lang, Jack. *Address delivered at the opening meeting of the symposium "Tribute to Picasso,"* UNESCO House, October 26, 1981.

Larkin, Maurice. *France since the Popular Front, Government and People 1936–1996*. Oxford: Clarendon Press, 1997.

Lawlor, Patricia. "Cultural Exchange through BD." *Contemporary French Civilization* 9, no. 2 (Spring/Summer 1985): 18–27.

"Le *Journal de Mickey* / répond il à son programme publicitaire?" *Éducateurs* (March–April 1953): 137–138.

Le Monde. Paris. November 10–11, 1991.

Le Nouvel Observateur. Paris. August 29, 1986.

"Le Seuil condamné pour une BD sur Marine Le Pen," NouvelObs.com, 24.06.2008. Online at: http://tempsreel.nouvelobs.com/actualites/culture/20071026.OBS1729/le_seuil_condamne_pour_une_bd_sur_marine_le_pen.html.

Lebovics, Herman. *Bringing the Empire Back Home: France in the Global Age.* Durham, NC: Duke University Press, 2004.

———. *Mona Lisa's Escort: André Malraux and the Reinvention of French Culture.* Ithaca: Cornell University Press, 1999.

———. "Open the Gates . . . Break Down the Barriers: The French Revolution, The Popular Front, and Jean Renoir." *Persistence of Vision,* Special Number of Cinema, no. 12/13 (1996): 9–28.

———. *True France: The Wars over Cultural Identity, 1900–1945.* Ithaca, NY: Cornell University Press, 1992.

Legèvre, Pascal, and Gert Meesters. "Aperçu Général de la Bande Dessinée Francophone Actuelle." *Relief, Revue Electronique de Litterature Française* 2, no. 3 (2008).

Lehan, Richard. *The City in Literature: An Intellectual and Cultural History.* Berkeley and Los Angeles: University of California Press, 1998.

Leighten, Patricia. "*Réveil anarchiste*: Salon Painting, Political Satire, Modernist Art." *Modernism/Modernity* 2, no. 2 (1995): 17–47.

"Les grandes dates du CNBDI." Centre nationale de la bande dessinée et de l'image. www.cnbdi.fr.

Levin, Miriam R. "Democratic Vistas—Democratic Media: Defining a Role for Printed Images in Industrializing France." *French Historical Studies* 18 no. 1 (Spring 1993): 82–108.

Libération. Paris. February 2, 1982.

Lipton, Sara. "'The Sweet Lean of His Head': Writing about Looking at the Crucifix in the High Middle Ages." *Speculum* 80 (2005): 1172–1208.

Lofficier, Jean-Marc, and Randy Lofficier. *French Science Fiction, Fantasy, Horror and Pulp Fiction: A Guide to Cinema, Television, Radio, Animation, Comic Books and Literature.* Jefferson, NC: MacFarland & Company, 2000.

Looseley, David. "Cultural Policy." In *Encyclopedia of Contemporary French Culture,* ed. Alex Hughes and Keith Reader. London: Routledge, 2002.

———. *The Politics of Fun, Cultural Policy and Debate in Contemporary France.* Oxford: Berg Publishers, 1995.

Lottman, Herbert. *The Michelin Men: Driving an Empire.* London: I. B. Tauris, 2004.

Louis-Philippe, l'homme et le roi. Paris: Archives nationales: en vente à la Documentation française, 1974.

"The Louvre embraces comics for the first time," *International Herald Tribune,* January 22, 2009.

Louvre. "Le Louvre Invite la Bande Dessinée." Communiqué de Presse, January 22, 2009.

Lucas, Edward Verrall. *A Wanderer in Paris.* New York: Macmillan, 1914.

Macridis, Roy C., ed. *De Gaulle Implacable Ally.* New York: Harper & Row, 1966.

Malraux, André. "Foreign News." *Time,* July 7, 1958: 20.

———. *Fallen Oakes, Conversations with de Gaulle.* Trans. Irene Clephane. London: Hamish Hamilton, 1972.

———. *La politique, la culture: Discours, articles, entretiens (1925–1975).* Ed. Janine Mossuz-Lavau. Paris: Gallimard, 1996.

Mandry, Michel. *Happy Birthday Mickey! 50 Ans d'histoire du Journal de Mickey*. Paris: Chêne, 1984.

Marcus, Jonathon. *The National Front and French Politics: The Resistable Rise of Jean-Marie Le Pen*. New York: New York University Press, 1995.

Markus, R. A. *Gregory the Great and His World*. New York: Cambridge University Press, 1997.

Marshall, Richard. "A History of Newspaper Syndication." In *The World Encyclopedia of Comics*, ed. Maurice Horn. New York: Chelsea House, 1984.

McCloud, Scott. *Understanding Comics*. New York: Harper Collins Publishers, 1993.

McKenzie, Brian. "Deep Impact: The Cultural Policy of the United States in France, 1948 to 1952." Ph.D. dissertation, State University of New York, Stony Brook, 2000.

———. *Remaking France: Americanization, Public Diplomacy, and the Marshall Plan*. New York: Berghahn Books, 2005.

McKinley, James C., Jr. "A Mexican Manual for Illegal Immigrants Upsets Some in U.S." *New York Times International*, June 1, 2005: A5.

McLuhan, Marshall. *The Mechanical Bride: Folklore of Industrial Man*. New York: Vanguard Press, 1951.

———. *Understanding Media: The Extensions of Man*, 2nd ed. New York: Signet Books, 1966.

McMillan, James F. *Twentieth-Century France: Politics and Society in France, 1898–1991*. London: Edward Arnold, 1992.

McMurray, David A. "La France arabe." In *Postcolonial-cultures in France*, ed. Alec G. Hargreaves and Mark McKinney. New York: Routledge, 1997.

McQuillan, Libbie. Presented Paper, "Trends in the BD critical field: A Brief History of Time." Presented at the annual International Comics Art Festival, Bethesda, Maryland, 2000.

Meinrath, Jacqueline. "La loi sur les publications destinées à la jeunesse." *Éducateurs* (September–October 1949): 450–454.

Mennelet, François. "On réclame une loi contre les journaux de gangsters 'stupéfiants pour enfants." *Le Figaro*, March 11, 1948.

Merton, Thomas. *Seven Storey Mountain*. Fort Washington, PA: Harvest Books, 1999.

Message, Kylie. *New Museums and the Making of Culture*. Oxford: Berg, 2006.

Mies van der Rohe, Ludwig, Detlef Mertins, and George Baird. *The Presence of Mies*. New York: Princeton Architectural Press, 2000.

Michallat, Wendy. "*Pilote*: Pedagogy, Puberty and Parents." *The Francophone Bande Dessinée*, ed. Charles Forsdick, Laurence Grove, and Libbie McQuillan, 83–95. Amsterdam: Rodopi, 2005.

Mignot, André. *Semences De Crimes:* La Démoralisation de l'Enfance et de la Jeunesse par les Publications Périodiques et par le livre. Paris: Cartel d'Action Morale & Sociale, 1948.

Miller, Ann. "Bande Dessinée." In *French Popular Culture, ed.* Hugh Dauncey. London: Arnold, 2003.

———. "Bande Dessinée: A Disputed Centenary." *French Cultural Studies* 10, pt. 1, no. 28 (February 1999): 67–87.

Minear, Richard H. *Dr. Seuss Goes to War: The World War II Political Cartoons of Theodore Seuss Geisel*. Intro. Art Speigelman. New York: New Press, 1999.

Mirzoeff, Nicholas. *Silent Poetry: Deafness, Sign, and Visual Culture in Modern France*. Princeton, NJ: Princeton University Press, 1995.

"Mission et organisation." Institut du Monde Arabe. www.imarabe.org.

Mitterand, François. "Preface, Grand Travaux." *Connaissance des Arts*, special issue, (August 1989): 5.

Moliterni, Claude, Philippe Mellot, and Laurent Turpin. *l'ABCdaire de la Bande dessinée*. Paris: Flammarion, 2002.

Monneron, Jean Louis, and Anthony Rowley. *Histoire du peuple français: les 25 ans qui ont transformé la France*. Paris: Nouvelle Libr. de France, 1986.

Morel, Eugène. *Bibliothèque, essai sur le développement des bibliothèques publiques et de la librairie dans les deux mondes*, vols I and II. Paris: Mercvre de France, 1908 and 1909.

Morton, Patricia A. "National and Colonial: The Musee des Colonies at the Colonial Exposition, Paris, 1931." *Art Bulletin* 80, no. 2 (June 1998): 357–377.

Mouly, Francoise, and Lawrence Weschler. "Covering the New Yorker: A Conversation between Françoise Mouly and Lawrence Weschler." *Covering the New Yorker: Cutting-Edge Covers from a Literary Institution*. New York: Abbeville Press, 2000.

Nora, Pierre. *Realms of Memory: The Construction of the French Past*, ed. Lawrence D. Kritzman, trans. Arthur Goldhammer. New York: Columbia University Press, 1998.

Noriel, Gérard. *The French Melting Pot: Immigration, Citizenship and National Identity*. Trans. Geoffroy de Laforcade. Minnesota: University of Minnesota Press, 1996.

Norindr, Panivong. "La Plus Grand France." In *Identity Papers: Contested Nationhood in Twentieth-Century France*, ed. Steven Ungar and Tom Conley. Minneapolis: University of Minnesota Press, 1996.

Norman, Buford, ed. *The Child in French and Francophone Literature*. Amsterdam: Editions Rodopi B. V., 2004.

Nyberg, Amy Kiste. *Seal of Approval: The History of the Comics Code*. Jackson: University Press of Mississippi, 1998.

Nye, Russel B. "Death of a Gaulois: René Goscinny and Astérix." *Journal of Popular Culture* 14, no. 2 (Summer 1980): 181–195.

O'Riley, Michael. "*La Bête est morte!*: Mending Images and Narratives of Ethnicity and National Identity in Post-World War II France." In *The Child in French and Francophone Literature*, ed. Buford Norman. Amsterdam: Editions Rodopi B. V., 2004.

Office of Population Research. "War, Migration, and the Demographic Decline of France." *Population Index* 12, no. 2 (April 1946): 73–81.

Ory, Pascal. "La Politique du ministère Jack Lang: un premier bilan." *French Review* 58, no. 1 (October 1984): 77–83.

———. *Le Petit Nazi Illustré "Le Téméraire" (1943–1944)*. Paris: Editions Albatros, 1979.

———. *Les Collaborateurs, 1940–1945*. Paris: Seuil, 1976.

———. "Mickey Go Home! La désaméricanisation de la bande dessinée (1945–1950)." *Vingtième Siècle* (Octobre 1984): 77–88.

Osgood, Samuel M., ed. *The Fall of France, 1940: Causes and Responsibilities*, 2nd ed. Lexington, MA: D. C. Heath and Company, 1972.

Parker, Daniel, and Claude Renaudy. *La Démoralisation de la jeunesse par les publications périodiques*. Paris: Cartel d'Action Morale, 1944.

"Paul Winkler, Disney Legend." Online at: http://legends.disney.go.com/legends/ detail?key=Paul+Winkler.

Paxton, Robert O. *Vichy France: Old Guard and New Order, 1940–1944*. New York: Columbia University Press, 1972.

"Pei's Palace of Art." *Time*, November 29, 1993.

Pells, Richard. *Not Like Us: How Europeans Have Loved, Hated, and Transformed American Culture since World War II*. New York: Basic Books, 1997.

Petrey, Sandy. *In the Court of the Pear King: French Culture and the Rise of Realism*. Ithaca, NY: Cornell University Press, 2005.

———. "Pears in History." *Representations* 35 (Summer 1991): 52–71.

Picheral, Jean-François. Séance du jeudi 30 janvier 2003 (compte rendu integral des débats). Online at: http://www.senat.fr/basile/visio.do?id=s20030130_9&idtable=s20030724_9|s20051102_4|s20060321_4|s20050623_7|s19970415_16|s20000120_12|s20070222_8|s20030130_9&_c=bande+dessinee&rch=g s&de=19870710&au=20070710&dp=20+ans&radio=dp&aff=sep&tri=p&off=o&afd=ppr&afd=ppl&afd=pjl&afd=cvn&isFirst=true.

Pierrard, André. "Les 'Comics' continueront-ils à contaminer notre jeunesse?" *Humanité*, July 9, 1949.

Pierre, Michel. "Illustrés, *Le Journal de Mickey*." In *Entre deux Guerres: La Création Française entre 1919–1939*, ed. Olivier Barrot and Pascal Ory. Paris: Éditions François Bourin, 1990.

Pilcher, Tim and Brad Brooks, *The Essential Guide to World Comics*. London: Collins & Brown, 2005.

Pilote hebdomadaire, Le Journal Qui S'Amuse A Reflechir. Paris: Dargaud, treizeme annee, nos. 604–611, 1971.

Plato. *Republic of Plato*. Trans. Alan Bloom. New York: Basic Books, 1991.

Polbernar, Jean. "L'Agoissante Question des Journaux d'Enfants Laisserons-nous corrompre notre jeunesse par les bande illustrées made in USA: Gangsters, pin-up, superman and Co . . . ?" *Ce Soir*, March 24, 1948.

Pratt, Murray. "Imagining Union: Cultural Identities in Pre-Federal Europe." http://72.14.203.104/search?q=cache:fuqNC7PaaHgJ:epress.lib.uts.edu.au/journals/portal/include/getdoc.php%3Fid%3D327%26article%3D83%26mode%3Dpdf+captain+euro+and+imagining+union-cultural+identities+in+pre-federal+europe&hl=en&gl=us&ct=clnk&cd=1.

"Profile: Jean-Marie Le Pen." BBC World News, April 23, 2002. Online at: http://news.bbc.co.uk/1/hi/world/europe/1943193.stm.

Proud, Judith. *Children and Propaganda. Il était une fois . . . ; Fiction and Fairytale in Vichy France*. Oxford: Intellect Books, 1995.

———. "Occupying the Imagination: Fairy Stories and Propaganda in Vichy France." *The Lion and the Unicorn* 22, no. 1 (January 1998): 18–43.

Quiquère, Georges. "30 ans de Bande Dessinée française." *La Vie Ouvrière* 1593, March 12, 1975. Article available at http://193.251.82.94/pif-collection/master.html?http://193.251.82.94/pif-collection/roger_lecureux_30ans.bd.html.

Rabelais, Françoise. *The Complete Works of Rabelais, Gargantua and Pantagruel*. Trans. Jacques Le Clercq. New York: The Modern Library, 1936.

"Relaxe requise par le parquet pour Charlie Hebdo." France5.fr., February 12, 2007.

Renard, Jean-Bruno. *Clefs pour la bande dessinée*. Paris: Seghers, 1978.

"Report for 1997." *L'Edition de Livres en France*, 1998. Paris: Syndicat national de l' Edition.

Rioux, Jean-Pierre. *The Fourth Republic, 1944–1958*. Trans. Godfrey Rogers. Cambridge: Cambridge University Press, 1989.

Robb, Graham. *The Discovery of France, A Historical Geography from the Revolution to the First World War*. New York: W. W. Norton & Co., 2007.

Roberts, MaryLouise. *Civilization without Sexes: Reconstructing Gender in Postwar France, 1917–1927*. Chicago: Chicago University Press, 1994.

———. *Disruptive Acts: The New Woman in Fin de Siècle France*. Chicago: Chicago University Press, 2002.

Rockwell, John. "In a Venerable French City, the Comic Book Seeks a Future." *New York Times*, January 29, 1994.

Rosenczveig, Jean-Pierre. "DEI Communiques Commentaires." May 5, 2007. Online at: http://www.dei-france.org/DEI-communiques-commentaires/2007/Lettre_defenseure_asterix.pdf.

Ross, Krisitin. *Fast Cars, Clean Bodies: Decolonization and the Reordering of French Culture*. Cambridge, MA: MIT Press, 1996.

Rousso, Henry. *The Haunting Past: History, Memory, and Justice in Contemporary France*. Trans. Ralph Schoolcraft. Philadelphia: University of Pennsylvania, 2002.

———. *The Vichy Syndrome: History and Memory in France since 1944*, rpt. ed. Trans. Arthur Goldhammer. Cambridge, MA: Harvard University Press, 2004.

Royal, Ségolène. *Le ras-le-bol des bébés zappeurs*. Paris: Robert Laffont, 1989.

Rubenstein, Anne. *Bad Language, Naked Ladies, and Other Threats to the Nation: A Political History of Comic Books in Mexico*. Durham, NC: Duke University Press, 1998.

Sadoul, Georges. *Ce Que Lisent vos Enfants: La presse enfantine en France, son histoire, son évolution, son influence*. Paris: Bureau d'Éditions, 1938.

Sahlins, Peter. *Boundaries: The Making of France and Spain in the Pyrenees*. Berkeley and Los Angeles: University of California Press, 1989.

Said, Edward. "Reflections on American 'Left' Literary Criticism." *The World, the Text, and the Critic*. Cambridge, MA: Harvard University Press, 1983.

Sanford, Alasdair. "French magazine sells quickly," BBC News, Paris, February 9, 2006. Online at: http://news.bbc.co.uk/go/pr/fr/-/2/hi/europe/465292.stm.

Sante, Luc. "She Can't Go Home Again," *New York Times*, August 22, 2004. Online at: http://query.nytimes.com/gst/fullpage.html?res=9A01E7DF173FF931A1575BC0A9629C8B63&sec=&spon=&pagewanted=1.

"Savez-vous ce qu'il y a dans les journaux d'enfants?" *Éducateurs* 11 (1947): 452.

Schain, Martin. "The National Front and the French Party System." *French Politics and Society* (Winter 1999).

Shaya, Gregory. "The Flâneur, the Badaud, and the Making of a Mass Public in France." *American Historical Review* 109, no. 1 (February 2004): 41–77.

Shennan, Andrew. *Rethinking France: Plans for Renewal 1940–1946*. New York: Oxford University Press, 1989.

Siegfried, André. *America Comes of Age*. Trans. H. H. Hemming and Doris Hemming. London: Jonathan Cape, 1927.

Silbermann, Alphons, and H. D. Dyroff, eds. *Comics and Visual Culture: Research and Studies from Ten Countries*. München: K. G. Saur, 1986.

Silver, Kenneth E. *Esprit de Corps: The Art of the Parisian Avant Garde and the First World War (1914–1925)*. Princeton, NJ: Princeton University Press, 1989.

Smith, Craig S. "The Islamic Flare-Up: France; Next Step by Weekly in Paris May Be to Mock the Holocaust." *New York Times*, February 9, 2006: Late Edition, A14.

Spang, Rebecca L. *The Invention of the Restaurant, Paris and Modern Gastronomic Culture.* Cambridge, MA: Harvard University Press, 2000.

Spiegelman, Art. *Maus: A Survivor's Tale.* New York: Pantheon Books, 1993.

———. *In the Shadow of No Towers.* New York: Pantheon Books, 2004.

Spigel, Lynn. "Innocence Abroad: The Geopolitics of Childhood in Postwar Kid Strips." In *Kids' Media Culture*, ed. Marsha Kinder. Durham: Duke University Press, 1999.

Starkey, Hugh. "Bande Dessinée: The State of the Ninth Art in 1986." *Contemporary France: A Review of Interdisciplinary Studies*, 3 vols., ed. Jolyon Howorth and George Ross. London: Frances Pinter, 1987.

Stevenage, Sarah. "Can Caricatures Really Produce Distinctiveness Effects?" *British Journal of Psychology* 86, no. 1 (February 1995): 127–147.

Storace, Patricia. "A Double Life in White and Black." *New York Review of Books* 52, no. 6, April 7, 2005.

Stovall, Tyler. "Introduction: Bon Voyage!" *French Historical Studies* 25, no. 3 (Summer 2002): 415–422.

Sullerot, Evelyne. *Bande Dessinées et Culture.* Paris: Opera Mundi, 1966.

Sweets, John F. *Choices in Vichy France: The French under Nazi Occupation.* Oxford: Oxford University Press, 1986.

———. *The Politics of Resistance in France, 1940–1944: A History of the Mouvements Unis de la Resistance.* De Kalb: Northern Illinois University Press, 1976.

Talbott, John. *The War without a Name: France in Algeria 1954–1962.* London: Faber, 1980.

Tiersky, Ronald. *François Mitterand.* New York: Palgrave MacMillan, 2000.

Tilleul, Jean-Louis. *Pour analyser la bande dessinée: Propositions théoriques et pratiques.* Louvain-la-Neuve: Academia, 1987.

Töpffer, Rodolphe. *Enter: The Comics, Rodolphe Töpffer's Essay on Physiognomy and the True Story of Monsier Crépin.* Trans. and ed. E. Weise. Lincoln: University of Nebraska Press, 1965.

———. *Töpffer: L'Invention de la bande desinée.* Ed. Thierry Groensteen and Peeters Benoit. Paris: Hermann, 1994.

Trigon, Jean de. *Histoire de la Littérature Enfantine, De Ma Mère l'Oye au Roi Babar.* Paris: Hachette, 1950.

Trilling, Lionel. "The Princess Casamassima." *The Liberal Imagination: Essays on Literature and Society.* New York: Viking Press, 1950.

Trumpbour, John. *Selling Hollywood to the World: U.S. and European Struggles for Mastery of the Global Film Industry, 1920–1950.* Cambridge: Cambridge University Press, 2002.

Turkel, Stanley. "Raymond Orteig and 'Lucky Lindy': How A NYC Hotelier Helped Conquer the Atlantic." *Cornell Hotel and Restaurant Administration Quarterly* 43, no. 2 (April 2002): 72–74.

Ungar, Steven, and Tom Conley, eds. *Identity Papers: Contested Nationhood in Twentieth-Century France.* Minneapolis: University of Minnesota Press, 1996.

Vaisse, Pierre. "Dix ans de grands travaux." *Contemporary French Civilization* 15 (Summer/Fall 1991): 310–328.

Varnum, Robin, and Christina T. Gibbons, eds. *The Language of Comics: Word and Image.* Jackson: University Press of Mississippi, 2001.

"Very Droll." *Economist*, December 20, 2003. Online at: http://www.economist.com/diversions/displaystory.cfm?storyid=2281647.

Vihlen, Beth. "Sounding French: Jazz in Postwar France." Ph.D. dissertation, State University of New York, Stony Brook, 2000.

Wakeman, Rosemary. "Nostalgic Modernism and the Invention of Paris in the Twentieth Century." *French Historical Studies* 27, no. 1 (Winter 2004): 115–144.

Wallon, Henri, ed. *Les Journaux pour enfants.* Numéro spécial de la Revue *Enfance.* Paris: Presses Universitaires de France, 1954.

Weber, Eugen. *The Hollow Years: France in the 1930s.* New York: W. W. Norton & Co., 1994.

———. *Peasants into Frenchmen: The Modernization of Rural France, 1870–1914.* Stanford, CA: Stanford University Press, 1976.

Wechsler, Judith. *A Human Comedy: Physiognomy and Caricature in the Nineteenth Century.* Chicago: University of Chicago Press, 1982.

Weil, Patrick. *Qu'est-Ce Qu'un Français? Histoire de la nationalité française depuis la Révolution.* Paris: Bernard Grasset, 2002.

Werth, Alexander. *The Twilight of France: 1933–1940, A Journalist's Chronicle.* London: Hamish Hamilton, 1942.

Wertham, Fredric. *Seduction of the Innocent.* New York: Rinehart & Company, 1954.

West, Richard. *Satire on Stone: The Political Cartoons of Joseph Keppler.* Champaign-Urbana: University of Illinois Press, 1988.

Wilson, Stephen. "The Anti-Semitic Riots of 1898 in France." *Historical Journal* 16, no. 4 (December 1973): 789–806.

Wohl, Robert. *A Passion for Wings: Aviation and the Western Imagination, 1908–1918.* New Haven, CT: Yale University Press, 1996.

Wolinski, Georges, Jean-Claude Simoën, and Pierre Duvernois (Rapporteur). "Rapport Sur La Promotion et La Conservation Du Dessin De Presse." *Mission Wolinski*, Mars 2007. Online at: http://www.culture.gouv.fr/culture/actualites/rapwolinski.pdf.

Wolk, Douglas. "Art Spiegelman's audacious but ultimately leaden take on Sept. 11, and a trio of contrasting delights." *Washington Post*, September 12, 2004: T13.

World Briefing / Asia-Pacific. "Japan: National Defense as a Comic." *New York Times*, July 7, 2004.

Wright, Gordon. *France in Modern Times: From the Enlightenment to the Present*, 5th ed. New York: W. W. Norton & Co., 1995.

Yagil, Limore. *"L'Homme Nouveau" et la Révolution Nationale de Vichy (1940–1944).* Paris: Presses Universitaires du Septentrion, 1997.

Yuval-Davis, Nira. *Gender and Nation.* London: Sage Publications, 1997.

Index